PICASSO'S CERAMICS

NORTON GALLERY & SCHOOL OF ART, INC.

GEORGES RAMIÉ

PICASSO'S CERAMICS

Translated from the French by KENNETH LYONS

A STUDIO BOOK

THE VIKING PRESS

NEW YORK

CÉRAMIQUE DE PICASSO

© *Ediciones Polígrafa, S. A. in Barcelona (España)*

Published in 1976 by The Viking Press, Inc.
625 Madison Avenue, New York, N. Y. 10022

Reproduction rights SPADEM - Paris

LIBRARY OF CONGRESS CATALOGING IN PUBLICATION DATA

Ramié, Georges.
 Picasso's ceramics.

 (A Studio book)
 Translation of Céramique de Picasso.
 Includes index.
 1. Picasso, Pablo, 1881-1973. 2. Pottery, French.
 3. Ceramic sculpture - France. I. Title.

NK4210.P5R2813 738'.092'4 76-2690
ISBN 0-670-55323-9

Printed in Spain by La Polígrafa, S. A. - Balmes, 54 - Barcelona-7 - Spain · Dep. Legal: B. 26061 - 1976

Contents

	Prologue	7
I.	Ceramics: a new adventure	10
II.	The art of making people live and see	19
III.	The challenge of new materials	39
IV.	The mastery of the technique	54
V.	The moment of confrontation	90
VI.	The potter's wheel	100
VII.	Research and experiments	147
VIII.	The possibilities of ceramics	210
IX.	A limitless creation	232
X.	An over-punctilious fortune	256
XI.	Forms of Picasso's ceramics	258
XII.	Rendezvous at Vallauris	266
	Works in Series	276
	Index of Illustrations	282

When this book was still in the press, Picasso's artistic activity seemed more intense than ever. So much was this the case that shortly after his death it was possible to hold an important exhibition of his new works, at which only a scant selection of his recent creations were represented. From 1946 to 1953 the great artist devoted himself particularly to ceramics, though without ceasing to work in painting, sculpture and engraving. Nevertheless he afterwards felt the need to return to this art form, often attracted by the unusual possibilities offered by the material used and by the flexibility with which he could adapt it to the dictates of his imagination. Considering the total commitment that characterized Picasso, there was every reason to hope that we should be able to admire still further series of ceramics from the Vallauris kilns.

The great artist's death, on 8 April 1973, put an abrupt end to his immense production, the richest and most meaningful of our time. Among the various facets of the total *œuvre* he left us, his work in ceramics has hitherto received little attention from the specialists, for the most part on account of the difficulty of localizing and studying the pieces. The need was felt for as complete a book as possible on the ceramics of Picasso; and no one could carry out this task better than Georges Ramié, who step by step observed this venture of the master whose collaborator he had been.

This present work deals with single pieces of ceramic, engraved pieces —of which various copies were made— and, lastly, copies of originals by Picasso, made on the latter's express authority.

In publishing this book the editors wish to help to make better and more widely known the work and personality of Picasso, and to offer their contribution to the homage due to the living reality of his art.

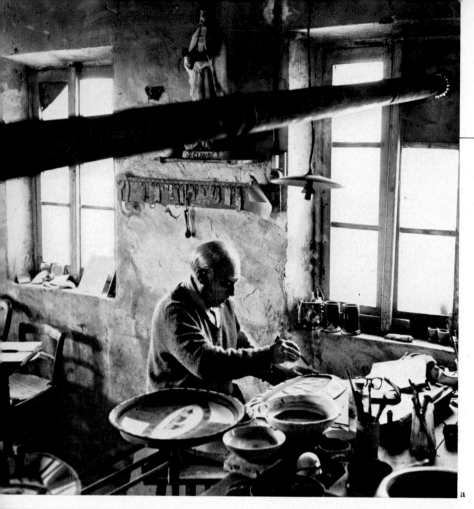

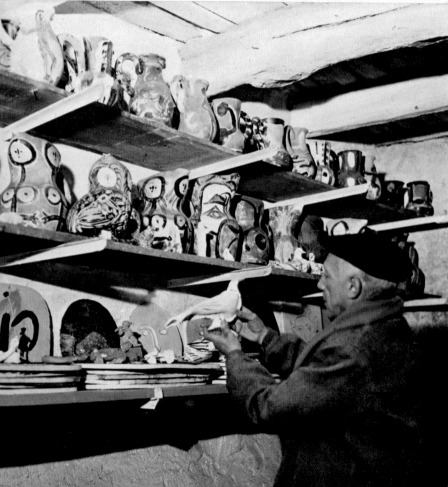

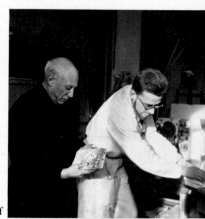

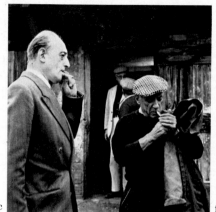

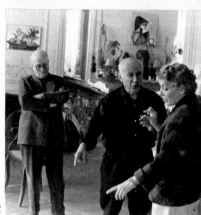

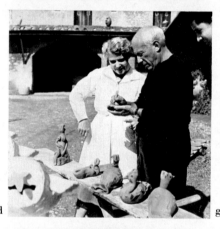

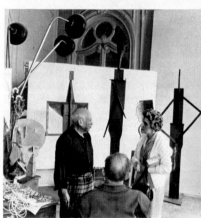

a. Picasso at work in the Madoura pottery.
b. Picasso with some of his ceramics.
c. Picasso and Georges Ramié.
d. Suzanne Ramié watches Picasso signing one of his works.
e. Yan, the dog, surrounded by Provençal tiles prepared for ceramics, at the Villa Californie.
f. Picasso with Jean Ramié, examining one of his pieces.
g. From left to right: Jaime Sabartés, Picasso and Mme. Ramié.
h. Georges and Suzanne Ramié at Picasso's home, the Villa Californie, near Cannes.
i. Picasso at work in the Madoura pottery.

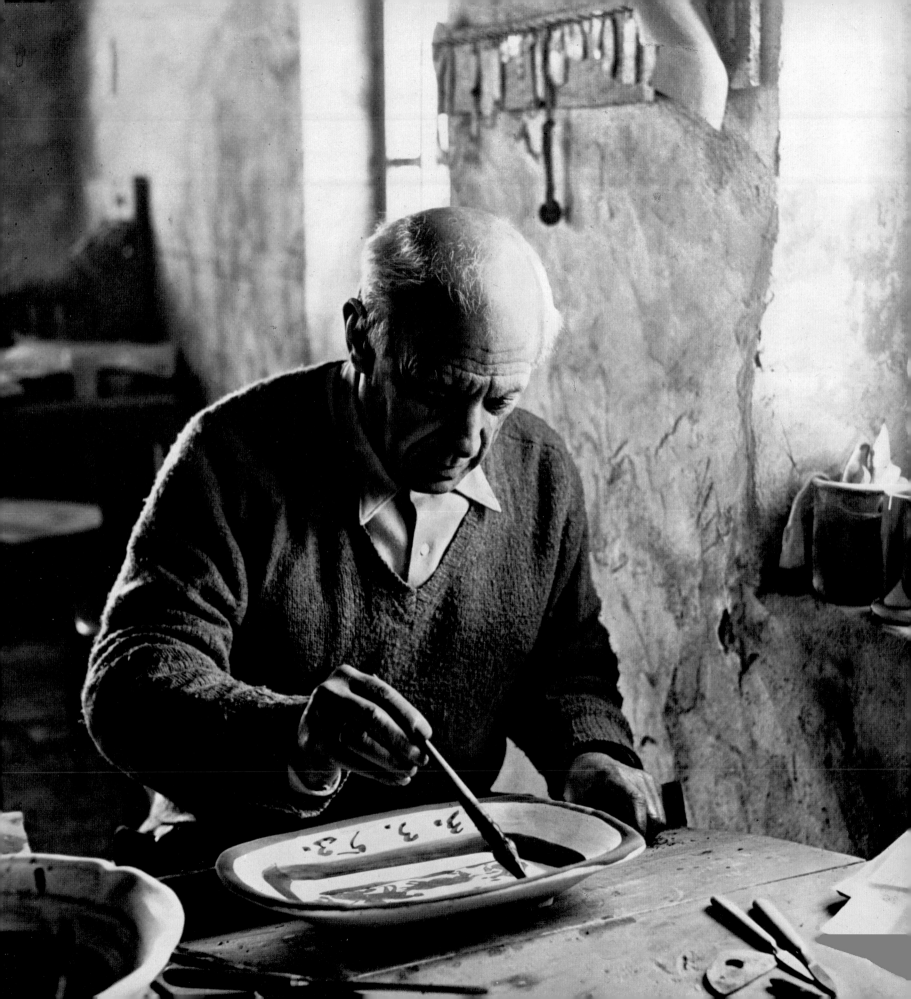

I. CERAMICS: A NEW ADVENTURE

Picasso 1946! A crucial epoch if ever there was one, when fate was slyly weaving its invisible yarns into a sequence of facts as yet uncertain, but which the future was to inscribe and illumine in the history of great deeds or small.

It was in that year, on 21 July to be exact, that Picasso, holidaying at Golfe Juan and probably having nothing very urgent to do, conceived the notion of visiting an exhibition he had heard well spoken of at the nearby village of Vallauris, where various local products were being shown, but above all and most particularly the works of about a score of the Vallauris potters.

The presence of these potters in Vallauris was originally due to the upheavals of population brought about by the still recent war, which had brought a whole phalanx of artists and craftsmen —from all over France and even from abroad— to seek a haven in this little Provençal town, where for thousands of years the livelihood of the inhabitants had depended on the local clay, baked over crackling logs from the neighbouring pine woods.

Peace to work in and means ready to hand —with the help of a certain degree of inventiveness— were to allow each one entire fullness of spirit to elicit the patient sap of his experience, his aspirations and his talent.

Working as they did with a constant passion, these artists liked to present some evidence of their activity and their merits at this traditional exhibition, held every year to show their work to the Riviera collectors.

It must be admitted that by 1946 their reputation was sufficiently established to justify Picasso's expectation of finding something worthy of an encouraging curiosity on this impromptu Sunday visit. And it is now even clearer that, in this group manifestation aimed at a common ideal, their collective presence, their faith and the wide range of their works had succeeded in establishing a centre for projects and a cynosure of encouragement towards the most favourable of destinies and the finest hopes. And so, though doubtless unintentionally, they had traced a noble path into the future for the man for whom this place had been predestined.

And now he had come! From curiosity certainly, but without doubt, through interest. This ceramic material, if not for him a revelation, nevertheless offered forms of plastic expression far from being definitive yet with a very wide range, infinitely variable in their processes and ever propitious to invention. Their generous solicitations held, for a spirit like that of Picasso, a powerful seduction.

1. Plate. Centaur and giant fighting. 29×65.5 cm. Dated 20-10-47.

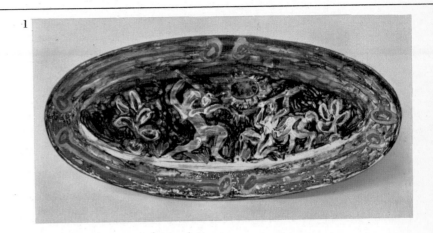

So ready was our tourist to be won over by such an allure, that shortly afterwards he abandoned his carefree summer holiday and, accepting the mischievous whims of fortune, became the most absorbed and attentive workman imaginable. Carried away by his vital need to discover all, he suddenly succumbed, and with infinite delight, to the temptation —provoked, whether consciously or not, by himself— to penetrate the mysteries of earth and fire. With fitting reverence he approached this magical material, so sensitive to a mere stroke of the thumb yet so implacable in its reactions to the least variations of humidity, so stubborn in the hands of the uncomprehending yet so docile when treated with respect, a material so fragile while it is still in the shaping, totally dazzled from its recent metamorphosis for all that, in order to become from then on incombustible and imperishable, still to be purified by the terrifying ordeal of fire.

For here, indeed, this substance of so precious a humility becomes, by its permanence, the truest bearer of the message of mankind: however far back in time one goes, the evidence of humanity from the earliest epochs reaches us, not engraved in stone which crumbles to dust and erodes, not cast in metal which rusts and powders, but on little tablets of baked clay, with graphic signs as expressive today as when beneath the stylus of the scribe who traced them.

All this, Picasso knew. And in order to know it still better he was to come face to face with all the exigencies, all the uncertainties, all the restlessness of this austere craft. But on the other hand he was to become enchanted by the sense of its magnificence, by the revelation of its surprises. He was to consent to meditate wisely certain propositions of occasionally deceptive nature, to be able, then, to accept the material for itself and pose to it, in his turn, some questions.

From the time of his arrival, on this spontaneous call as an interested bystander, Picasso was received with all the consideration due to his renown and to his authority. Surrounded, as he so often liked to be, by a whole retinue of friends, he at once took an interest in the total scene, in everything happening around him, in everything he ascertained, in everything he assumed. He was provided swiftly with a corner of a bench and a lump of well-kneaded clay, which he seized with enthusiasm. That day, three pieces emerged from his hands: three pieces which stayed there and remain still, for the witnesses of those exciting hours, the most powerful of talismans. Much rarer than any prototypes, they represent for us all the most precious preface to an epoch

2. Plate. Faun's head. 31.5 × 37.5 cm. Dated 15-10-47.
3. Plate. Faun's head. 32 × 38 cm. Dated 11-10-47.
4. Plate. Faun's head. 32 × 38 cm. Dated 16-10-47-X.

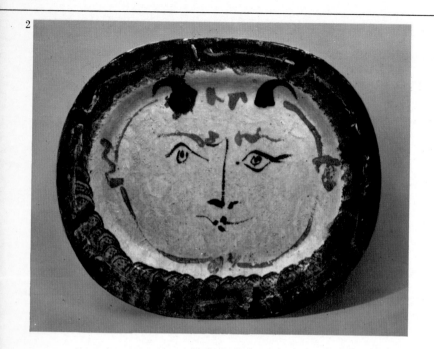

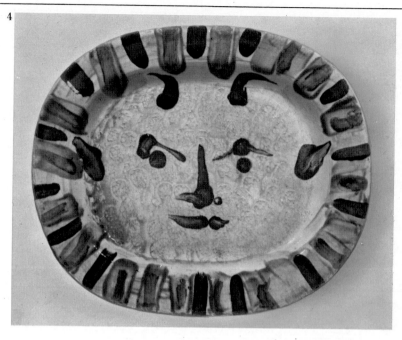

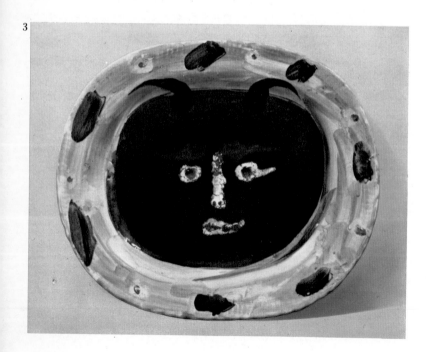

fruitful in works and in friendship, of too rare worth: a little head of a faun and two bulls modelled by hand. A good many years later, celebrating the memory of those historic moments, these three little pieces for the joy of all were cast in bronze.

Once finished, they stayed on the bench to be completely dried before being baked in the kiln, but their author disappeared without sending any news.

The months elapsed, the pieces left behind could have been fired over and over again and we believed that this attempt, to Picasso's mind, constituted only a nice pastime that allowed him to occupy himself pleasantly, in a potter's studio, always cool, one midsummer afternoon.

But —exactly as in the *Romaunt de la Rose*— one year later to the day, Picasso, again on holiday, took the route of Vallauris and of its Exhibition. He rediscovered with delight the studio of his

5. Plate. Faun's head. 32 × 38 cm. Dated 10-47.
6. Plate. Woman's head. 32 × 38 cm. Dated 1947.
7. Plate. Bird. 32 × 38 cm. Dated 1947.
8. Plate. Spotted face. 32 × 38 cm. Dated 1947.

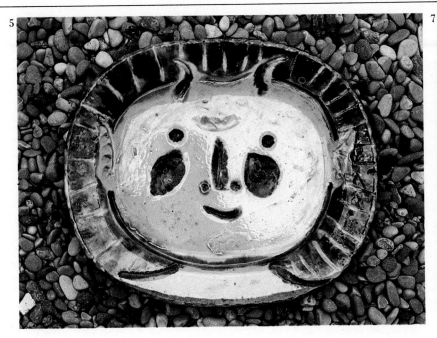

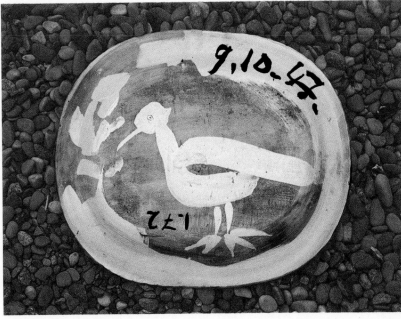

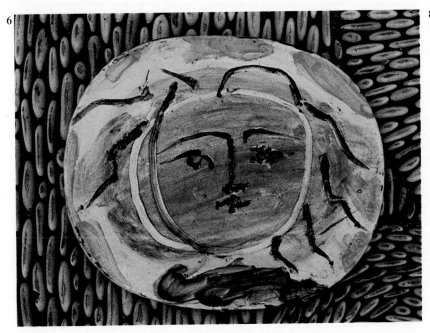

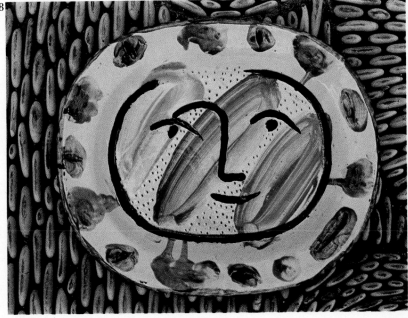

14

9. Plate. Polychrome face. 32×38 cm. Dated 1947.
10. Plate. Small incised face. 32×38 cm. Dated 1947.
11. Plate. Painted face. 32×38 cm. Dated 1947.

9

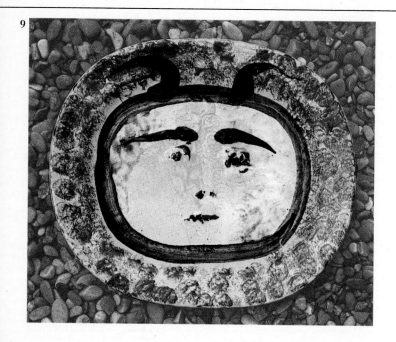

11

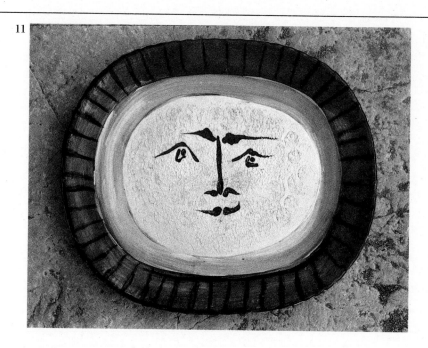

10

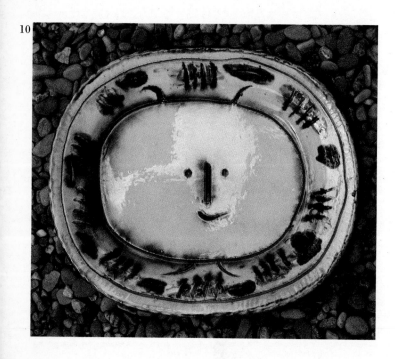

first trial and, with an exultant surprise, the three pieces of the preceding year, which, in an excess of unreasoning pessimism, he had thought lost in one never knows what final mishap.

This time, however, he did not appear as an amateur; during the winter, this episode of summertime ceramics had held his imagination in a state of permanent disquiet: he had studied a multitude of projects, and this time he presented himself laden with the sketches all accumulated during the course of these promising meditations. When Picasso collides with a question, he immediately ignores common reality. He now brought with him a cardboard box full of designs: to be displayed, discussed, argued over, wondered at. This time, apparently, he was seriously interested: thus the great new adventure begins.

That day Picasso took possesssion of a place of his own in our workshop, that venerable workshop hundreds of years old, in which so many generations of potters down through the centuries

12. Plate. *Corrida.* 31.5 × 37.5 cm. Dated 1947.

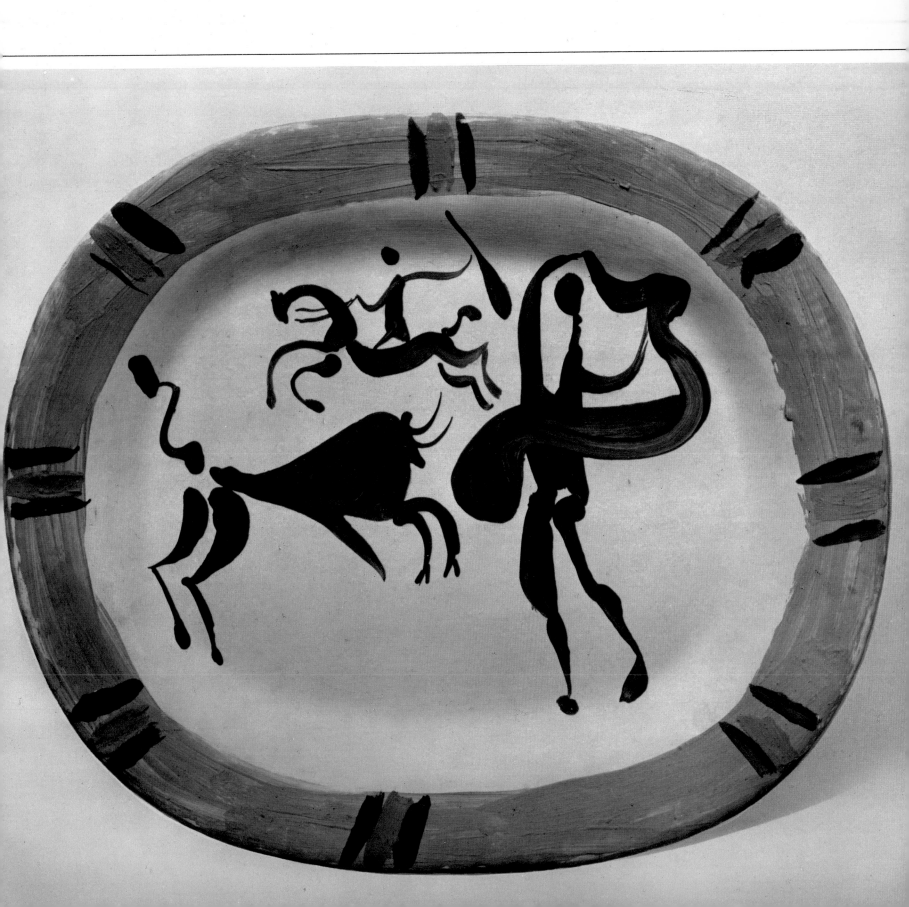

13. Plate. Bearded faun's head (on blue ground). 38 × 32 cm. Dated 11-12-47-II.
14. Plate. Centaur with bow. 31.5 × 37 cm. Dated 1947.
15. Plate. Fish (in relief). 38 × 31.5 cm. Dated 1947.
16. Plate. Bird. 32 × 38 cm. Dated 2-10-47.

13

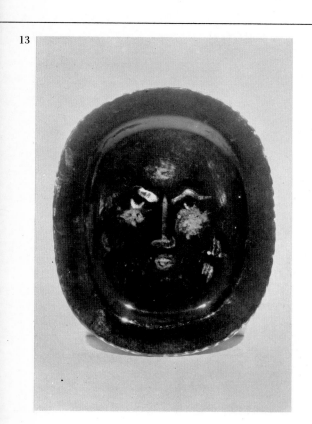

14

17

15

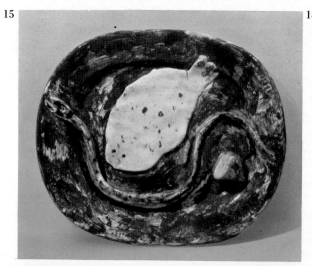

18

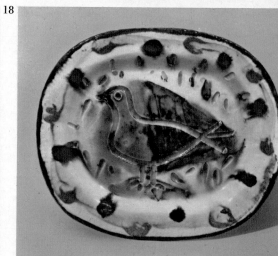

16

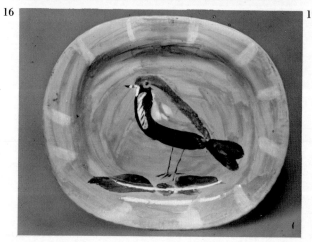

19

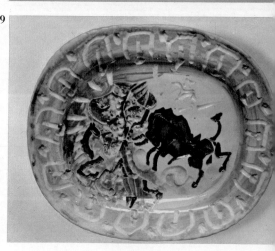

17. Plate. Water-melon. 37.5×31 cm. Dated 1947.
18. Plate. Bird. 31.5×38 cm. Dated 1947.
19. Plate. *A pass with the cape.* 32×38 cm. Dated 24-9-47.
20. Composition of four elements. Faun's head. 50×40.5 cm. Dated 1947.
21. Plate. Faun's head. 38×32 cm. Dated 19-1-48-IV.

20

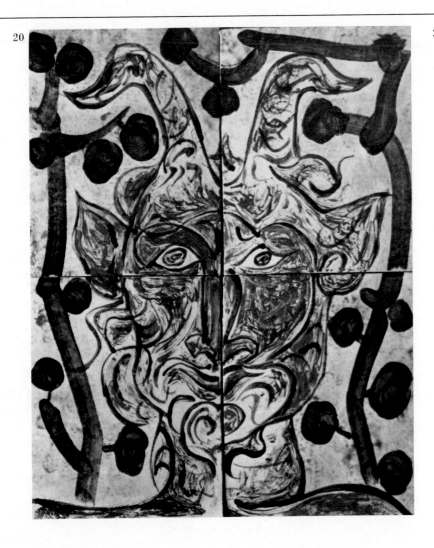

21

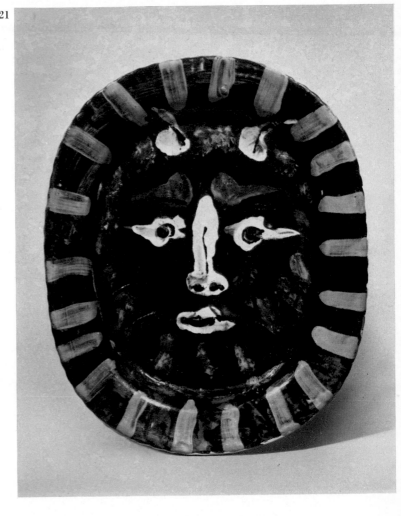

have fashioned thousands and thousands of every-day objects in the honest clay of Vallauris. Like these potters he sat down at his bench and —exacting, diligent, alert, almost feverish, taciturn— he too began his first piece, the forerunner of the multitude of pieces he was to shape throughout these long years of hard, ceaseless work. Forsaking Paris, his habits and his friends (even neglecting his brushes, his pencils and his graver), he deliberately broke through the visionary frontier of his new mission.

Unnecessary to add, he gave himself up to it heart and soul, with that tireless vehemence he brought to everything, the indomitable ardour of those vocations that are all the more fruitful for being slow to appear. And it was from that moment —and thanks to the prestige of the work Picasso was to do— that ceramics, which many had always considered a minor art, began to enjoy an eminence hitherto unsuspected and now universally admitted.

All this happened over twenty years ago, twenty years that have fled with the lightness of a breath, swift as the invisible flight of an arrow, and yet incomparably rich in treasures, for in the relativity of one man's existence the most indefin-

able factors may play their part in the cycle of time: the overlong time of events that never quite come to pass, the fleeting time in which everything happens with the brutal intensity of lightning, the time of too-distant memories, the hours of burning fever in which all ideas are lost, the hours of grating impatience that crush, stretch and devour themselves in defiance of reason.

Throughout those years that we evoke today, as much with emotion as with respect, all these multiple factors, whose very essence is the salt of life, may well have mingled day after day in the spirit, the hands and even the tools of Picasso, this great workman, so meticulous, impatient and tenacious. How many alarms, indeed, must startle those hours in which, diligent and secretive, he sets formidable snares for the fire. How much ill-contained impatience must possess him when, in the closed and silent depths of their incandescent chamber, the mysteries of volatile exchanges and the evolution of imponderable substances are slowly working out. How much interest, too, when his pieces emerge from the kiln and he discovers the answers to his questions, sometimes propitious, sometimes surprising, but always, as he says himself, passionately absorbing.

And so, taking shape from the continuous pooling of intentions, projects and ideas, this immensely fertile period has seen the completion of that marvellous expansion that conditions the attachment of beings and things in a process of serene ripening. In a sequence of circumstances in which nothing counts but the accomplishment of what has to be done, everything tends, naturally, to a harmonious concourse of effort towards the goal one is seeking.

In truth the value of time in its evanescent flow can be measured by the rhythm of our heart, that marvellous sand-glass of our most secret moments, which the weight of our sentiments empties, accelerates or slows down, making the sands of our life too light or too heavy.

But for those of us fortunate enough to experience them, the auspicious hours of those years of salutary interdependence were hours of fullness, hours that passed with incomparable lightness.

II. THE ART OF MAKING PEOPLE LIVE AND SEE

Despite all those constant interchanges, despite all the shared intentions, despite the years spent working side by side, to pretend to define Picasso still seems to me a presumptuous enough undertaking. After this daily life in which, with the same words, the same tools and even the same feelings, we also shared the same sense of striving to make identical discoveries, there are still countless imponderables that make it impossible to analyse what it is, in this exceptional man, that goes to make up the person, the personage, the personality.

It is true, indeed, that every human being is multiple in himself, uniformly variable at every moment, constantly transformed by the incessant impetus of individual evolution throughout the fateful course of life. Are we really the same this evening as we were this morning? Or the same today as yesterday? Can we say that ten years from now we shall be anything like what we are at this moment? This diversity of individuals, as much from one to the other as within each one, very naturally comes from the proportion of constancy or variability evinced by each character in the existential rhythm of his perceptions and reactions.

And it is at this point that we are faced with the vexing problem of creative imagination, which intrudes upon and takes possession of the spirit, the judgment and sometimes even the hand of the man it visits.

If, in this way, Picasso evolves in his day-to-day activities, he becomes many-sided at the very moment when, in whatever work he is engaged on, he is visited by these attitudes. One can feel some mysterious current running through him, a sudden sequence of imperious influences that must be obeyed immediately, in accordance with an irresistible power that must be satisfied wholly and essentially.

This inner force that takes possession of him hastens his inventive progress in an effort to assuage this unquenchable thirst to express the message of the moment. To express it but also to consume it, in a course of long duration in which an obsessive theme is taken up again and again in proliferating and continually renewed variations, reflecting the teeming intensity of the changing aspects of composition.

Thus one begins a cycle within which develop, in successive sequences, a multitude of modulations in chromatic evolution of a theme that will be treated with passion to the furthest conceivable limit.

A limit which, any day, can be extended to infinity or can give way to other, parallel medi-

22. Plate. Fish. 31 × 38 cm. Dated 1948.
23. Plate. Octopus. 32 × 38 cm. Dated 1948.
24. Plate. Black-pudding and eggs. 31 × 37 cm. Dated 1948.

22
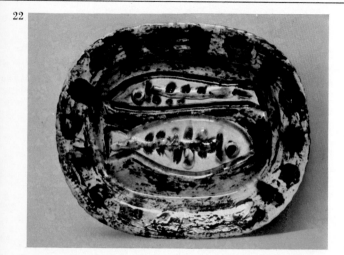

23
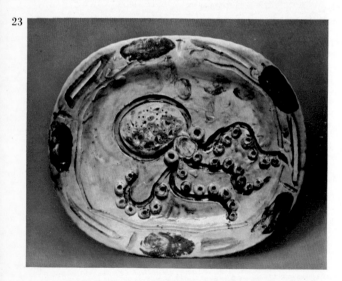

24
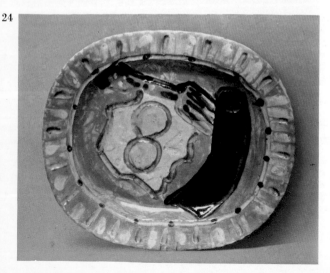

tations, under the ascendancy of an enormous and generous wealth of invention, unpredictable in its substance and constantly reborn in protean visions.

In this dramatic universe that Picasso creates for us in such disconcerting profusion we can divine a temperament in perpetual tension, relentlessly pursuing its quest and subject to every contrast. A person who knows how to seek out the treasures hidden in the depths of his work may find Picasso, at one and the same time, quite strictly consequent in the most chaotic diversity, firmly disciplined and full of rectitude, yet with the air of a frenzied libertarian, zealous and respectful within apparently anarchic distortions, his flashing line the result of unhurried meditations, sometimes even harmonious amidst the most destructive stridencies, perfectly balanced in the shattering of fragments, sumptuous in the simplicity of his means, spiritedly seeking truth in the excess of his forms, capable of evoking tenderness just when the line is most particularly violent and of maintaining a seemly restraint in the midst of the most tortuous intricacies.

But these are just superficial appearances, a vivid testimony of his constant quest for discipline in discovery, unceasingly vigilant in giving and taking, becoming abundant and also recollecting himself, cursing and repenting in the same breath, letting sparks fly in order to unbosom himself all the better immediately afterwards.

Discipline, certainly...! But then this is a word that very easily, among some people, suggests a thought of scandal...! This monumental *œuvre* does indeed have the unformulated aspect of absolute freedom in its indefatigable impetus, its unremitting effort to renew and reconstruct appearances, to re-create concepts and to revise plastic notations. All of which is true, provided

25. Plate. Face. 32 × 38 cm. Dated 1948.
26. Plate. Faun's head. 38 × 32 cm. Dated 10-3-48-IV.
27. Plate. Faun's head. 38 × 32 cm. Dated 10-3-48-III.

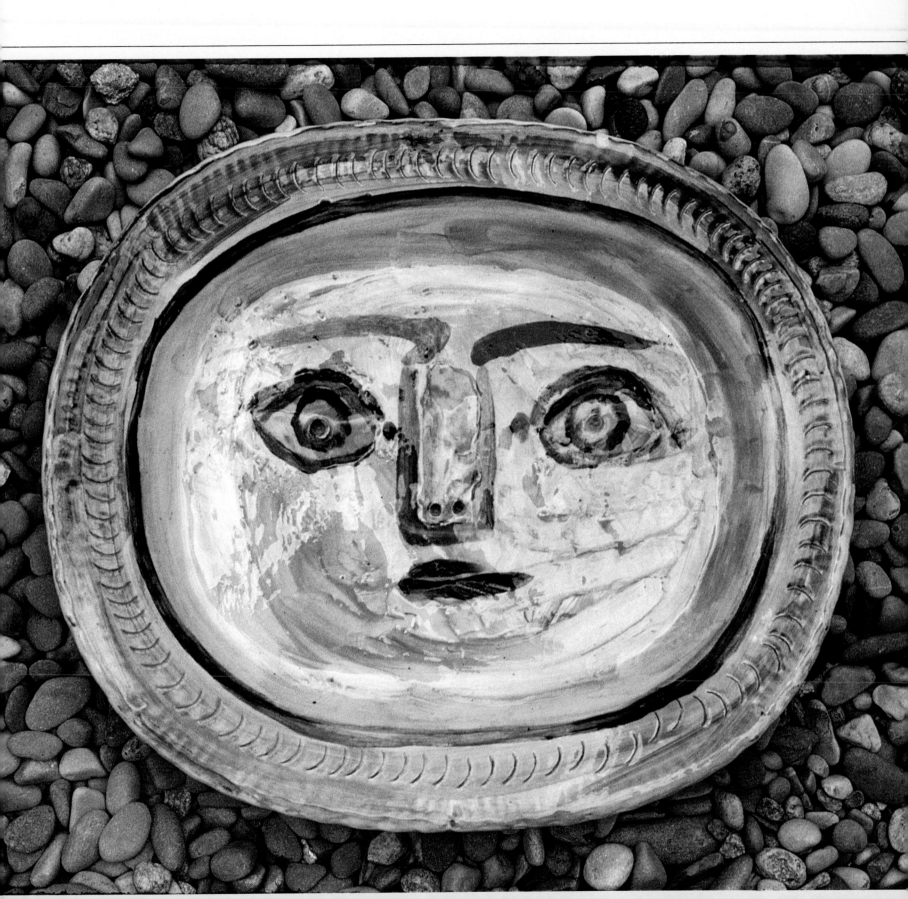

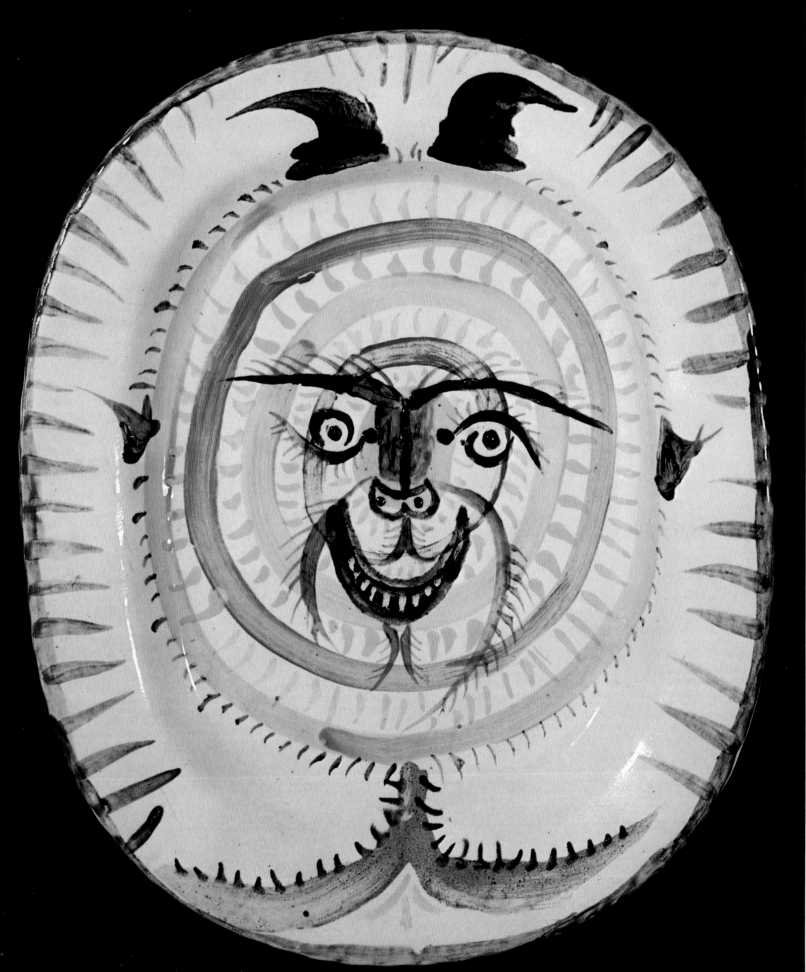

26

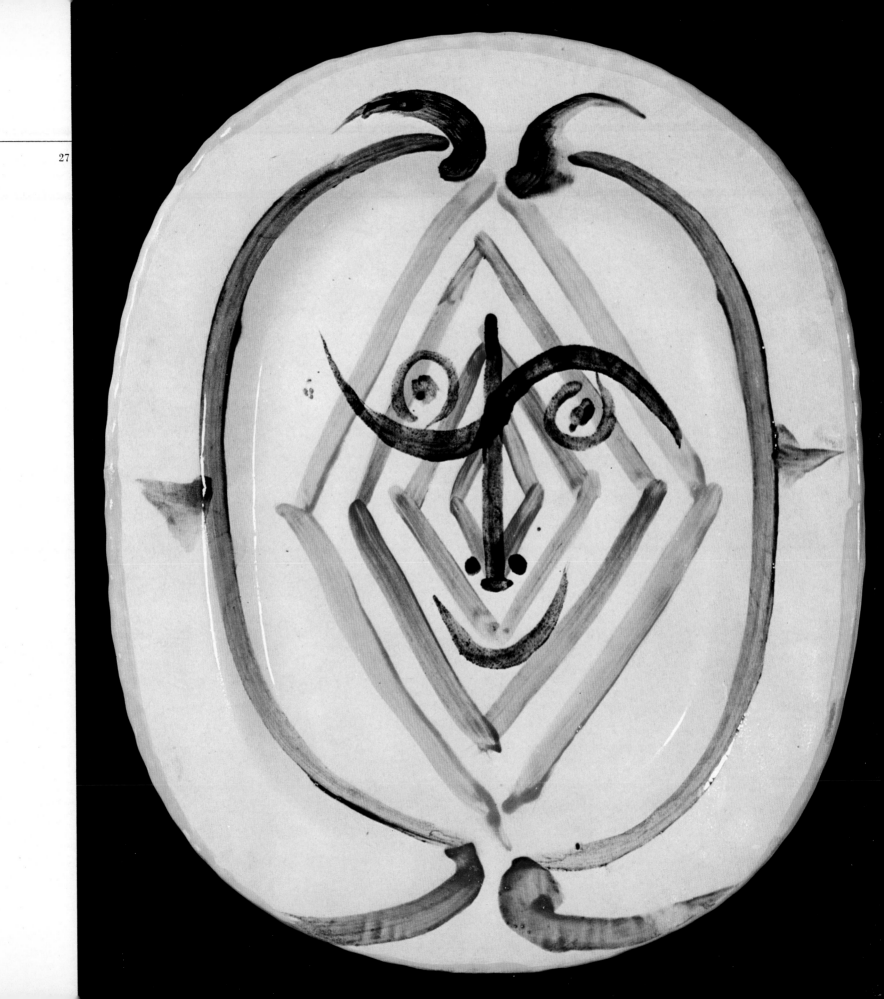

28. Plate. *Banderillero.* 32 × 37 cm. Dated 1948.

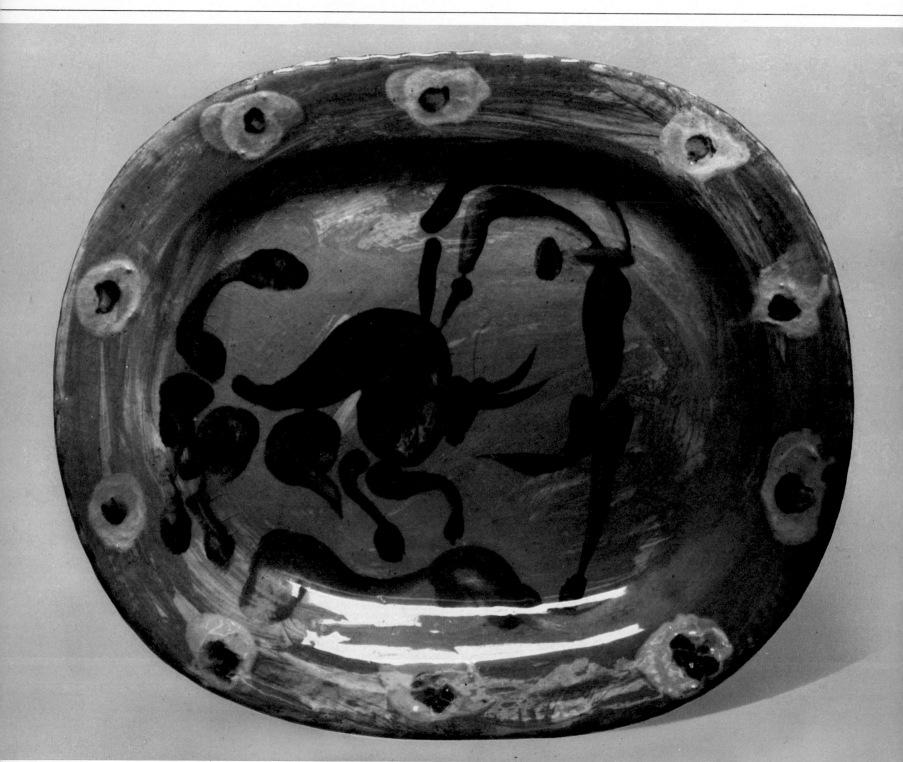

29. Plate. Faun's head. 39 × 32 cm. Dated 10-3-48.

29

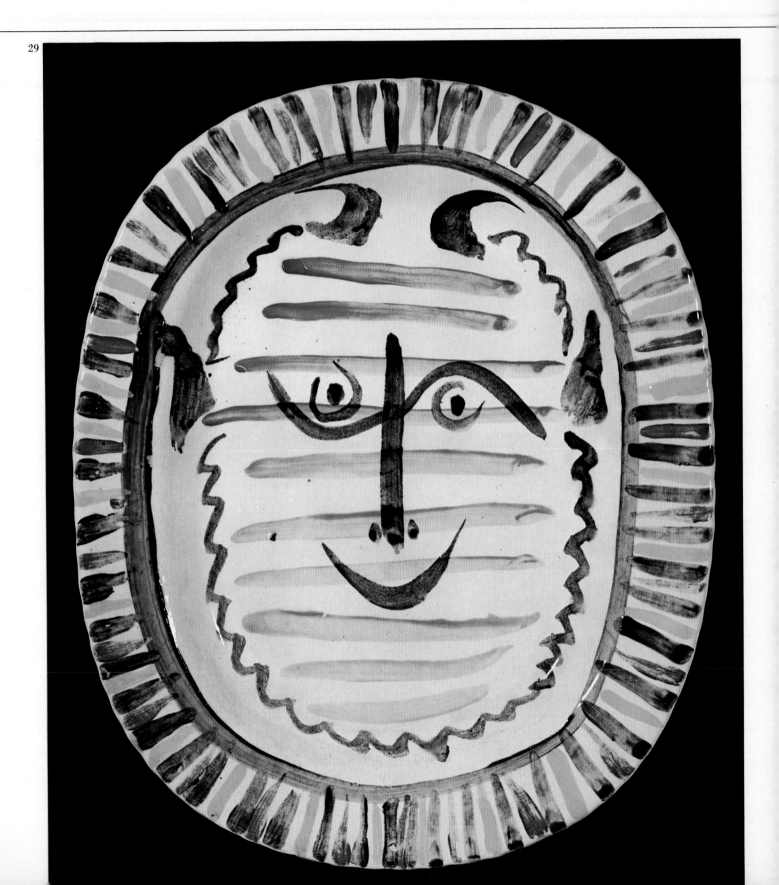

30. Oval plate. Faun's head. 29 × 65.5 cm. Dated 8-3-48-II.
31. Plaque. Woman's bust. 52 × 32.5 cm. Dated 1948.
32. Plaque. Woman's head. 36 × 33.5 cm. Dated 1948.
33. Plate. Faun's head. 32 × 38 cm. Dated 9-3-48-I.

34. Plaque. Coffee-pot and glass. 33.5 × 36 cm. Dated 1948.
35. Plate. Faun's head. 38 × 32 cm. Dated 12-3-48.
36. Plate. Faun's head. 32.5 × 38.5 cm. Dated 6-3-48-II.
37. Plaque. Fruit-dish. 33 × 52.5 cm. Dated 1948.

30
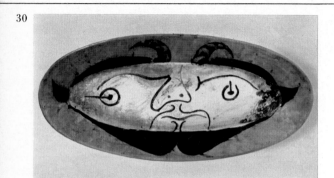

32
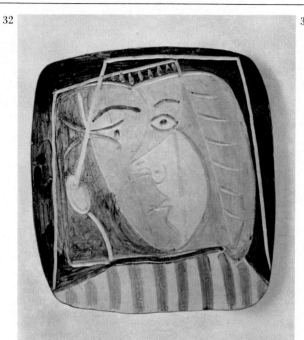

35
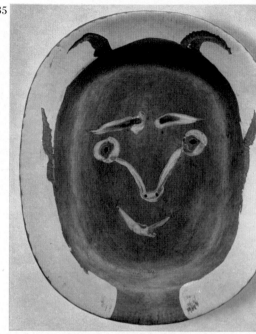

31
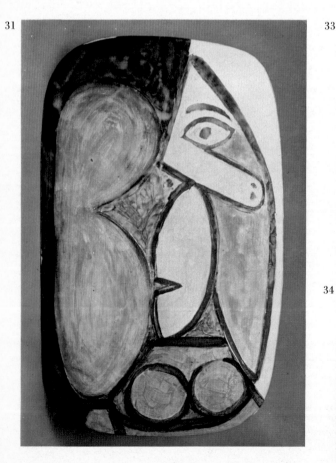

33
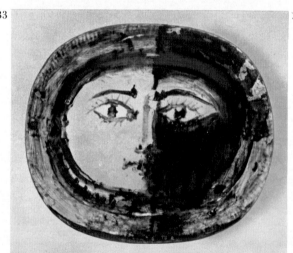

36
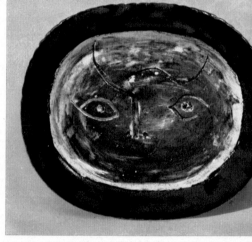

34
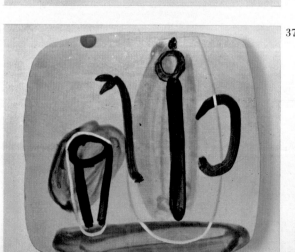

37
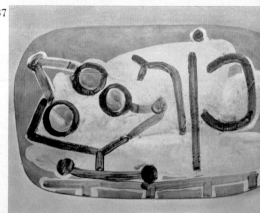

38. Vase, turned and modelled. Woman. Height 47.5 cm. Dated 1948.
39. Still life on a sphere. Height 42 cm. Dated 1948.
40. Still life on a sphere. Height 42 cm. Dated 1948.
41. Still life on a sphere. Height 42 cm. Dated 1948.
42. Still life on a sphere. Height 42 cm. Dated 1948.

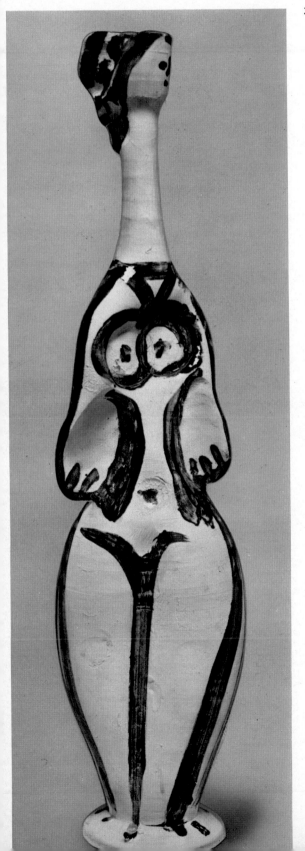

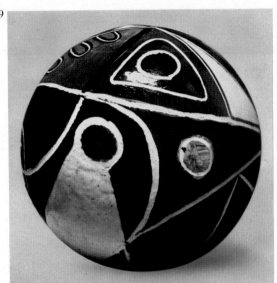

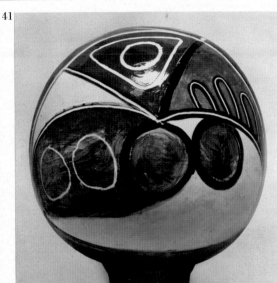

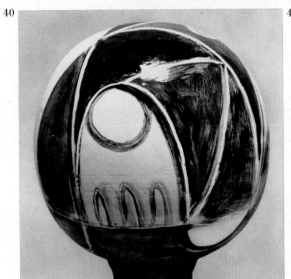

28

43. Plate. Polychrome bird. 32 × 38 cm. Dated 1948.
44. Plate. Incised bird. 32 × 38 cm. Dated 1948.

45. Plate. The blue pigeon. 31 × 37 cm. Dated 1948.
46. Plate. Bird in flight. 31.5 × 38 cm. Dated 1948.
47. Plate. Bird. 32 × 38 cm. Dated 1948.
48. Plate. Owl. 31 × 37.5 cm. Dated 1948.

43

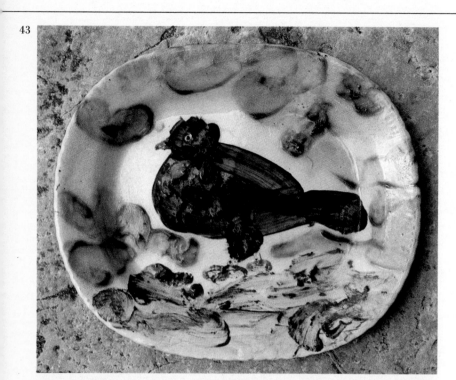

44

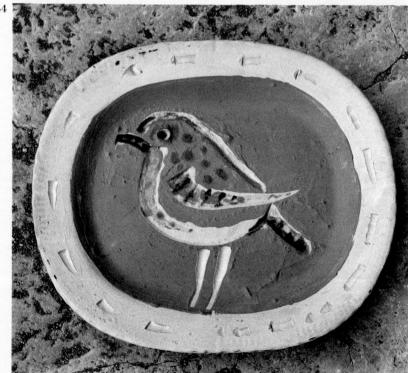

45

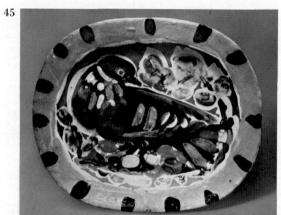

46

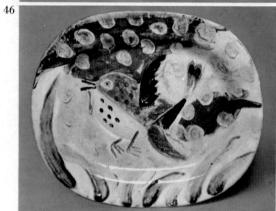

47

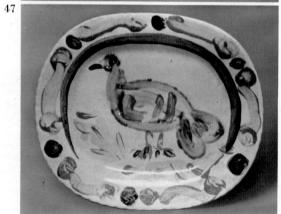

48

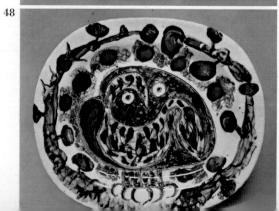

49. Plate. Bird and flowers. 32 × 38 cm. Dated 1948.
50. Rounded square plate, 4 Profiles. 26.5 × 26.5 cm. Dated 1948, original print, edition.
51. Plate. Red bird. 31 × 37 cm. Dated 1948.
52. Plate. Bird on decorated ground. 31 × 37 cm. Dated 1948.

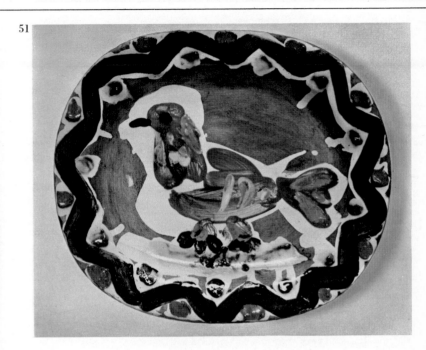

51

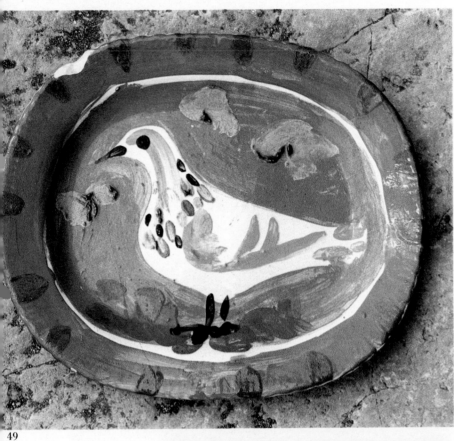

49

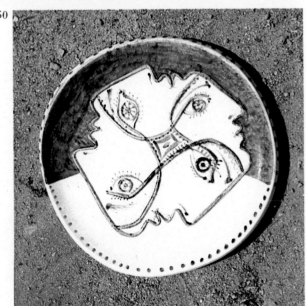

50

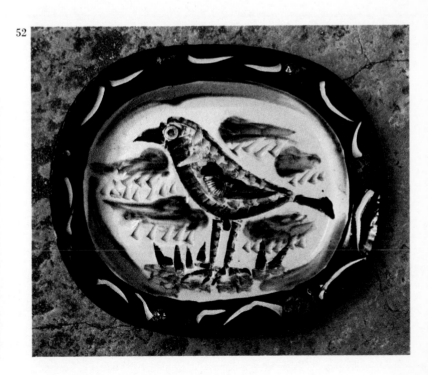

52

53. Plate. Face painted in relief on grained ground. 31×37 cm. Dated 12-4-48.
54. Plate. Reverse of No. 53. 31×37 cm. Dated 12-4-48.
55. Plate. *The Horseman*. 37.5×31 cm. Dated 1948.
56. Plate. *Banderillas*. 31×37.5 cm. Dated 1948.
57. Plate. Picador. 32×38 cm. Dated 1948.

53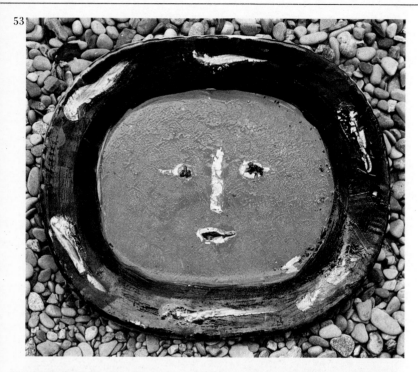

54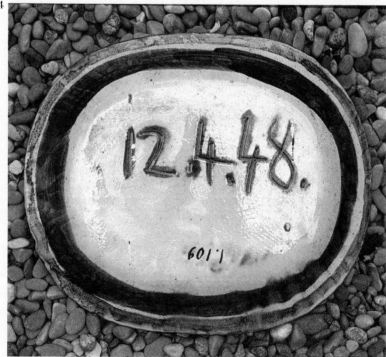

55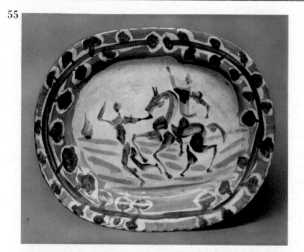

56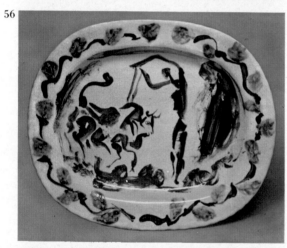

57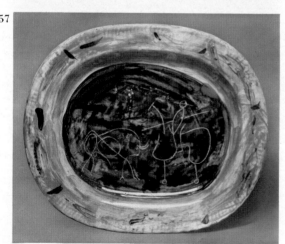

58. Plate. Centaur. 31 × 37.5 cm. Dated 1948.
59. Plate. Faun with pipes. 31 × 37 cm. Dated 1948.

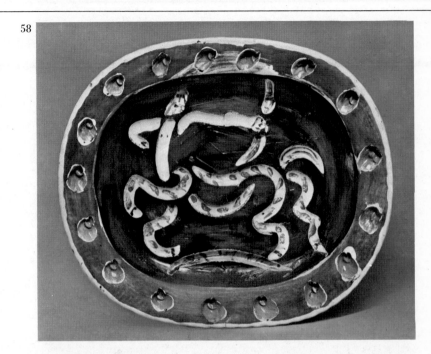

58

we do not confuse the idea of freedom with that illusory faculty that permits anybody at all to create anything at all, and in whatever way he likes. For such a faculty depends rather on the most sterile and incoherent licence than on the true freedom that is all-important here. An avid, engrossing, tyrannical freedom, one that is strictly limited to the requirements of the moment, confining each act to its intrinsic value, without encroaching on another's territory, inflexibly obedient to the individual's rules of thought. A severe spiritual discipline imposed by the unbending effort of character.

For anyone who travels in Picasso's company along the winding paths of his creations, this observation becomes self-evident. Despite the presence of certain of his variable traits, one will always find him to be permanent and consequent in the evolution of his art. Though there may sometimes be surprising episodes, the chain goes on in a series of links that are always forged in the strictest continuity.

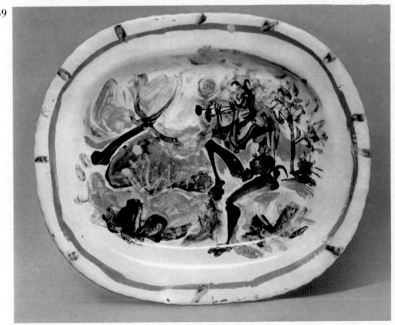

59

In this we find an essential attitude —voluntary or unconscious, acquired or conceived— that is of real value inasmuch as it is the dominant force that creates the very personal system of ethics constituted by Picasso's progress through the universe of expression. A universe built wholly on this prophetic relativity of sensorial perception with respect to the reality of facts. The ascendancy of the sensibility, with its reflections eternally changing in space, over the pretext evoked almost immaterially. Multiplicity of principles, disparity of the symbols that demand, for him who wants to receive them, a creative participation of the formal imagination, in order to transpose and complete at will the given suggestion and to finish to his own taste the barely formulated vision.

60. Plate. Fish. 24.5 × 32.5 cm. Dated 1948. Museum für Kunst und Gewerbe, Hamburg.
61. Oval plate. Grapes. 32.5 × 24.5 cm. Dated 1948.
62. Plate. Cluster of grapes (blue ground). 38 × 30.5 cm. Dated 1948.
63. Plate. Grapes and apple. 31 × 37.5 cm. Dated 1948.

64. Oval plate in colour. Mottled fish. White earthenware. 34 × 41.5 cm. Dated 1952, several versions, original print, edition.
65. Plate. Melon and knife. 31 × 37 cm. Dated 1948.
66. Plate. Melon with cutlery. 31 × 37 cm. Dated 1948.

60
61
62
63

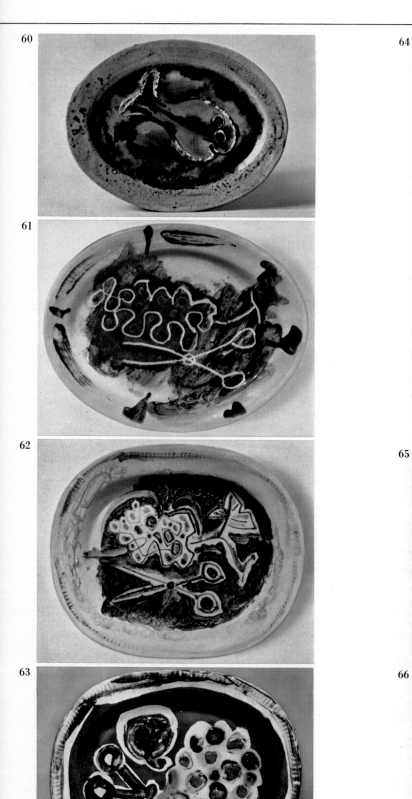

64

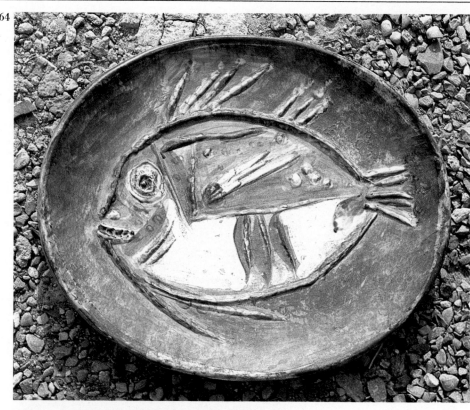

65

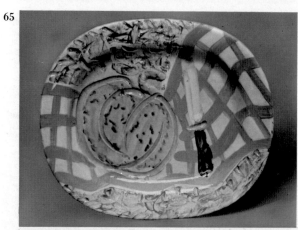

66

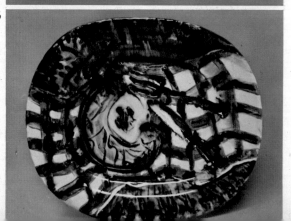

67. Oval plate in colour. Fish in profile. White earthenware. 25 × 33 cm.
 Dated 1951, original print, edition.
68. Oval plate in colour. Version of No. 67, original print, edition.
69. Oval plate in colour. Version of No. 67, original print, edition.

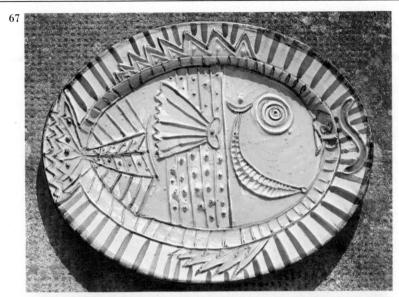
67

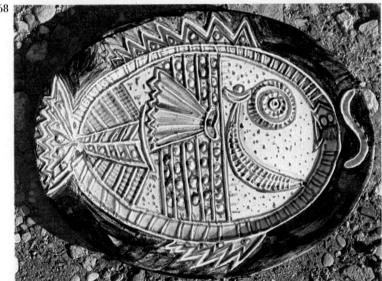
68

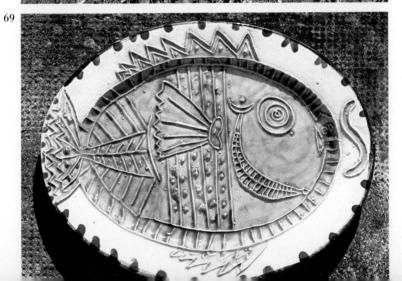
69

What Picasso expresses, in its natural state, is a fundamentally living testimony, in a permanent process of conversion and demanding the co-operation of whoever is at one with him in seeking to penetrate into the very reason of things, the analysis of forms. And this very fluid mobility quite naturally leads to the restructuring of the Universe in a wholly personal attitude. An unexpected attitude, too, for on the one hand it calls into question once again our sensorial impressions as against reality, while on the other hand it has no immediate reference to the more usual appearances.

For the artist in our time is no longer a simple narrator of known or conventional circumstances, meekly employed in the purely manual business of copying commonplace, definitive elements of visions. Mechanical or photographic reproduction can take care of that only too well by now. His mission, now and in the future, is to continue his description beyond visible objects, making it traverse the emotional state in which he perceives them and transmitting them by the means of expression most right for him. And it is, precisely, the quality of these means which define his inner life in relation to his subject.

A living testimony then...! For through the simple interpreter of an evocation or of a Mallarmé-like photograph that barely skims the surface, our quest, following the influences of the moment, is going to bring unlimited participation in this present proposition.

For we will find ourselves attracted, from the very beginning, by the effervescence of a continual tension. Henceforth each one of us, multiplied within himself in space and modified in himself at every moment, is sufficiently omnipotent to compose for himself alone the endless birth of a new vision.

34

70. Vase. Condor. Height 34 cm. Dated 1948.
71. Jug. Centaur. Height 25 cm. Dated 1948.
72. Jug. Men's heads. Height 33 cm. Dated 1948.
73. Jug. Shepherds. Height 25.5 cm. Dated 1948.

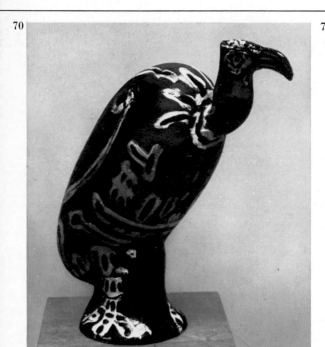

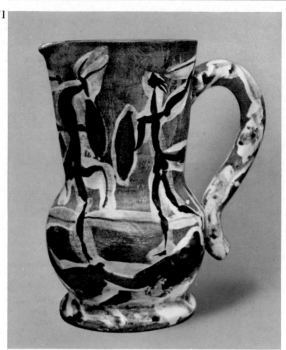

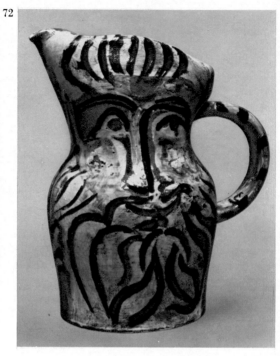

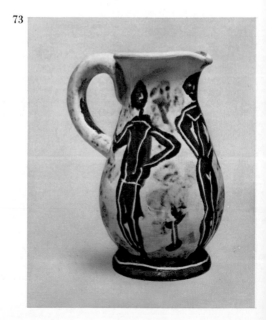

Therefore, as explained, a particularly imponderable determinant has been introduced between the perceptible fact and its emotional resonance, thus giving rise to a permanent inner dialectic, comparing the essential fact with the specific content of the subject. One might go so far as to say that as from this moment the object, in a stupefying transmutation, is about to change its destination and become the subject. The true subject of our thoughts, of our aspirations, of our changes of heart and even of our illusions.

May one speak, then, of critical art, spontaneous art, art finally liberated, questions which concern so many restless spirits of our age? The art of Picasso neither abolishes nor scorns references already acquired, but makes use of them for translation into some metamorphoses, into some new, unexpected springs of genius. Here the first objective of the method is to learn how to do without the references, and virtuosity is pressed

74. Candlestick. *The three women.* 28 × 19 cm. Dated 22-1-48. Dedicated 'Pour Mme. Ramié'. 30-8-63. Not issued.

75. Vase. Woman with draperies. Height 37.5 cm. Dated 1948.

76. Modelled piece. Woman's head. Height 28.5 cm. Dated 1948.

77. Vase. Goat. Height 32 cm. Dated 1948.

78. Modelled piece. Sitting bird. 23.5 × 39 cm. Dated 4-2-48.

75

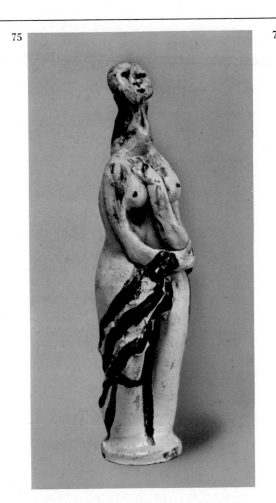

77

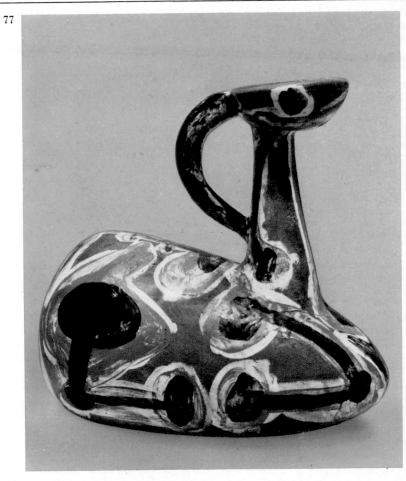

74

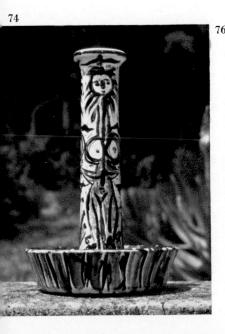

76

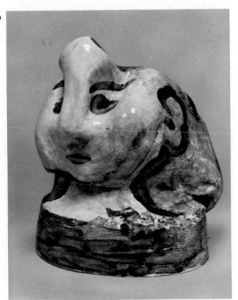

78

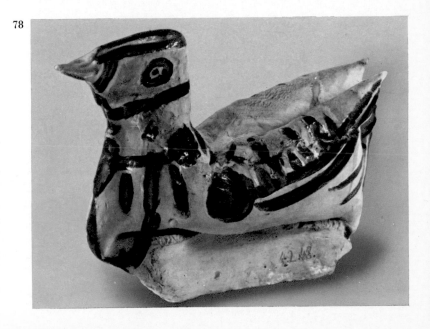

79. Jug. Painted nudes. Height 34 cm. Dated 1948.

79

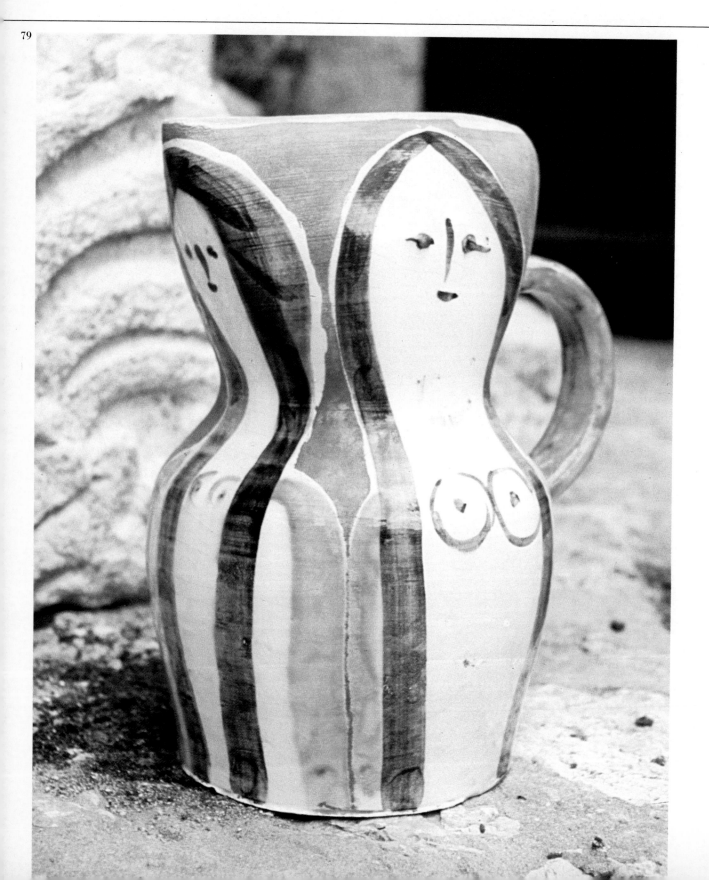

80. Jug. Nudes. Height 34 cm. Dated 1948.

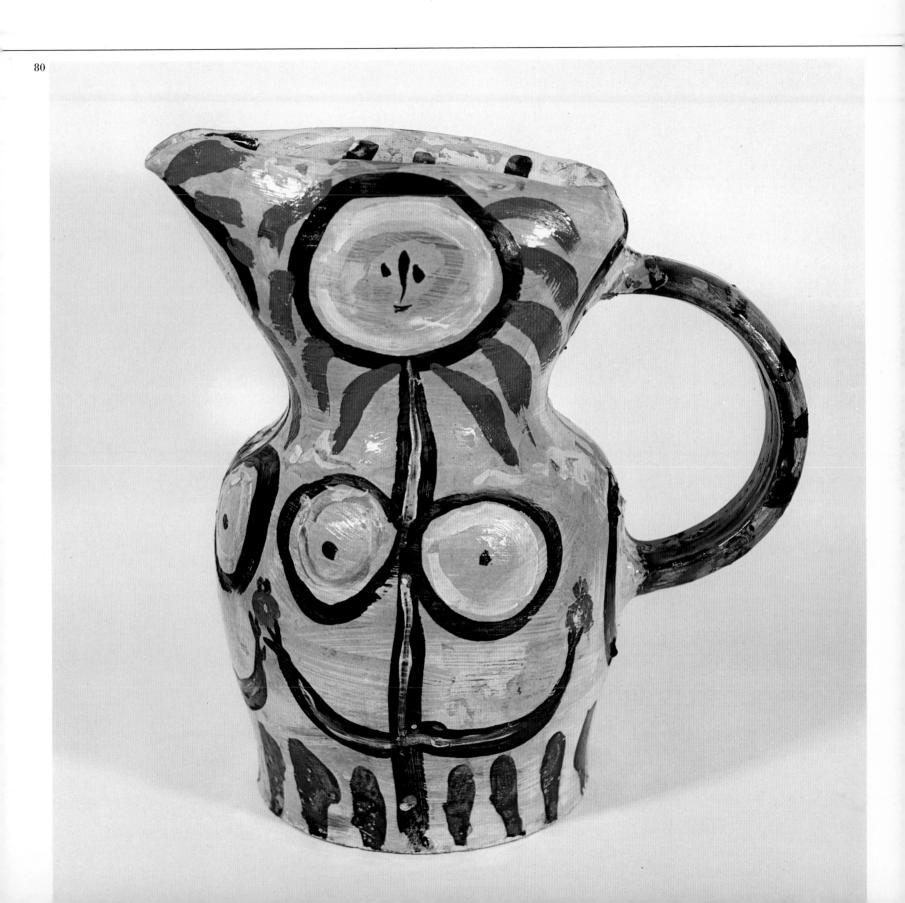

into the service of the spirit in order to free the imaginary. The subject just evoked becomes the inner wrapping in which our meditations are to be shrouded for a long time. The art of Picasso, then, is rather an art of making people live, of making them see. Though he is at once a chronicler of social events, a denouncer of the abuses of temporal history, a witness to everyday reality and a singer of the idylls of mythology, he nevertheless shuns anecdote.

At the very most he will try to make it difficult to identify in the transcription he gives us. With equal frequency, however, he subjects it to a disarticulation of form, a structural disintegration by which he declares the freedom of his power of expression.

It is then, of course, that some people begin to shout about outrage, indecency, imposture, scandal! With solemn indignation they bemoan the wounding of their smug complacency by so many disquieting manifestations. These are usually the sort of people who take the family to shelter their curiosity in public monuments on a rainy Sunday afternoon, for it sometimes happens that these monuments are used as museums or solemn pantheons, or even both things at once. These are the people who perpetuate their imaginary exploits in their belated reminiscences, or who seem to move through existence backwards and insist on finding their satisfaction in what they already know.

This was what led Baudelaire to say that in the presence of genius the vast majority of the public behave like a clock that claims to tell the right time but is actually about half a century slow. From time immemorial history has shown that the real men of each century are prophets. And have the prophets not clearly used ordinary, everyday words in their parables? And yet their language, for most people, is incomprehensible. When men's spirits are befogged or absent, prophecy is apt to sound like a mysterious discourse. Some protest at its incoherence, others —the wiser ones— examine their consciences. And later, much later, when the wheel of time has turned full circle and the light slowly rises, the sense of the forgotten messages appears in all its simplicity.

How many among us are in harmony with the rhythm of their age? How many are there among us, as the Athenian sage declared, whose applause for the discus thrower means that they themselves endeavour to hurl the discus equally far?

III. THE CHALLENGE OF NEW MATERIALS

Whenever Picasso decides to tackle new materials, in order to satisfy his insatiable desire to discover the particular features of each medium, he feels that he is liberated from any kind of gravity that might impede his flight. He seems to develop a new acuteness in his pursuit of hazardous encounters with noxious interferences that tease him in the shadows. And this immediately fills him with an incredible ingenuity of a practical order. Hardly have the essential principles been established when he hastens to evade them. The notions acquired by custom or tradition may, if really necessary, be used as a starting-point for his venture, but always quite optionally, with a view to basing his judgment on them and estimating to what extent they can be accepted. This amounts to a preliminary way of learning how to do without them and then determining by what means they may help him to discover others. For he could hardly be expected to remain forever hemmed in by the same restrictions, to be eternally subjected to formalist precepts, unconditional definitions or undemonstrable functions. In the normal exercise of the faculties of this *métier*, it is true, a great number of possible avenues are regarded as taboo, simply by tradition, without any trial other than an assertion repeated and transmitted. But unfavourable circumstances at some distant date in the past may well have created in a sacrosanct law of stray impulses an element that might be held to be a perfect foundation for success.

Such procedures, though of great interest, may well have been discarded through lassitude as much as through ignorance or preference. And so we have a whole field of exciting experiments to be approached again, like a universe that is known too well or not well enough, too regularized, taking itself too seriously without any reason and fated to be put back, without delay, among the attempts at reform that favour the re-invention of the lost past. Is it not the destiny of created things, after all, to lie in incompletion and perpetual re-creation?

It was with an appearance of anarchic empiricism, therefore, that this exuberant period of rediscovery and renewal, to say nothing of astonishing inventions, was to unfold. It should be confessed straight away that our love of the unexpected made us plunge headlong into this unorthodox adventure. The explorer's spirit is conditioned by the serious risks he takes and that is undoubtedly what enables him to recover from the mishaps he incurs of his own free will. He is a natural nonconformist. In a strictly ordered parkland his attitude would seem at best suspicious

81. Sculpture. Owl mounted on a base. 20 × 21 × 13 cm. Dated 30-12-49.
82. Rounded square plate. Picador incised in thick relief. 20 × 24 cm., original print, edition.
83. Plate. Bird on blue ground. 31 × 37.5 cm. Dated 1949.
84. Plate. Bird eating a worm. 32 × 38 cm. Dated 1949.

81
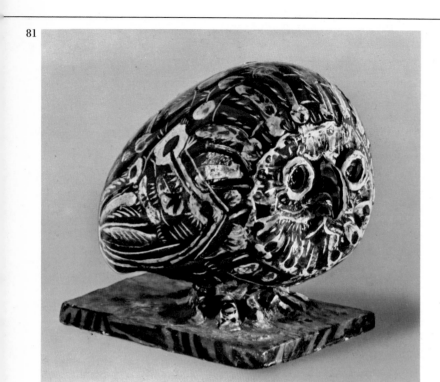

83
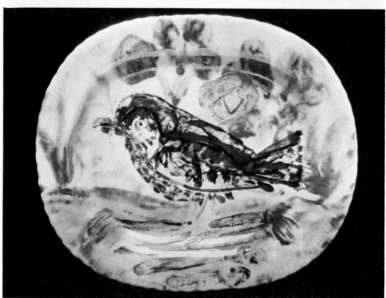

84
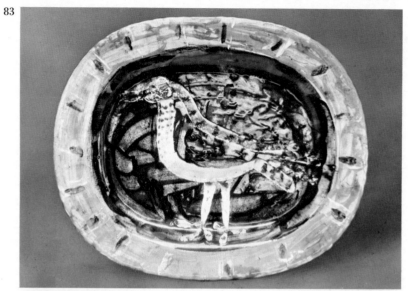

82
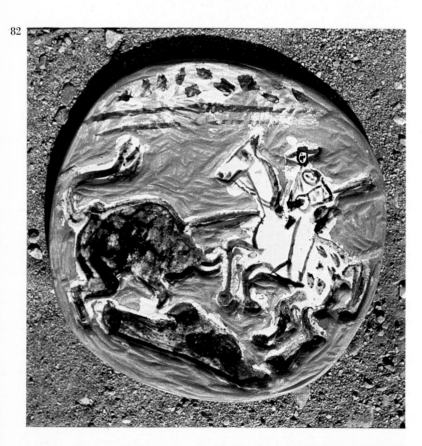

85. Plate. Dove on bed of straw, signed and dedicated to Mme. Ramié.
 32 × 39 cm. Dated 22-12-49.

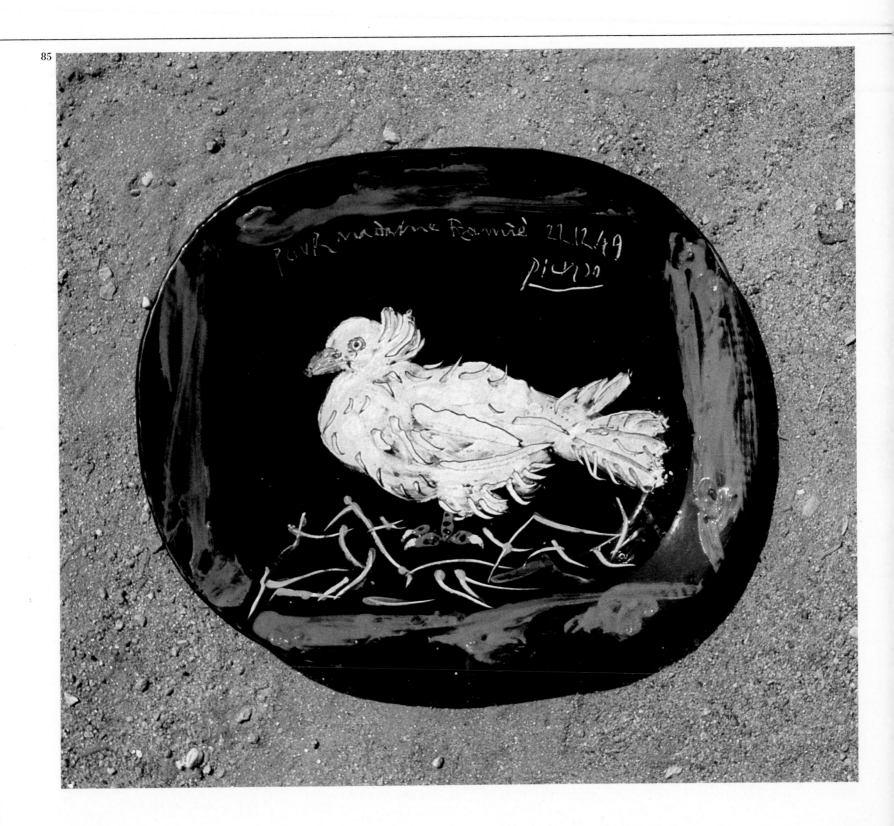

85

86. Plate. Bearded faun. 39 × 32.5 cm. Dated 8-2-49.
87. Plate. Faun's head. 38 × 32 cm. Dated 8-2-49.
88. Plate. Faun's head. 32.5 × 38.5 cm. Dated 8-2-49.
89. Plate. Faun's head. 32 × 38.5 cm. Dated 5-2-49.
90. Plate. Satyr's head. 35 × 35 cm. Dated 30-1-49.

86

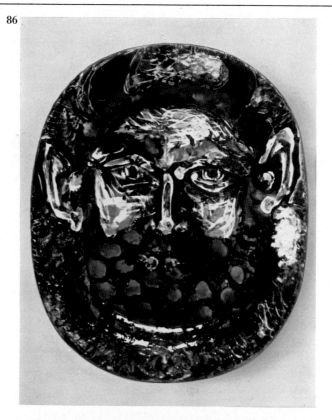

and perhaps even reprehensible. But out in the wilds, where everything is possible...!

And it is out in the wilds that Picasso develops; he makes it his business to discover what nature intends to do in the normal course of her little personal habits, and then suggests that she envisage some other course. Something much more exciting, much more aggressive, than the usual product of her melancholy routine.

From the outset one might well think that the spirit of the established order of things would draw herself up in offended dignity and tell this intruder to be off about his business and insist no more. Nobody can tell whether that has happened or not. Except that Picasso has insisted. With that curious, mischievous little laugh that one hears when he is preparing some trick, or when he persists in forcing an obtuse and misleading fate, or goes off to prepare some venture for which the most experienced authorities predict inevitable failure, given the present state of carefully-garnered knowledge.

And then we see him setting a problem —a difficult, compromising problem, one that may even be tragic in its premeditated unseemliness— for the mysterious, capricious reactions of the kiln and its burning auguries.

And it is then that we see the expert calculations, the most reputable treatises and the most fundamental laws of experiment all at once called into question. And what should have been reduced, according to all the most expert opinions, to a miserable devastation bursting into barbaric fragments is seen to be an affirmation of new principles and evident possibilities. These possibilities had hitherto existed in the sterile shade and only now emerge from their inexplicable neglect. Just so can we find latent powers, fossilized in immobility or oblivion, waiting only for a liberator

87

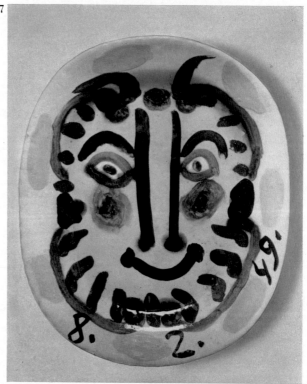

91. Plate. Picador (on pink ground). 32 × 38 cm. Dated 1949.
92. Plate. Picador (on blue ground). 32 × 38 cm. Dated 1949.
93. Plate. Centaur hunting. 31 × 37.5 cm. Dated 1949.

94. Plate. Picador (brown). 31 × 37.5 cm. Dated 1949.
95. Plate. Lance-thrust. 32 × 38 cm. Dated 1949.
96. Plate. Picador (blue). 32 × 38 cm. Dated 1949.

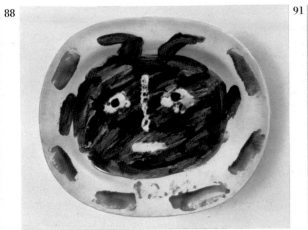

88

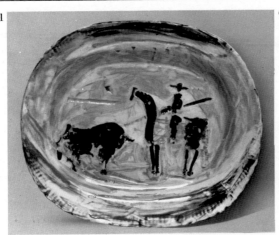

91

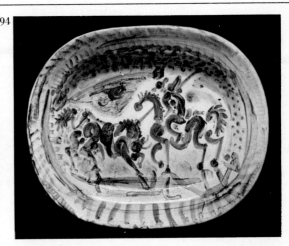

94

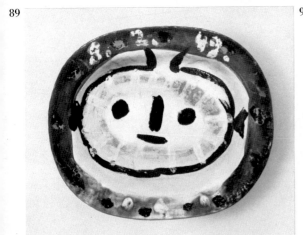

89

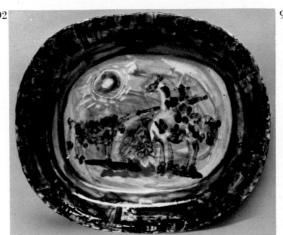

92

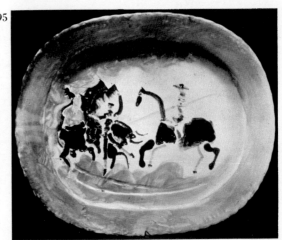

95

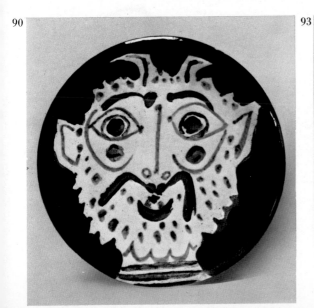

90

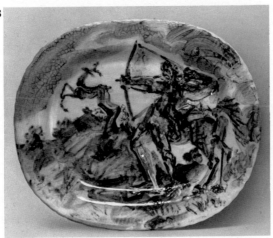

93

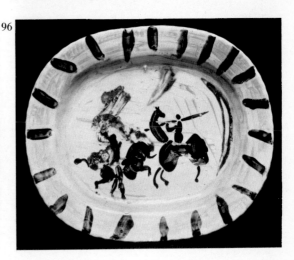

96

97. Plate. Picador (brown and white). Diameter 22 cm. Dated 29-9-53, original print, edition.
98. Rounded square plate. Polychrome picador. 24 × 24 cm. Dated 29-5-53, original print, edition.

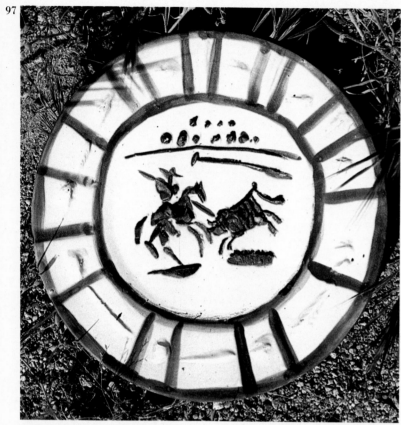

97

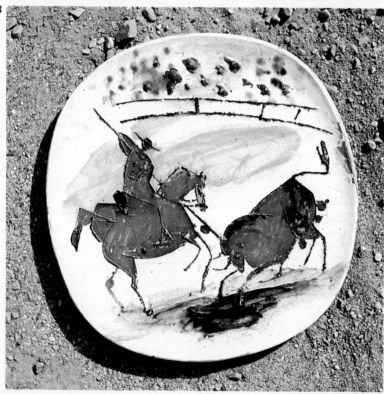

98

who will let them follow the course of their spontaneous stimulations once more.

And so the case is proven. The door is open to all kinds of obstinate attempts to produce very strange combinations, ready to dissolve into the totally unpredictable. It is all rather like the chess-player who moves his men on the squares with his eyes closed and then successfully mates in three moves.

For an analysis of the total number of contingencies that may arise from the interplay of the enamels and the metal oxides will readily confirm that we are faced with a complexity of possible developments almost as vast as in the game of Palomeda. Each kind of matter influences and determines the others, either separately or together, under very specific conditions. The result of their interaction tends to be constantly altered by reactions of an elementary kind that may produce superimposed modifications, destroying each other, strengthening each other, exacerbating each other, dividing, repelling or multiplying each other, all these phenomena being determined by the temperature, the humidity and the duration, and sometimes even by the influence of very old residues. And thus, in a multiplicity of incidents, we find impinging on each other the peculiar characteristics of components that include, among others, fusibility, volatility, opacity, retractability, transparency, sensitivity to heat, rapidity, dullness, brilliance, etc.

As one can see, the field is enormous. Like every other sphere of human knowledge, it has an unlimited area for exploration. The more we learn of it, the more we realize the immensity still to be learnt. The smallest discovery is sometimes capable of producing a vertiginous attraction that holds as much promise as uncertainty. But is it permissible to seize all these possibilities

99. Large plate. Picador, incised and painted. Diameter 42 cm., original
 print.

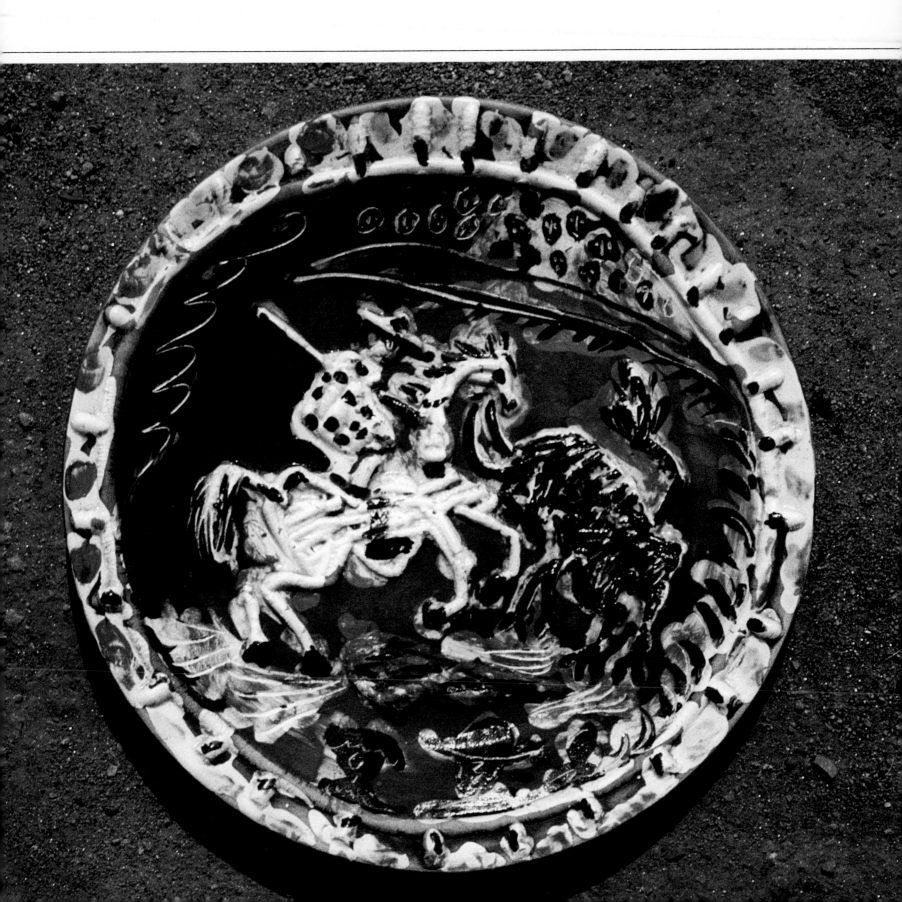

100. Turned and modelled figurine. Woman with hands hidden. 47 × 15 × 9 cm.
 Dated 1949.
101. Wheel-thrown and modelled figurine. Lady in mantilla. 47 × 11.5 × 7 cm.
 Dated 1949.

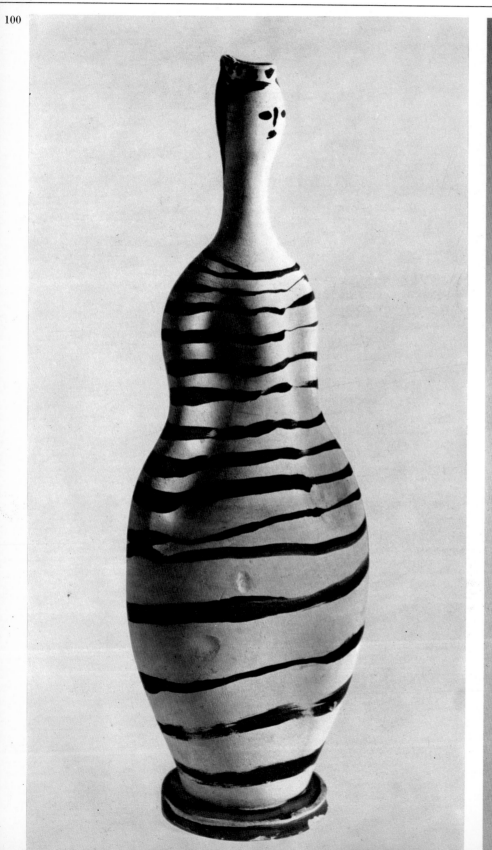

100

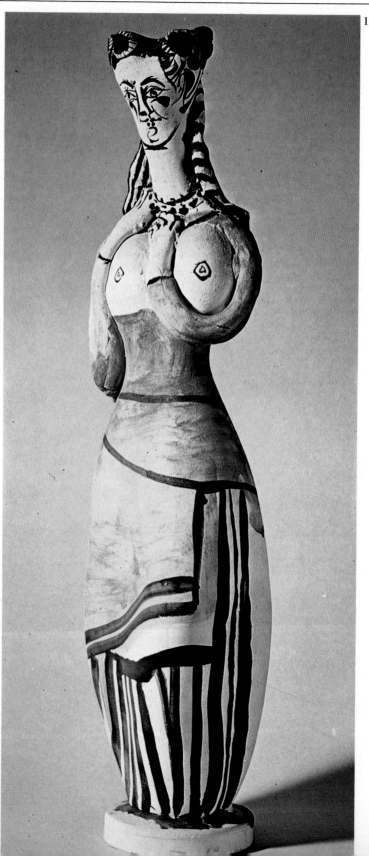

101

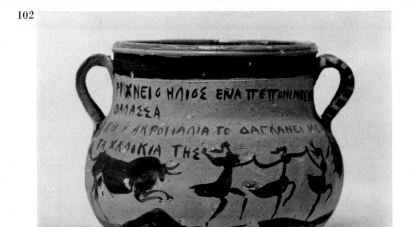

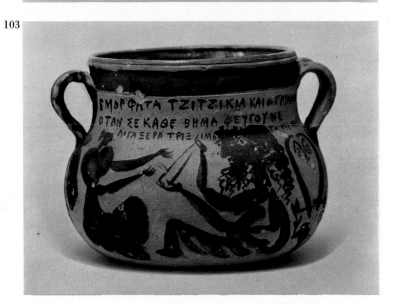

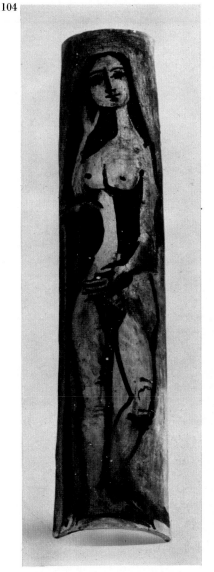

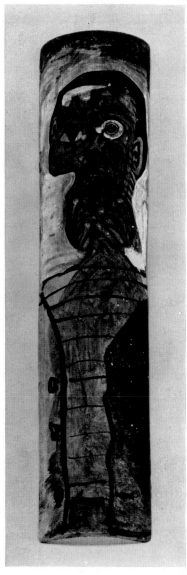

102. Pot. Other side of No. 103. Height 19 cm. Dated 15-9-50.
103. *Hercules and Omphale.* Height 19 cm. Dated 15-9-50.

104. Kiln piece. Woman standing. Painted in engobe on refractory clay. 102 × 22.5 cm. Dated 18-9-50, Vallauris.
105. Kiln piece. Man's face. Painted in engobe on refractory clay. 101.5 × 20.5 cm. Dated 23-9-50, Vallauris.

at once? Nature compels us to remain within her own dimensions and from this range of attractive propositions to choose only one, which may be validly analysed and tested. And even this one will immediately open out, through an infinity of resultants, on a fabulous horizon of probabilities still to be explored.

Thus the circle widens unceasingly; it will never be closed again. And far from feeling crushed by this revelation of immensity, each one sets out once more to climb, indefatigably and sometimes even frenziedly, this infernal rock of Sisyphus!

And with this we have entered into the insidious domain of unusual investigations. Picasso, with that swift intuition he shows whenever he wants to penetrate into the inmost essence of anything, will incline towards everything that

106. Ornamental panel composed of four plaques. Still life. 98.5 × 99 cm.
Dated 1950, Musée Picasso, Antibes (France).

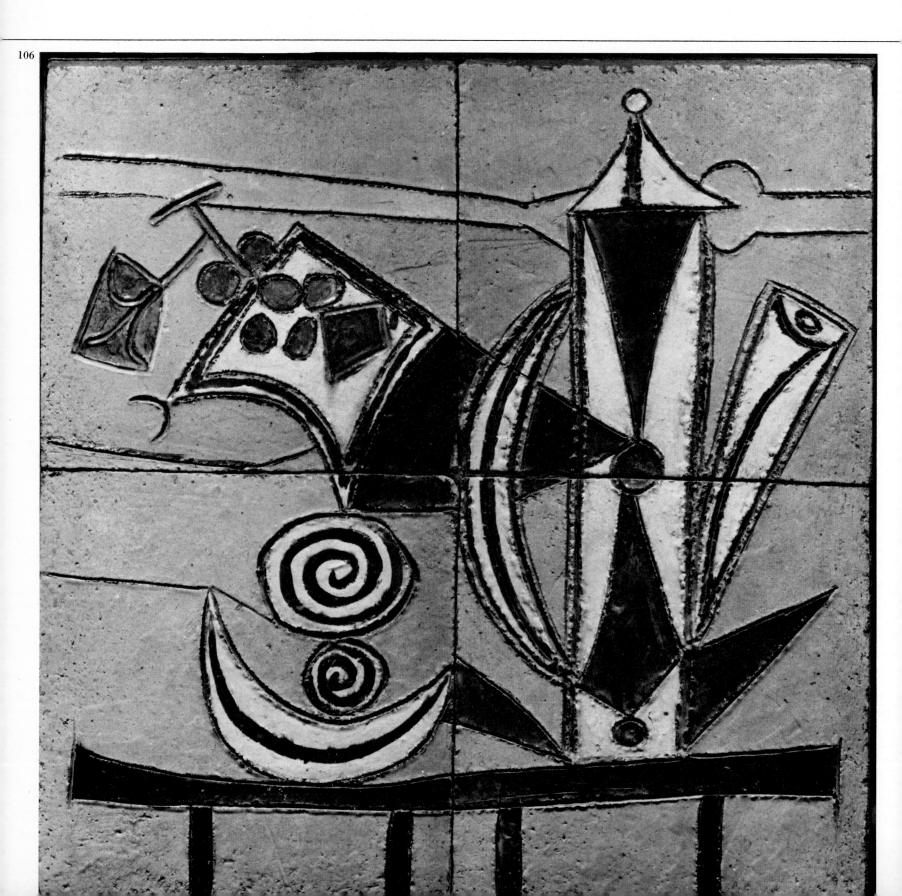

106

107. Plate. Man's head. 44 × 42 cm. Dated 1951.
108. Plate. Bearded faun. 35 × 35 cm. Dated 1952.
109. Sculpture. Black owl. Height 33 cm. Dated 1952.

110. Sculpture. White owl. Height 33 cm. Dated 1952.
111. Sculpture. Owl (white face). Height 34 cm. Dated 12-12-52.
112. Sculpture. Owl painted in engobe. 34 × 35 × 22 cm. Dated 11-11-51.

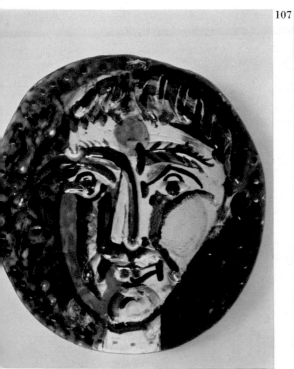

107

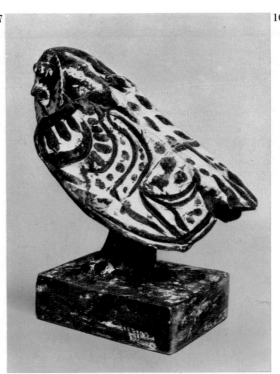

109

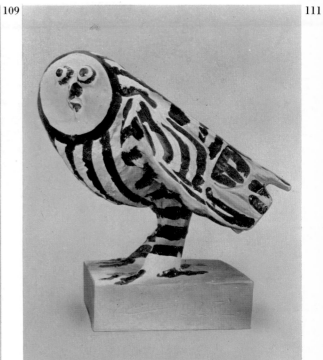

111

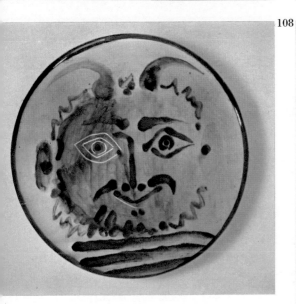

108

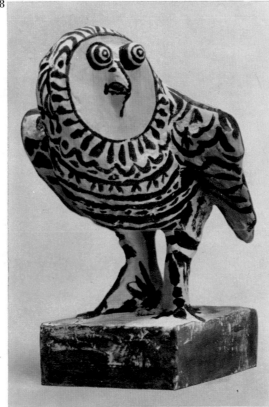

110

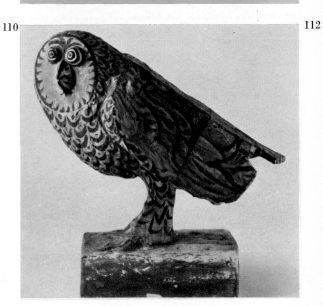

112

113. Sculpture. Black and white owl. Height 34 cm. Dated 10-11-52.
114. Two-handled vase. Double face. 39 × 48 × 20 cm. Dated 1952.

113

114

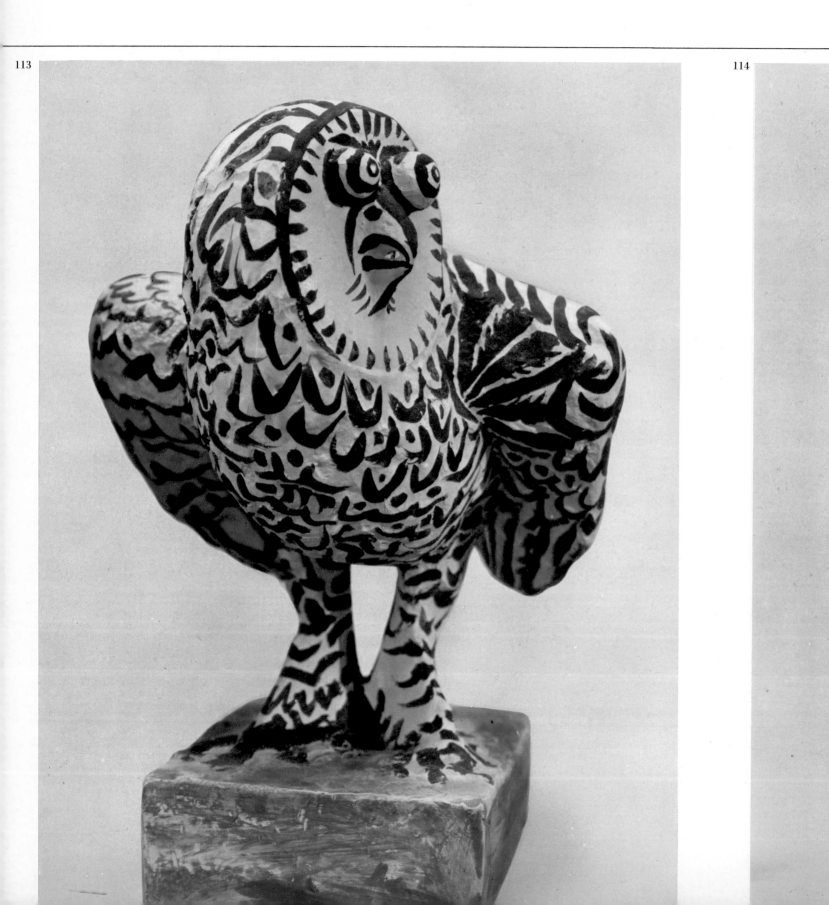

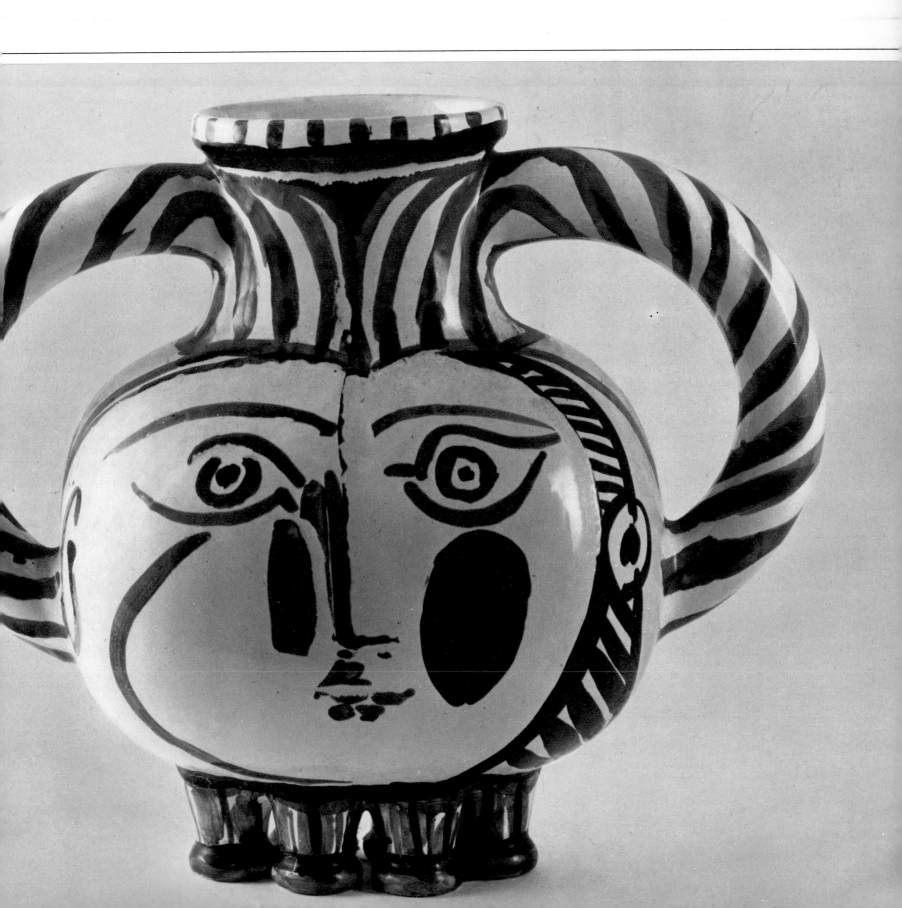

115. Jug. Parrot. Height 25 cm. Dated 1952.
116. Large vase (green). 39 × 45 cm. Undated.
117. Jug. Women at the water's edge (incised). 35 × 28 cm. Dated 9-11-52.

115

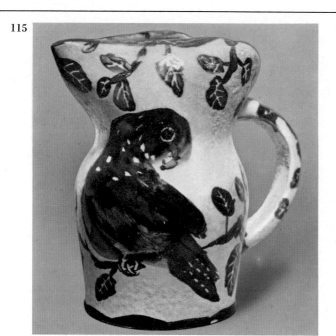

116

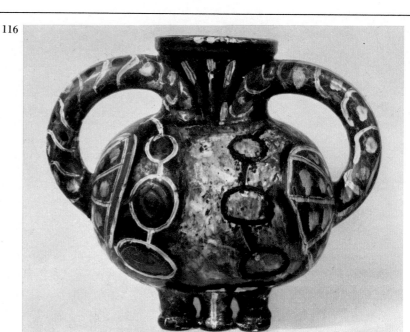

custom has excommunicated, towards all that is traditionally considered an unapproachable myth or a respectable assumption which must not be upset.

This obstinate contrariness in Picasso is quite in keeping with his usual —and necessary— way of working. The difficulty or scale of the irruption he sees himself making in this new technique, far from frightening him, rather spurs him to even greater haste. And is it not true, after all, that this fashion of approaching principles by way of their contraries, inversions or even negations often gives rise to the most fruitful discoveries? Is not a well-founded reason in itself reversible?

In this exploration that he has chosen, partly by chance but also from preference, an exploration strewn with perfidious ambuscades, countless complexities and stimulating perspectives, Picasso feels perfectly at ease and ready for the fiercest onslaughts. He penetrates, ever alert, to the heart of all the problems and uses all available means to organize his plans of action for reducing the substance of the strange elements confronting

117

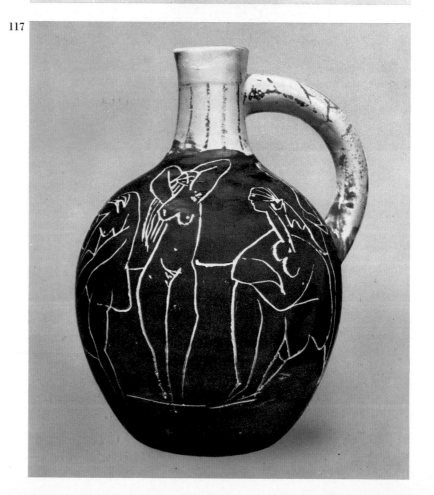

him, elements that possess subtle, sensitive possibilities.

One must readily admit that he very quickly acquired a total mastery of the potentialities that would let him put all his verve into the work and enforce his own concepts. The moment he felt capable of expressing quite freely the impression of the moment, he gave himself up, with the inexhaustible facility of which the sum of his work is the proof, to that frenzy of creation that was to lead him to the great accomplishments that are today only just beginning to be understood to their full extent.

But it is no easy task to explain the manner and reason of this facility to anybody who has not seen him expanding in the act itself.

His manner makes you think of some irrepressible force which is always ready to imagine, to transform, to pursue the immediate perception beyond itself in order to create a new one, different and unexpected. A force that springs as much from the constant diversity of invention as from the skill directed at catching in all the freshness of the instant the fleeting plosion of a thought.

As for the cause, can there be one for this faculty with countless different facets that permit it to multiply in the most improbable conditions; whether passing through the 'stages' of a work which, though alone in itself, can nevertheless be split up in such a way as to explode into a series of descriptive episodes, or in the enormous 'suites', throughout which the same theme appears and reappears, indefatigably modulated, affirmed, revised, rejected, reconstructed, without any necessity for a definitive conclusion?

We might find some sort of explanation in that fury of genuine, incessant activity which Picasso feels as a physiological necessity that is as essential to life as the breathing reflex. Untiring as he is, always in pursuit of the work before him or its successor, his tools never out of his hands, using up all possible plastic procedures and inventing new ones if the accepted ones are not suitable enough, practising this exercise of self-liberation day after day, night after night (and for how many years?), it is only to be expected that in the course of this maturing process his spirit should have acquired a presence continually prepared to accept new rhythms, familiar with all immediately creative attractions. And it also follows logically, therefore, that his hands, those superb performers, should have come to possess the suppleness and dexterity of the most diligent of workmen.

It is thus, undoubtedly, that he has with such simple means built up this extraordinary accumulation of knowledge, judgment, experience and capacity that is ready at any given moment to adapt his circumstances to his imagination.

Picasso is supposed to have once said: 'I do not seek; I find'. Though he has a fundamental horror of analysing himself in order to regale the world with historic aphorisms, this phrase may well be considered genuine. But it should be understood as referring to somebody who first crams his money-box quite full and then smashes it to discover what it contains. It is in just such a state of mind, indeed, that Picasso, after so many years, without having to seek very far, smashes his money-box every morning to find what was there the night before.

IV. THE MASTERY OF THE TECHNIQUE

Picasso's work in ceramics, with its exuberant articulations, grew after the fashion of a marvellous universe. A universe of exceptionally vast dimensions, and yet reduced, as far as means are concerned, to the rudimentary elements of the world in an Empedoclian triad. Is there any reason to be astonished by the fact that, in this age of constant acceleration and frantic change, acceptance may still be given to a concept of activity that professes, within an apparently anachronic ethical system, such an Aristotelian humanism? The point is that for the potter it is precisely this rudimentary quality that constitutes at once his discipline, his strength and his challenge. Limiting himself, with timeless formulas, to expressing what he wants to say in a contemporary message, he must seek a multiplicity of effects within the very paucity of his means. Thus he endeavours to assert his sense of vocation, which led him to choose the most rustically simple materials in order to translate them into the most complex manifestations.

And it must be supposed that for him this asceticism is worth pursuing and that there will be other men, for many years to come, who will pursue and attain it; for premeditated love of the absolute, for the inner satisfaction of expanding in this precarious grandeur and also in order to find once more in the strictness of the natural laws their own supreme and only reason for existing. Many have already discovered this, and many more will discover it again, for it is good to linger late in the evening in the cool fullness of those places where the clay, with its silky touch, sacrifices its nature by delivering itself up to the mercies of a redoubtable alchemy, to be reborn in a completely different and unknown form.

But what is the mysterious origin of this immanent urge that comes from the remotest depths of mankind and, incessantly and everywhere, impels singular spirits to respond to this belated but passionately insistent vocation?

In the beginning was the earth, and from that earth came man, that remote primate whose instinct to survive led him to dig a hole in the clay in which to keep the water from the sky. Much later came another man, one already travelling apace along the roads of progress, who conceived the idea of cutting out this hole hollowed by his ancestor in order to make it more easily transportable. This man's initiative bore within it all the postulates of the potter of the future, capable of fashioning objects of baked earth, familiar, rustic objects for everyday practical use. And to

118. Plate. Still life (in relief). 37.5 × 31 cm. Dated 1954.
119. Oval plate. Bull charging. 30 × 66 cm. Dated 24-11-53.
120. Oval plate. Lance-thrust. 30 × 66 cm. Dated 24-11-53.
121. Oval plate. Two picadors. 30 × 66 cm. Dated 24-11-53.

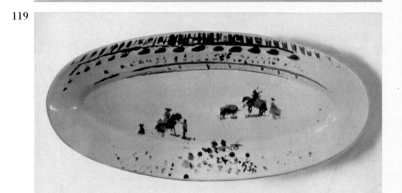

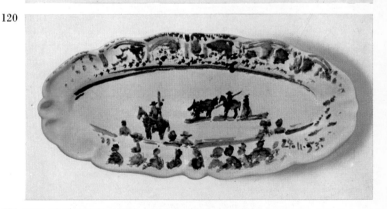

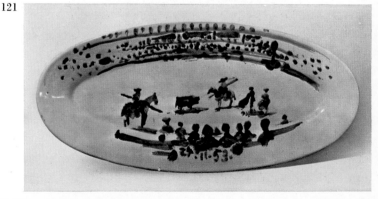

carry out this innovation —which today, after so many centuries, we may perhaps find banal, but which was nevertheless one of the most inspired discoveries of primitive humanity— all we need are the three eternal, sacred elements: earth, fire and water.

Nor had Picasso any need of others. One enters the field of pottery rather as one enters a religious order: one must have faith, a vocation, a great simplicity of nature and intention, a ready spirit and a persevering heart. And all of this, with the passing of the years, is apparently capable of leading the generous of spirit to an incomparable blessedness. And not an inert, senseless beatitude, but one that is active and thought-provoking to a high degree.

Picasso's ceramic work affirms this abundantly and constantly; he desired to follow the stony paths that lead, through joy, to the summit of man's accomplishment, and throughout this ceramic adventure he has untiringly sung the delicious peace of the spirit, the serene sweetness of those halcyon days and the fruitful joy of creation in absolute freedom.

His universe came into being imperceptibly: the long days of feverish work followed each other over the years, unremittingly, without so

56

122. Rounded square plate. Picador's horse rearing. 36.5×36.5 cm. Dated 1953.

123. Rectangular plate. Picador in bull-ring. 32×38 cm. Dated 1948, dedicated to Mme. Ramié.

124. Rectangular plate. Picador and bull-fighter. 31×49 cm. Dated 23-3-53.

125. Rectangular plate. Picador. 32×51 cm. Dated 23-3-53.

126. Oval plate. Lance-thrust and drawing away of the bull. 87×31 cm. Dated 23-3-53.

127. Square plate. Lance-thrust. 33×32 cm. Dated 23-3-53.

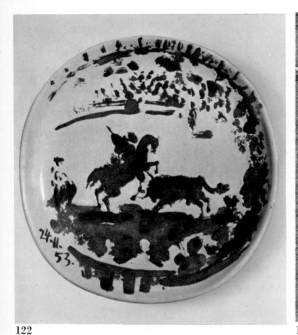
122

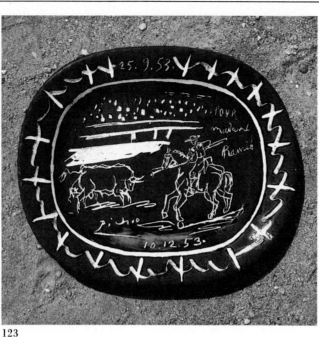
123

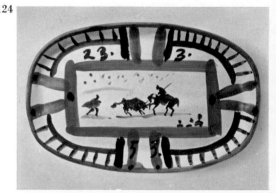
124

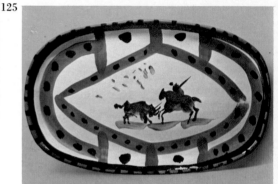
125

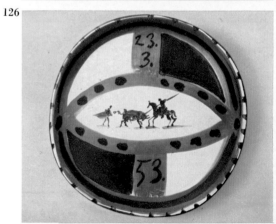
126

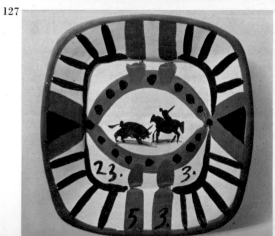
127

much as an intermission or even a day off on Sundays! At the outset an inevitable preliminary training period entailed a suitably prudent rhythm of work; he had to have more than one long look at this new material before mastering it. But very quickly our sorcerer's apprentice succeeded in learning the magic words that unleash the surging floods of spells —and then the living forces were set free! Those who watched over the progress of affairs very soon had to make sure that all his needs were promptly supplied and that all processes could be carried out at a regular rhythm.

Very soon, too, the drying-rooms were filled with unfired pieces, finished at a lively pace and placed there to harden in the salutary warmth of the dry, moving air. There they awaited —certainly with a fair measure of confidence under such conditions— the fateful moment of truth

128. Plate. Lance-thrust. 37 × 37 cm. Dated 21-3-53.

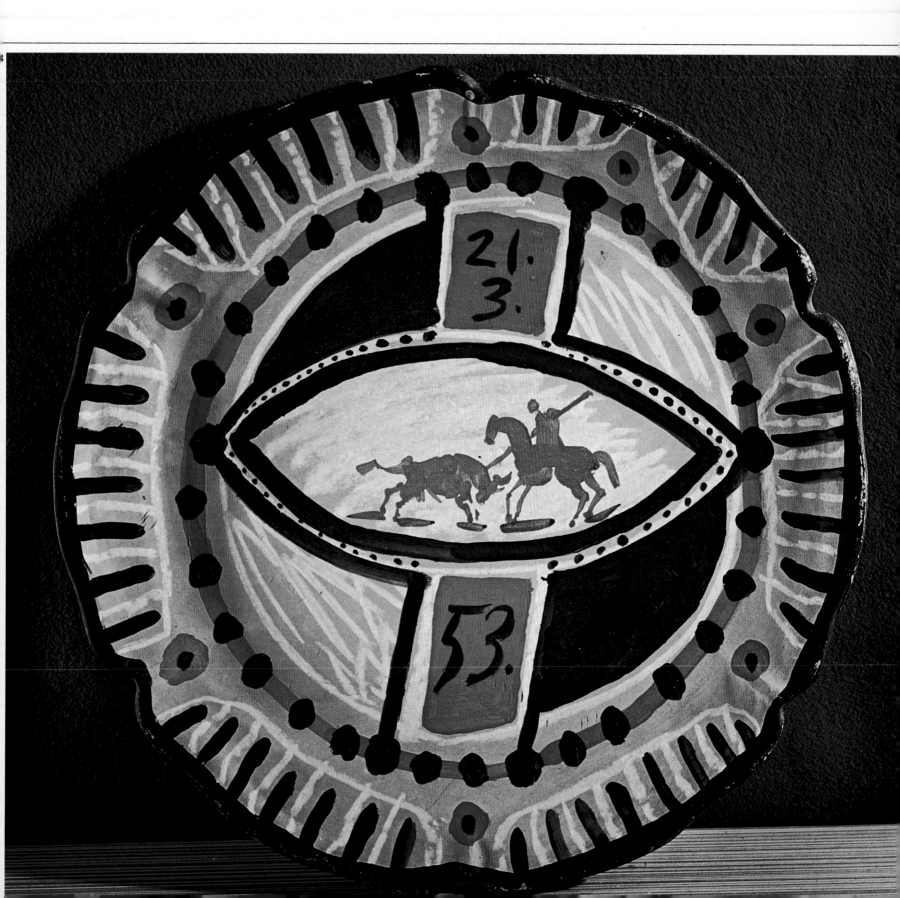

now imminent. This ordeal by fire, consuming the offering only to restore it with a new nature and under a new appearance, was rather like the medieval 'Judgment of God': jousting in the lists, with lowered vizors, where the victory is to the valiant. A triumph that sometimes requires several reprises, either in obligation to the normal estimates or because some unforeseen defect makes it necessary to perfect the conclusion.

There is nothing so moving as the moment when the pieces leave the kiln, even for the most hardened of these workers led by a possibly unusual vocation to entrust to the rigours of the flames the objects that hold all their dreams, their thoughts and their faith. This is indeed the moment when feelings see-saw between absolute satisfaction and gloomy contrariety. But even in the depths of adversity the unfailing hope remains; once again one must re-assert one's abiding confidence by staking one's all on a fresh appeal, to a second hearing, for a carefully studied alteration. And quite often these failures of the first firing, neglected by fortune in so much confusion, emerge the second time triumphantly rehabilitated and in almost unhoped-for magnificence. These surprising reversals used to delight Jean Cocteau, who was an occasional and very alert witness of these strange polemics decided in a series of passionate rejoinders, leading him to conclude, in typically theatrical fashion, that 'in the kilns of Vallauris even the flops are hits'.

Once fired and taken from the kiln, unhurried attention had to be given to a careful, reasoned examination of each piece. It was at such moments that secrets were revealed and new questions insistently suggested meditations and suppositions. So many new horizons to be reached, so many immediate conquests to be imagined! In the face of such tremendous attractions a newly-acquired ardour made our good companion redouble his stubborn endeavours.

The shelves were quickly filled. Then one day it was decided that they could really hold no more, so we fitted out special rooms to take the copious results of each working day; but soon these rooms, too, were declared to be insufficient, so we had to resign ourselves to arranging certain pieces of like volume or form in piles. If one wished to examine them a little more closely, one could turn them over like the pages of a book. Sitting cross-legged, one took them from one's right and put them back on one's left. And so one advanced, from one pile to the next, through the strange labyrinth of this vertically arranged collection.

It is as well to make a distinction between two rather different periods as regards the technique of this work. From the beginning the firing took place in our old Roman kiln, of the free-chamber type traditional in Vallauris, heated by the acid flames of wood from the Aleppo pines that cover the chalky slopes of the nearby forests. In this type of kiln (the *four à balancier*) the flame is alternately sucked in and driven back by smothering, thus provoking a rocking movement between the treatment chamber and the exterior of the furnace and compressing the flame so that it will enwrap the pieces placed inside in staggered piles.

Depending on the kind of glazing required, the pieces are either left to the oxidation of the flame or protected in cases made of insulating or 'muffle' bricks set up in the chamber itself. I, however, am hardly the right person to intone a hymn to that unforgettable human epic of the strict thermal control of such a firing, abandoned to the tender mercies of atmospheric humidity, the acid content of the wood, the regularity of

129. Modelled piece in white clay. Small bull. 9 × 25 × 13 cm. Dated 1953.

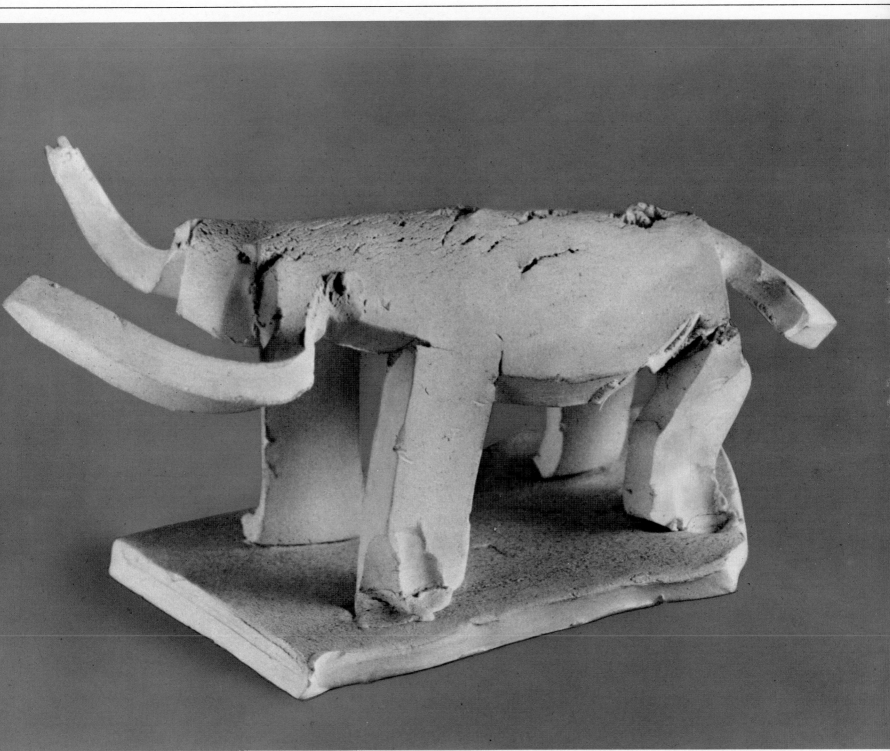

130. Turned and modelled figurine. Woman standing. 39 × 10.5 × 5.5 cm. Dated 1953.

131. Wheel-thrown and modelled figurine. Woman with clasped hands. 29 × 7 × 7 cm. Dated 1953.

132. Figurine on a base, wheel-thrown, modelled and painted. Woman with unbraided hair in long dress. Height 30 cm., base 15 × 23 cm. Dated 1953.

133. Wheel-turned and modelled figurine. Woman squatting. 29 × 17 × 15 cm. Dated 1953.

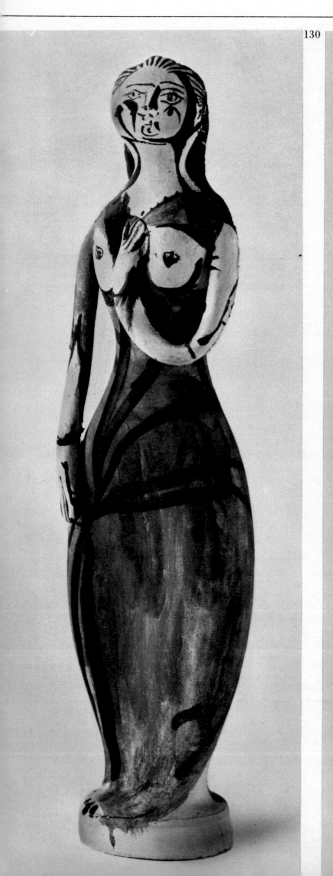

130

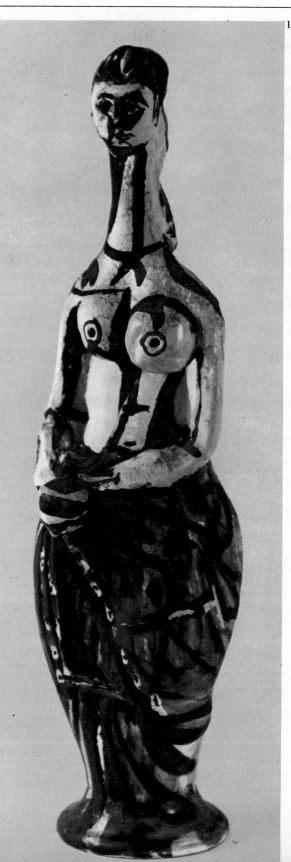

131

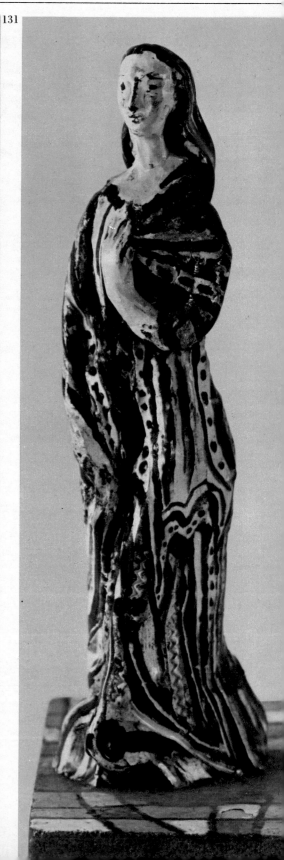

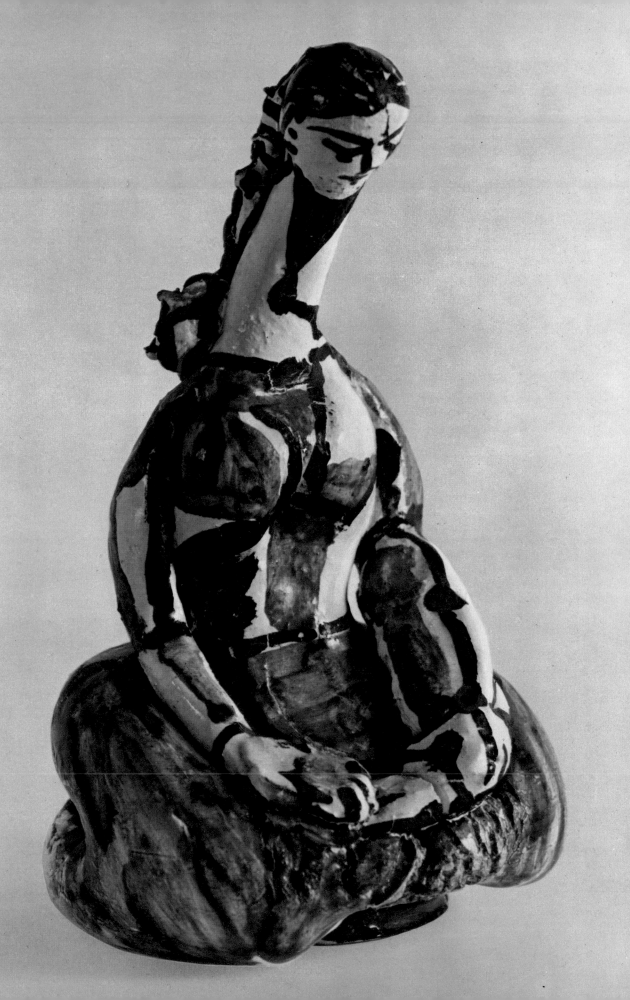

134. Sculpture on turning. Ruffled pigeon. 20×21 cm. Dated 29-1-53.

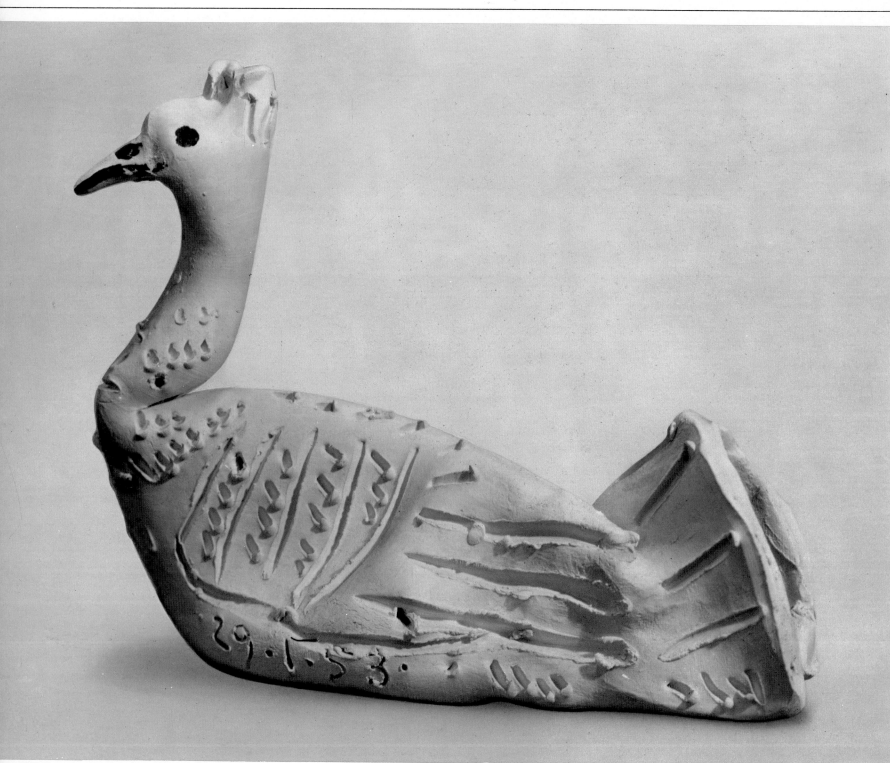

135. Piece modelled after turning. Pigeon, incised and painted. Height
 13 cm., length 23 cm. Dated 14-10-50, dedicated to Mme. Ramié.
136. Dedication of No. 135. 'Pour Madame Ramié. Son élève Picasso'.

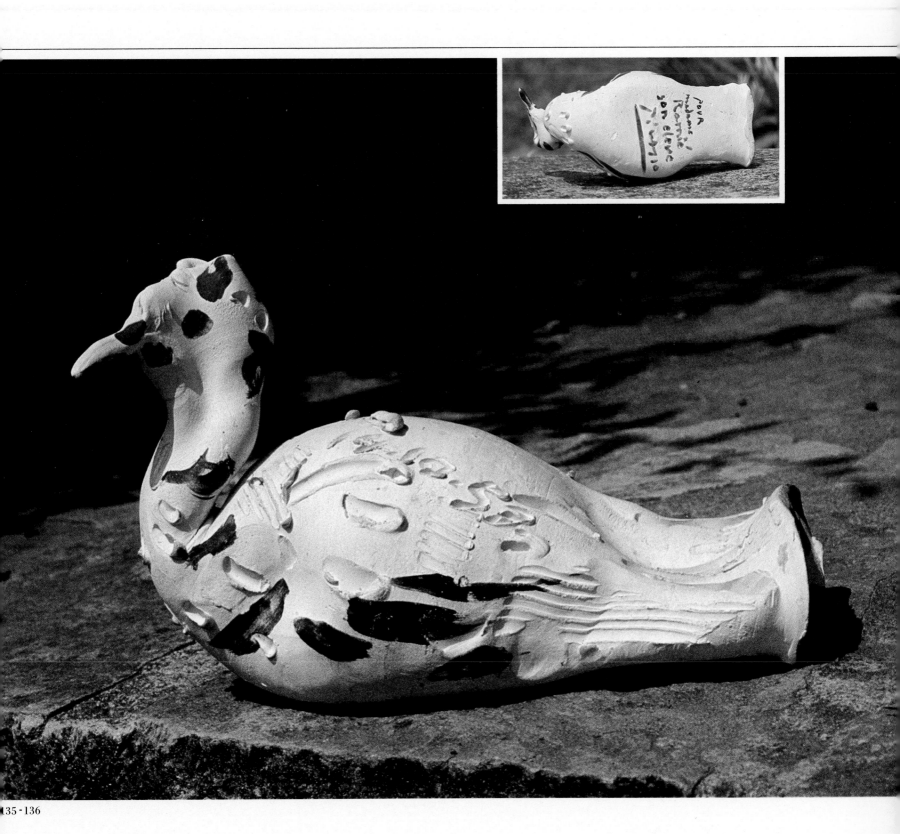

137. Modelling on a rough piece of clay. Dove. 14×20×10 cm. Dated 7-1-53.
138. Sculpture on turning. White pigeon sitting. 12×17 cm. Dated 26-1-53.

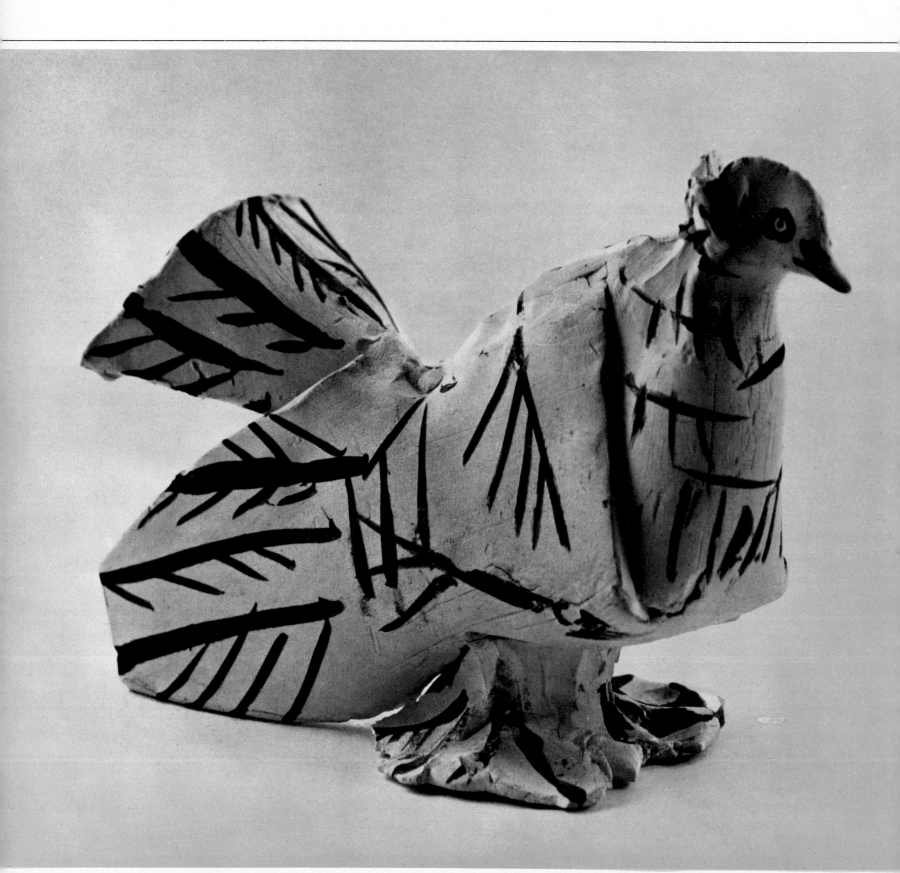

139. Sculpture on turning. Grey pigeon sitting. 16 × 27 cm. Dated 27-1-53.

140. Sculpture on turning. Crested pigeon. 25 × 29 cm. Dated 27-1-53.

141. Modelling on a rough piece of clay. Dove. 15 × 25 × 13 cm. Dated 1953.

142. Modelling on a rough piece of clay. Dove with eggs. 14 × 22 × 20 cm. Dated 29-1-53.

143. Sculpture on turning. Pigeon brooding. 17 × 18 cm. Dated 27-1-53.

144. Sculpture on turning. Blue pigeon sitting. 24 × 14 cm. Dated 29-1-53.

138
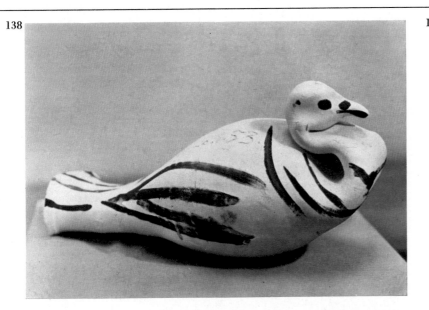

141
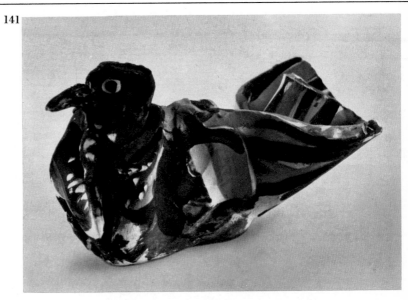

139
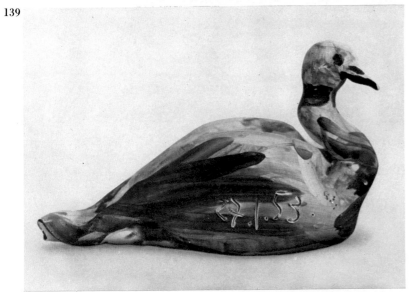

142
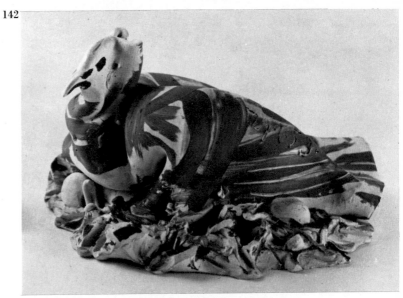

140
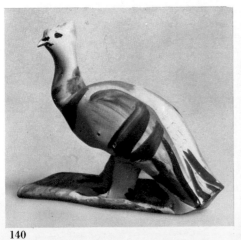

143
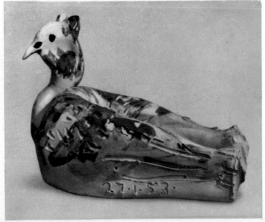

144
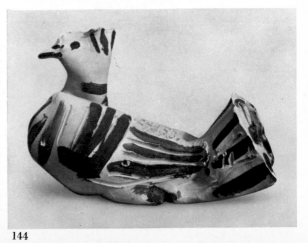

145. Sculpture on turning. Chestnut pigeon. 14.7×24.5 cm. Dated 27-1-53. Museum für Kunst und Gewerbe, Hamburg.

146. Sculpture on turning. Pigeon scratching. 21×25 cm. Dated 27-1-53.

147. Sculpture on turning. Black and white pigeon. 22.5×19 cm. Dated 26-1-53.

148. Modelling on a rough piece of clay. Dove. 15×26×13 cm. Dated 1953.

149. Sculpture on turning. Blue pigeon. 30×25 cm. Dated 27-1-53.

145
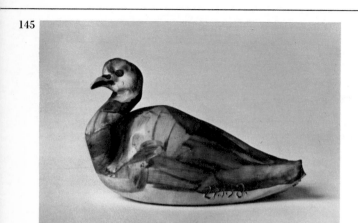

146
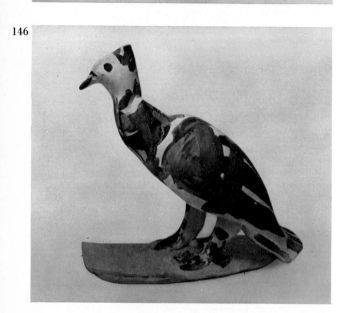

147
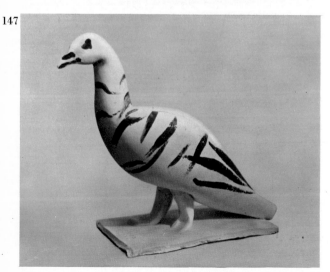

148
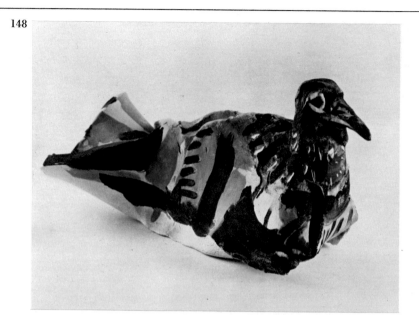

149
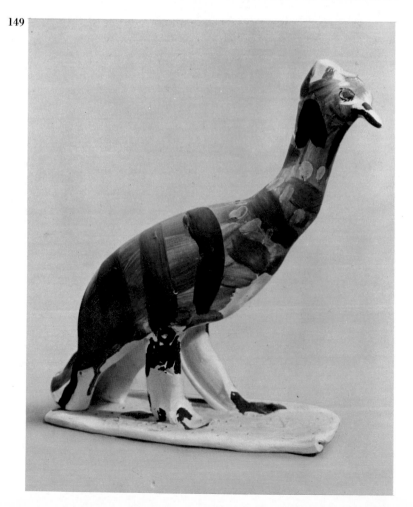

150. Modelling on a rough piece of clay. Dove. 12×22×13 cm. Dated 1953.

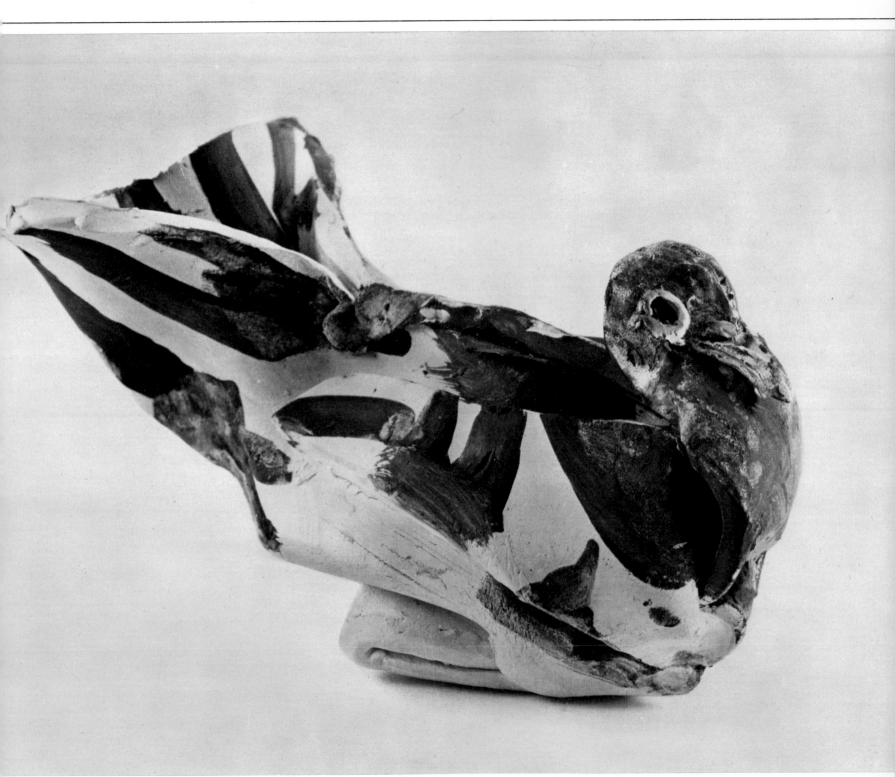

68

151. Sculpture. Owl (red-streaked). Height 34 cm. Dated 22-2-53.
152. Sculpture. Owl (red and grey). Height 34 cm. Dated 7-2-53.
153. Sculpture. Owl (red and white). Height 34 cm. Dated 22-2-53.

154. Sculpture. Grey owl. Height 34 cm. Dated 1953.
155. Sculpture. Angry owl. Height 30 cm. Dated 1953.
156. Sculpture. Angry owl. Height 30 cm. Dated 1953.

151

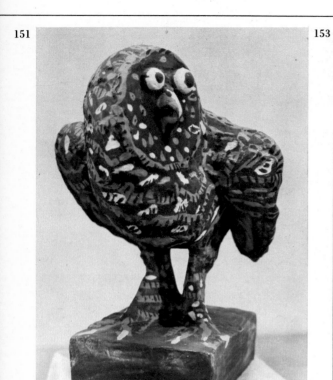

153

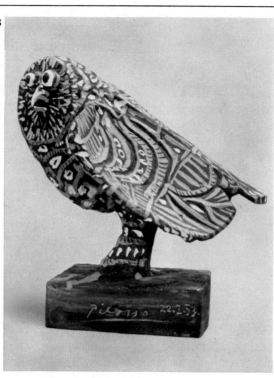

155

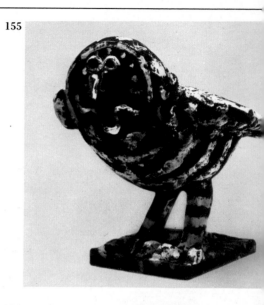

152

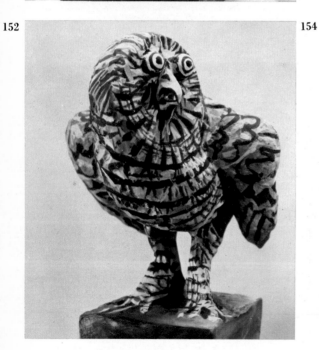

154

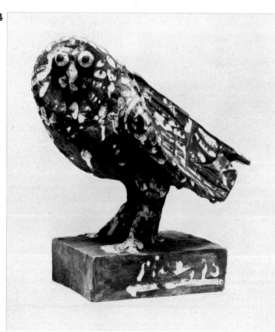

156

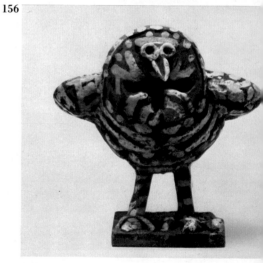

157

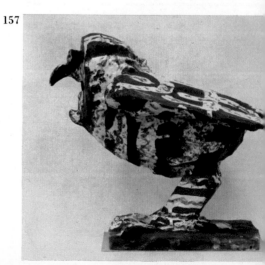

157. Sculpture. Angry owl. Height 30 cm. Dated 1953.
158. Sculpture. Owl painted in engobe. 34.5 × 26 × 33 cm. Dated 5-1-53,
 Vallauris. Signed.

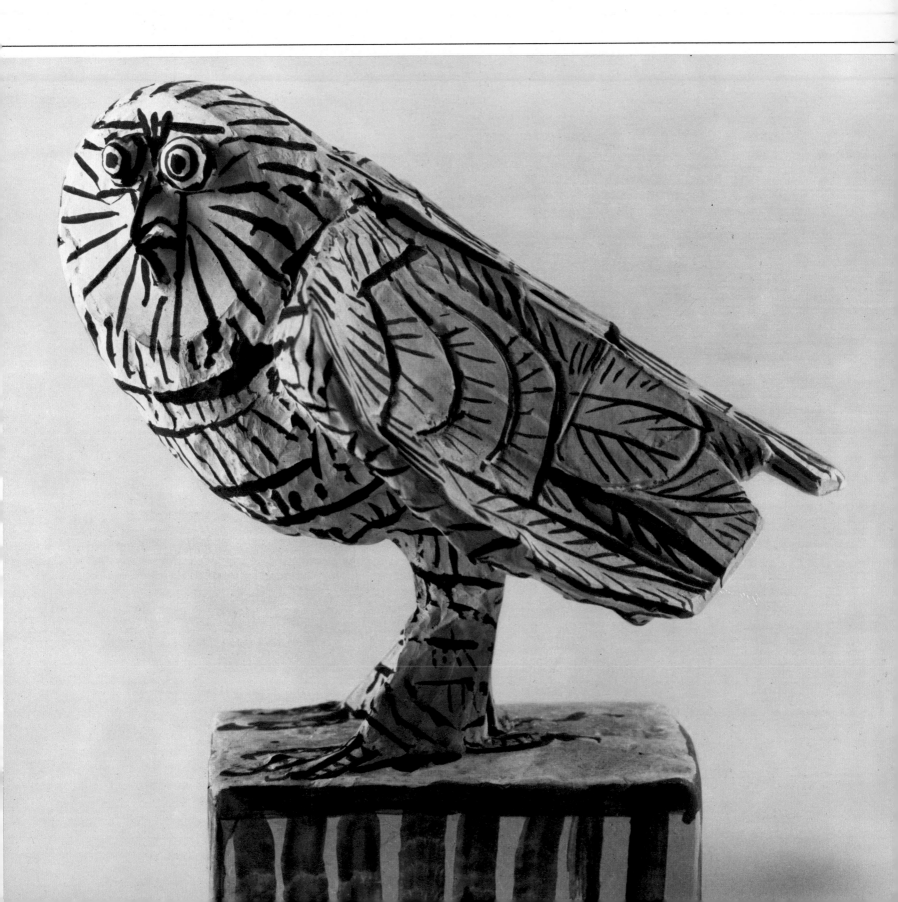

159. Sculpture. Owl (grey layer-work). Height 34 cm. Dated 1953.
160. Sculpture. Owl (ochre layer-work). Height 34 cm. Dated 1953.
161. Sculpture. Owl (grey). Height 34 cm. Dated 9-2-53.

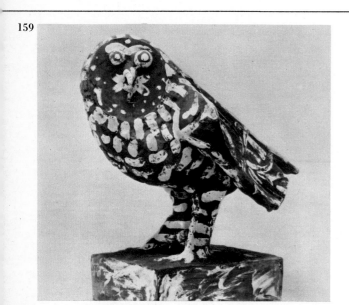

159

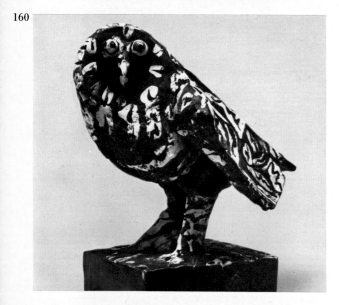

160

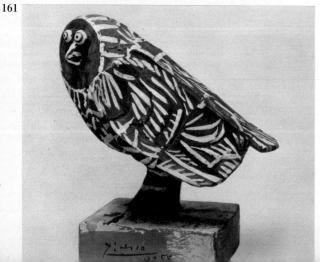

161

the heating and the correct placing of the pieces in the kiln; to say nothing of the last two or three loads of wood, towards the end of the process, when the definitive temperature is very empirically calculated and the fate of the whole firing depends on one man's irrevocable decision. Great efforts, indeed, possibly great merits and risks; but what incomparable trophies are won in return!

This intense participation and feverish attention must be maintained by the potter for at least twenty-four hours, during which, at an unfailing and strictly measured rhythm, he throws, together with several tons of wood, a part of himself into that fire with its dying red glow, his efforts consecrating his humble human offering and magnifying it in the nobility of the results his unstinting labours will accord to him.

This process of firing with oxidising flames was the one used until 21 January 1953 and all the pieces produced before that date were produced in this way. But then we installed one of the new electric potter's kilns developed after the war and, after a long period during which it was used alternately with the wood-fired kiln, eventually it replaced the latter entirely. A technique, assuredly, totally different as much in the thermal rhythm as in the chemical nature of the glazes effected; consequently, it greatly modified the processes and the genre of material produced. Another advantage gained was the smaller volume of the chamber, which allowed more frequent firings and at the same time reduced the long, impatient wait for results. Progress in research was thus facilitated by avoiding the loss of interest that inevitably comes from an overlong withdrawal of attention.

And so it was possible to array the ripe fruits of the latest creations in the kiln at an average rate of twice a week. Despite all this range of

162. Vase. Three faces. 24.5 × 28 cm. Dated 5-12-53.

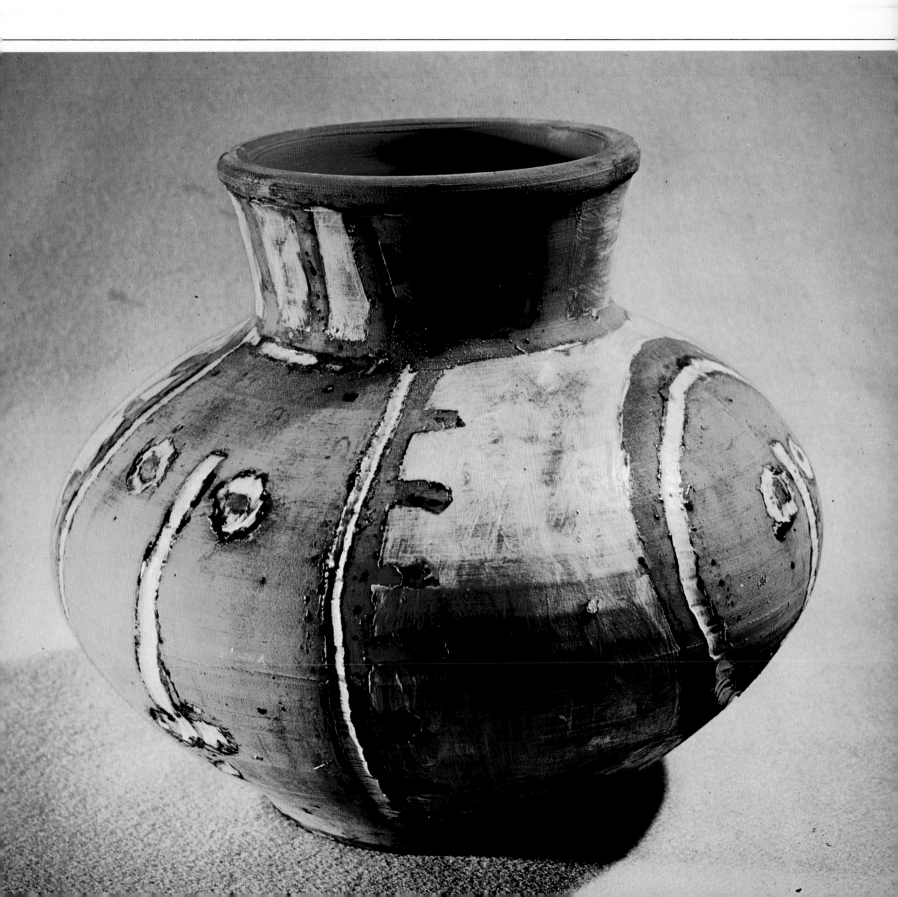

163. Jug. Sun (in pastel crayon). 33 × 26 cm. Dated 4-6-53.
164. Jug. Woman's head. 36.5 × 25 cm. Dated 7-8-53.
165. Jug. Beach scene. 33 × 26 cm. Dated 4-7-53.

163
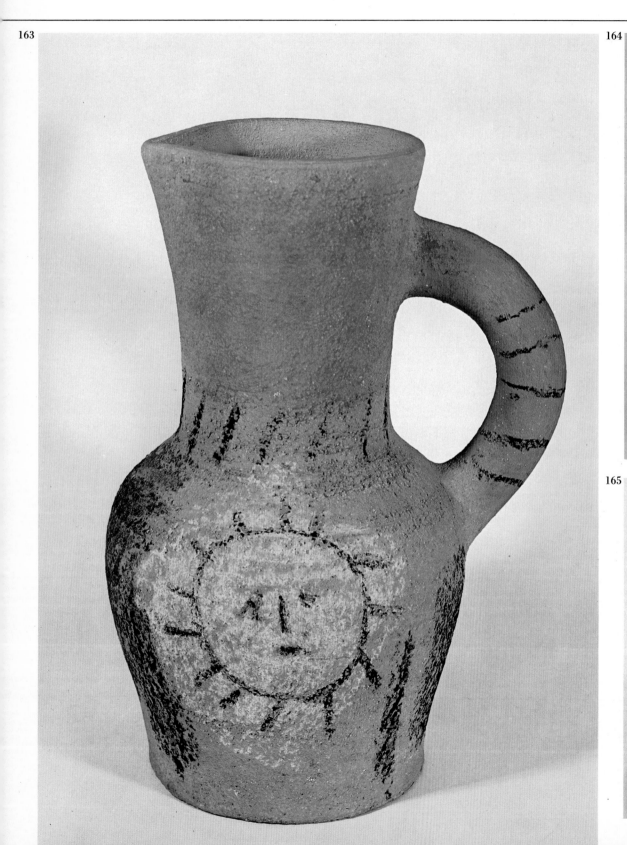

164
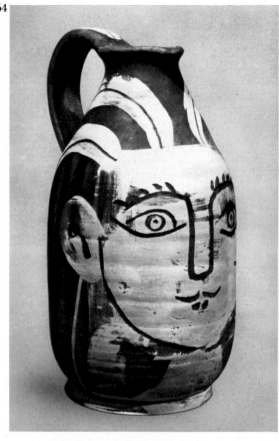

165
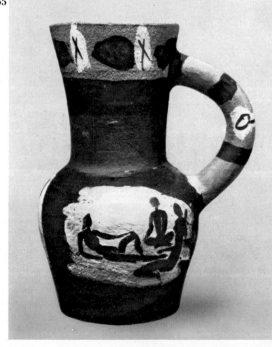

166. Jug. Arum lilies. Height 30 cm. Dated 20-4-53.

166

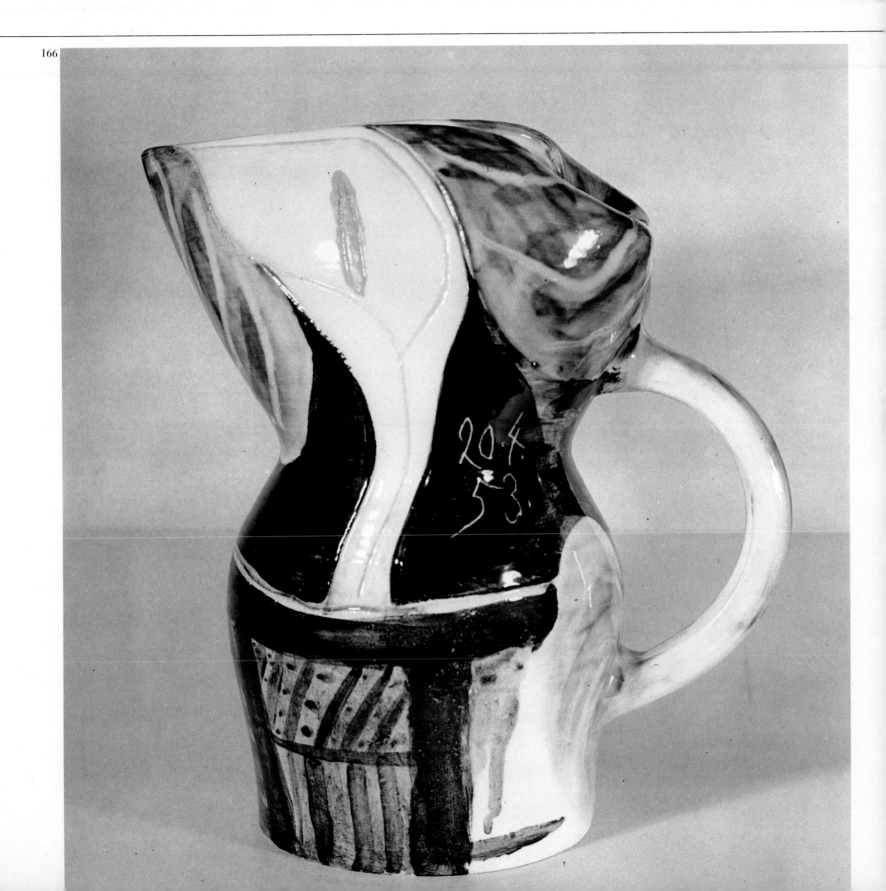

74

167. Jug. Female nude. Height 32 cm. Dated 1953.
168. Vase. Centaur and face. 27 × 25 cm. Dated 15-4-53.
169. Jug. Circus scenes. 35 × 18 cm. Dated 9-1-54.

167

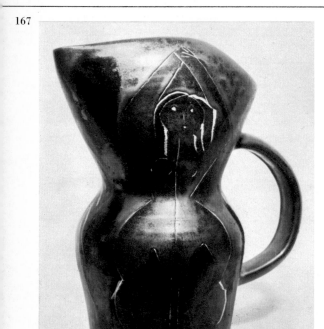

168

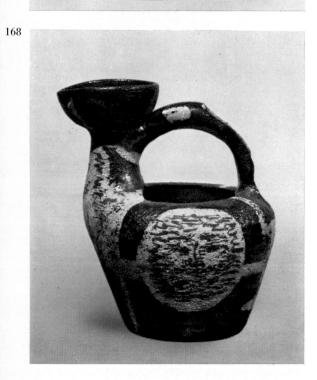

169

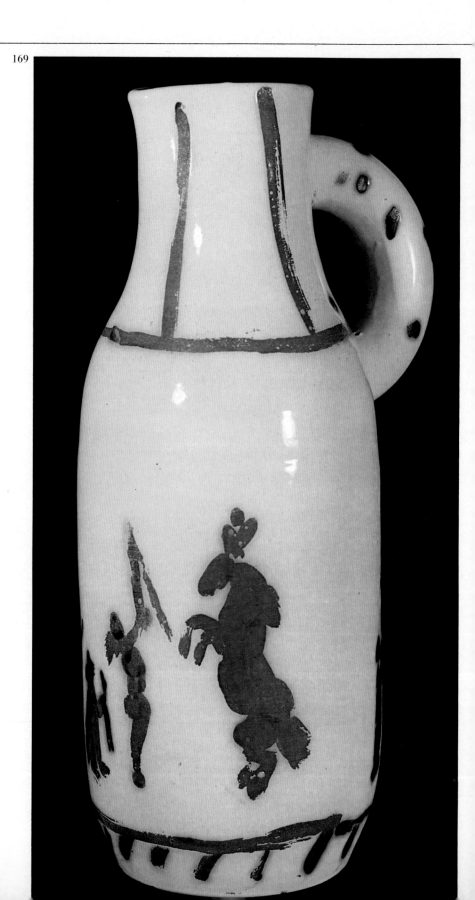

170. Vase. Other side of No. 172. Decorated with strokes. 24 × 28 cm. Dated
19-12-53.

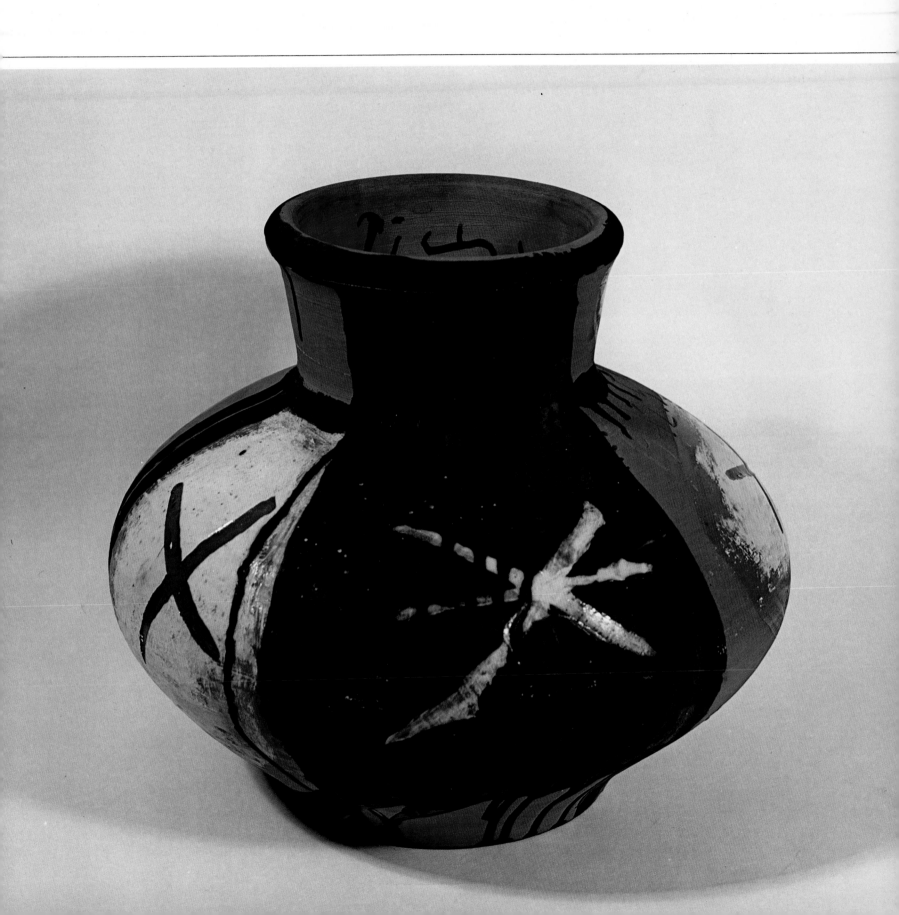

171. Jug. Decoration painted on patinated ground. 29.5×24 cm. Dated 12-1-54.

171

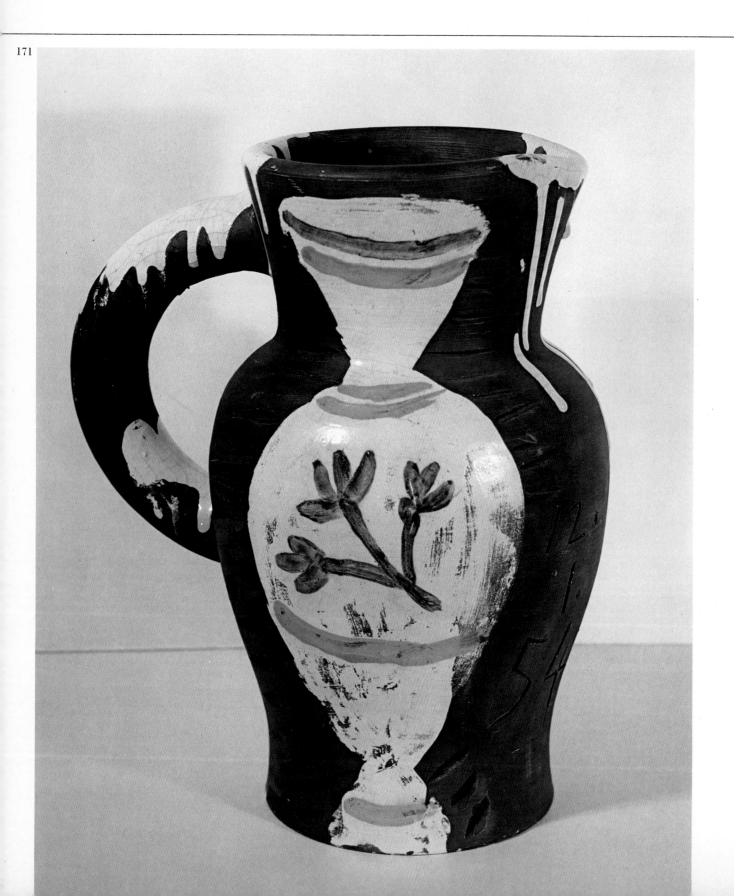

172. Vase. Face in profile. 24 × 28 cm. Dated 19-12-53.

172

to the universal. In the course of this long period dedicated to ceramic work the permanence of the personal option taken by the artist is to be found in his rapports with the import of a thing and the absolute choice he has made in it.

The strict law of contrasts, when fervently obeyed by its greatest supporters, will always restore to the spirit the price of its sacrifice.

possibilities thus opened up to him, Picasso could not linger too long in the facility of effects already exploited by a host of lazier artists; he quickly passed on to the purest of all difficulties: that of seeking out the humblest and most austere of materials and transforming them into a dazzling wealth of composition, thus making the primacy of the spirit sing through the voice of the modesty of the materials.

To penetrate a man's secrets we need a lot of intuition and a considerable degree of friendship, as well as much reflection. Personal sentiment, after so many approaches and so many plans laid together, gains us the happy satisfaction of having here discovered one of the secrets of Picasso's complex nature. One evident trait in his character, in effect, is that basic need which, through all his works, in all circumstances and under all aspects, unceasingly leads him from the particular to the general, from the individual

173. Plate. Fish in relief. 31 × 31 cm. Musée d'Art Moderne, Céret (France).

173

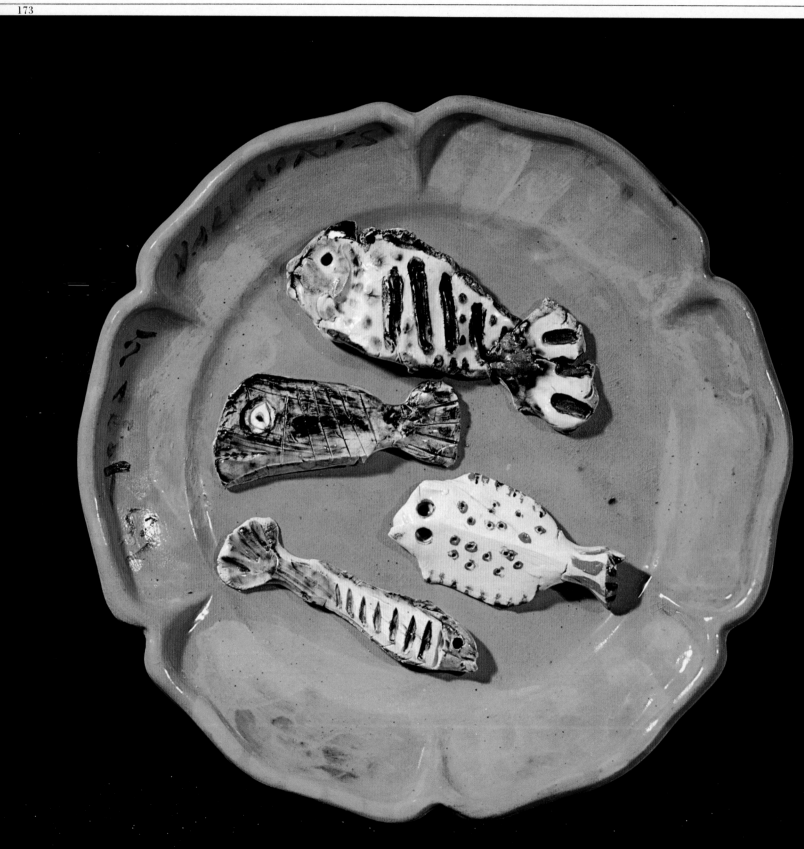

174. Plate. Black-pudding and eggs. 31 × 37 cm. Dated 28-3-51, Musée d'Art
Moderne, Céret (France).

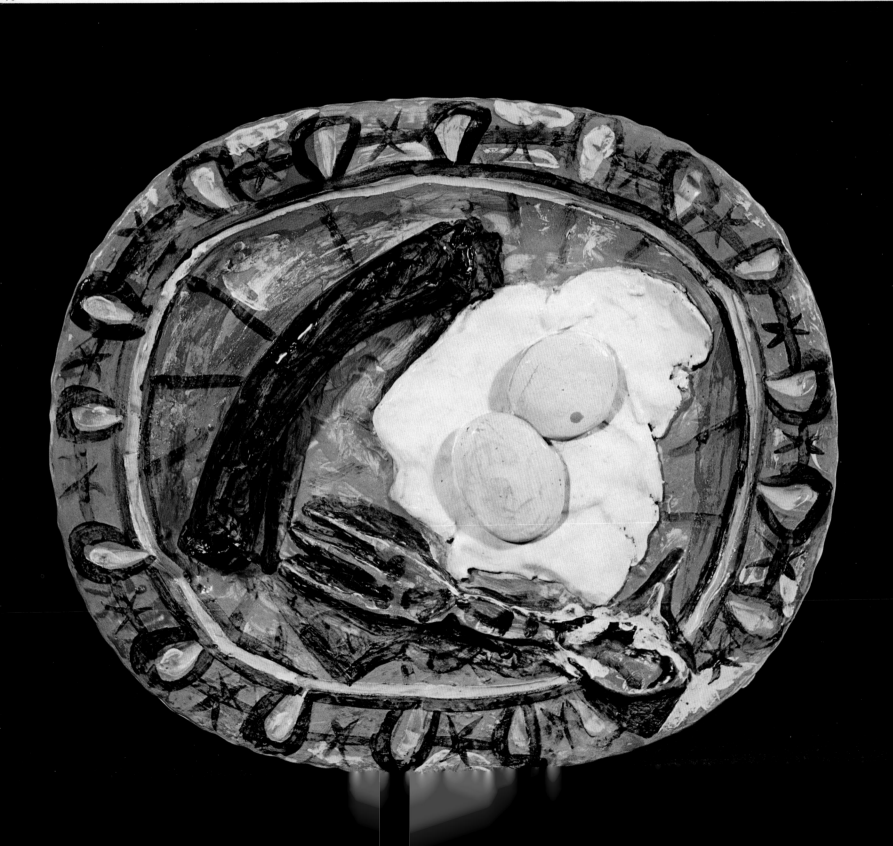

175. Cupel. *Corrida*. Diameter 17.3 cm. Dated 14-4-53, Musée d'Art Moderne, Céret (France).

176. Cupel. *Corrida*. Diameter 17.3 cm. Dated 14-4-53, Musée d'Art Moderne, Céret (France).

177. Cupel. *Corrida*. Diameter 17.3 cm. Dated 14-4-53, Musée d'Art Moderne, Céret (France).

178. Cupel. *Corrida*. Diameter 16 cm. Dated 13-4-53, Musée d'Art Moderne, Céret (France).

175
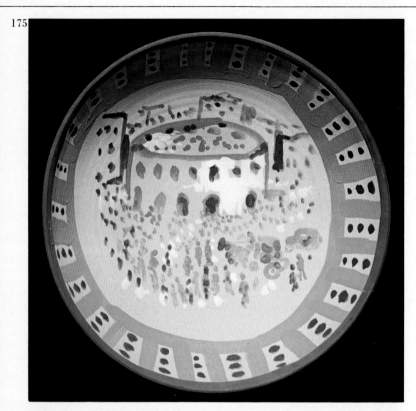

177
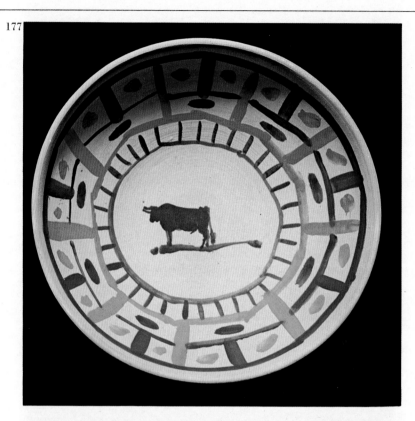

176
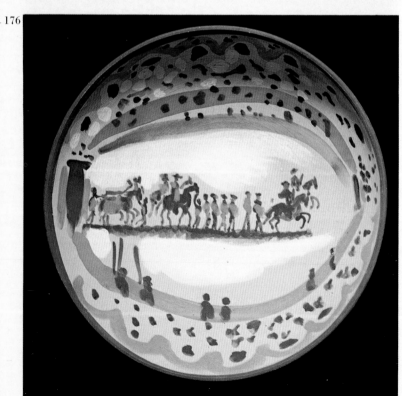

178
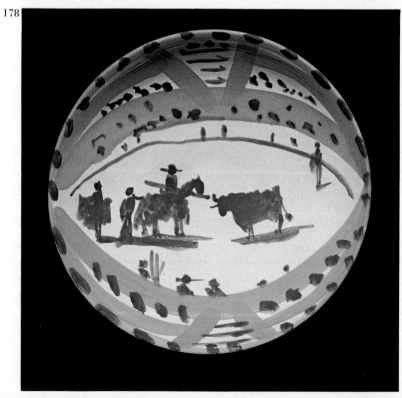

179. Cupel. *Corrida*. Diameter 17 cm. Dated 17-4-53, Musée d'Art Moderne, Céret (France).

180. Cupel. *Corrida*. Diameter 17 cm. Dated 17-4-53, Musée d'Art Moderne, Céret (France).

181. Cupel. *Corrida*. Diameter 16.5 cm. Dated 14-4-53, Musée d'Art Moderne, Céret (France).

182. Cupel. *Corrida*. Diameter 17 cm. Dated 14-4-53, Musée d'Art Moderne, Céret (France).

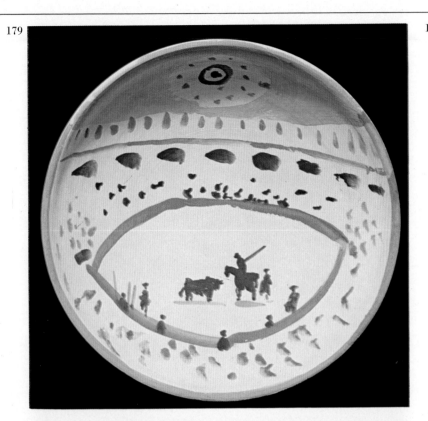

179

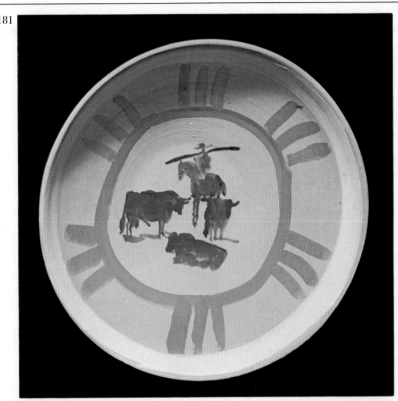

181

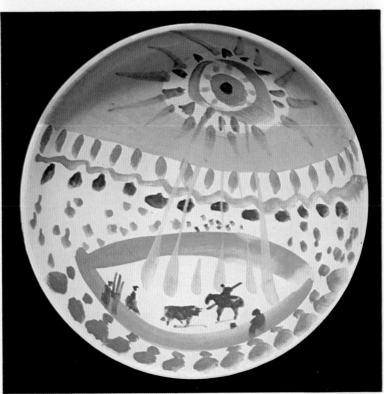

180

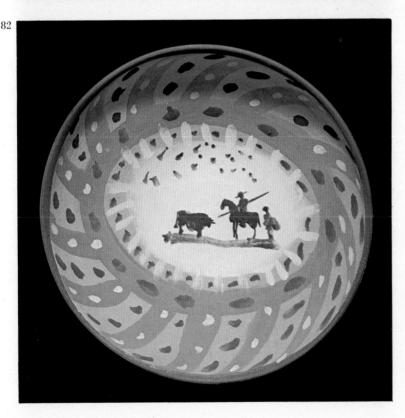

182

183. Cupel. *Corrida*. Diameter 16.6 cm. Dated 14-4-53, Musée d'Art Moderne, Céret (France).

184. Cupel. *Corrida*. Diameter 17.6 cm. Dated 14-4-53, Musée d'Art Moderne, Céret (France).

185. Cupel. *Corrida*. Diameter 17.5 cm. Dated 16-4-53, Musée d'Art Moderne, Céret (France).

186. Cupel. *Corrida*. Diameter 17.2 cm. Dated 17-4-53, Musée d'Art Moderne, Céret (France).

183

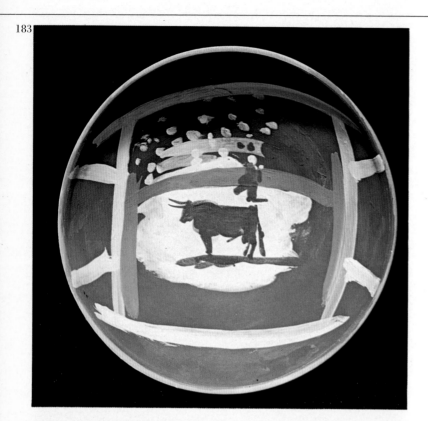

185

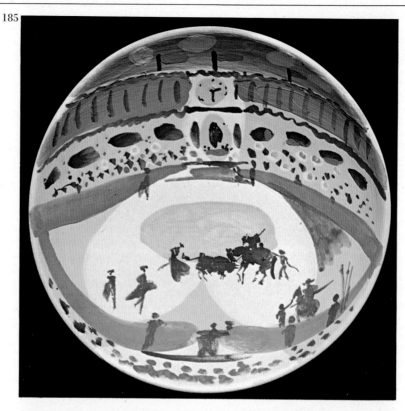

184

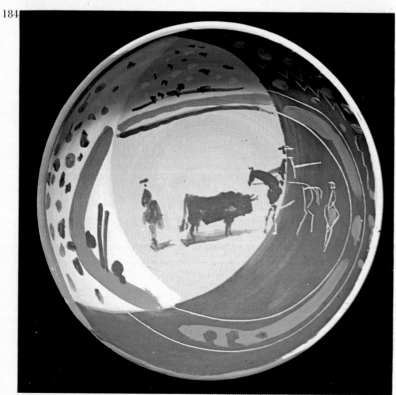

186

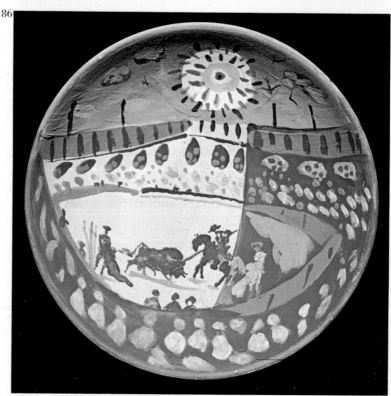

187. Cupel. *Corrida*. Diameter 16.3 cm. Dated 15-4-53, Musée d'Art Moderne, Céret (France).

188. Cupel. *Corrida*. Diameter 16 cm. Dated 15-4-53, Musée d'Art Moderne, Céret (France).

189. Cupel. *Corrida*. Diameter 17 cm. Dated 17-4-53, Musée d'Art Moderne, Céret (France).

190. Cupel. *Corrida*. Diameter 16.5 cm. Dated 17-4-53, Musée d'Art Moderne, Céret (France).

187

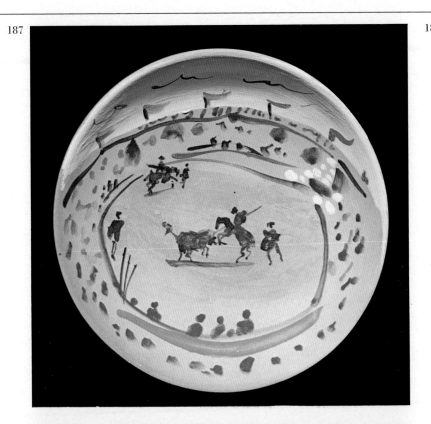

189

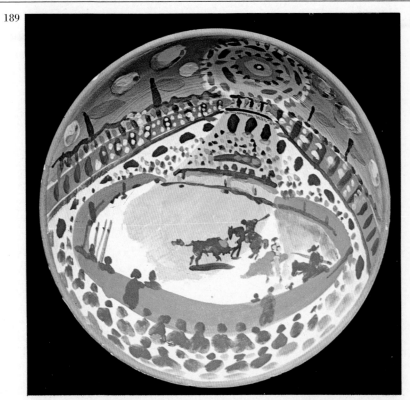

188

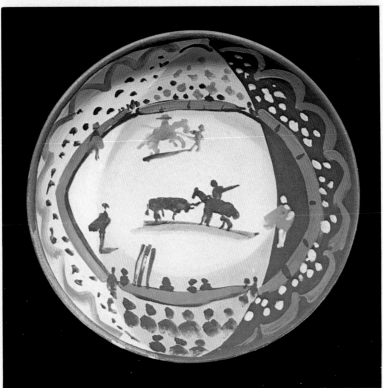

190

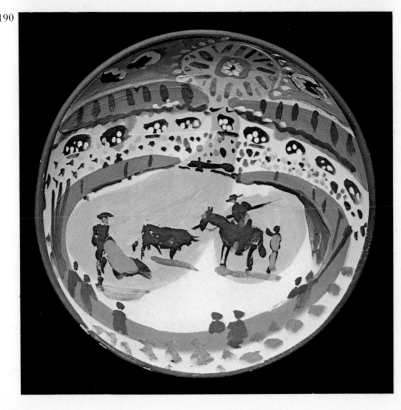

84

191. Cupel. *Corrida*. Diameter 17.5 cm. Dated 16-4-53, Musée d'Art Moderne, Céret (France).

192. Cupel. *Corrida*. Diameter 17 cm. Dated 16-4-53, Musée d'Art Moderne, Céret (France).

193. Cupel. *Corrida*. Diameter 17 cm. Dated 15-4-53, Musée d'Art Moderne, Céret (France).

194. Cupel. *Corrida*. Diameter 17 cm. Dated 14-4-53, Musée d'Art Moderne, Céret (France).

191

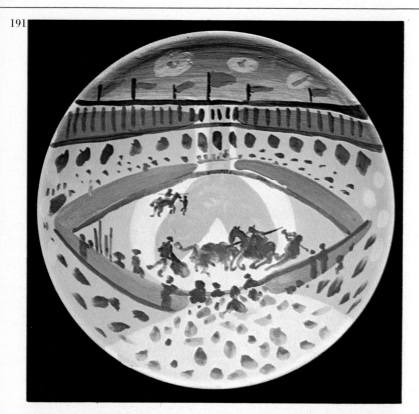

193

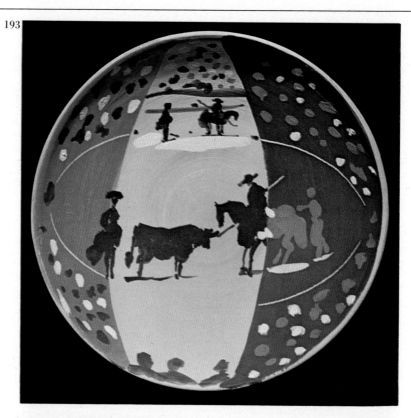

192

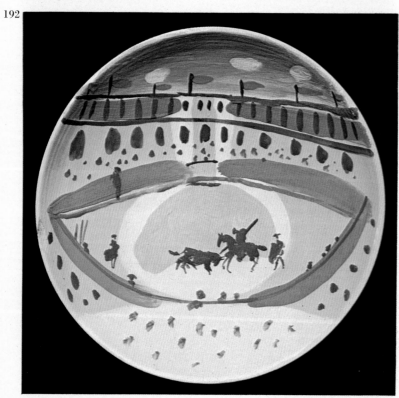

194

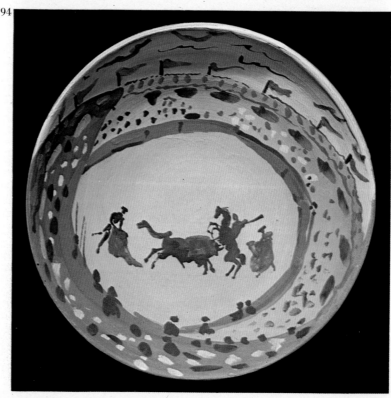

195. Cupel. *Corrida*. Diameter 17 cm. Dated 16-4-53, Musée d'Art Moderne, Céret (France).

196. Cupel. *Corrida*. Diameter 17 cm. Dated 16-4-53, Musée d'Art Moderne, Céret (France).

197. Cupel. *Corrida*. Diameter 17 cm. Dated 15-4-53, Musée d'Art Moderne, Céret (France).

198. Cupel. *Corrida*. Diameter 17.5 cm. Dated 16-4-53, Musée d'Art Moderne, Céret (France).

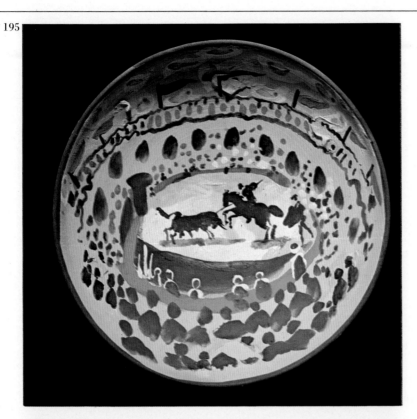

195

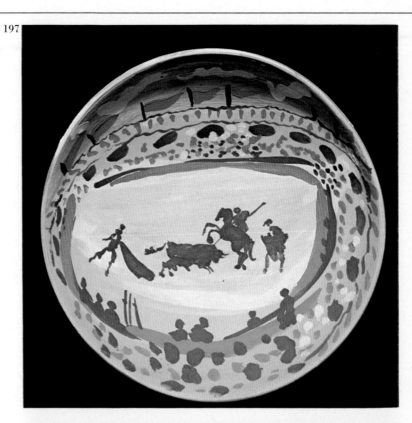

197

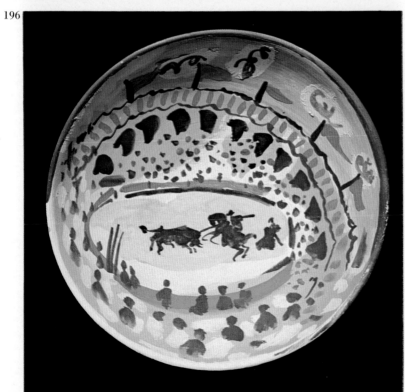

196

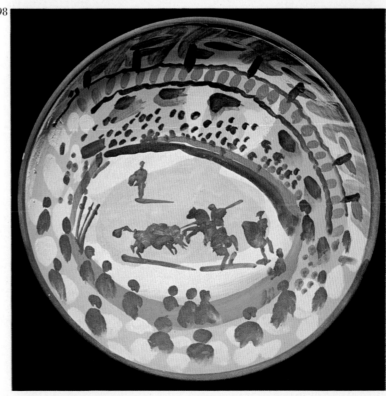

198

199. Cupel. *Corrida.* Diameter 16 cm. Dated 13-4-53, Musée d'Art Moderne, Céret (France).

200. Cupel. *Corrida.* Diameter 15.6 cm. Dated 12-4-53, Musée d'Art Moderne, Céret (France).

201. Cupel. *Corrida.* Diameter 16 cm. Dated 14-4-53, Musée d'Art Moderne, Céret (France).

202. Cupel. *Corrida.* Diameter 17.5 cm. Dated 16-4-53, Musée d'Art Moderne, Céret (France).

203. Cupel. *Corrida.* Diameter 15.5 cm. Dated 14-4-53, Musée d'Art Moderne, Céret (France).

199

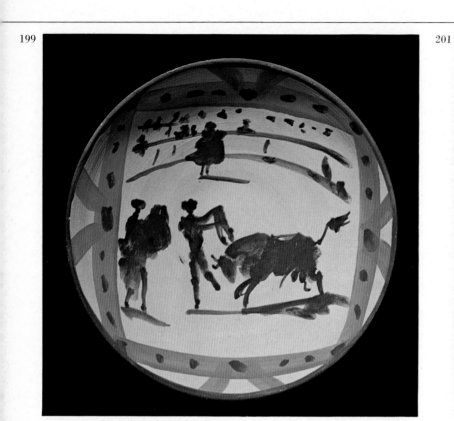

201

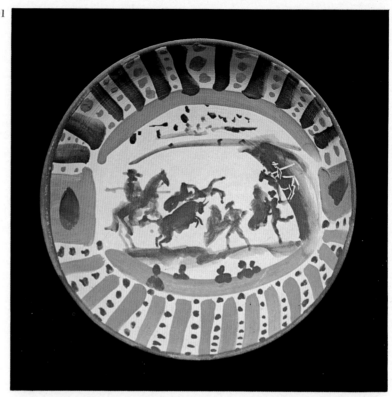

200

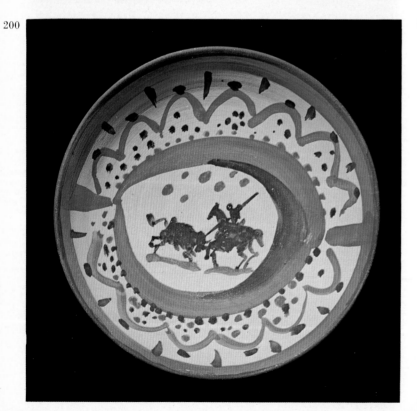

202

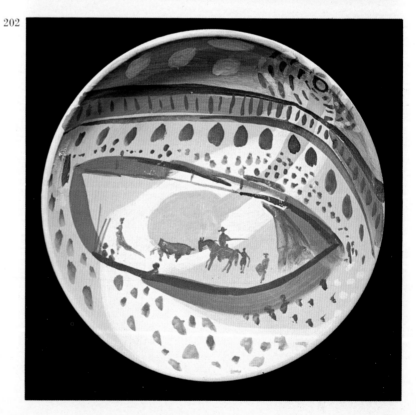

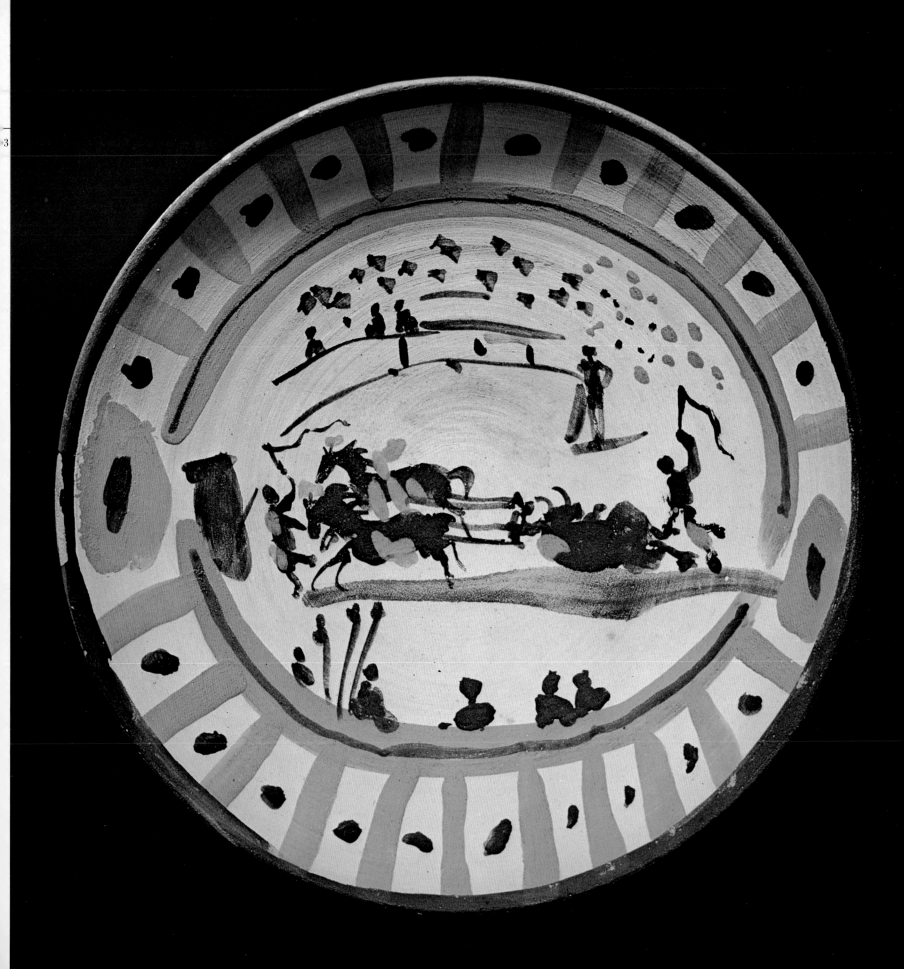

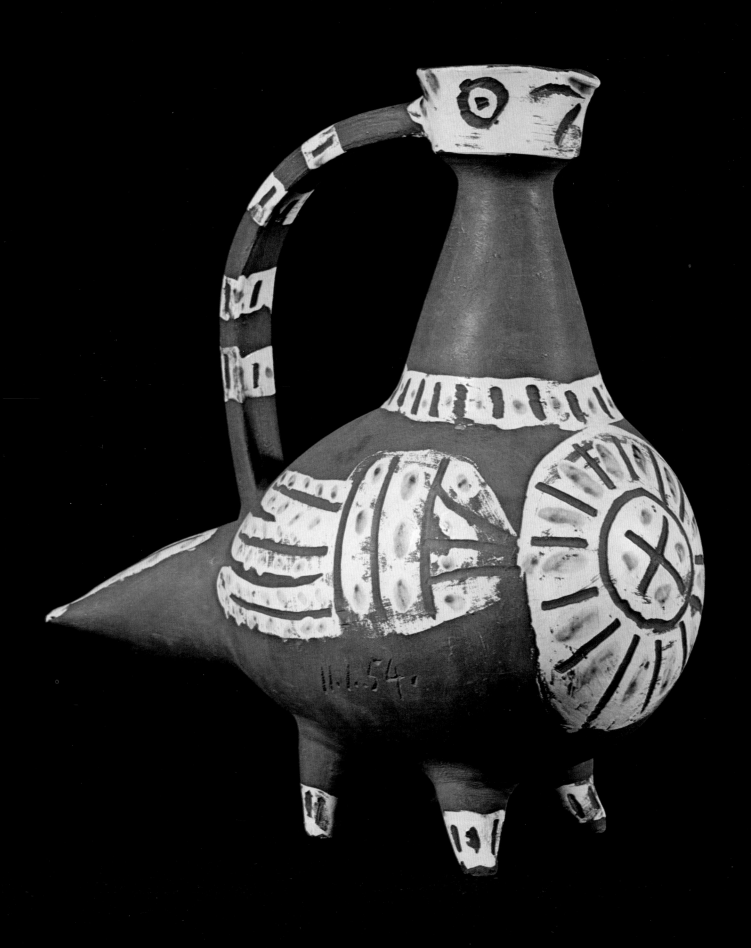

204. Vase. Animal form with handle and four feet. Height 36 cm. Dated
11-1-54, Musée d'Art Moderne, Céret (France).
205. The pigeon. Dated 14-10-53, Musée d'Art Moderne, Céret (France).

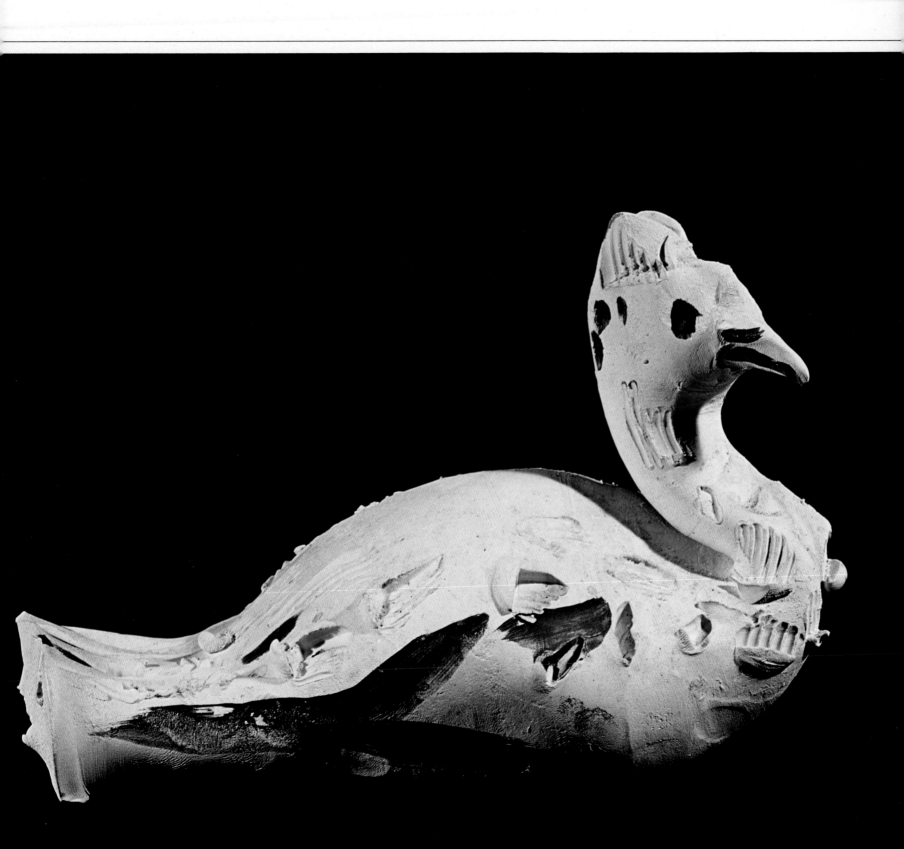

90

206. Rounded square plate. Profile of Jacqueline. White earthenware, 41.5×41 cm. Dated 22-1-56, edition, Musée d'Art Moderne, Céret (France).

V. THE MOMENT OF CONFRONTATION

There are artists who take pleasure in standing for some time, in silent satisfaction, before the works they have just finished. In this we can see a profoundly natural human reaction: his instinct impels the creator to seek himself even at the moment when he is about to cast off the extension of himself formed by the work he has just created. He cannot help retiring within himself to live that tragic moment of renunciation when his own substance is about to be delivered up to the sacrilegious voracity of a fate as yet uncertain, possibly indifferent and perhaps even hostile.

In reliving the emotion he felt before, between the moment of conception and that of the act of translating it, it is understandable that the artist's thoughts should be dramatically invaded by a series of doubts, regrets, complications or reproaches.

As a general rule Picasso does not spend too long on this irresistible narcissism. Admittedly, he is always willing to make a close examination of whatever has just come from his hands. But at these moments he does not give the impression of a man holding a bitter debate with the work that is about to leave his immediate orbit. He seems, rather, in this act of meditation that is typical of him, to be gathering reasons for pur-

suing, in fresh surges and along unknown lines, the idea he has imposed upon himself.

It is his hour of self-confrontation, of self-criticism, of deductions and lessons, the moment for balancing everything and making it bend!

Sometimes, too, this is the moment of censure, when perhaps one of the pieces arraigned before him, as if in the dock, will find no mercy. The result it proposes seems stupefyingly incoherent. The surprise it causes is so acute that this attitude takes on an air of scandal, in defiance of all relevant judgment. There seems to be no way out... It is then that a special pile is started in a corner to house the solitary meditations, in the dust of penitence, of these sad, repudiated, rejected orphans, innocent victims of heaven knows what obscure machinations. Such decisions as these represent are rare. But we should remember that things are not always so ductile as not to become unseemly at times. They have to be given time to understand what is expected of them. Unless, of course, it is they who suddenly unveil their incomprehensible mystery and make us, in turn, understand what they expect of us!

This is a fact well-known to everybody. And yet an insidious curiosity frequently arises regarding the wretched indignities suffered by these

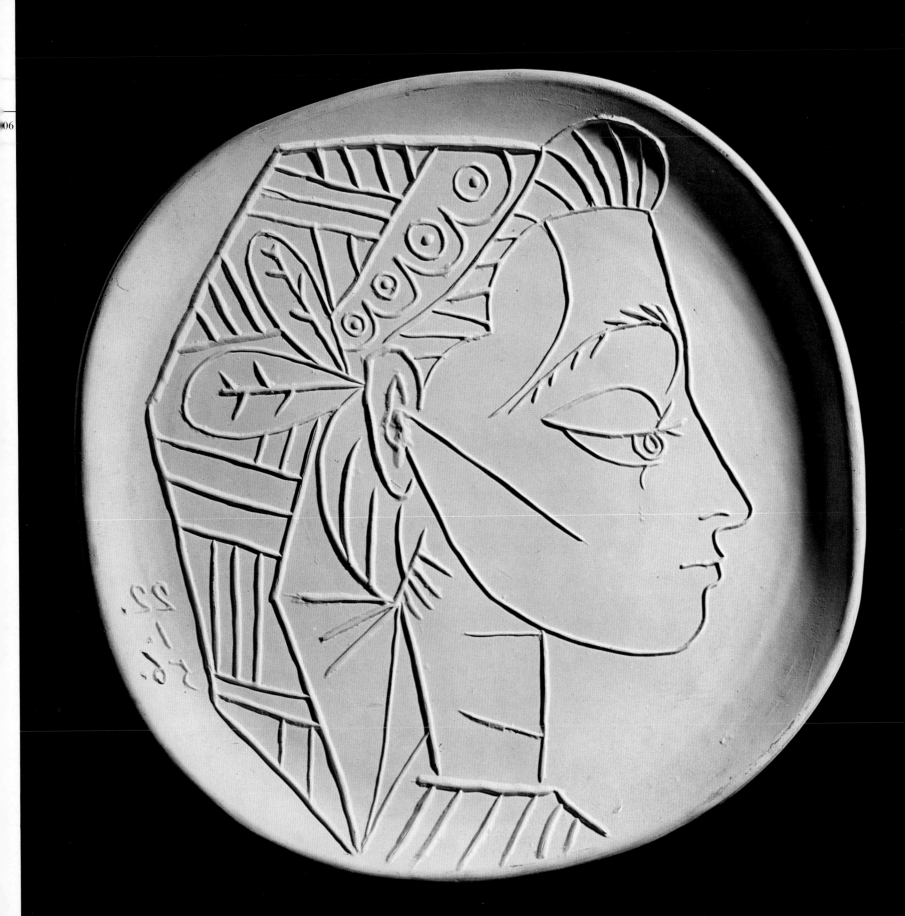

207. Jug. Female nude. Height 35.5 cm. Dated 9-1-54, Musée d'Art Moderne, Céret (France).

207

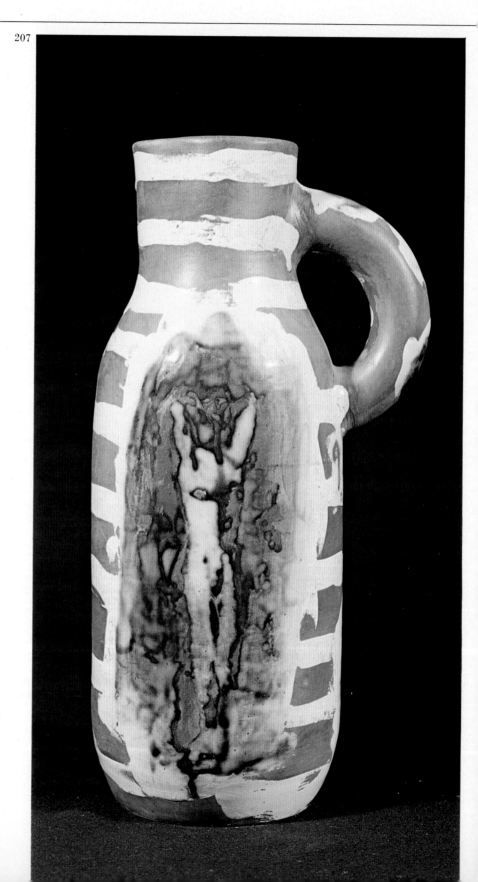

unloved pieces. And sometimes, when the pressure of work slackens, one finds it tempting to go through the contents of the fatal pile.

This, of course, is an act of pure charity to oneself, but it also enables one to test once more an opinion which, for one reason or another, may have changed with the passing of time and this restorative retirement. And when one reaches the pile, one's heart never fails to miss a beat; are not these black sheep really one's most deserving children — and sometimes even the most gifted? And is there not an appreciably unexpected quality about this piece that one could not reasonably imagine before? Looking at it a little more closely, one might even admit that it is its very unusualness that gives it a value of singularity well worth keeping!

Did I not say just now that in many cases things know how to make themselves understood? Now we see how their qualities are no longer defects and their misdeeds are transformed into achievements!

As for those declared without argument to be inadmissible, no harm will come to them; they will be left intact, for nothing of what has been will be destroyed, nor will anything that cannot be remade be unmade. And so they will share the fate of others, more perfect in some eyes. They will bear witness of humility towards man; man who, like all living beings, goes through hours of triumphant exaltation and moments of unutterable dejection.

In this manner it will be given to anyone who will want to concern himself at a later date to read the natural development of the *oeuvre* as a manuscript in which the artist's changing states of mind will be recorded with absolute honesty. It is in this way that man's history is written from a point outside man himself, unsuited as he

208. Jug. Landscape. Height 31 cm. Dated 26-9-58, Musée d'Art Moderne,
Céret (France).

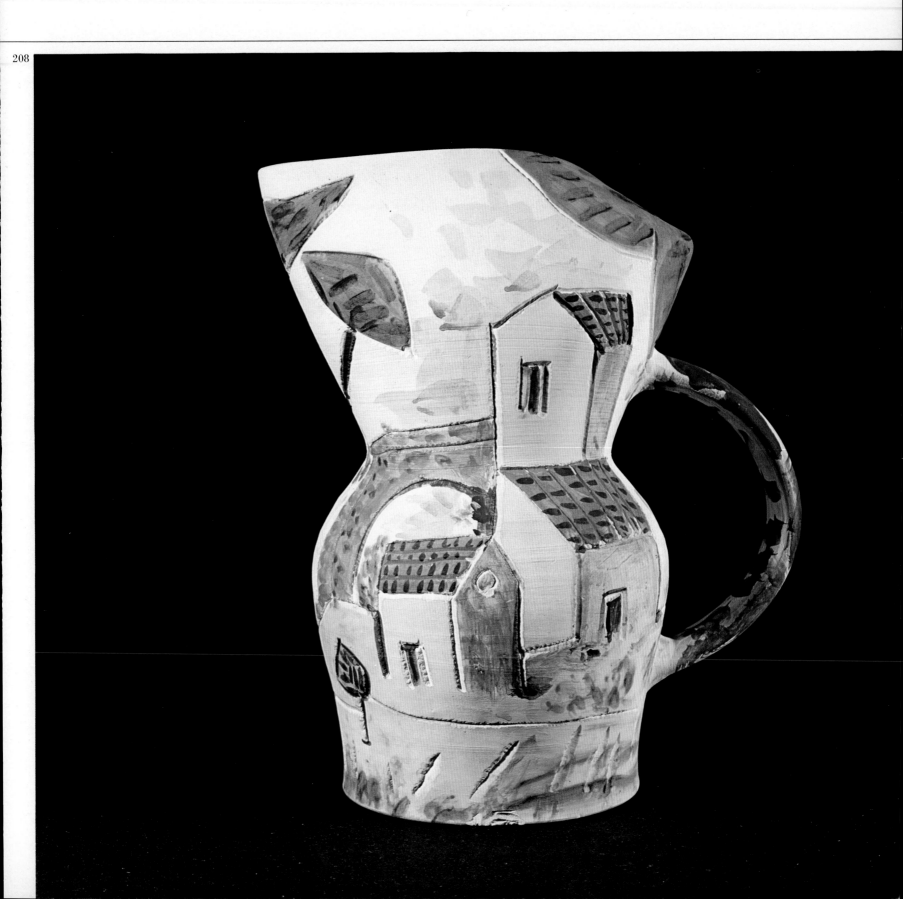

209. Rectangular plate. Blue ground, face painted in relief. 38.5 × 31 cm. Dated 29-10-47, Musée Picasso, Antibes (France).
210. Plate. Reverse of No. 209. Dated 29-10-47, Musée Picasso, Antibes (France).

209

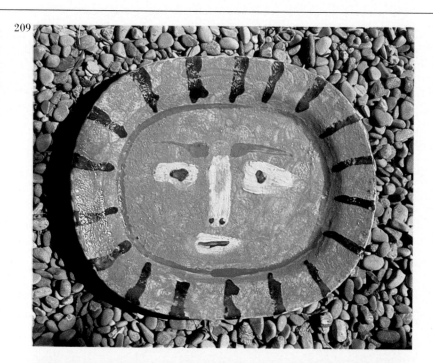

210

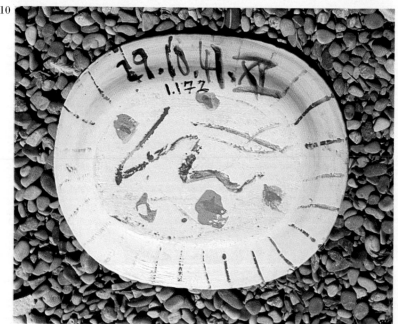

is to judge or destroy what he believes to be his own reality. And for him alone it is a most meritorious act of modesty not to attempt, by contributions later repented and withdrawn, to stir up its true content.

So now we see the work handed over in its entirety to public judgment, without any hypocritical cheating or false shame. And also, I need hardly say, inconclusively! For indeed, as I write these lines, this festival of invention in ceramics is still one of Picasso's most pressing concerns. And it is of small consequence, therefore, to attempt to determine its extent; what I can affirm is that it constitutes a very considerable *ensemble*, with the numbering of its pieces running into thousands. Such an immense amount of work, kept up at the incredible speed that Picasso untiringly demands of himself, naturally had to expand one day in a vast exuberance of experiments, attempts and successes composed of innumerable episodes following one another without respite.

Without intermission! And yet, knowing the beginnings of the work with some degree of precision, it would be rather tempting, if only for the satisfaction of the spirit, to measure its whole content and importance. But it is rare for any of Picasso's ventures to lead to a strictly-defined conclusion; everything about him seems to be either limitless or involved in a permanent process of extension. When he has swept you away with him on a headlong gallop towards unknown horizons and the discoveries he hoped to make of them have fulfilled and calmed him, he is immediately anxious about other territories to explore. Then he will very probably bring his current quest to a sudden close and leave everything, to confront other, still more impenetrable mysteries.

If you wish, in this case, to continue alone, nothing in truth is preventing you. However,

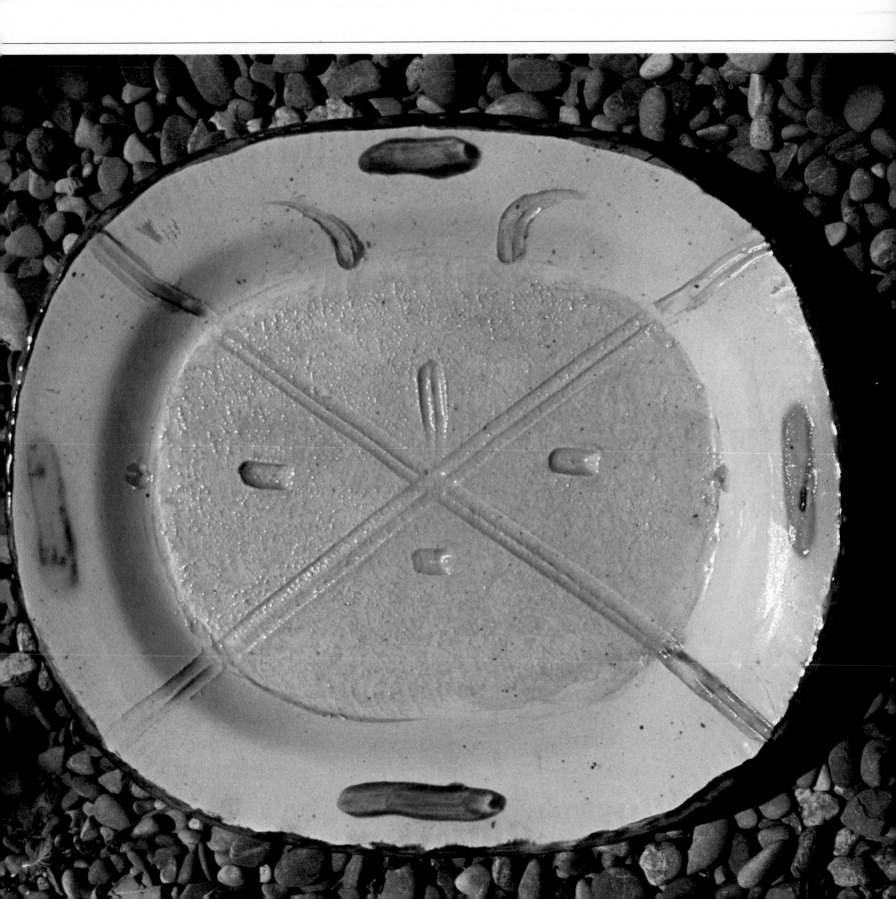

211. Rectangular plate. Faun's face incised, very light colouring. 38.5 × 31 cm.
Dated 1947, Musée Picasso, Antibes (France).

212. Rectangular plate. Small face incised on patinated ground in beige and green. 38.5 × 31 cm. Dated 1947, Musée Picasso, Antibes (France).
213. Rectangular plate. Face in blobs of paint with green border. 38.5 × 31 cm. Dated 1947, Musée Picasso, Antibes (France).
214. Rectangular plate. Face in thick dabs of white enamel on a brown ground. 38.5 × 31 cm. Dated 1947, Musée Picasso, Antibes (France).

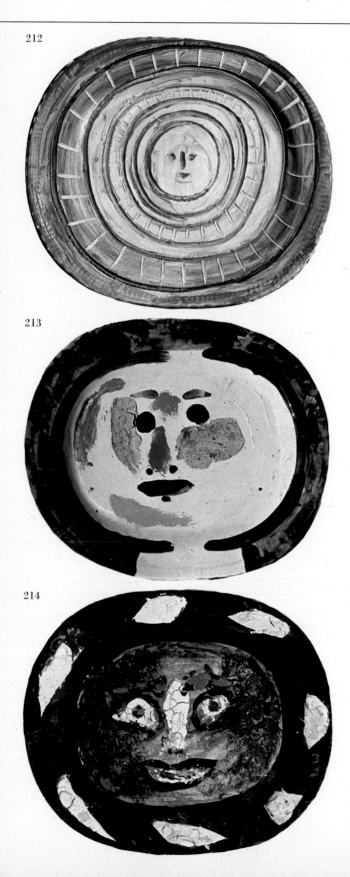

212

213

214

without waiting, it will be revealed that with him the charm of the shared interpretations has flown and that without him the impulse toward descriptive innovation is quickly attenuated. An over-hasty conclusion, undoubtedly, and one that has led some, in their impotent despair, to claim that Picasso has opened all the doors of endeavour only to close them again immediately, after having stolen all that lay within. But maturer reflection will surely lead to the more judicious view that, on the contrary, after flinging open all these doors Picasso would have absented himself from the field, leaving his whole world exposed to an indescribable wind of change that might well prove fatal to many a spirit of feebler constitution. For these doors are still open, now and for ever, leading to a vast range of possibilities and available to the discretion of anyone who wishes to enter.

Is it possible that, depending on the weather, the shade may dazzle us more than the light itself? Thanks to heaven knows what sort of pitiable lassitude, nobody has yet ventured to enter this shade that is supposed to be deserted, in order to discover what lies in its depths. It is like a gift of suprising revelations, within one's reach and yet abandoned in the midst of a disintegrating uncertainty and relinquished because of preconceived ideas. Thus the too-deafening echoes are not always heard by those who listen with the liveliest attention. The only ones with any right to be pleased with themselves will be those who persevere in the assiduous pursuit of what this contemporary authority of the future intimates henceforth.

Here we might also speak of those countless people who have understood the spirit of renewal imperfectly, or who have succeeded in recognizing either the meaning or the character of its evolution. Despite themselves, and by some strange kind of

215. Rectangular plate. Faun's head in wide strokes on a beige ground.
38.5 × 31 cm. Dated 1947, Musée Picasso, Antibes (France).

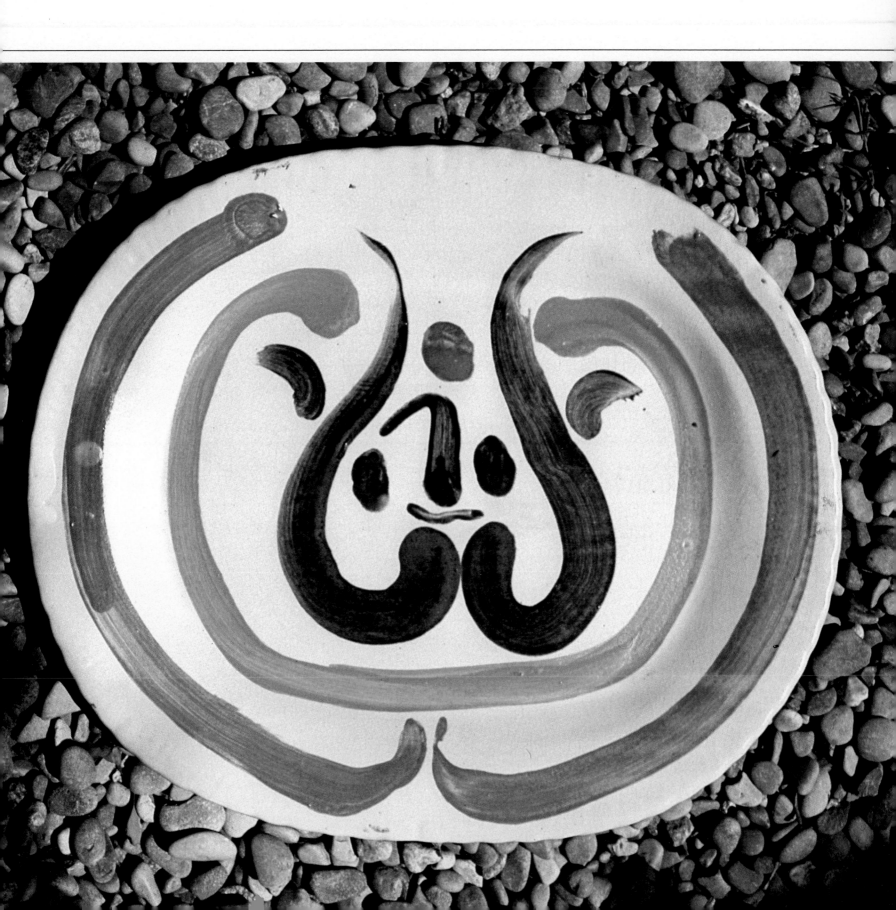

osmosis, they have absorbed superficial and conventional solutions, without assimilating the essential contribution of deeper influences.

Is it a phenomenon peculiar to our age that so many people who believe themselves to be generators of movement should lack the ability to discern the components of the forces that animate them? Confusing exactitude with truth, they take themselves in all good faith for the forerunners of future conceptions, while all the time they are standing perfectly still. If they were only granted a certain faculty of discernment, they would find in it their best means to enter effectively into the act of continuous conversion which is the natural course of evolution. And thus they would fulfil their human mission of participating in the edification of the present through a personal revision of their criteria and an effective stimulation of their pursuits.

In this venture, however, the effects were the opposite. Some temperaments emerged from it gravely impaired, their means of expression limited to some perilous and incomprehensible system of which these beautiful minds immediately found themselves prisoners. The earth-shaking liberation of which they thought themselves the heroes was evidently too violent for them; it offered them the incomparable power of re-transcribing and re-modelling the perceptible world to their own taste. And this moment of fecundity, before they could even conjecture about it, became remote from them. Convinced that they are creating original works, works that spring from their inmost being, they can only serve up again —undigested, spurious and distorted— the results of out-of-date or unanalysable conceptions. What Picasso tellingly describes as his beginner's gargoyles.

Renaissance artists moved among a faithful, studious crowd of scholar-pupils or art-students, always ready to follow their precepts, to seek their advice, to discuss new tendencies and formulas, to be learners or teachers —sometimes both at once.

And in their workshops, which remind one rather of the courts of love of medieval poetic joustings, the master painters watched over their pupils, spurring them on to work, entrusting them with the execution of works begun by themselves and handed over to these diligent young students to continue. The latter, whether apprentices or already qualified painters, were zealously taught, guided and controlled by the master himself, who did the retouching, the finishing and, of course, the signing of the piece, thus justifying his presenting it as his own creation.

Through this unhurried schooling of new masters were transmitted the particular precepts, the metaphysical characteristics, the practical skill and the personal intentions of the presiding genius of the schoool. And later on his pupils, on their own, developed according to their several temperaments, their personal creations continuing to serve the ethical system to which they had been bound from the beginning.

Transposing the idea to our own time, and thinking particularly of Picasso, what could we expect from such a system? Can we really imagine him taking part in such an extravagant enterprise, dispensing judgments and pontificating? Such fancies would quickly lead to disaster, for the mere evocation of such a picture would immediately reveal itself as basically contrary to all that might —even with the greatest indulgence— be considered acceptable from one of his character, his nature, his way of creating and living. And further reflection would very soon invest the idea with an impossibly comic air. One cannot, in all honesty, imagine Picasso analysing himself,

216. Rectangular plate. Faun's face in a square incised on a brown and russet ground. 38.5 × 31 cm. Dated 1947, Musée Picasso, Antibes (France).

217. Rectangular plate. Face with downcast eyes, in relief with a brown border. 38.5 × 31 cm. Dated 1947, Musée Picasso, Antibes (France).

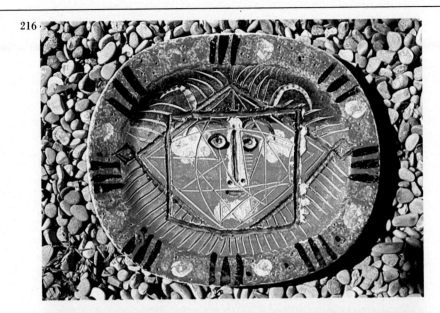

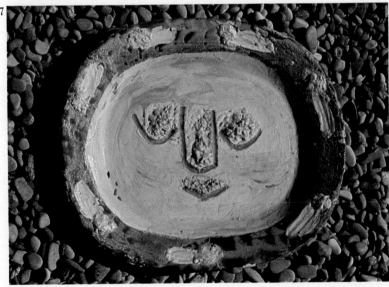

showering his listeners with examples, lavishing oracular maxims on a group of captivated disciples!

It is, no doubt, a great pity for all concerned. But for anyone who has seen Picasso at work, absorbed to his very depths, crushing some furious inner dragon and racked by the torture inflicted on him by the idea he is pursuing, the reason is evident: Picasso communicates with the outer world only through the medium of his work. And this work speaks loud and clear enough to obviate any need for academic rhetoric, complementary information or systematic dissertation.

Imitators, followers and plagiarists Picasso will certainly have, and already has. But pupils, never!

218. Rectangular plate. Picador leaving the bull-ring, blue ground, brown border. 38.5 × 31 cm. Dated 1947, Musée Picasso, Antibes (France).

219. Rectangular plate. Fauns dancing, light brown on ivory ground. 38.5 × 31 cm. Dated 1947, Musée Picasso, Antibes (France).

220. Rectangular plate. Bull-fight scene, picador on blue ground. 38.5 × 31 cm. Dated 1947, Musée Picasso, Antibes (France).

221. Rectangular plate. Bull-fight scene, picador in black on grey ground with black border. 38.5 × 31 cm. Dated 1947, Musée Picasso, Antibes (France).

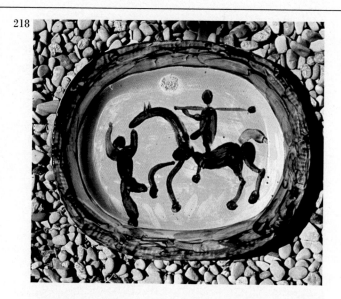

218

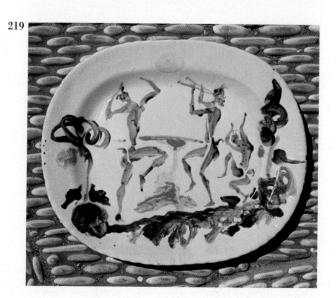

219

VI. THE POTTER'S WHEEL

From the moment Picasso felt definitely absorbed by his new vocation and contemplated pursuing it to its furthest extremes of promise, he embraced the potter's life with the serene simplicity of nature. Wishing to live in hiding, he tried to stay as long as possible out of sight of all curious eyes, whether of professionals or of simple well-wishers, so as to work in peace and solitude. This circumstance enforced on us all an existence that soon became almost conspiratorial: dodging, lurking, parrying over-insistent bores, not answering any questions (which were, by definition, incomprehensible) and keeping everything absolutely secret.

But the secret, as may be imagined, did not take long to become a very open one indeed. The news travelled both fast and far. So far, indeed, that from all the corners of the globe came friends, known or unknown, painters, sculptors, engravers, poets, musicians, to pay their compliments and see for themselves in what curious fashion this illustrious Cubist painter could be dealing with the rotundities of the balls of potter's clay.

All at once it was as if we were back in the courts of love. And in reality it was one of them! But while the assembly did not sit in plenary session, making a perfect circle round the sounding

222. Rectangular plate. Bull-fight scene, picador on green ground. 38.5 × 31 cm. Dated 1947, Musée Picasso, Antibes (France).

223. Rectangular plate. Bull-fight scene, picador in black on grey ground with pink border. 38.5 × 31 cm. Dated 1947, Musée Picasso, Antibes (France).

224. Rectangular plate. Bull-fight scene, picador in brown on beige ground. 38.5 × 31 cm. Dated 1947, Musée Picasso, Antibes (France).

225. Rectangular plate. Brown bull on beige ground with green border. 38.5 × 31 cm. Dated 1947, Musée Picasso, Antibes (France).

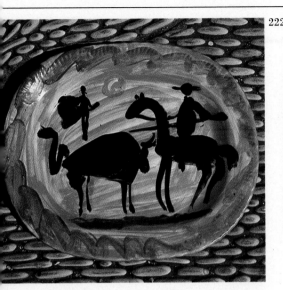
222

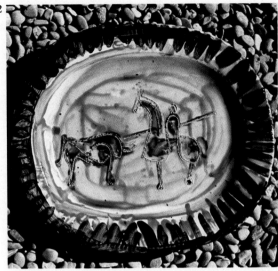
222

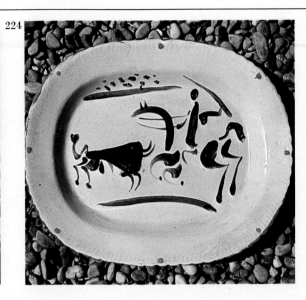
224

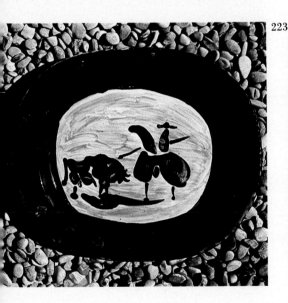
223

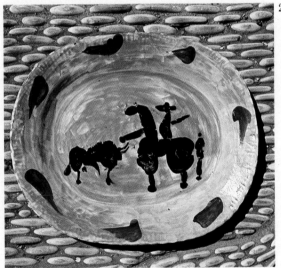
223

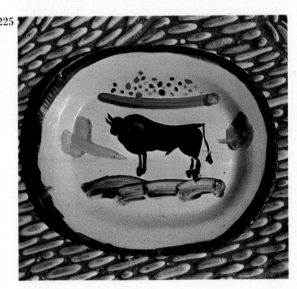
225

226. Rectangular plate. Bull-fight scene, picador in brown strokes on beige
ground. 38.5 × 31 cm. Dated 1947, Musée Picasso, Antibes (France).

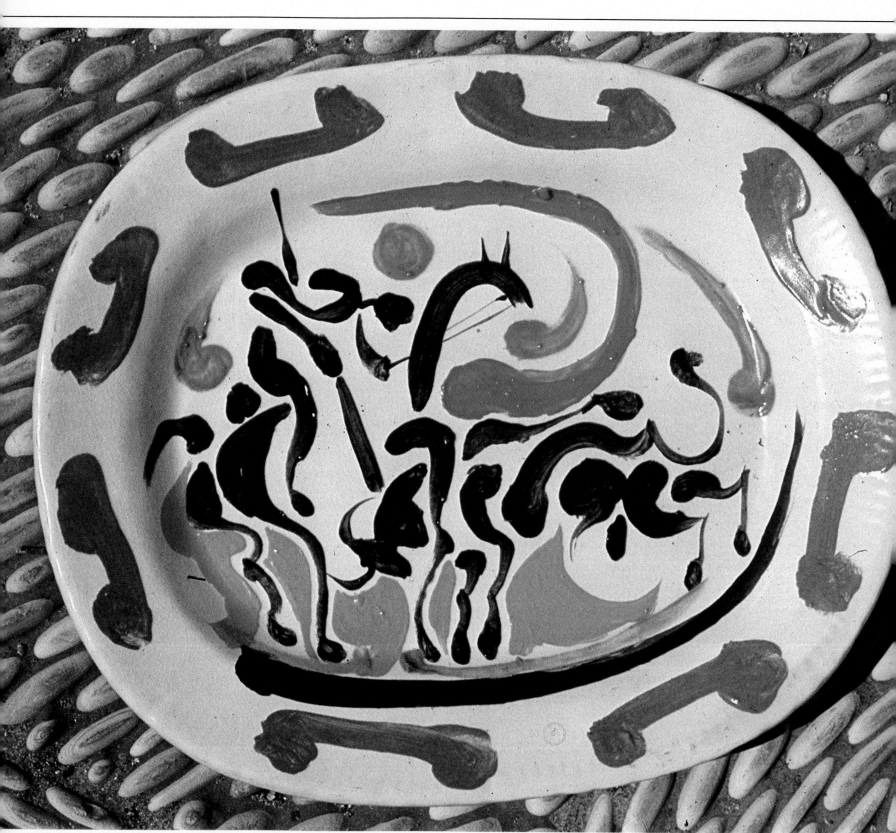

226.

227. Rectangular plate. Bull-fight scene, *banderilleros* in brown on light
ground. 38.5 × 31 cm. Dated 1947, Musée Picasso, Antibes (France).

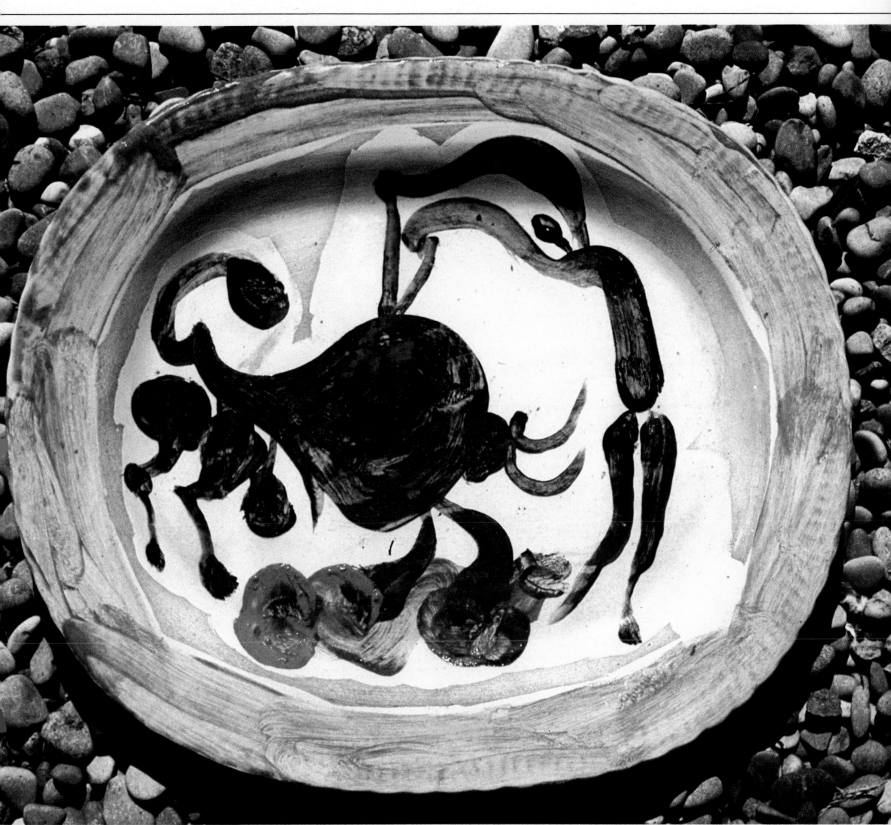

228. Rectangular plate. Centaurs fighting, in russet on cream ground with yellow and black border. 38.5 × 31 cm. Dated 1947, Musée Picasso, Antibes (France).

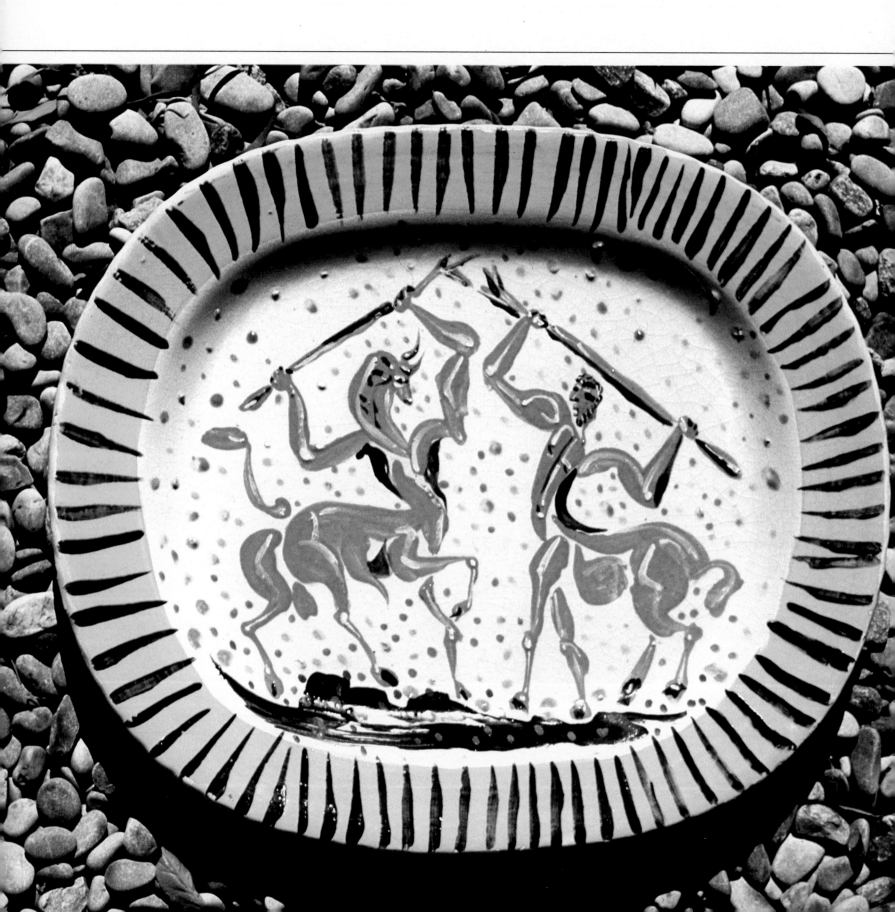

229. Reverse of No. 228.

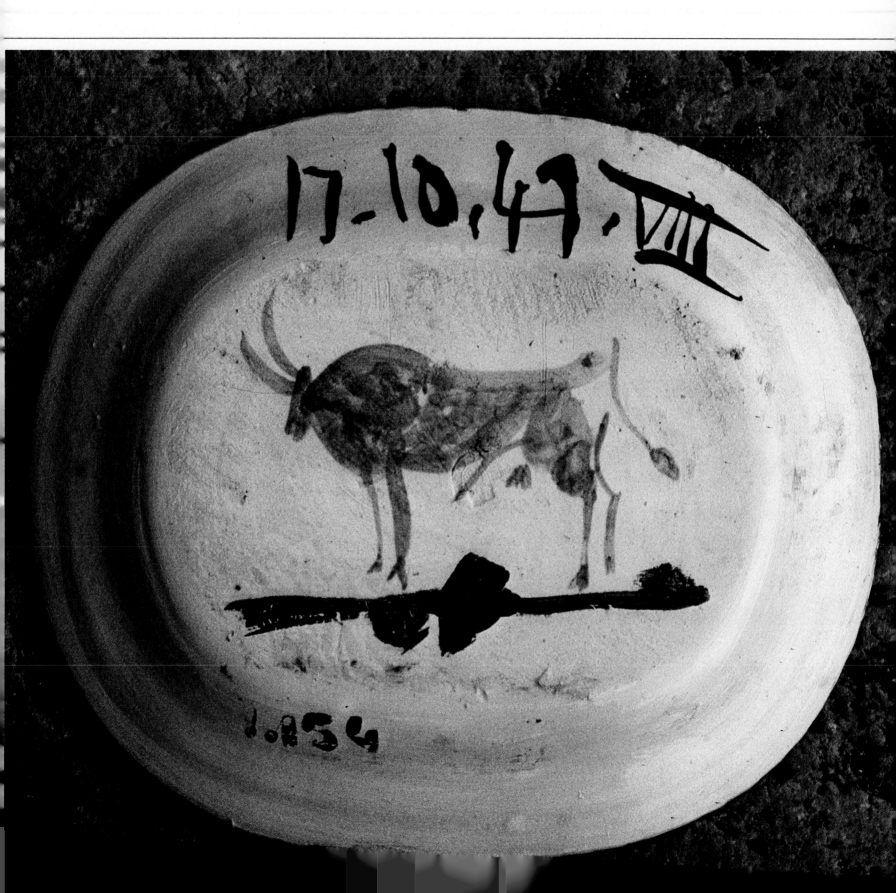

230. Rectangular plate. Two blue fish on an ivory ground with brown border. 38.5 × 31 cm. Dated 1947, Musée Picasso, Antibes (France).

231. Rectangular plate. Two fish (1 russet, 1 blue) in relief, with brown and green border. 38.5 × 31 cm. Dated 1947, Musée Picasso, Antibes (France).

232. Rectangular plate. Two fish incised, ivory with touches of green. 38.5 × 31 cm. Dated 1947, Musée Picasso, Antibes (France).

233. Rectangular plate. Two fried eggs and a piece of black-pudding on a grey ground. 38.5 × 31 cm. Dated 1947, Musée Picasso, Antibes (France).

234. Rectangular plate. Two fish painted (1 blue, 1 beige) on an ivory ground with red border. 38.5×31 cm. Dated 1947, Musée Picasso, Antibes (France).

235. Rectangular plate. An aubergine and a knife on a checked ground in two different blues. 38.5 × 31 cm. Dated 1947, Musée Picasso, Antibes (France).

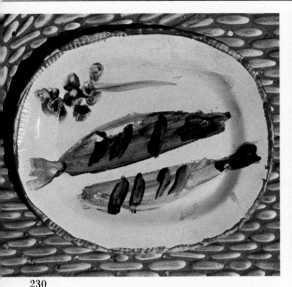

230

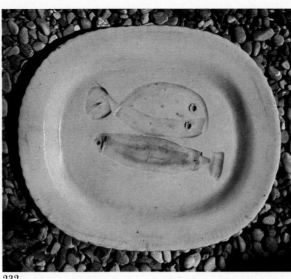

232

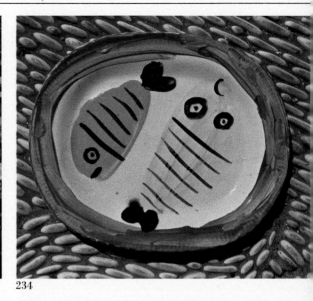

234

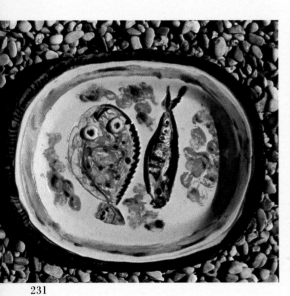

231

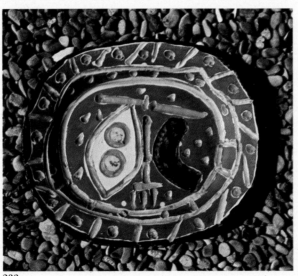

233

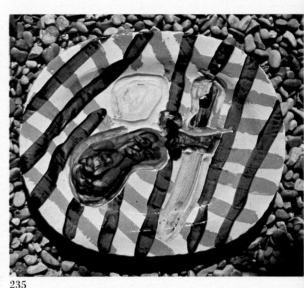

235

107

236. Rectangular plate. Still life with a candlestick, on a black and white ground. 38.5 × 32 cm. Dated 1947, Musée Picasso, Antibes (France).
237. Rectangular plate. Still life with glass and apple, in brown, beige and blue. 38.5 × 32 cm. Dated 1947, Musée Picasso, Antibes (France).
238. Rectangular plate. Still life with grapes on a russet ground. 38.5 × 32 cm. Dated 1947, Musée Picasso, Antibes (France).

239. Rectangular plate. Still life with grapes and scissors, in beige and brown. 38.5 × 32 cm. Dated 1947, Musée Picasso, Antibes (France).
240. Rectangular plate. Still life with tomatoes on a russet ground. 38.5 × 32 cm. Dated 1947, Musée Picasso, Antibes (France).
241. Rectangular plate. Melon on a checked ground in blue. 38.5 × 32 cm. Dated 1947, Musée Picasso, Antibes (France).

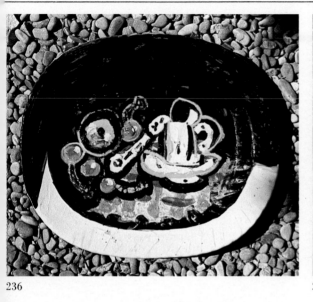

236

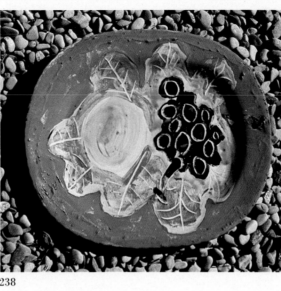

238

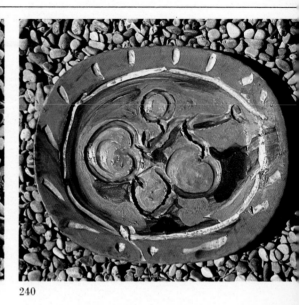

240

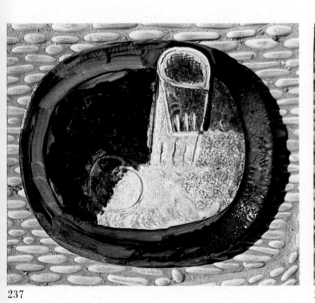

237

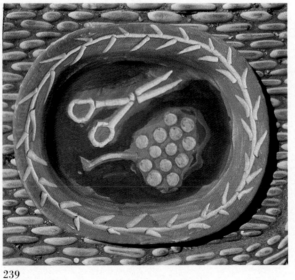

239

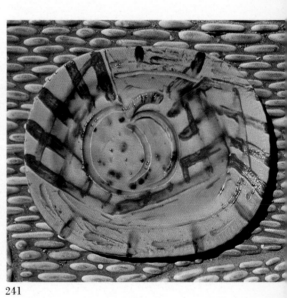

241

242. Rectangular plate. Brown bird on green ground with blue border. 38.5 × 32 cm. Dated 1947, Musée Picasso, Antibes (France).

243. Rectangular plate. Owl incised on a brown ground with touches of beige. 38.5 × 32 cm. Dated 1947, Musée Picasso, Antibes (France).

244. Rectangular plate. Owl incised on a beige ground with touches of green. 38.5 × 32 cm. Dated 1947, Musée Picasso, Antibes (France).

245. Jug. Female busts in matt paint. Height 25 cm., width 14 cm. Dated 1947, Musée Picasso, Antibes (France).

246. Jug. Other side of No. 247.

247. Jug. Green floral motifs and white enamel. Height 24 cm., width 10 cm. Dated 1947, Musée Picasso, Antibes (France).

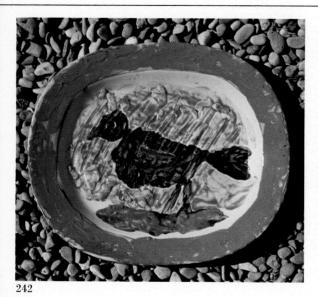

242

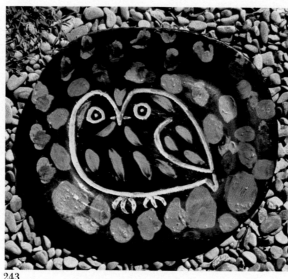

243

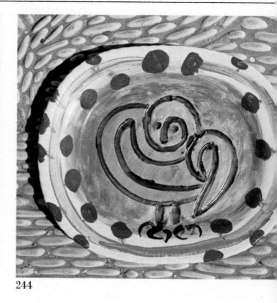

244

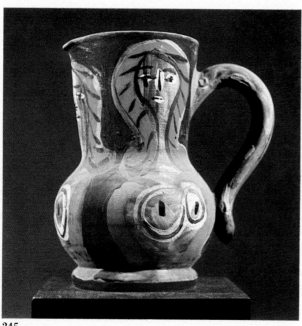

245

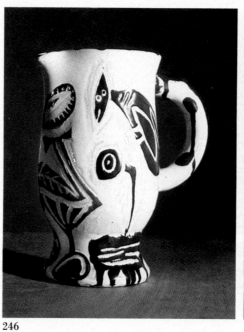

246

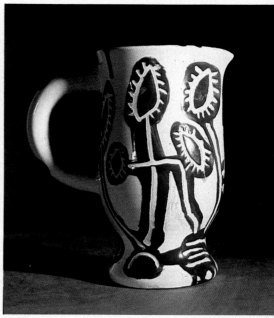

247

248. Jug. Decorated with female nudes in glossy black and white. Height 24 cm., width 10 cm. Dated 1947, Musée Picasso, Antibes (France).

249. Jug. Decorated with a goat in matt patina. Height 25 cm., width 13 cm. Dated 1947, Musée Picasso, Antibes (France).

250. Other side of No. 249. Piper.

251. *Bourrache* (Provençal wine-jug). Floral decoration in black and ivory on patinated ground. Height 60 cm., width 30 cm. Dated 1947, Musée Picasso, Antibes (France).

252. Large bird with two handles. Decorated with superimposed faces. Height 49 cm., width 30 cm., length 33 cm. Dated 1947, Musée Picasso, Antibes (France).

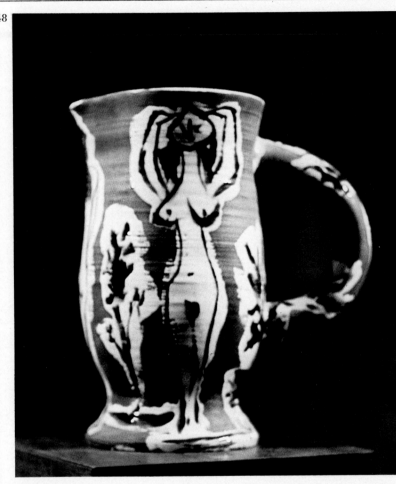

248

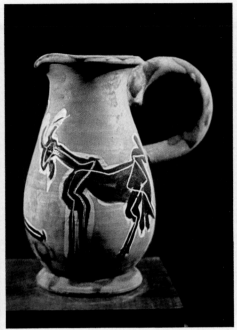

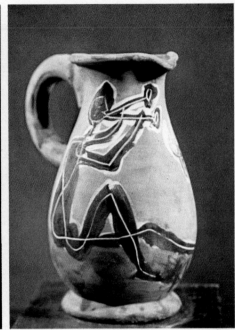

249

250

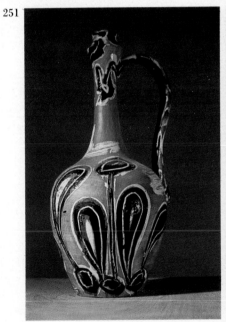

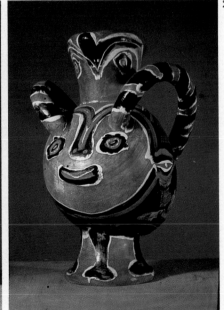

251

252

253. Large piece composed of four elements forming a bird. Height 71 cm.,
width 18 cm., length 35 cm. Dated 1947, Musée Picasso, Antibes (France).
254. Other side of No. 253.

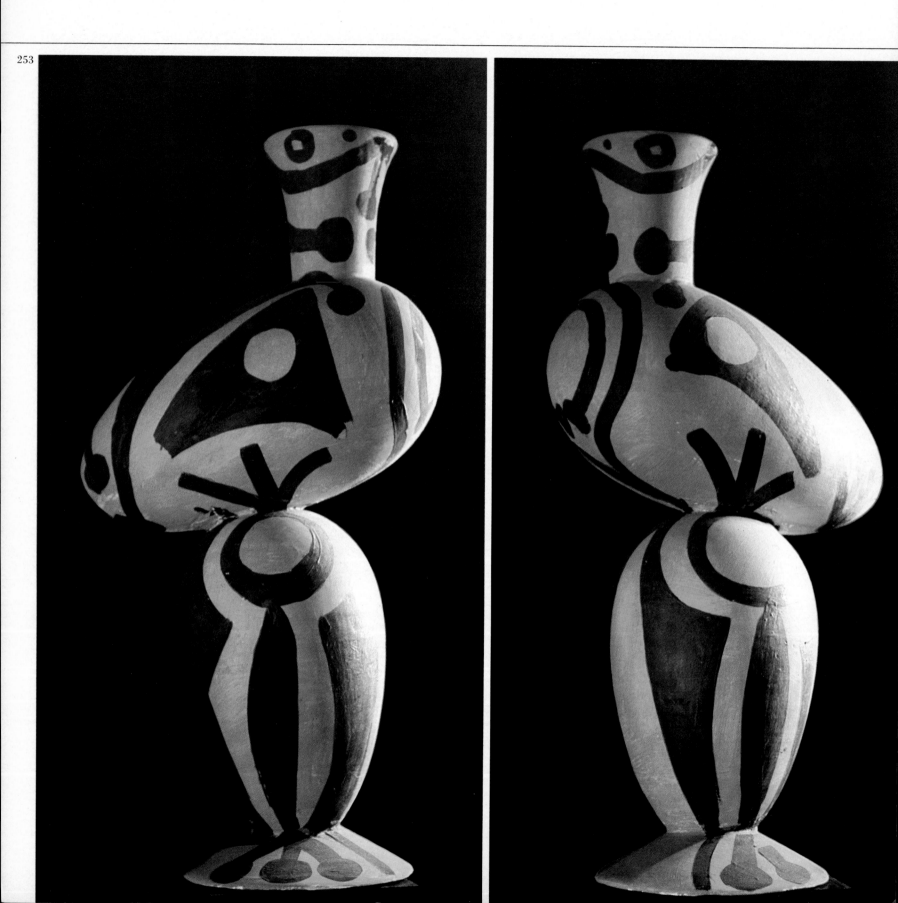

253

255. Turned, modelled and painted piece. Condor in russet and brown. Height 39 cm., length 41 cm., width 15 cm. Dated 1947, Musée Picasso, Antibes (France).

255

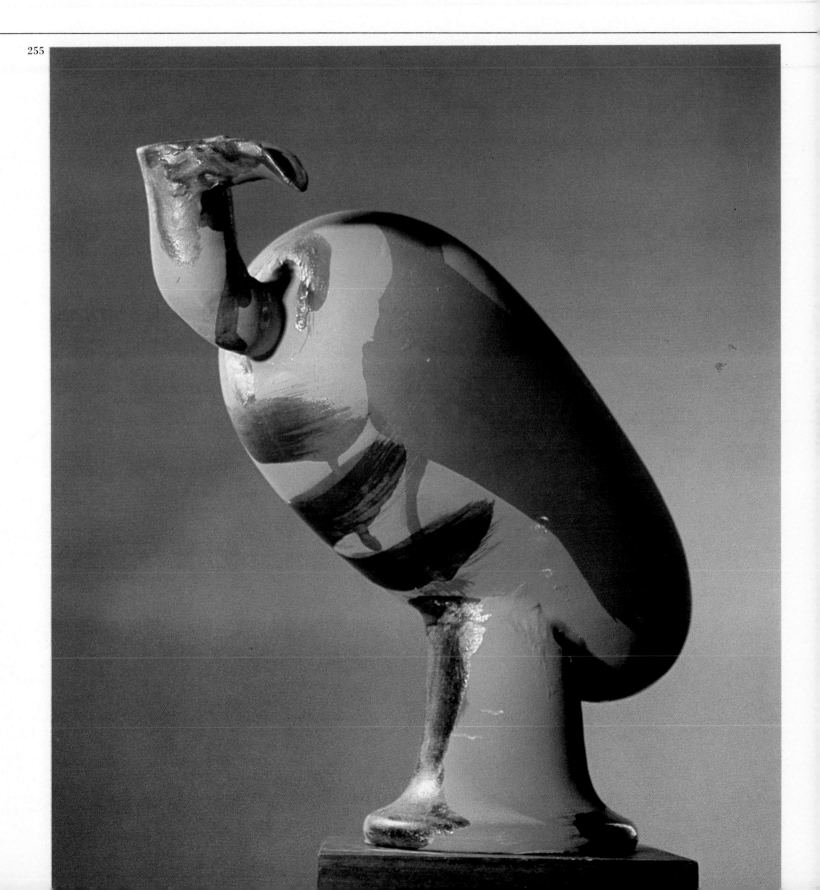

256. Turned piece. Owl, eyes in relief, yellow lead sulphide glazing. Height. 22 cm., length 25 cm., width 12 cm. Dated 1947, Musée Picasso, Antibes (France).

257. Another view of No. 256.

258. Formed piece composed of an assembly of turned elements. Bull on pink earth ground. Height 37 cm., length 37 cm., width 23 cm. Dated 1947, Musée Picasso, Antibes (France).

259. Formed piece. Kid, decoration painted in engobe. Height 32 cm., width 15 cm., depth 28 cm. Dated 1947, Musée Picasso. Antibes (France).

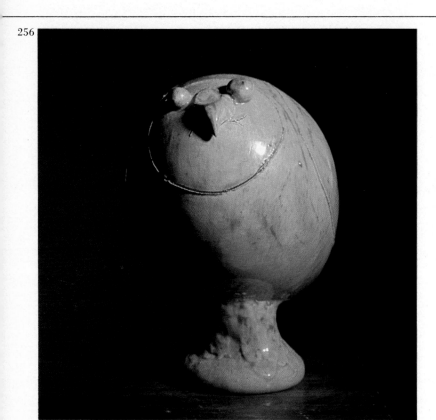

256

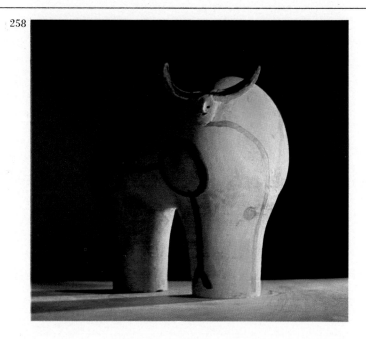

258

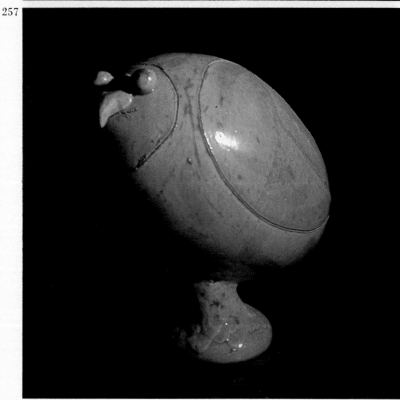

257

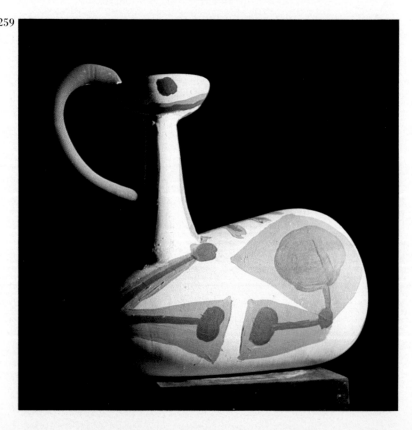

259

260. Other side of No. 258.

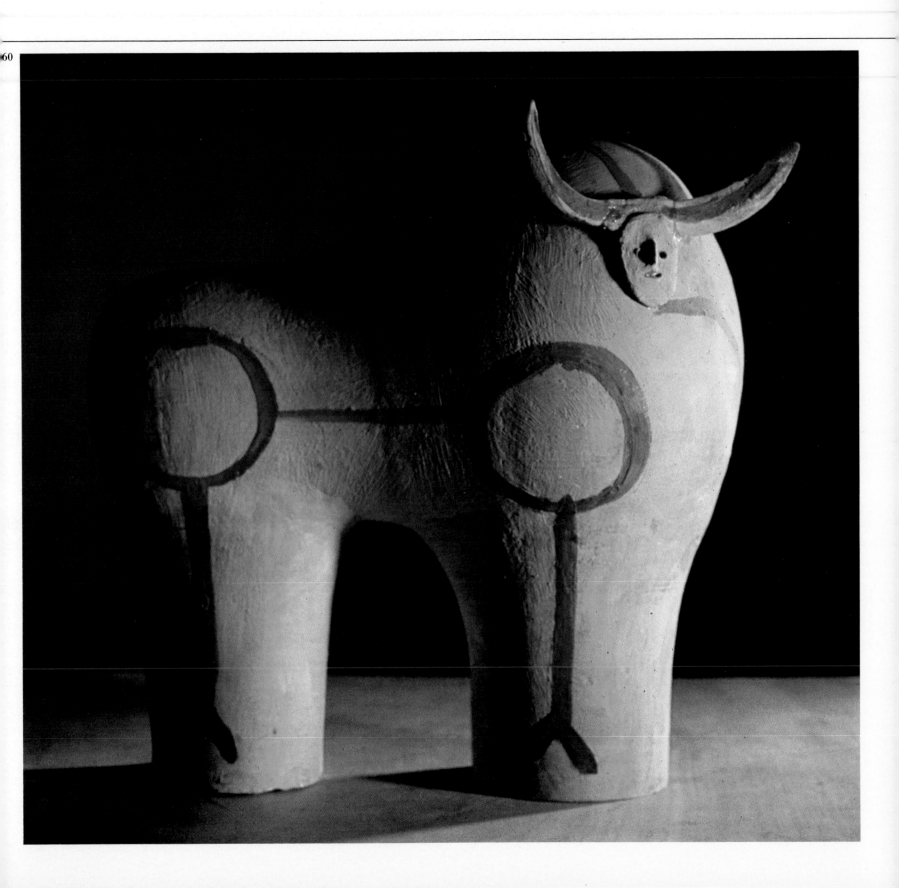

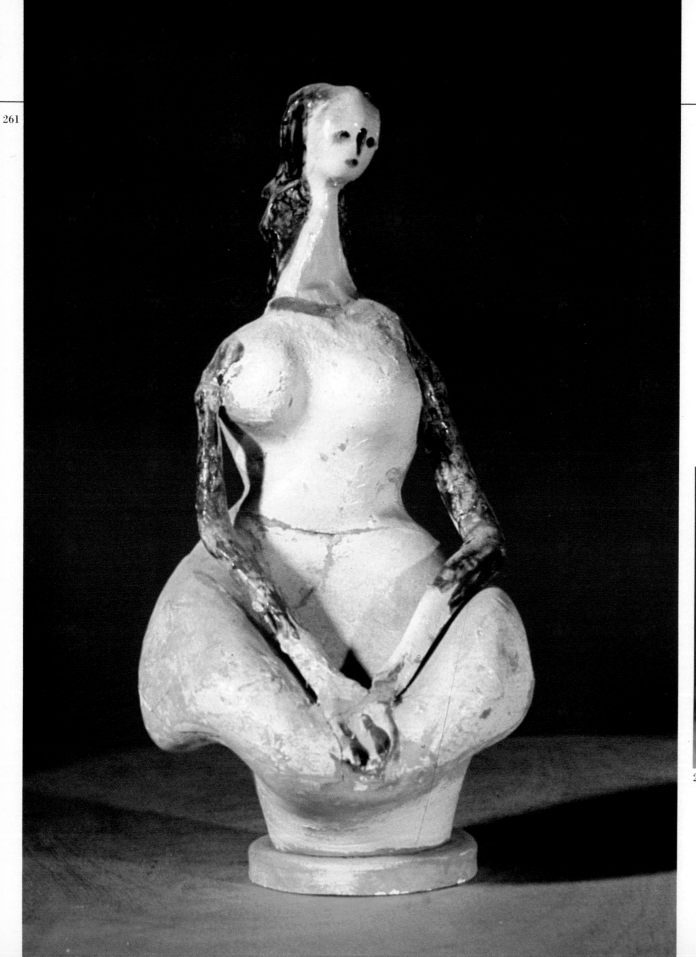

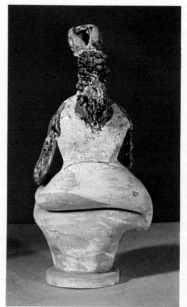

262

261. Turned, modelled and painted piece. Woman, engobe decoration under beige-brown glaze. Height 30 cm., width 13 cm., depth 13 cm. Dated 1947, Musée Picasso, Antibes (France).

262. Other side of No. 261.

263. Formed piece composed of an assembly of turned elements. Grey and black bird. Height 38 cm., width 12 cm., depth 29 cm. Dated 1947, Musée Picasso, Antibes (France).

264. Other side of No. 263.

265. Turned, modelled and painted piece. Woman with long neck in pink and black clay. Height 28 cm., width 9 cm. Dated 1947, Musée Picasso, Antibes (France).

266. Turned and assembled piece. Woman with amphora, engobe decoration on natural ground. Height 45 cm., width 32 cm., depth 14 cm. Dated 1947, Musée Picasso, Antibes (France).

267. Other side of No. 266.

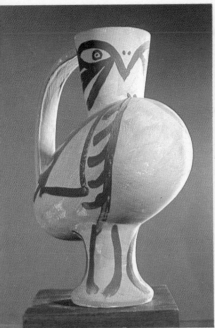

263

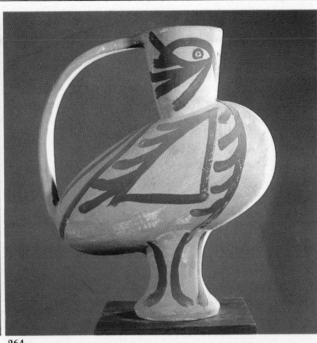

264

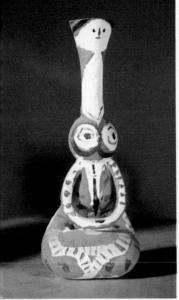

265

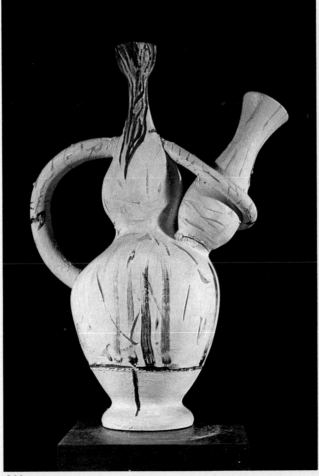

266

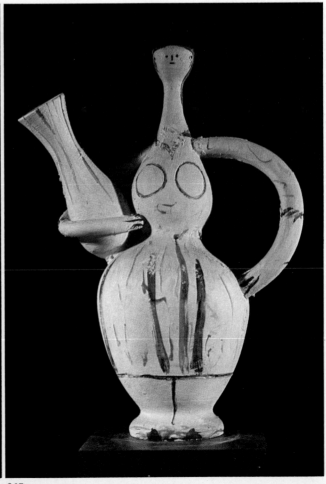

267

268

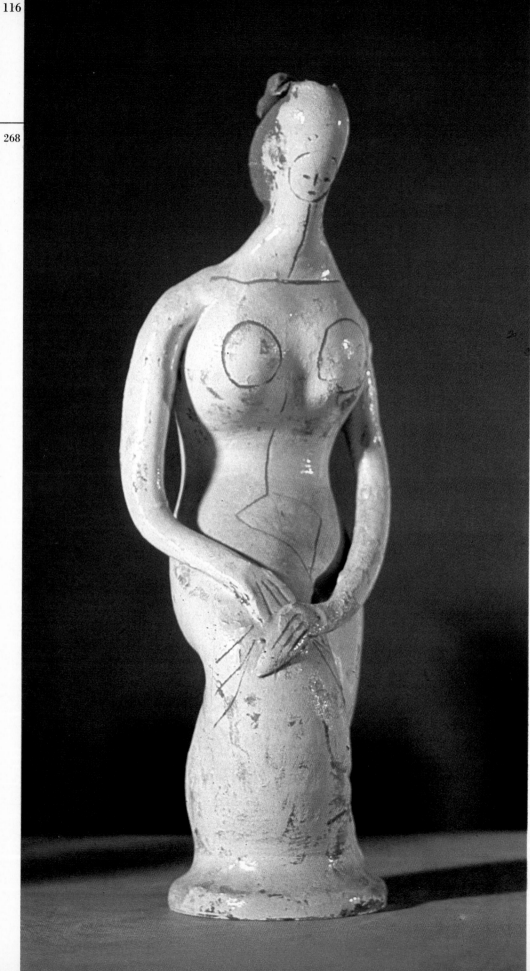

269

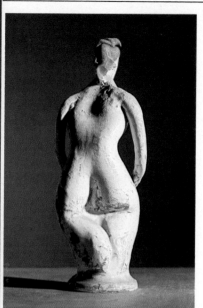

268. Turned, modelled and incised piece. Woman in ivory and brown under glaze. 35×11×11 cm. Dated 1947, Musée Picasso, Antibes (France).

269. Other side of No. 268.

270. Turned, modelled and painted piece. Woman, 29×9×7 cm. Dated 1947, Musée Picasso, Antibes (France).

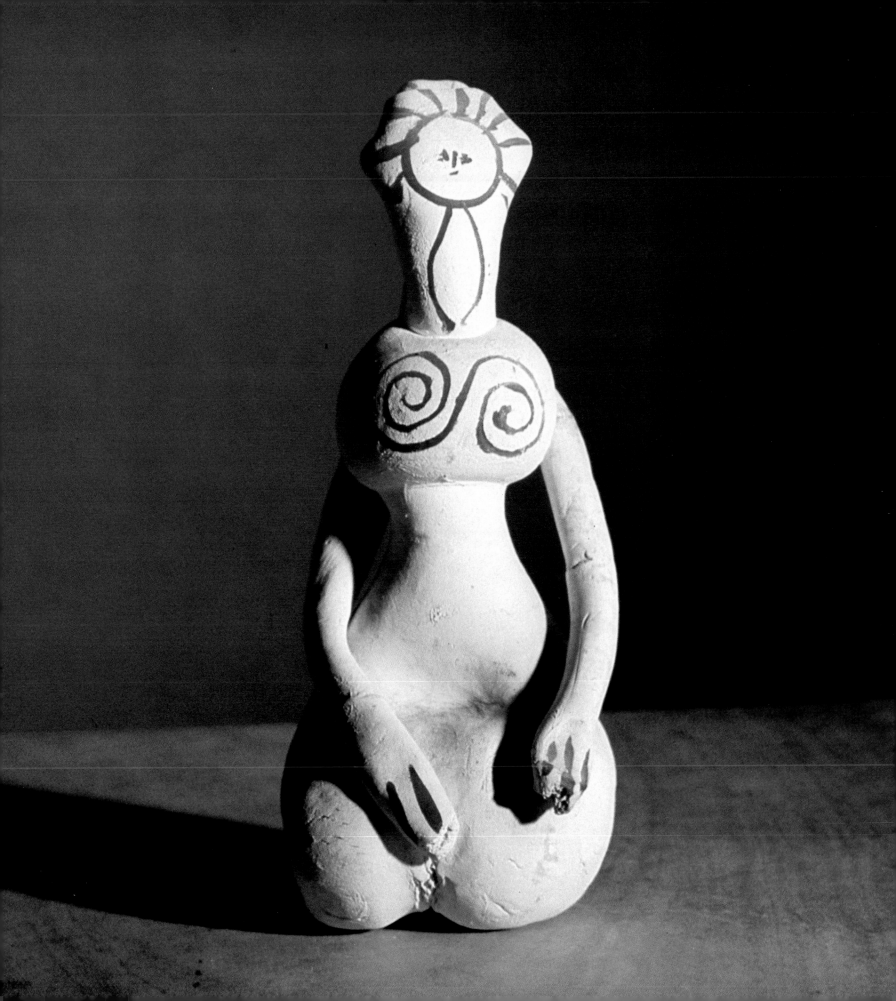

271. Square plate in colour. Still life with spoon in white earthenware. 33 × 33 cm. Dated 22-12-52, original print, edition.

272. Provençal *Bourrache* Faun playing pipes. 59 × 33 cm. Dated 6-10-47, signed and dedicated 'Pour Mme Ramié'.

273. Other side of No. 272. Centaurs fighting.

274. Provençal *bourrache*. Polychrome decoration with woman and flowers, Musée de St.-Étienne (France).

lute, those who attended took part in turns, arriving day after day to inquire, to report and also to marvel. These occasions might be cordial and prolonged or quickly terminated; frequently they could even be avoided altogether, though with a great deal of diplomatic precaution. And when the frequency of arrivals threatened to become too great an encroachment, the door would suddenly remain unyieldingly shut, without any consideration for the rank or mission of the visitor. The orders had to be strict; the workshop could not be turned into a permanent exhibition for curious strangers to gape at unique phenomena. The workshop, in fact, must uncompromisingly respect its role as a sanctuary of work. But then, a few days later, there might be an insidious temptation to exchange a few words with some congenial beggar. The result was that we lived, as is often the case with Picasso, in a sort of pendular swing, one day accepting all sorts of visits with alacrity, the next turning away some over-insistent nuisance, then repenting such severity and receiving the next initiative more graciously.

The museum curators, naturally, were all on the alert and did everything they could to stay in the lists, hoping to be favoured with some significant donation from a collection of works that they could already guess to be of exceptional importance. The ones who succeeded hastened home in triumph with their considerable booty, justifiably pleased with themselves and losing no time in placing their new treasures in their most prominent show-cases.

As a result of these repeated and irregular departures, which escaped any kind of checking or analytical indexing of the work, it was decided to compile a catalogue, an authoritative record that would be as technically and historically accurate as possible, with a detailed description

271

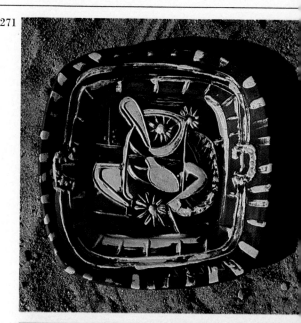

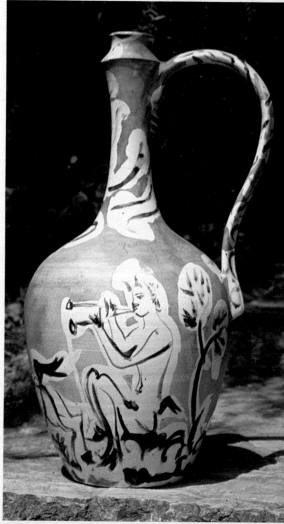

272

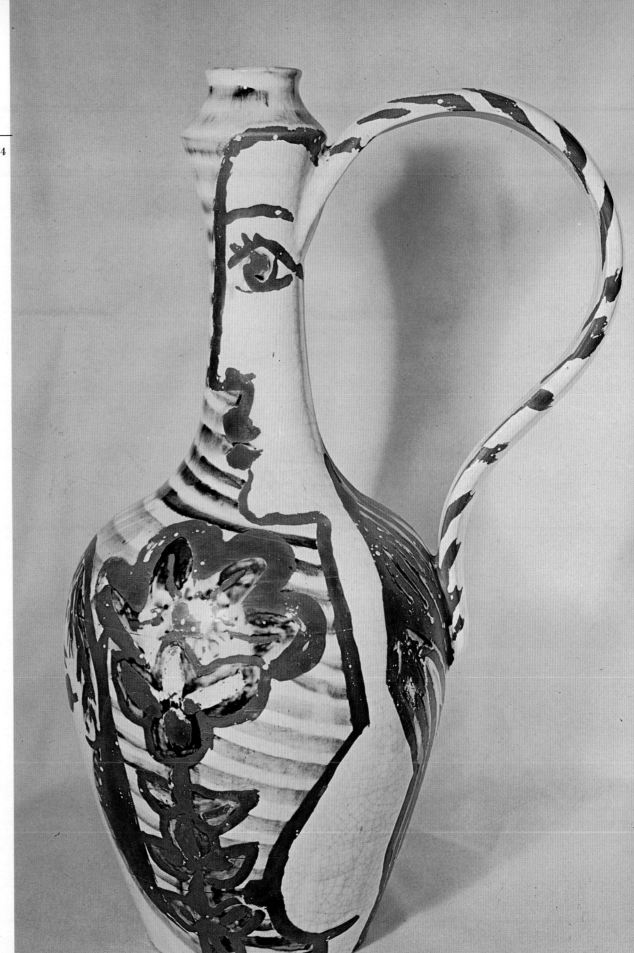

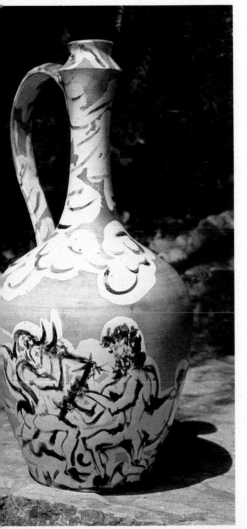

274

273

275. Plate. Figures in matt finish on green ground. Diameter 23 cm. Dated 23-3-53.

276. Round bowl in colour. Hands on fish in pink earthenware. Diameter. 31.5 cm. Dated 1953, original print, edition.

275

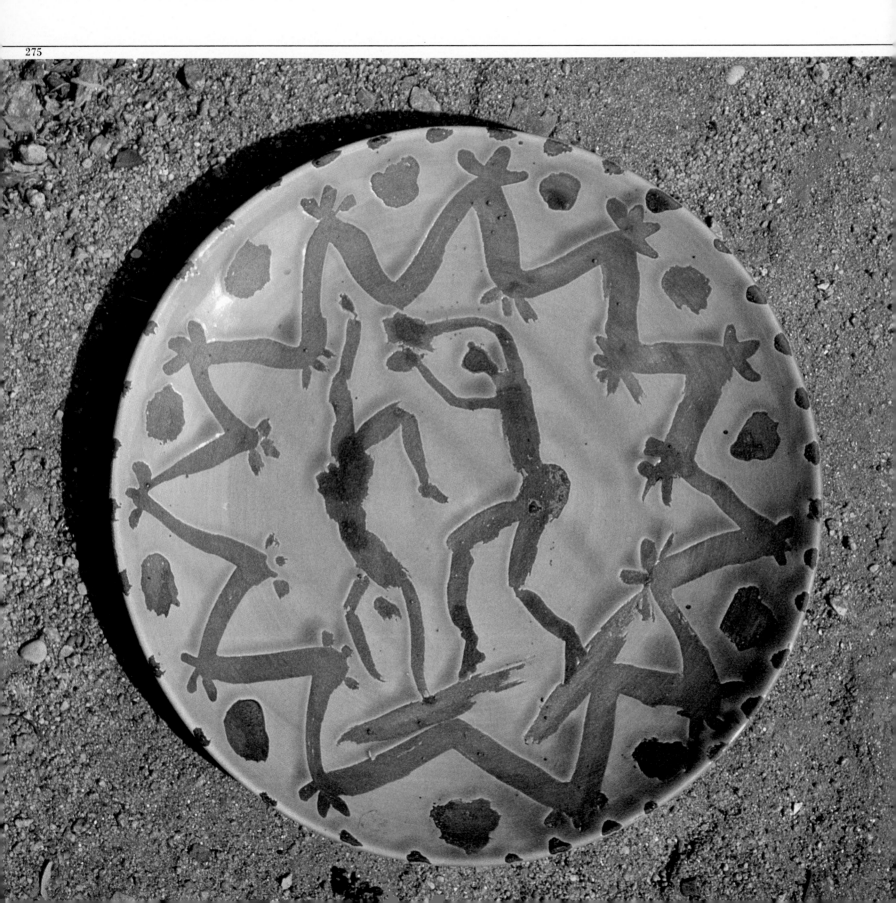

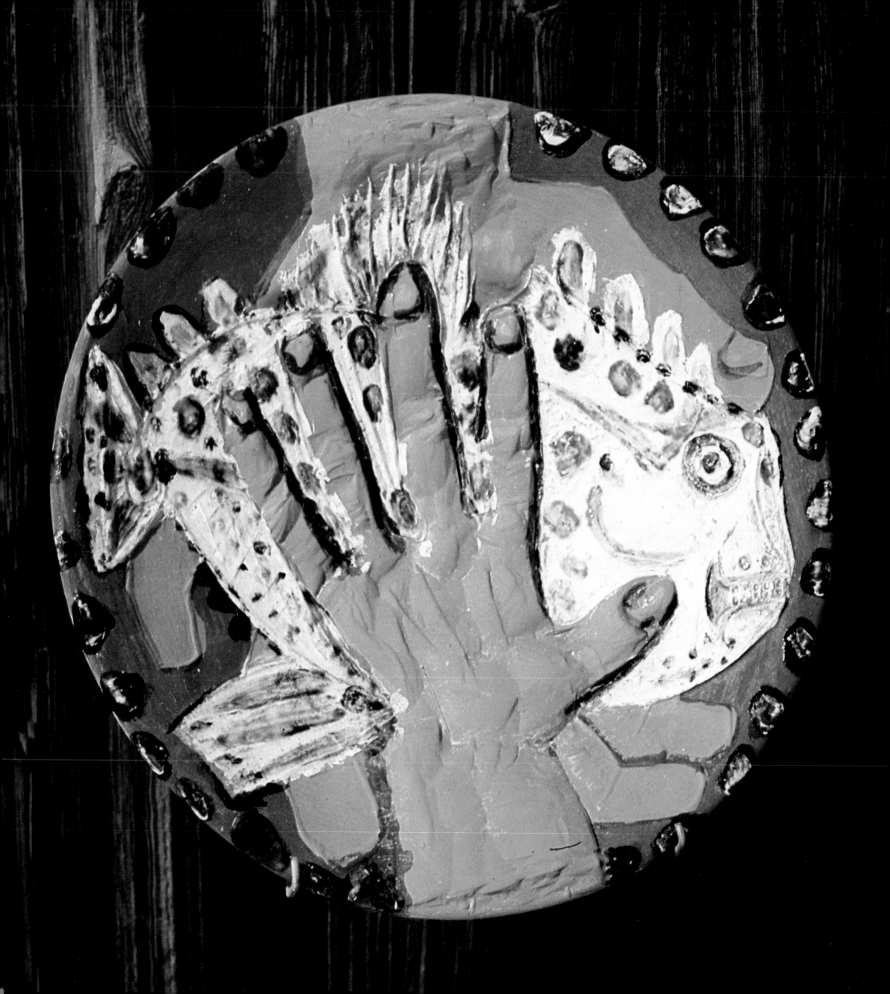

277. Oval plate. Coloured variation on Nos. 67, 68, 69 (obverse). Width 25 cm., length 33 cm. Dated 1949, original print, Museo de Cerámica de Barcelona (Spain).

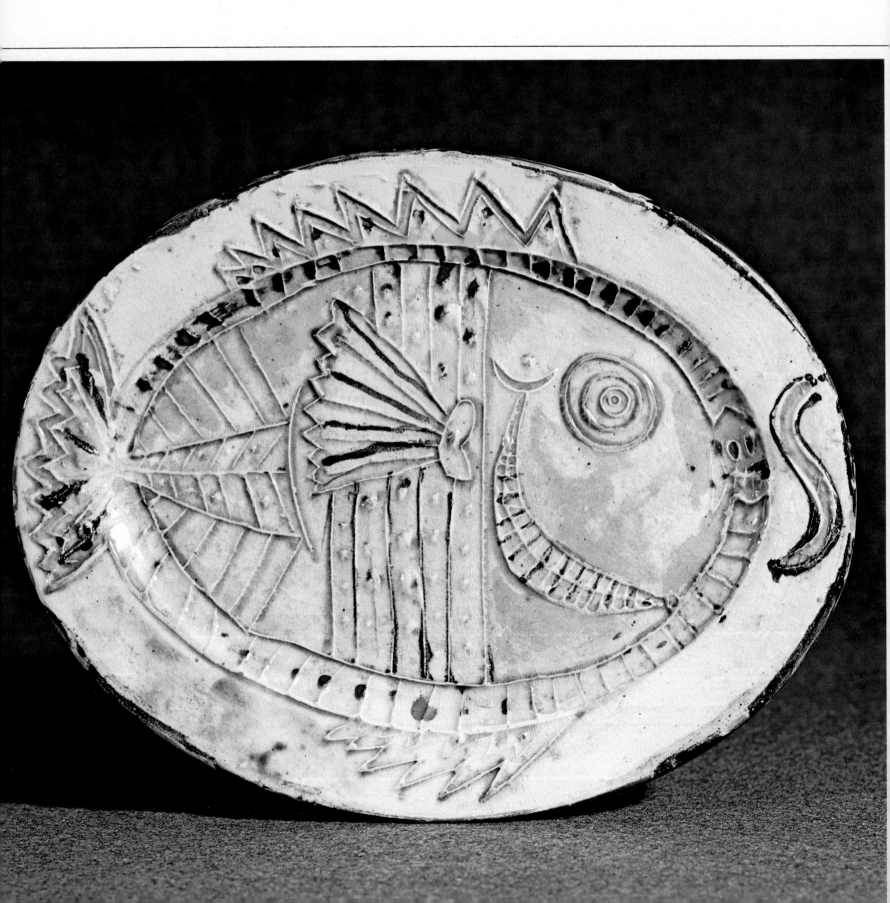

278. Oval plate. Coloured variation on Nos. 67, 68, 69 (obverse). Width 25 cm., length 33 cm. Dated 1948, original print, Museo de Cerámica de Barcelona (Spain).

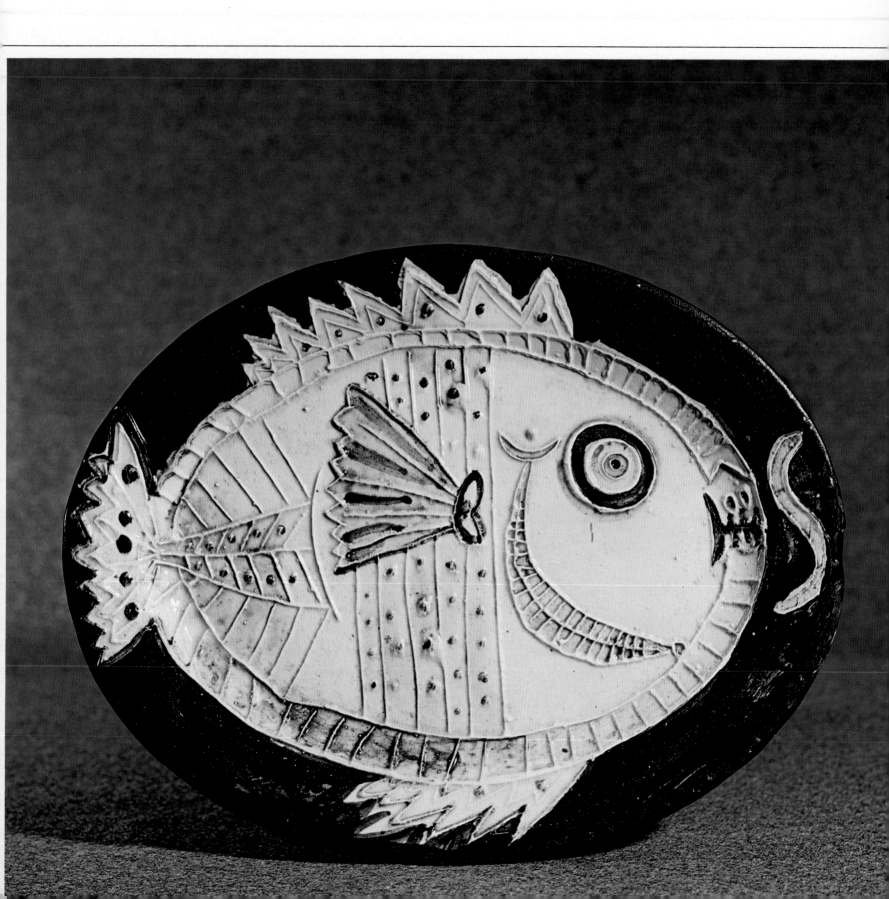

279. Rectangular plate. Water-melon with knife and fork. Width 30 cm., length 37 cm. Dated 1949, Museo de Cerámica de Barcelona (Spain).

280. Rectangular plate. Dove on bed of straw. Width 32.5 cm., length 38.5 cm.
Dated 1949, Museo de Cerámica de Barcelona (Spain).

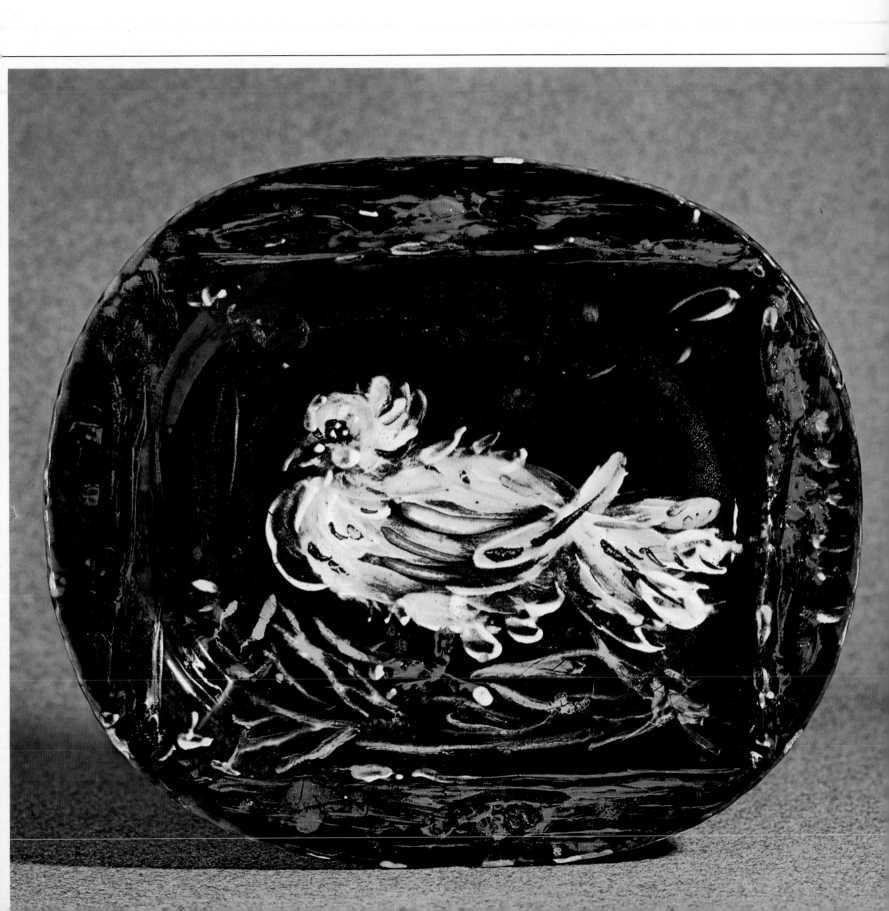

281. Large Provençal *bourrache*. Decorated with faces. Height 61 cm., diameter at base 16 cm. Dated 3-8-52, Museo de Cerámica de Barcelona (Spain).

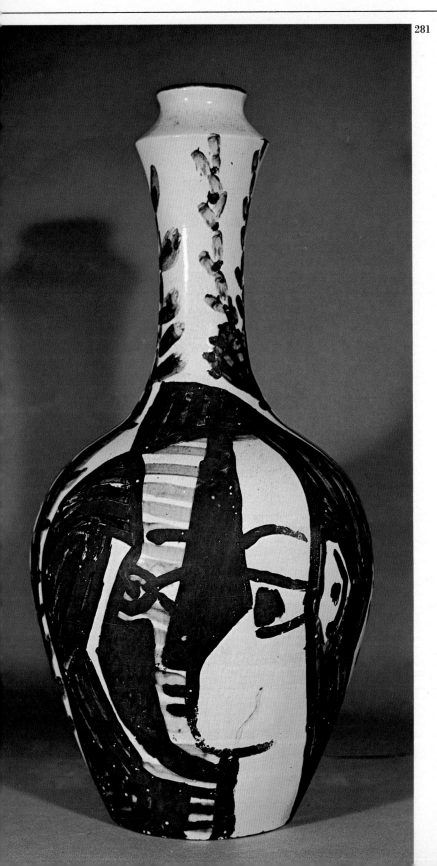

281

and a numbered index-card for each and every piece included. But the importance, the number and the diversity of the works to be listed made this an almost impossible task; to perform it properly we should have needed a secretarial and photographic service working full-time every day to study each piece from the moment it was quite finished. And Picasso would undoubtedly have had no difficulty in keeping them busy!

After several months of continuous work this cataloguing, though essential, was driven from our minds by other pressing matters; and when it came up again we had to agree that the scope intended was beyond the means then available. Anyway Picasso was almost hostile to such a cataloguing of his collections. Possibly he found it unseemly to treat them as if they were so many aprons or night-caps; or so, at least, one might have thought from the allusions he made to the subject then. But with Picasso one must remember that, though he will stand by what he says at a certain moment, it is his reflections on the matter, then or later, that really torment him; and these two states of mind do not always coincide entirely. From which we may conclude that later on he was undoubtedly to regret that this important task had not been carried out in its entirety.

The fact remains that we are now faced with an *ensemble* of work that radiates in all directions, whose beginnings may be determined more or less exactly in time, but which remains indefinable as regards any precise knowledge of its elements. Though revealed to some extent by the frequent exhibitions held to present some fragments of the whole, this work has never been the subject of a definitive study. And to attempt one now, even if only a carefully selected anthology, would certainly be a wonderfully rewarding task, but one very difficult to carry out successfully.

282. Two-handled vase. Height 19.5 cm., diameter at base 16 cm. Dated
9-5-51, Museo de Cerámica de Barcelona (Spain).

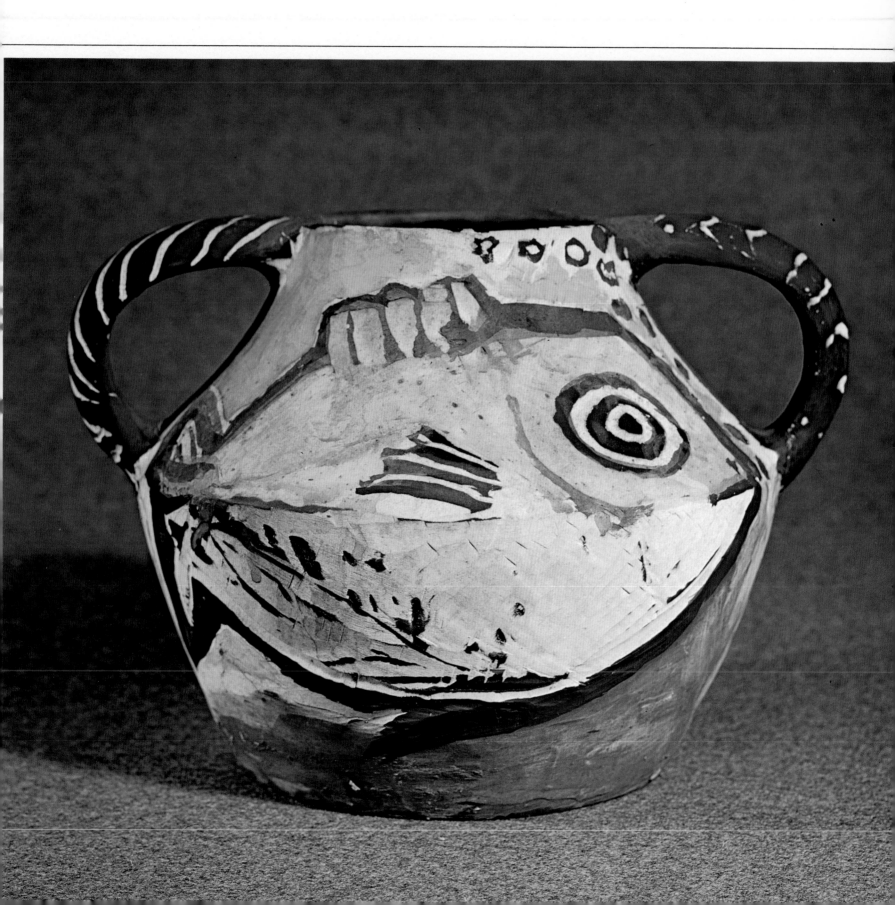

283. Jug. One handle and two spouts. 21×24×15 cm. Dated 1952, Museo de Cerámica de Barcelona (Spain).

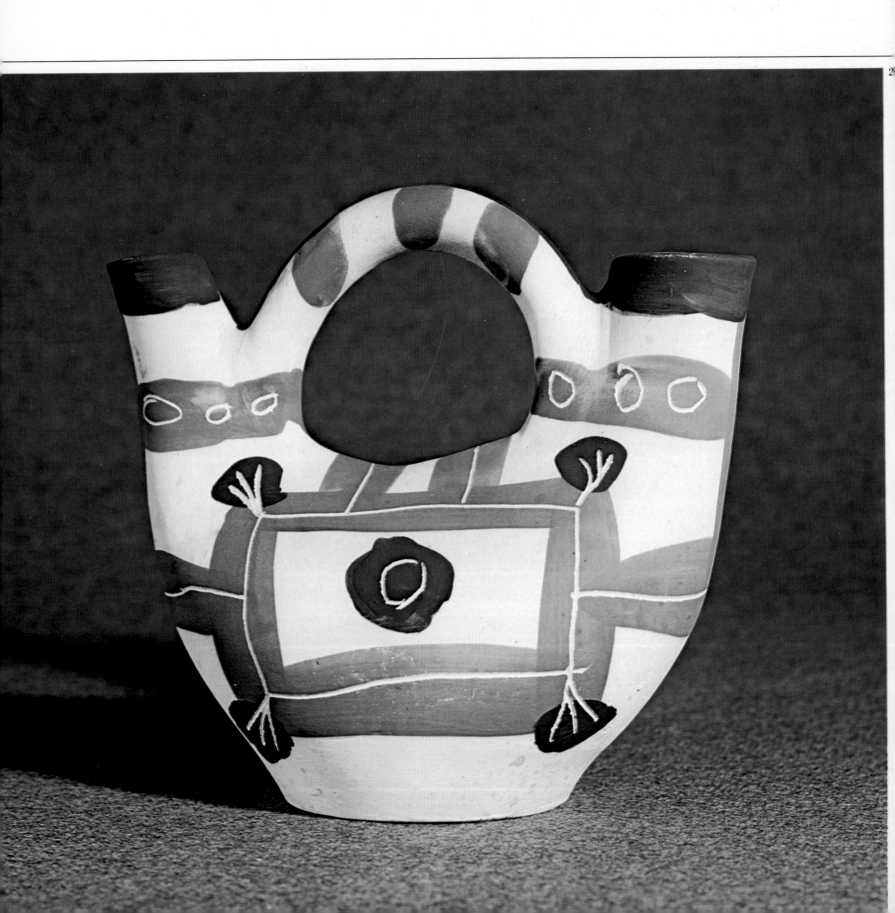

284. Reverse of No. 50. Dedicated to S. Ramié and signed Picasso, Vallauris 17-3-35 (by mistake instead of 17-3-53).

285. Rectangular plate. Man's head incised on black ground. Width 32 cm., length 38.5 cm. Dated 14-10-53, Museo de Cerámica de Barcelona (Spain).

285

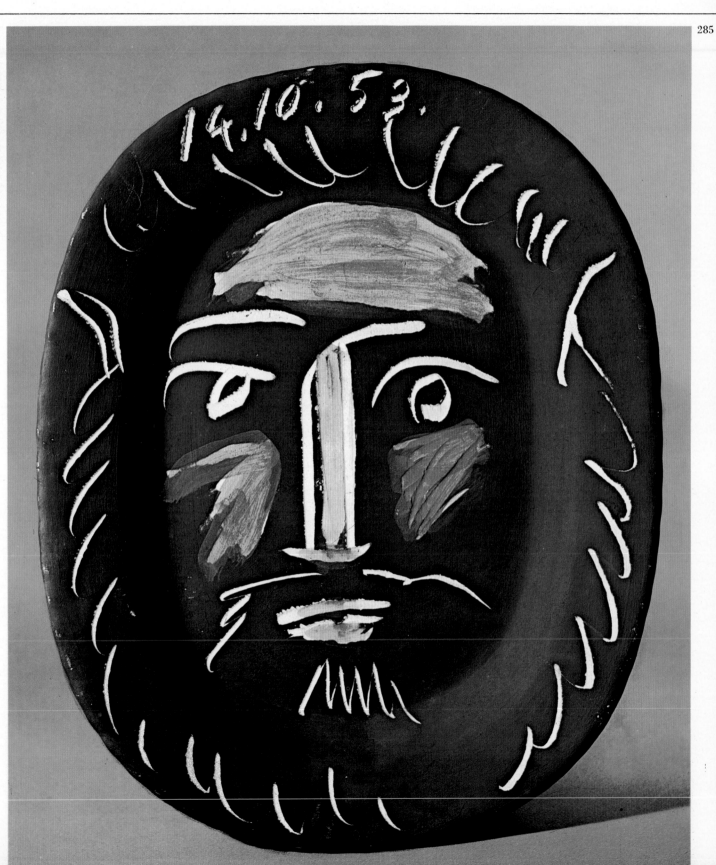

286. Jug. Animal form with handle and four feet. 35 × 17 × 30 cm. Dated 5-1-54, Museo de Cerámica de Barcelona (Spain).

287. Vase. Two handles. Dated 7-1-54, Museo de Cerámica de Barcelona (Spain).

288. Jug. One handle and two spouts. Dated 1954, Museo de Cerámica de Barcelona (Spain).

Perhaps we might find somebody to make such a study among all those honourable visitors who in those days would find Picasso companionably busy in a workshop where each one went about his own tasks in a silence that more or less respected the diligent labours of the others. It is particularly noticeable that Picasso usually likes to reflect and to approach his work in modest solitude, to bring it forth in the strictest privacy and then to dream over it, retreating into the silence of this same workshop, where he is safe from any stranger's gaze. It is true, after all, that man, in each and every one of his creative acts, is liberating himself of his most secret essence, an essence that has grown in his most deeply hidden fibres. At the same time as he frees it, casting it on the fateful whirlwind of external contingencies, he plunges deep into his own isolation, for nothing must be allowed to disturb that tremendous moment when idea and action coalesce.

Yet here we had Picasso consenting to forsake the enchantments of inner concentration, screened from indiscreet eyes and working in the midst of this little audience of fellow-workers, spontaneously sharing the common demands of the workshop. Each of these workers attended quite freely to the needs of his task, though all kept a discreet watch on their impetuous companion, to make sure that he lacked none of the various commodities placed at his disposal. This relaxed, unpretentious freedom, the almost transparent presence of this circle of friends watching over his affairs, assiduously but without overpowering curiosity, provided a kind of independence that could neither intimidate or annoy. And on days when his zest for work was on a level with his invention, the pieces flowed from his hands at a rate that was hard to keep up with. Then Picasso would be really delighted and would boast of his powers with the pride of a champion who has beaten a stronger rival. Thus everything conspired to satisfy and foster the vigour of the most unexpected impulses. And, to our great joy and personal satisfaction, events certainly lavished such impulses on us.

In these essentially manual surroundings Picasso found himself neither out of place nor embarrassed; he has for many years been accustomed to handling tools for all sorts of difficult or intricate work. He is, indeed, proud to make use of this faculty of adaptation that enables him —unhurriedly but with well-directed vigour, using the most suitable action and instrument in every sort of circumstance— to apply himself to the task before him, no matter what kind of work it entails.

This everyday practice in the use of tools as dependable performers makes it easy for him to assume the attitude of a real craftsman working with his fingers. And it is on that account that he has such a great respect for his hands, those nimble workers and faithful messengers, always prompt to undertake and succeed, always apt to seize both the idea and the best means of conveying it.

It would even seem that the thought often finds itself outstripped by the tool, which sanctions it, facilitates it and even precedes it in its solution. It is rather like a musician reading his score, who feels the next note already coming to life under his fingers.

These docile antennae are aware that they are directed by a will that knows how to use them to the fullest extent of their power to construct, a power of which they are both promoters and media, instigators and function, masters and servants.

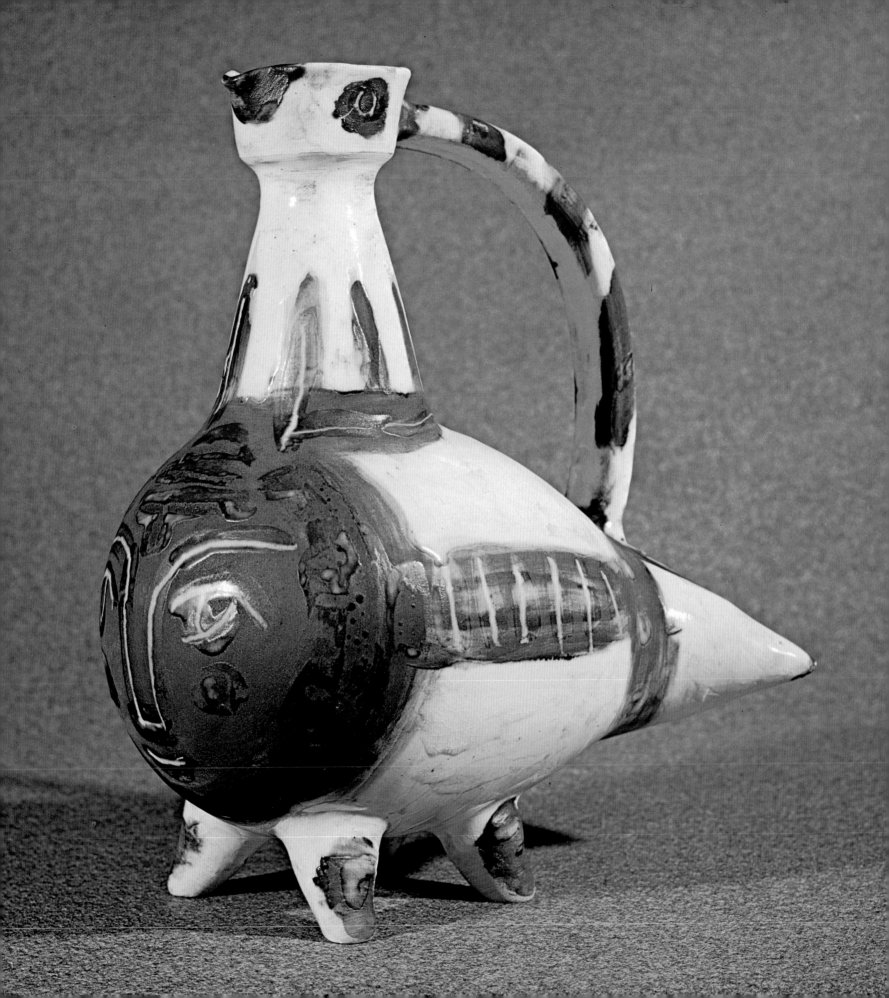

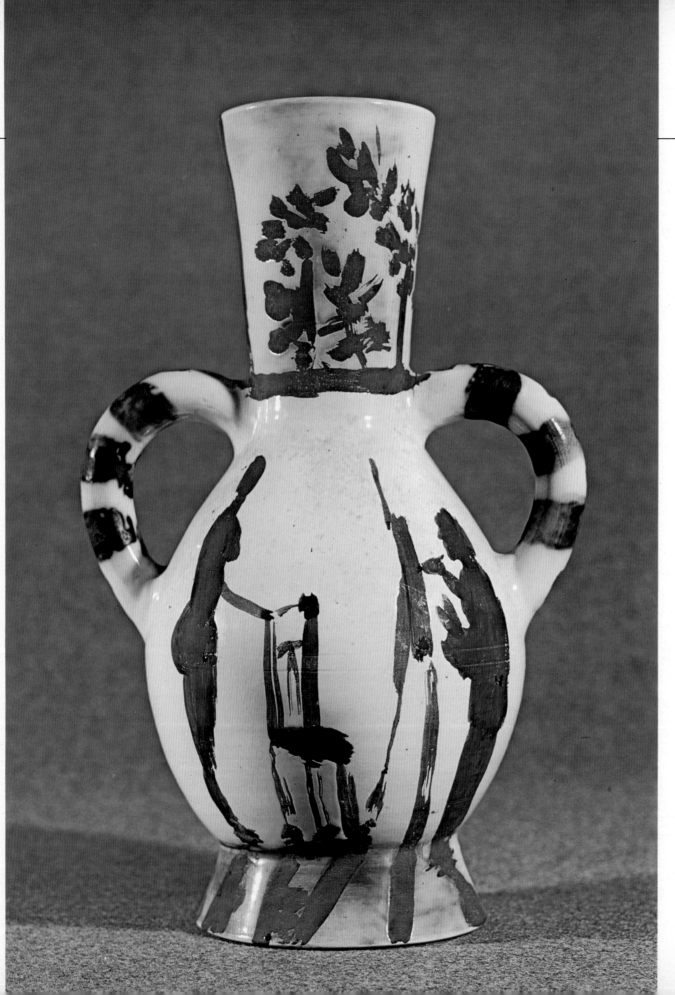

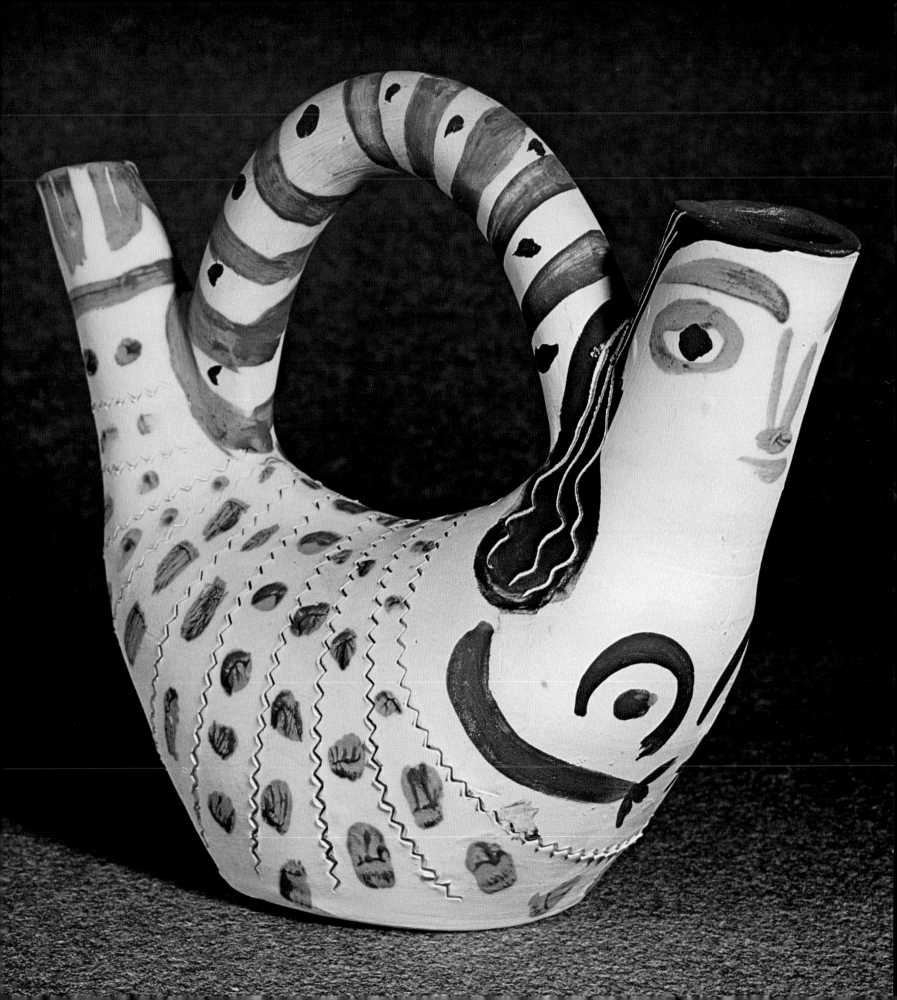

289. Jug. With handle. Height 31.5 cm., diameter at base 12 cm. Dated
 10-2-54, Museo de Cerámica de Barcelona (Spain).

289

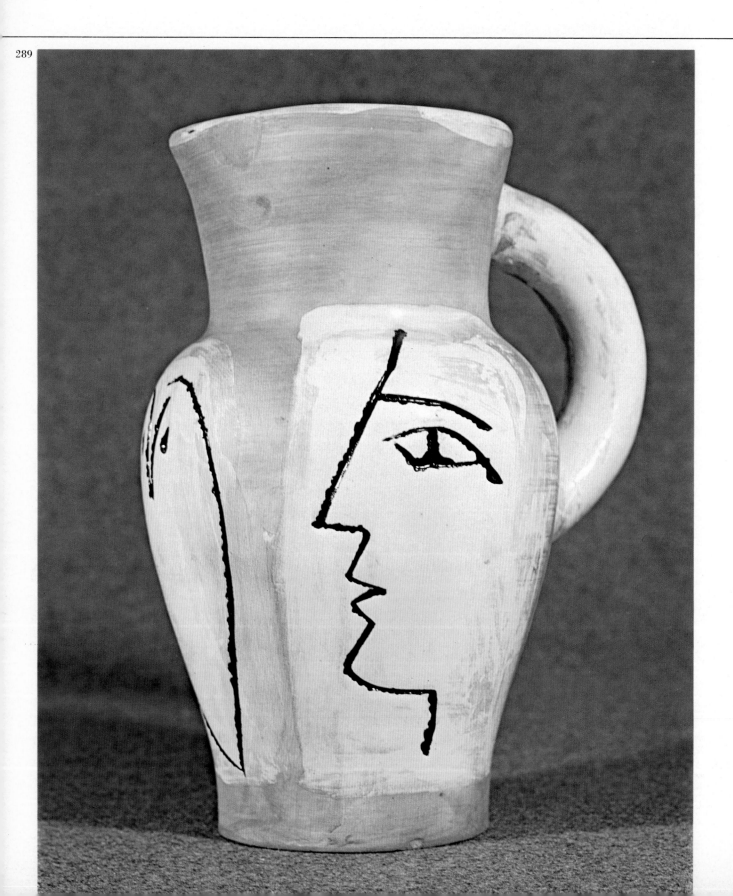

290. Jug. Circus scenes with handle. Height 35 cm., diameter at base 10 cm. Dated 9-1-54, Museo de Cerámica de Barcelona (Spain).
291. Jug. Decorated with figures dancing the *sardana*. Height 22.9 cm., diameter at base 11 cm. Dated 1953, Museo de Cerámica de Barcelona (Spain).

291

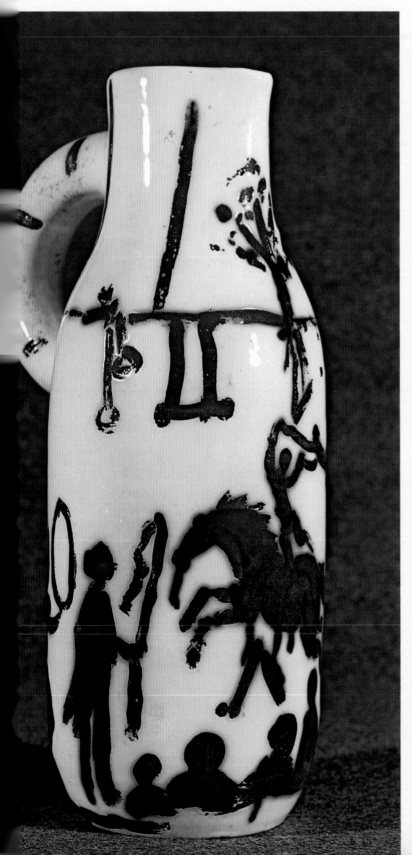

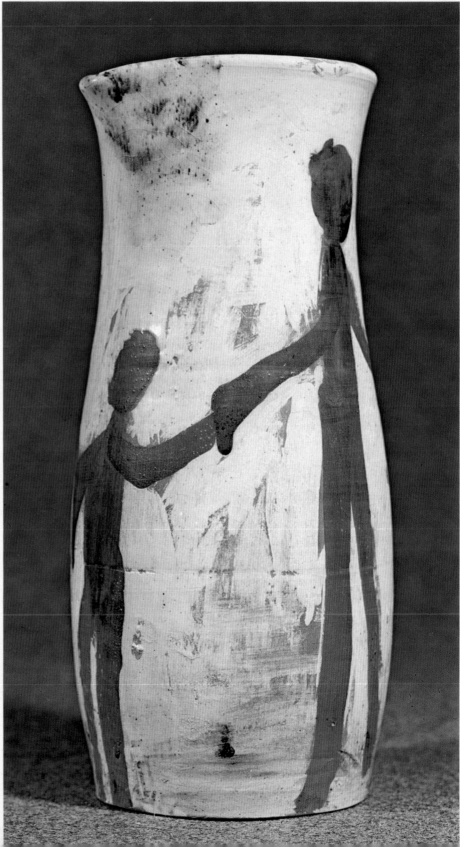

292. Hexagonal tile. Bull-fight scene (obverse). 4×39×20 cm. Dated 7-2-57, Museo de Cerámica de Barcelona (Spain).

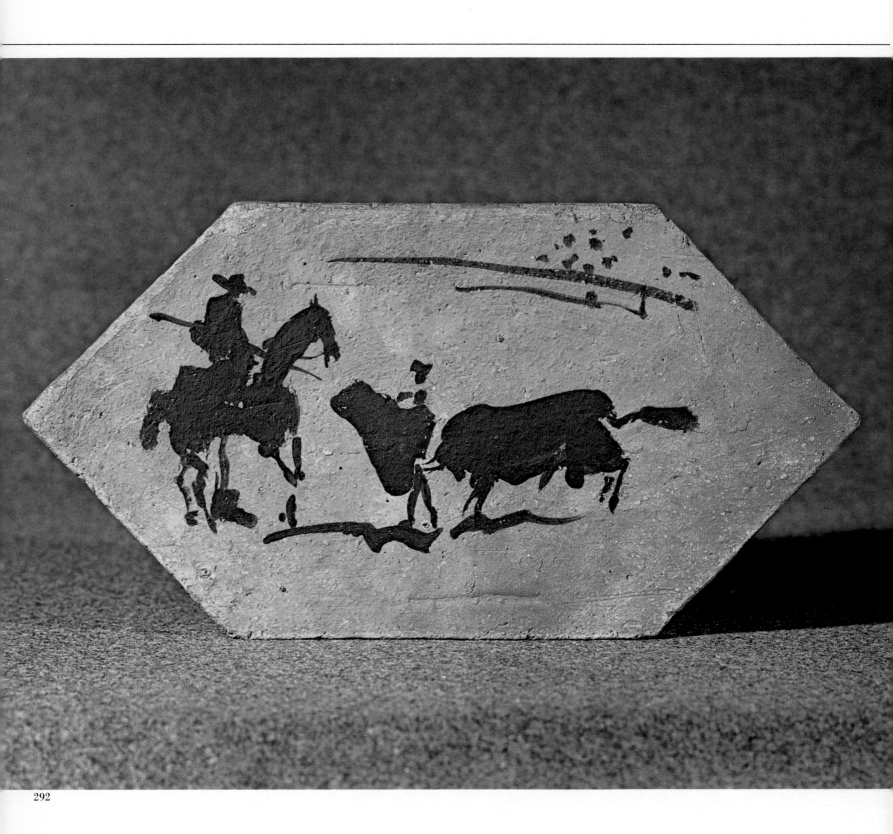

292

293. Hexagonal tile (reverse). 4×39×20 cm. Dated 7-2-57. Museo de Cerámica de Barcelona (Spain).

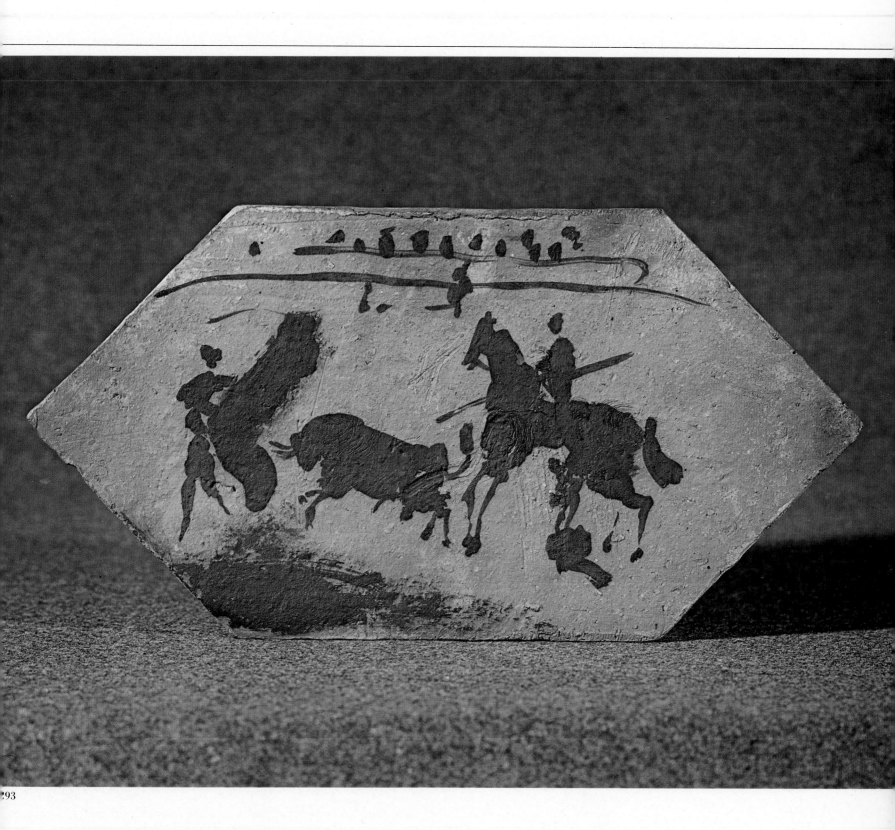

294. Jug. Landscape decoration with handle. Height 31.5 cm., diameter at base 12.5 cm. Dated 10-2-54, Museo de Cerámica de Barcelona (Spain).

294

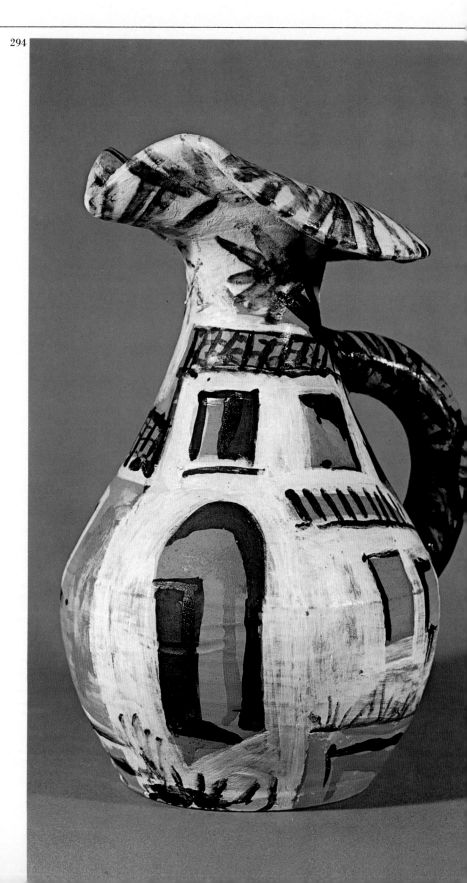

That is why, when Picasso is absorbed in his work, he seems to be really manufacturing something, so that the physical work of his hands appears to receive far more of his attention than even the subject of his conception. Nothing of what resists or yields is alien to him, for from the beginning he appreciates the value of the effort that will be demanded by the contact with his material.

The honesty, the balance and the vigour of these hands of Picasso, so wonderful to watch as they busily fly about, must have been acquired after the same fashion as those unsurpassable qualities we find in faithful servants who love their service. These hands, of course, must have received incomparable training in those periods during which Picasso spent long months working on his immense series of dry-point etchings. In this technique the graver, cutting its straight, clean furrow in the copper, does not tolerate any kind of botching or patching. Everything has to be said simultaneously, without doubt or hesitation: the line is incised with a firm and supple thrust.

And so, when it came to engraving the negatives of the ceramic casts on moulds of plaster that was almost as hard as marble, the same powers of skill and endurance were called into play with the greatest of ease. Even, one might almost say, with a rather broad grin of satisfaction, for Picasso excels and delights above all things in conceiving and perfecting the rather rudimentary and absolutely personal means that he uses at every moment —with methods peculiar to himself and a very accurate knowledge of mechanics— in his studio work.

And what material, after all, has he not had occasion to deal with? He has created sculptures in wood, paper and concrete. He has engraved on bronze, copper, plaster, terracotta, pebbles,

295. Jug. Animal form. 35 × 31 cm. Dated 5-1-54.
296. Two-handled vase. Decoration painted on patinated ground. 40 × 23.5 cm.
Dated 1954.

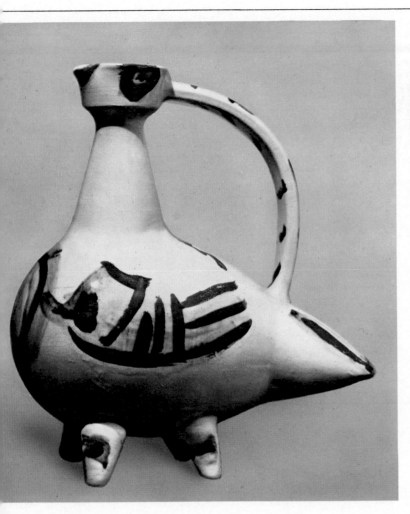

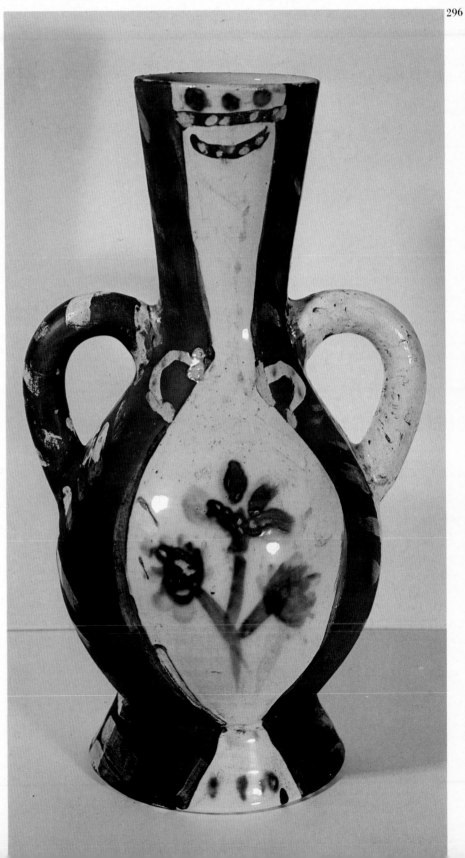

297. Large round plate. Picador. Diameter 42 cm. Dated 11-3-53, original print, edition.

298. Round cupel, incised. Picador. Diameter 18 cm. Dated 30-1-54, original print, edition.

299. Jug. *The painter and his model.* 38 × 26 cm. Dated 5-1-54.

300. Jug. Other side of No. 299. *The painter and his model.* 38 × 26 cm. Dated 5-1-54.

301. Round cupel, incised. Bull standing. Diameter 18 cm. Dated 30-1-54. original print, edition.

297

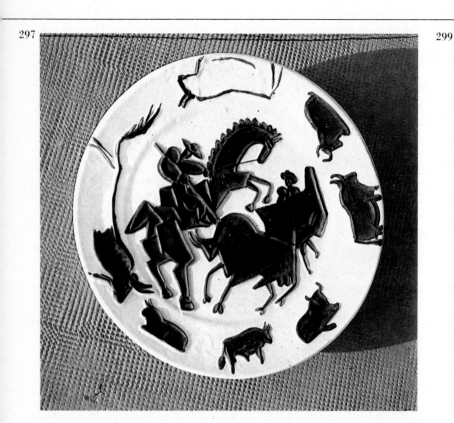

299

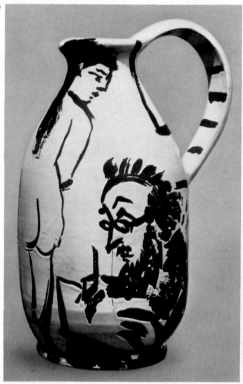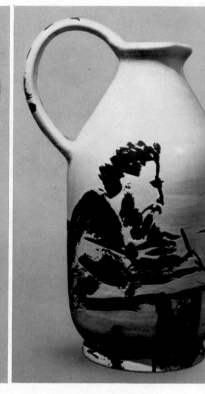

298

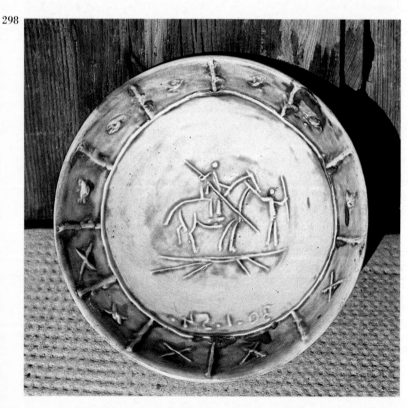

301

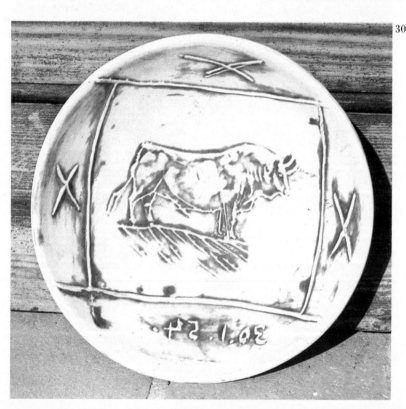

302. Jug. Birds, same technique as No. 309. 38.5×26 cm. Dated 11-3-54,
Museum für Kunst und Gewerbe, Hamburg.

303. Other side of No. 302.

302

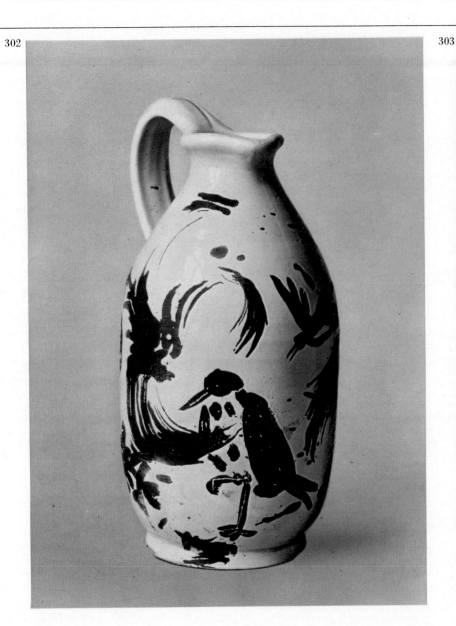

303

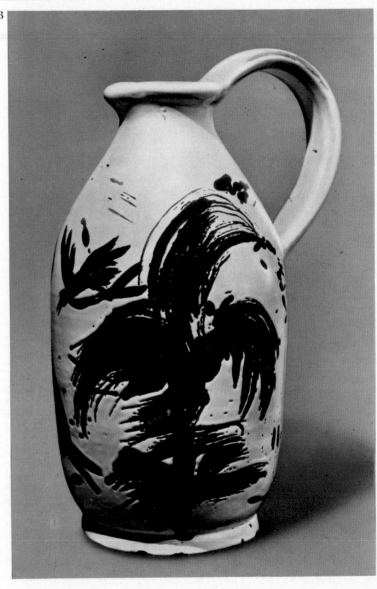

304. Large square vase. Owl. 50×28 cm. Dated 1954.

305. Jug. Owl. Height 30 cm. Dated 1954.

306. Jug. Decoration painted on patinated ground. 29.5×24 cm. Dated 12-1-54.

307. Vase. Artist at his easel. Height 58 cm. Dated 1954.

308. Mask. Rough piece of clay, modelled and painted.

304
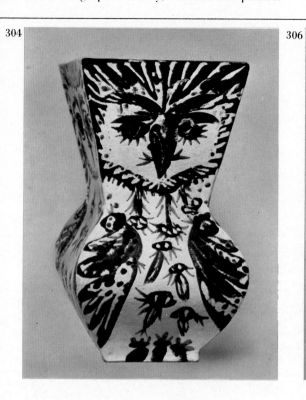

306
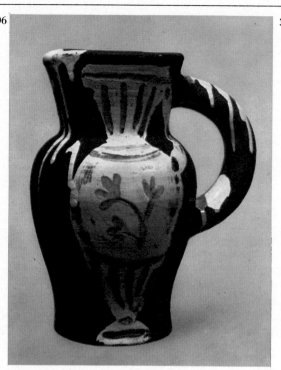

308
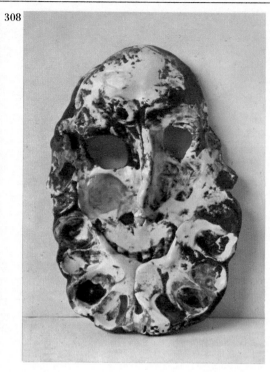

305
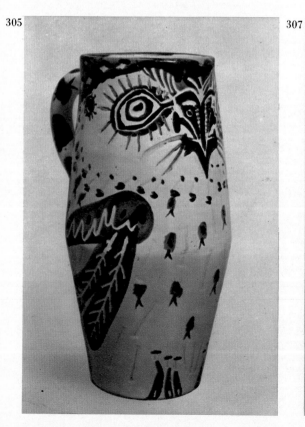

307
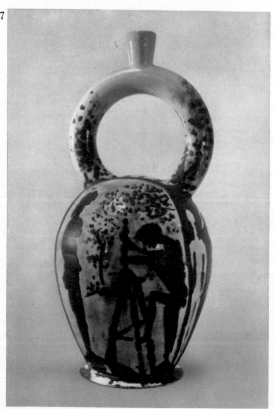

309. Vase. Circus scenes, painted in brown resist under white enamel. Height
 58 cm. Dated 9-1-54.
310. Other side of No. 309.

310

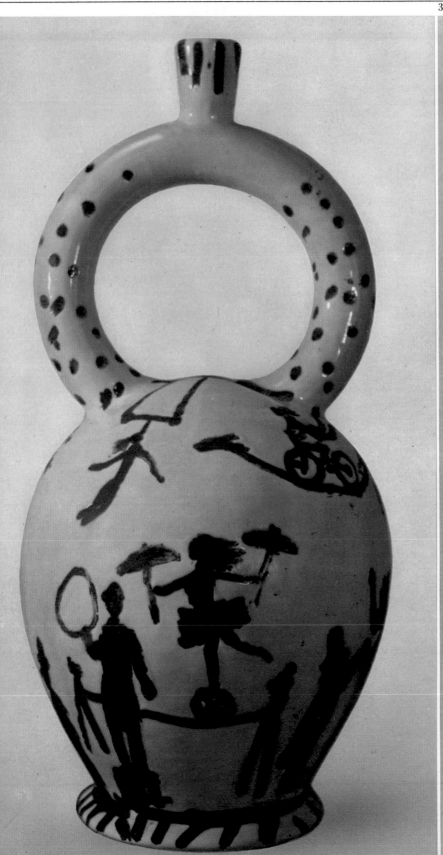
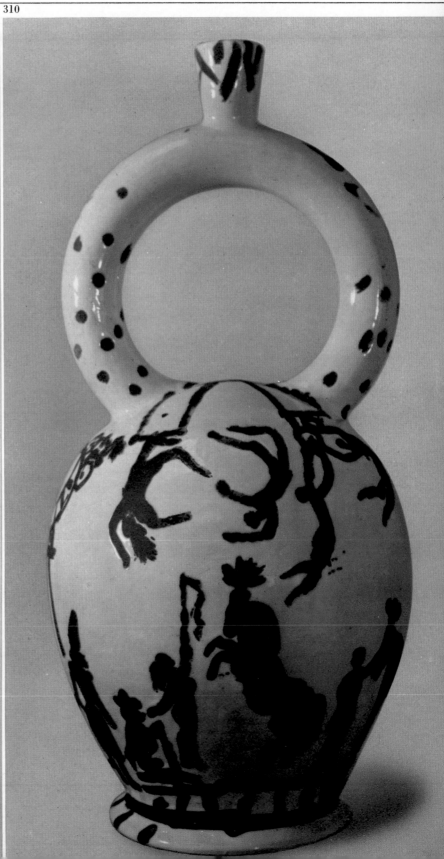

311. Jug. Painter with two models. 27 × 33 cm. Dated 6-1-54.
312. Large vase. Fish and birds on white earthenware. Height 51 cm., diameter at bulge 50 cm. Dated 1955, original print, edition.
313. Oval plate in black. Face in white earthenware. Length 38.5 cm., width 32 cm. Dated 8-4-55, original print, edition.

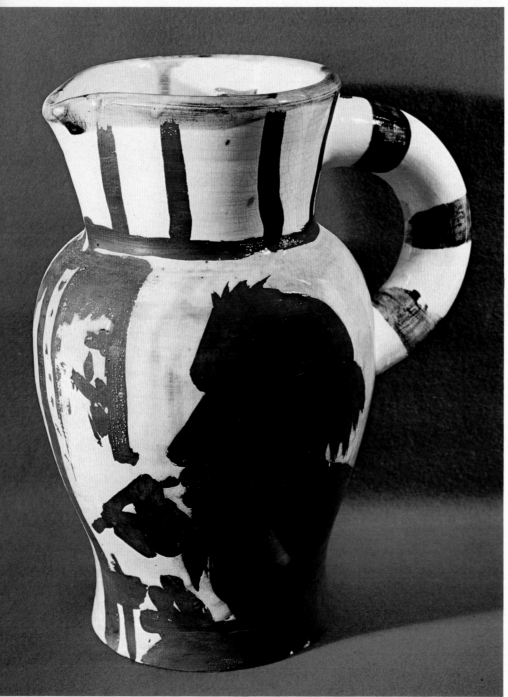

311

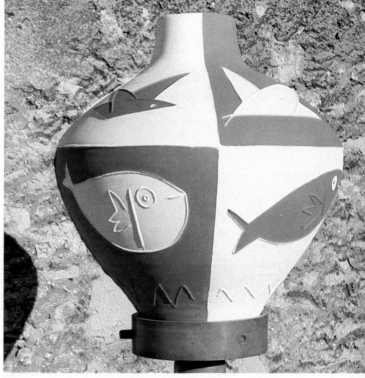

312

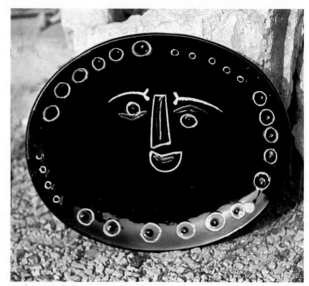

313

314. Other two sides of No. 316.
315. Jug. *The painter and his model.* 28.5 × 25 cm. Dated 7-1-54.
316. Large square vase with panels. Figures and heads in relief on pink earthenware. Four different sides. Dated 1954, original print, edition.

316

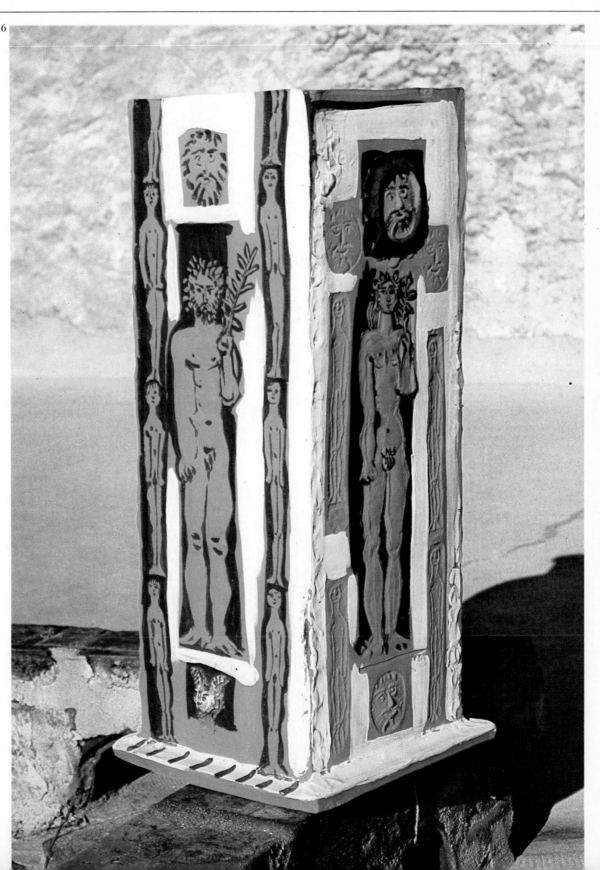

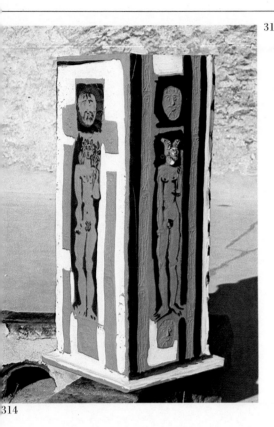

314

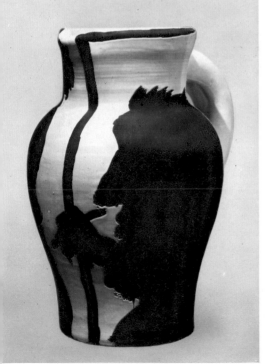

315

linoleum, gold, silver and stone. He has modelled iron, sheets of ceramic paste, cardboard, wax, bread and gold. He has cut and carved in sheet-iron, raw clay and tin. And he has assembled multitudes of elements —the most heterogeneous, decrepit and abandoned imaginable— and with them created new structures.

These fashionings of such very different materials are, one suspects, avidly sought after on account of their great diversity of technique, involving particular problems of resistance, flexion and adherence that are as formidable as they are cleverly solved.

For these reasons the early experimental modellings were very productive for the successful development of a ceramic trade as well as representing an excellent opportunity to turn this astonishing experiment with tools to the best account and to show, at the same time, an exemplary awareness in keeping them in perfect condition. Picasso approached them with an evident and willing self-possession.

It must be said that, if the potter's is usually one of the dirtiest of jobs, since it is, after all, mud, of different degrees of firmness, that he is handling, for that same reason it demands absolute cleanliness even in the least important operations. Meticulous care is taken in preparations which, though really very simple, are quite essential parts of the process.

These continuous exercises, this complicated work with the hands which excludes any element foreign to it, anything dirty and undesirable, these had about them something to delight, with joy and respect, so profoundly constructive a spirit as that of our guest.

A constructive spirit...! But also, and even more so, a tenacious spirit mastering this hostile element, the very resistance of which he chose as the victorious bearer on which to engrave his message.

When he sits down in front of his potter's wheel, Picasso immediately enters into a state of confrontation; he takes on the air of those who, with an unshakeable and combative faith, feel the need to conquer, uproot and beat into shape everything they have to tell us.

VII. RESEARCH AND EXPERIMENTS

Following the twists and turns of the imaginary, Picasso's work in ceramics develops at the bidding of his fancy, though this fancy is lucidly held together by the reassuring thread of research and experiment.

If the design is not the form itself but the way we see the form, and if it is also desirable to forget objects themselves and retain only their relationships, then we have now entered into a world of complementary principles, not in respect of the relationships of things forgotten or the way of describing forms observed, but surely in the possibility of bringing forms and volumes into contact.

But before the period of experimental structures, of transposed interpretations based on volumes, a period of transition began during which the easel painter had to renounce the use of his palette with colours in fixed pigmentations in favour of one with mute colours. For ceramic colours, in fact, generally reveal their true quality only under the action of temperature changes; before use they have a rather imprecise appearance which has not much in common with that which one expects of them following thermic action. One must learn, therefore, to mistrust these deceitful appearances and thus avoid confusions which may have irreparable consequences. And one must not, above all, let oneself be led by force of habit into forming compositions of colour elements which are immediately perceptible, but whose transformation by fire might produce some bitter disappointments.

One rather curious consequence of this principle, indeed, was that our painter found himself in a strangely paradoxical situation. Whereas he had on principle asserted some degree of freedom in the universe of appearances, transposing the object he was dealing with into an essentially arbitrary formal concept, circumstances now confronted him with the obligation of dealing with the same object under conditions of pictorial value in which the appearances were both virtual and systematically arbitrary!

The nicely-tempered irony of this situation was sufficient reason for him to enter into it with a certain alacrity. The first background for this new discipline was easily found in the ornamenting of large plates, the surface of which recalled a field of action he was familiar with, while the form proposed also recalled that of his customary canvas.

As a matter of fact these plates, which were of a slightly elongated square shape with rounded

317. Tile. Faun's head. 20.5 × 20.5 cm. Dated 24-1-56 - V.

317

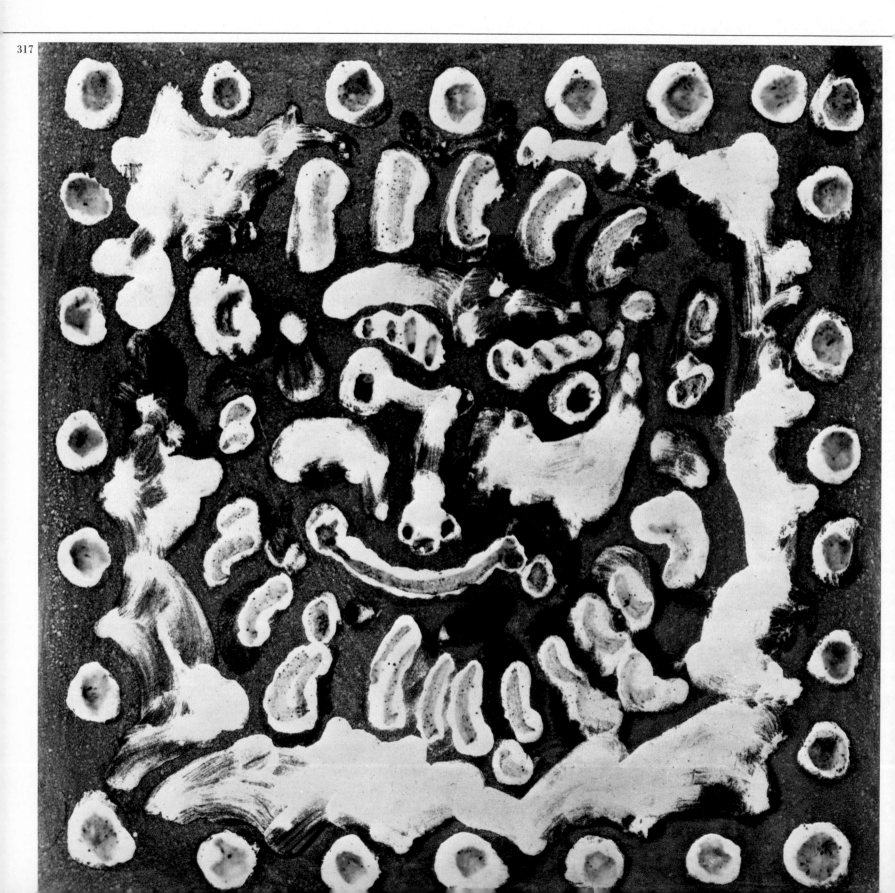

318. Tile. Faun's head. 15.3 × 15.3 cm. Dated 7-7-56 - II.

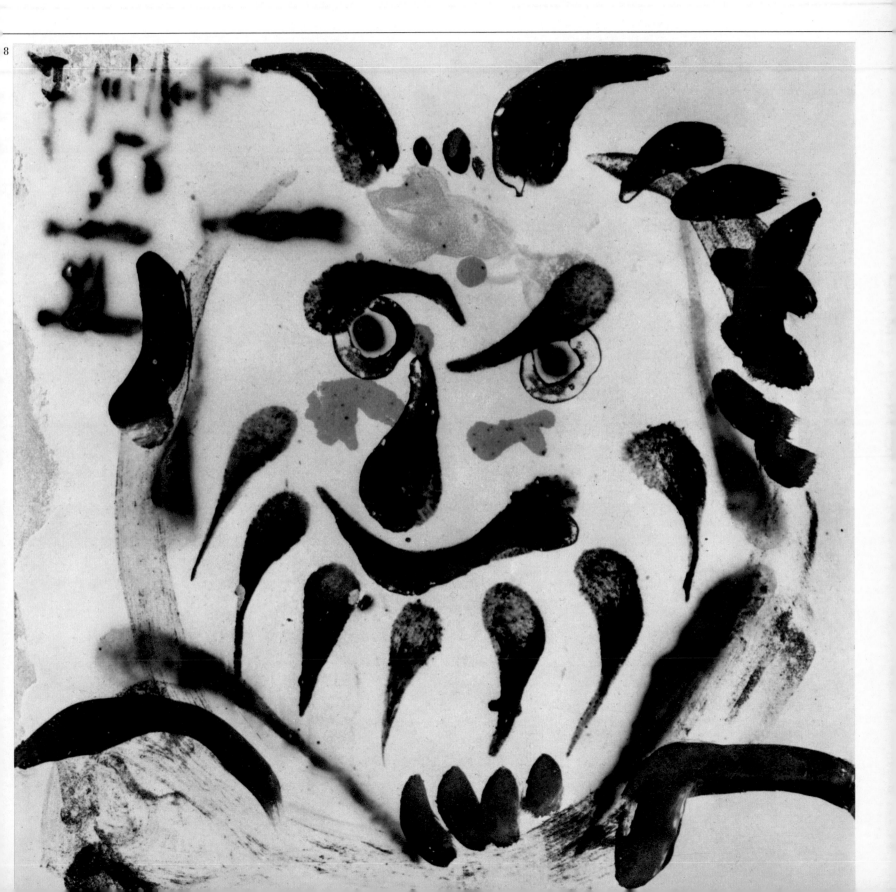

150

319. Tile. Faun's head. 15.3×15.3 cm. Dated 1956.
320. Tile. Bearded faun. 15×15 cm. Dated 7-7-56 - IV.
321. Tile. Faun's head. 20.5×20.5 cm. Dated 24-1-56 - XI.
322. Tile. Faun's head. 20.5×20.5 cm. Dated 27-1-56 - IV.
323. Tile. Bearded faun. 20.5×20.5 cm. Dated 25-1-56 - II.

324. Tile. Faun's head. 20.5×20.5 cm. Dated 24-1-56 - IX.
325. Tile. Faun's head. 20.5×20.5 cm. Dated 24-1-56 - X.
326. Tile. Bearded man's head. 20×20 cm. Dated 24-1-56 - III.
327. Tile. Faun's head. 20.5×20.5 cm. Dated 24-1-56 - IV.

319
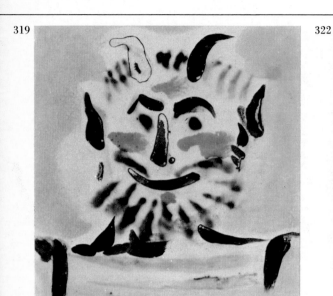

322
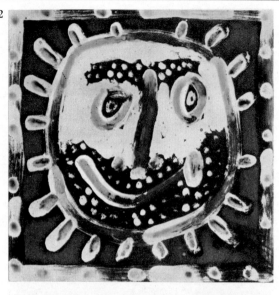

325
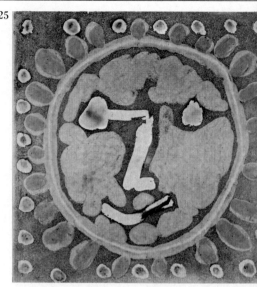

320
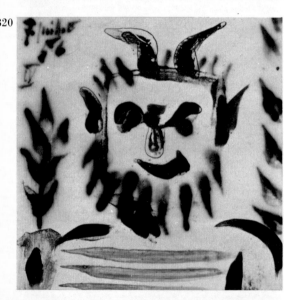

323
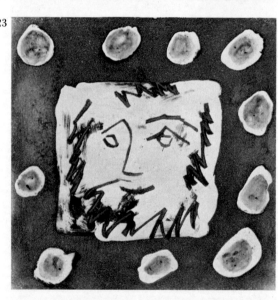

326
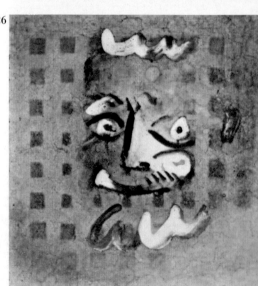

321
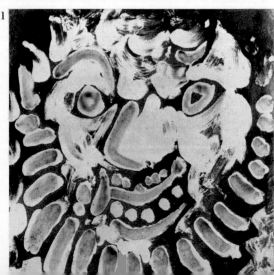

324
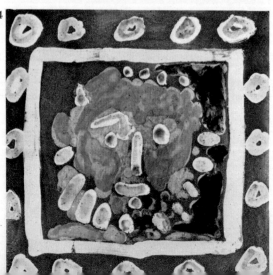

327
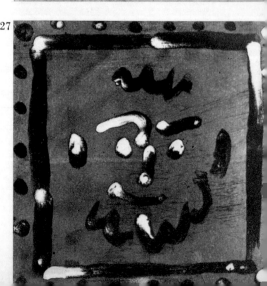

328. Tile. Faun's head on green ground. 15 × 15 cm. Dated 1956.
329. Tile. Faun's head in grey and white. 15 × 15 cm. Dated 1956.
330. Tile. Young faun. 15 × 15 cm. Dated 1956.
331. Tile. Young faun. 15 × 15 cm. Dated 9-5-56.
332. Tile. Faun's head. 15.3 × 15.3 cm. Dated 7-7-56 - II.

333. Tile. Young faun. 15 × 15 cm. Dated 1956.
334. Tile. Faun's head on grey ground. 15 × 15 cm. Dated 1956.
335. Tile. Faun's head on grey ground. 15 × 15 cm. Dated 1956.
336. Tile. Faun's head. 15 × 15 cm. Dated 1956.

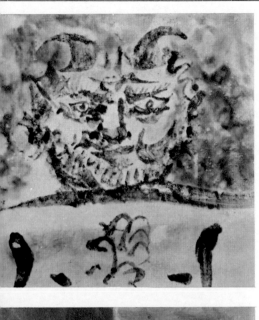

331

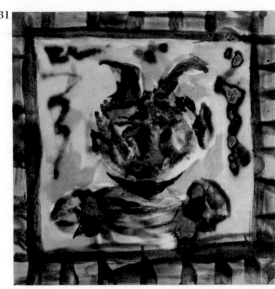

334

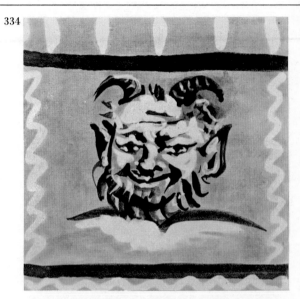

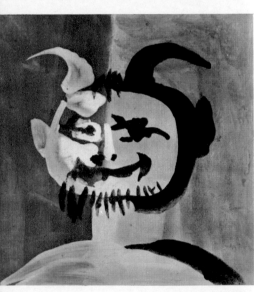

332

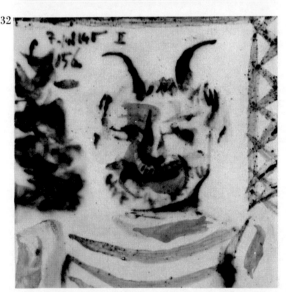

335

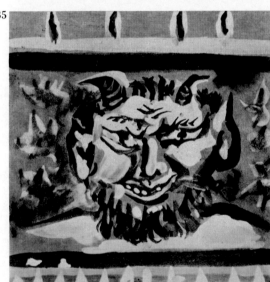

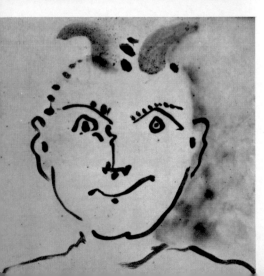

333

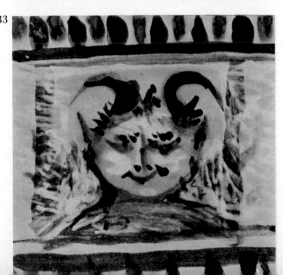

336

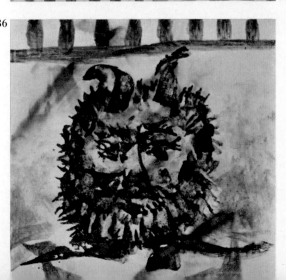

337. Tile. Faun's head. 20.5×20.5 cm. Dated 24-1-56 - VI.
338. Tile. Bearded faun's head. 15×15 cm. Dated 1956.

339. Tile. Faun's head. 15.3×15.3 cm. Dated 7-7-56 - XV.
340. Tile. Faun's head. 15.3×15.3 cm. Dated 7-7-56 - XI.
341. Tile. Faun's head. 15.3×15.3 cm. Dated 7-7-56 - V.
342. Tile. Bearded faun. 15×15 cm. Dated 7-7-56.

337
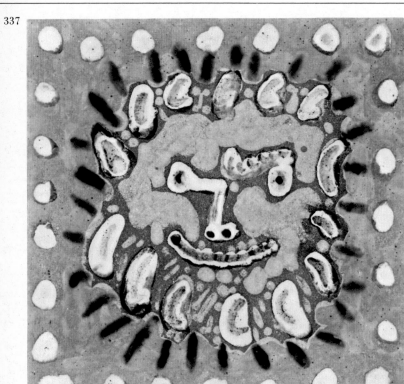

339

34
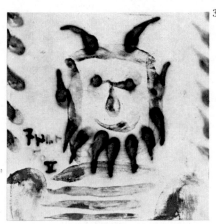

340
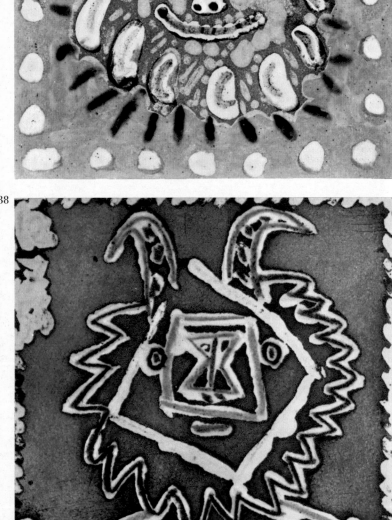

342
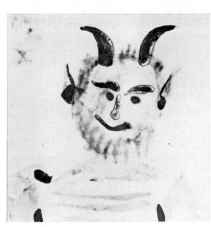

338

343. Tile. Face. 20.5 × 20.5 cm. Dated 22-2-56.

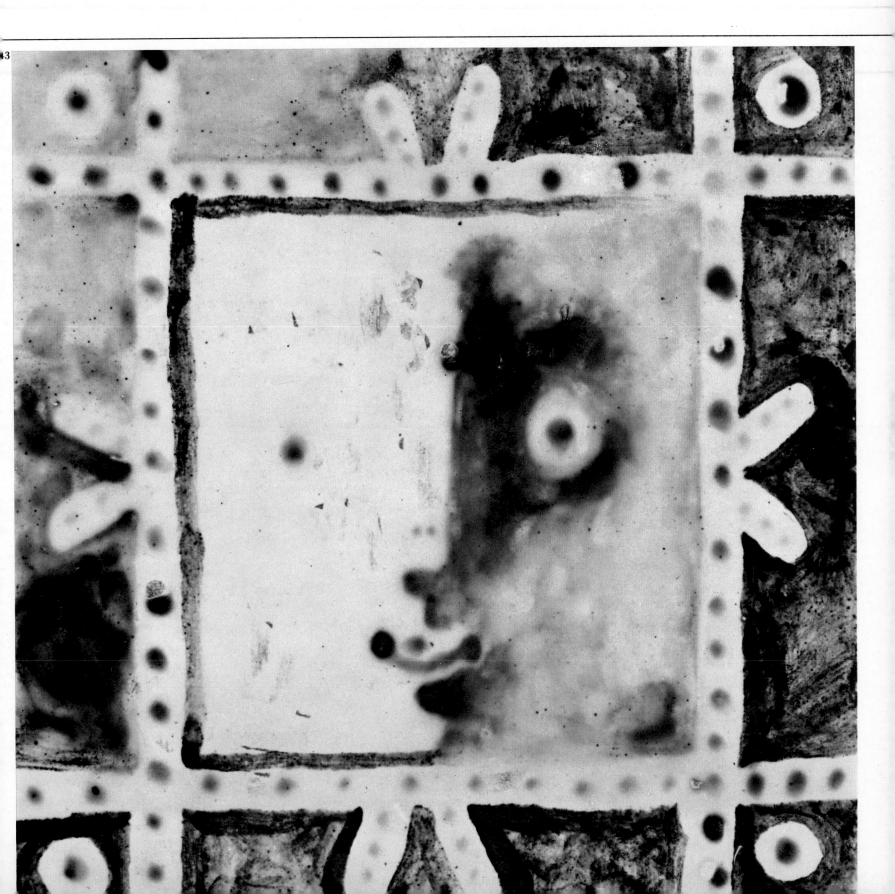

344. Tile. Faun's head. 20.5 × 20.5 cm. Dated 24-1-56 - VIII.
345. Tile. *The workshop*. 20.5 × 20.5 cm. Dated 18-2-56 - V.

344

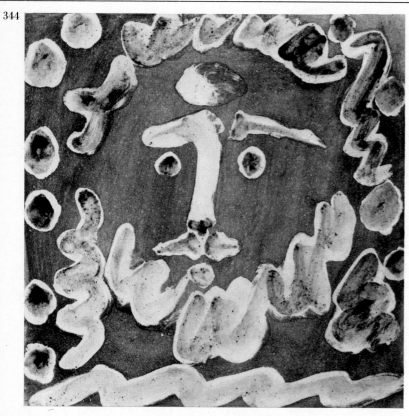

345

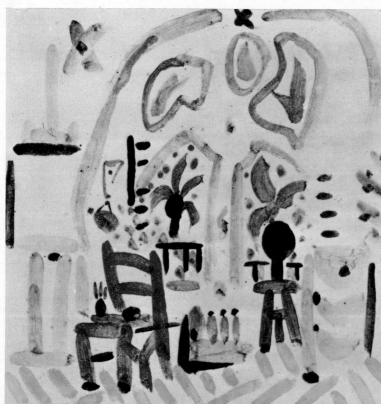

corners, were then being studied in the workshop and undergoing casting tests.

Picasso instantly adopted these and set to work on them at a cracking pace, not stopping until he had run off several hundred specimens. By now, of course, this shape has become world-famous; adopted, interpreted and widely proclaimed, it has been more than sufficiently employed by a generation of young artists who found in it a facile vehicle for their self-expression as ceramists.

For the moment the news spread that Picasso had become a potter, a new world suddenly awoke. Ceramics had always been considered a minor art, an art reserved for a few effete initiates, finicking aesthetes drooping over the glories of a past definitively completed. To tell the truth, nobody paid it any attention. No mind that was even slightly open could seriously entertain even a remote impulse to make itself known to it. And then, all of a sudden, this imp of a man took it into his head to devote himself heart and soul to this form of plastic expression and to take an interest in all its possibilities.

This event plunged many spirits into a tumult of reflections and even inspirations: perhaps this new discovery was really going to bring forth some absolutely new media! So it became a matter of urgency to go and look into all this a little more closely. And it was then that we saw once more that well-known phenomenon of Picasso opening a door and everybody pushing to cross the threshold. This time it was the door to ceramics that was flung open so resoundingly, and the multitudes immediately rushed through. As if by magic a renewed interest arose in the practice of all the arts of fire. The world had never seen so many ceramists! And to feed the inspiration of these pressing cohorts, the shape of the plates in

346. Tile. Faun's head. 19.5×19.5 cm. Dated 1956.
347. Tile. Faun. 15×15 cm. Dated 10-5-56.
348. Tile. Bearded man's head. 20×20 cm. Dated 25-1-56 - VIII.
349. Tile. Faun's head. 20.5×20.5 cm. Dated 28-1-56 - III.
350. Tile. Mask. 20×20 cm. Dated 27-1-56 - I.

351. Tile. Faun's head. 20.5×20.5 cm. Dated 24-1-56 - II.
352. Tile. Face. 20.5×20.5 cm. Dated 28-1-56 - I.
353. Tile. Bearded faun. 20.5×20.5 cm. Dated 25-1-56 - IV.
354. Tile. Faun playing pipe. 15.2×15.2 cm. Dated 11-7-56.

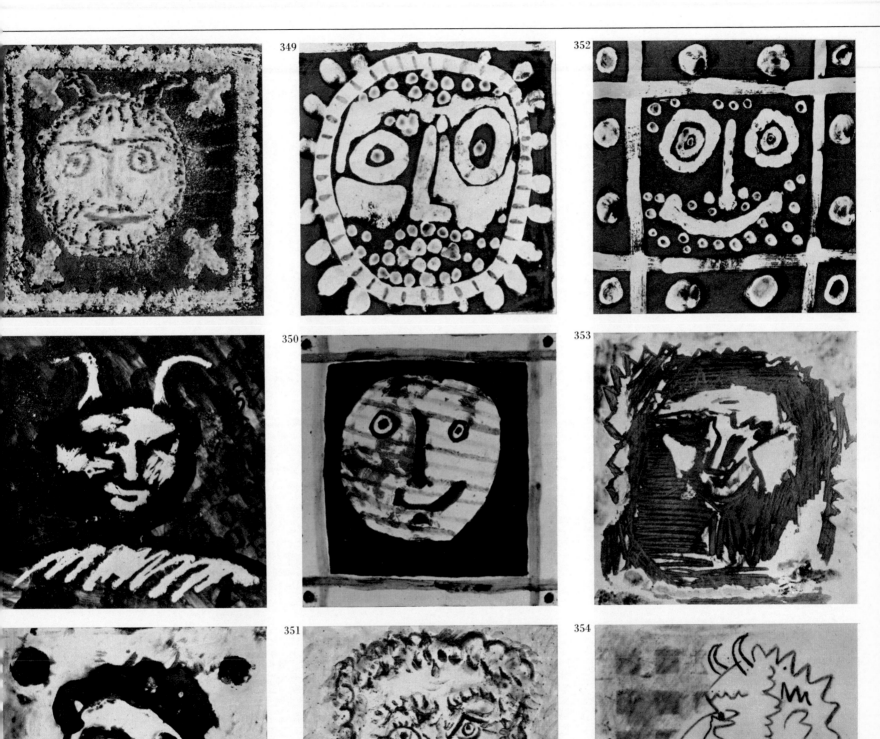

355. Tile. Two nudes. 20.5 × 20.5 cm. Dated 16-3-56.

355

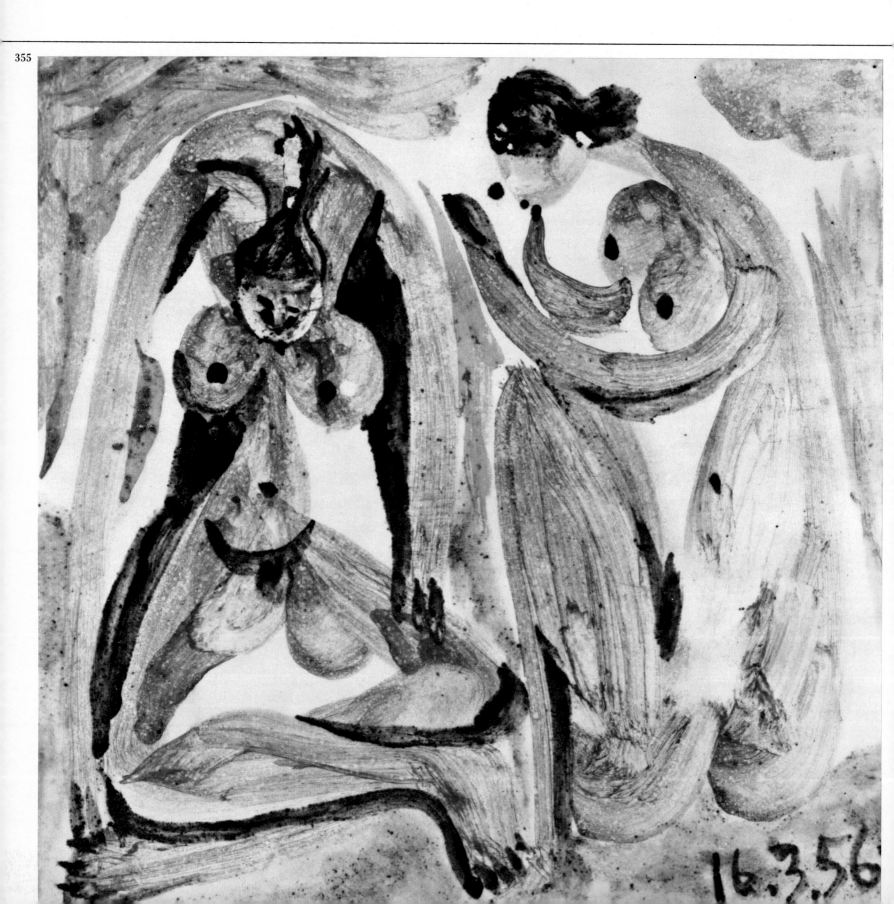

356. Tile. Mask. 20×20 cm. Dated 27-1-56 - X.

356

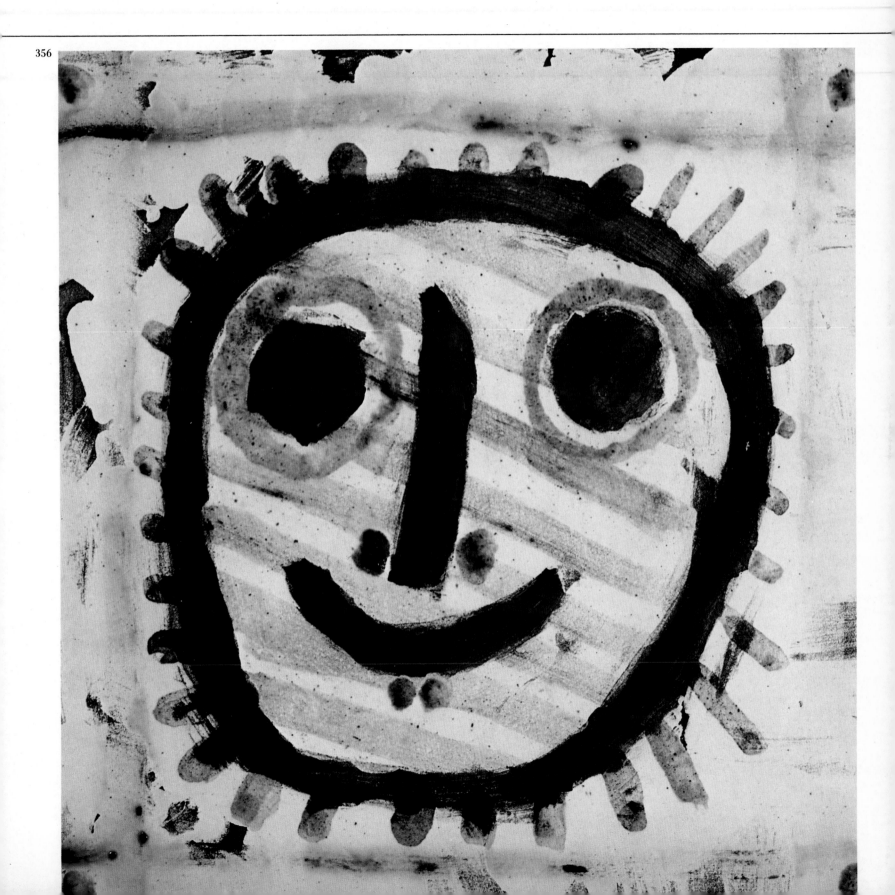

357. Tile. Interior of the workshop 'La Californie'. 20.5 × 20.5 cm. Dated 18-2-56 - III.

358. Tile. Window of the workshop 'La Californie'. 20.5 × 20.5 cm. Dated 18-2-56 - VI.

359. Tile. Window of the workshop 'La Californie'. 20.5 × 20.5 cm. Dated 18-2-56 - IV.

360. Tile. Window of the workshop 'La Californie'. 20.5 × 20.5 cm. Dated 18-2-56 - I.

361. Tile. The painter's studio at 'La Californie'. 25.3 × 30.5 cm. Dated 1956.

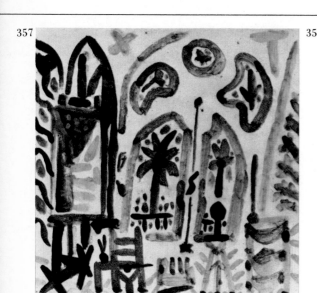

357

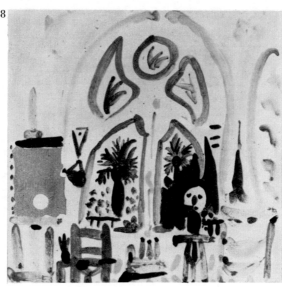

358

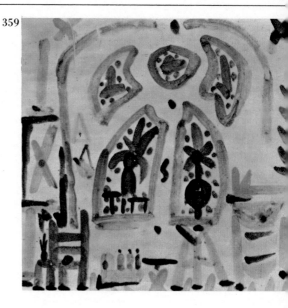

359

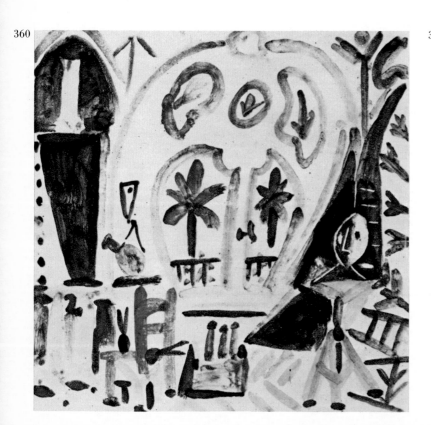

360

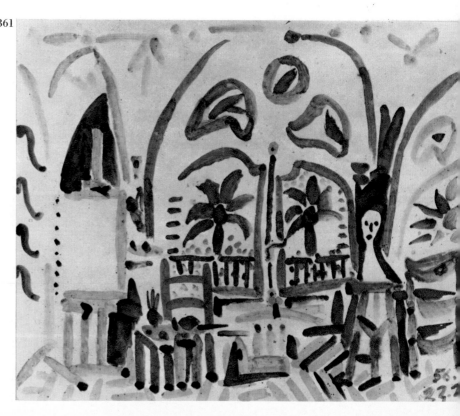

361

362. Tile. In the workshop 'La Californie'. 20.5 × 20.5 cm. Dated 18-2-56 - II.

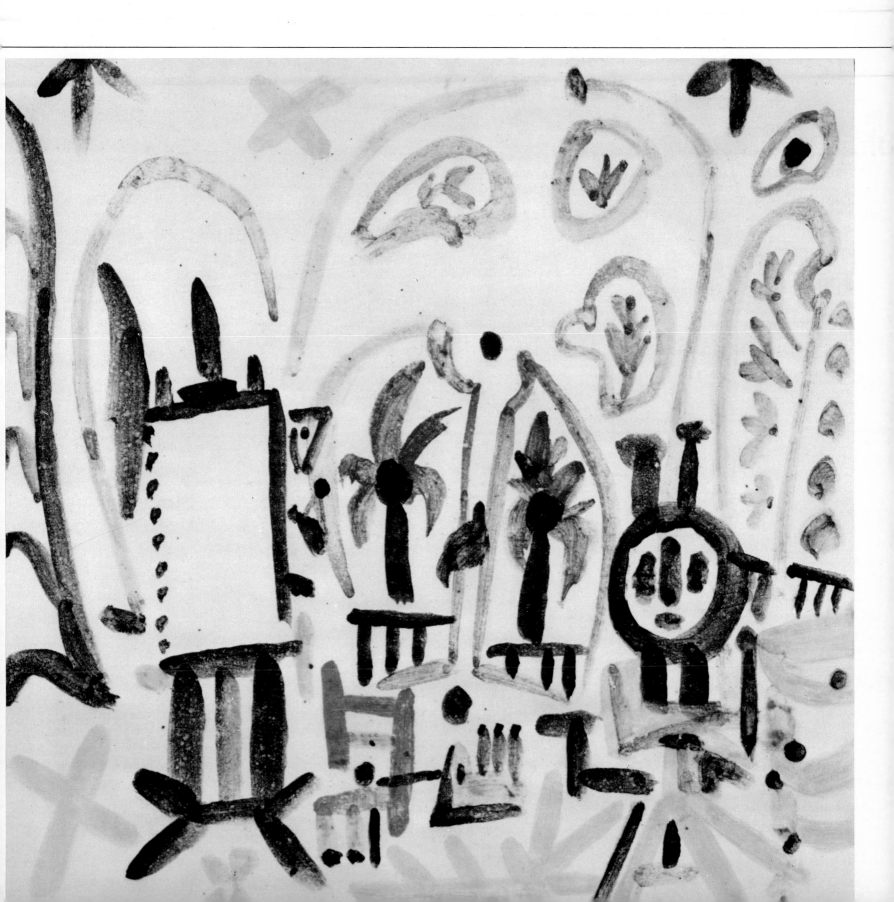

363. Tile. Woman squatting. 20.5 × 20.5 cm. Dated 10-2-56 - II.
364. Tile. Two women. 20.5 × 20.5 cm. Dated 16-3-56.
365. Tile. Nude squatting. 20.5 × 20.5 cm. Dated 16-3-56 - III.
366. Plaque. Six bearded heads. 23.5 × 30.5 cm. Dated 5-12-56.
367. Plaque. Nine little pictures (9 faces). 25.5 × 25.5 cm. Dated 5-12-56.

363
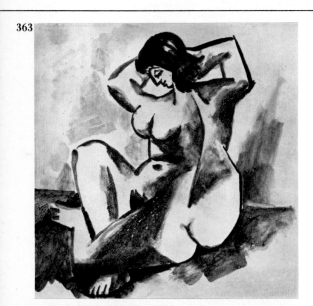

364
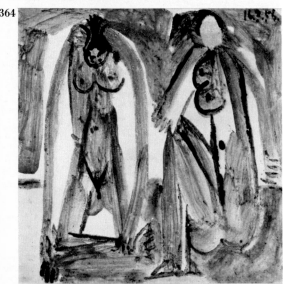

365
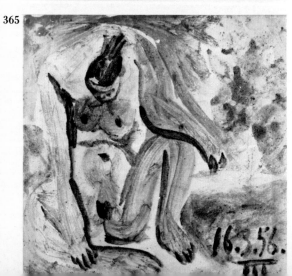

366
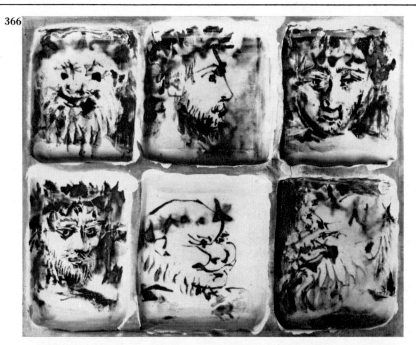

367
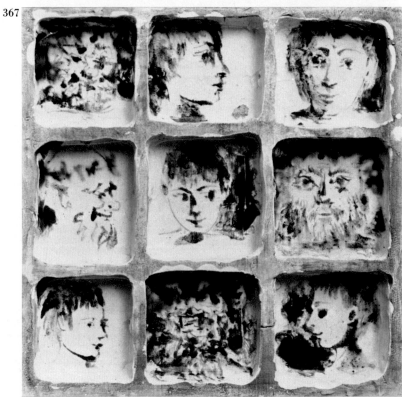

368. Plaque. Twelve little pictures. 30.5 × 25.5 cm. Dated 5/6-12-56.

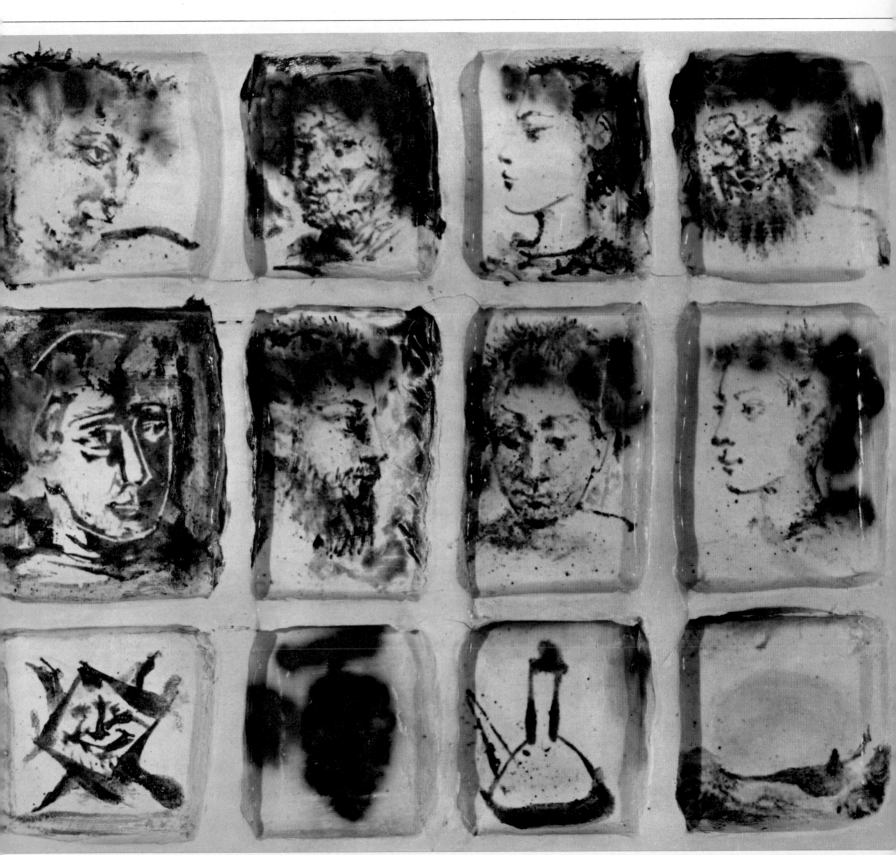

369. Plaque. Bearded man. 31 × 25.5 cm. Dated 19-10-56.
370. Plaque. Man's head. 30.5 × 25.5 cm. Dated 19-10-56.
371. Plaque. Head. 30.5 × 25.5 cm. Dated 19-10-56.

372. Plaque. Sun-head. 30.5 × 25.5 cm. Dated 19-10-56.
373. Plaque. Man in striped jersey. 31 × 25.5 cm. Dated 19-10-56.
374. Plaque. Adolescent. 30.5 × 25.5 cm. Dated 19-10-56.

369
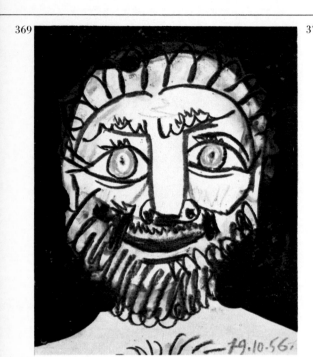

371
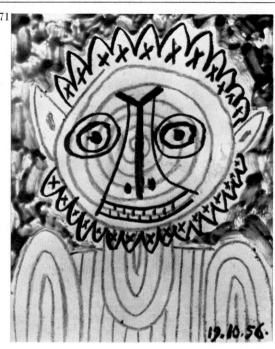

373
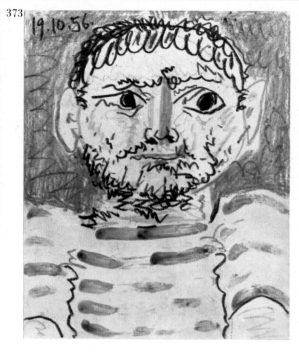

370
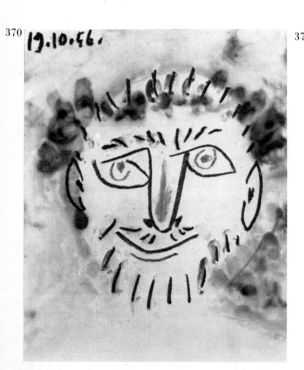

372
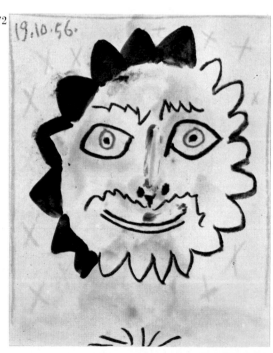

374
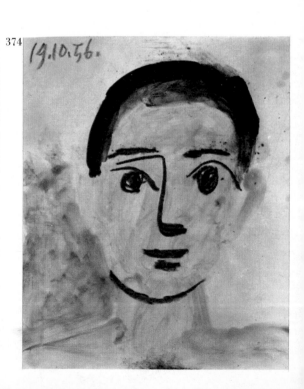

375. Plaque. Bearded man with spectacles. 30.5×25.5 cm. Dated 12-8-56.
376. Plaque. Boy's head. 30.5×25.5 cm. Dated 8-8-56.
377. Plaque. Bearded man. 30.5×25.5 cm. Dated 12-8-56.

378. Plaque. Bearded man in half-profile. 31×25.5 cm. Dated 12-8-56.
379. Plaque. Alfresco concert. 30.5×26 cm. Dated 14-10-56.
380. Round plaque. Head. 30.5×29.5 cm. Dated 1956.

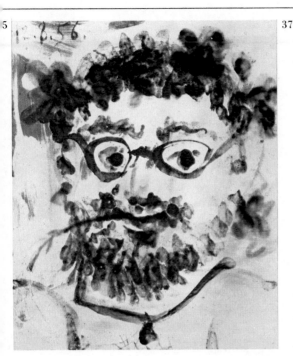

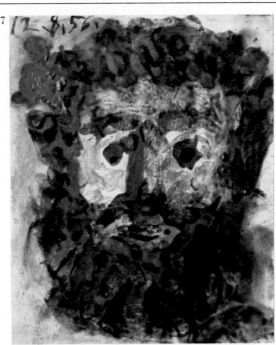

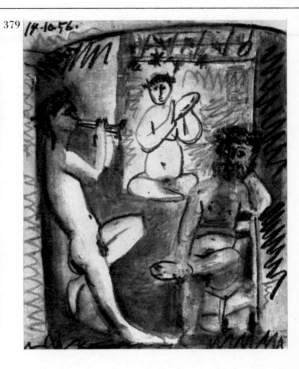

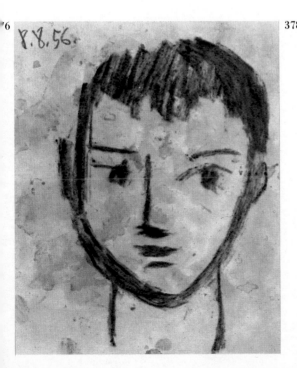

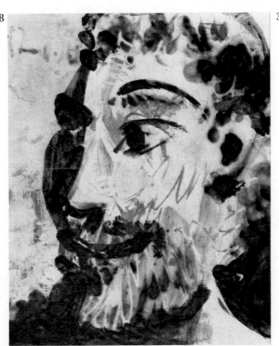

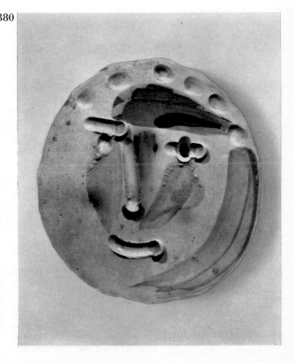

381. Tile. Clown's head. 20.5×20.5 cm. Dated 15-2-56 - III.

382. Assembled tiles. Three figures holding hands. 46.5×46 cm. Dated 20-7-56.

383. Tile. Bearded faun. 20.5×20.5 cm. Dated 15-2-56 - II.

384. Tile. Clown's head on blue ground. 20.5×20.5 cm. Dated 15-2-56 - V.

385. Assembled tiles. Woman's head. 61×61 cm. Dated 1956.

386. Tile. Horse. 20.5×20.5 cm. Dated 25-1-56.

387. Tile. Clown's head on white ground. 20.5×20.5 cm. Dated 15-2-56 - IV.

388. Tile. Woman's head. 20×20 cm. Dated 7-1-56.

389. Tile. Lance-thrust. 15×15 cm. Dated 1956.

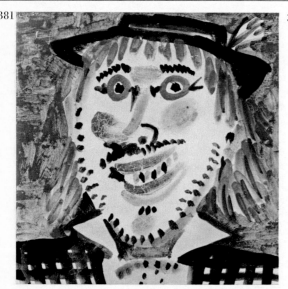

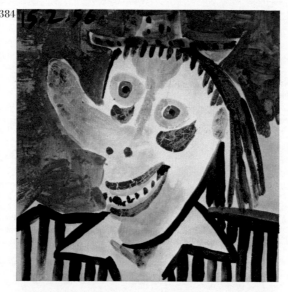

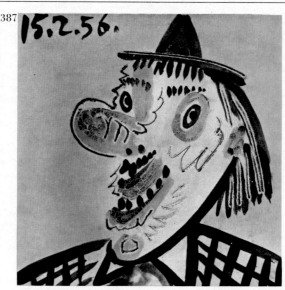

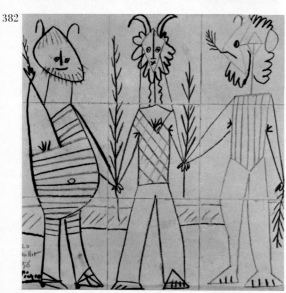

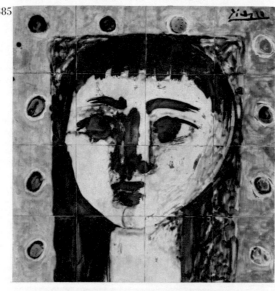

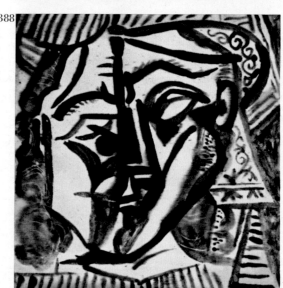

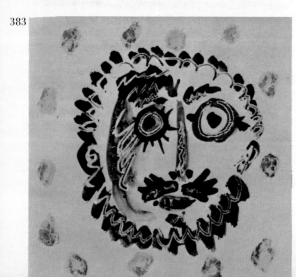

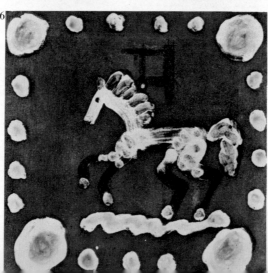

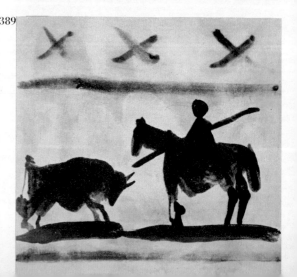

390. Assembled tiles. Branch in glass. 30.5 × 15.3 cm. Dated 1956.

391. Tile. Picador. 19.5 × 19.5 cm. Dated 17-12-56.

392. Tile. Picador (reverse of No. 391). 19.5 × 19.5 cm. Dated 17-12-56.

393. Large rounded square plate. Profile of Jacqueline, painted. Diameter 41.5 cm. Dated 1956, original print.

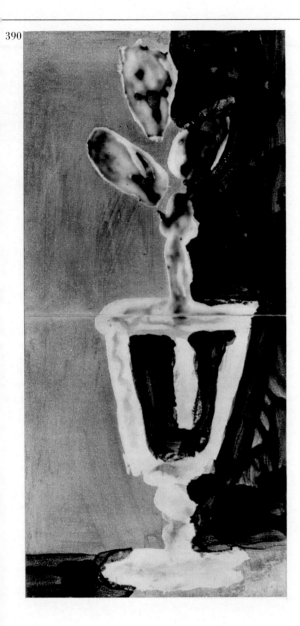

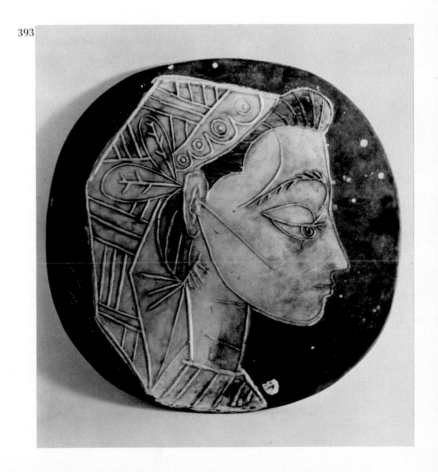

394. Large plaque. Head. 56.5×33 cm. Dated 1956.
395. Large plaque. Head. 56.5×32.5 cm. Dated 1956.
396. Large plaque. Head. 56.5×32 cm. Dated 1956.

397. Rounded square plate. Goat. Diameter 26.2 cm, original print. edition.
398. Rounded square plate. Another version of No. 397. Diameter 26.2 cm. original print, edition.

394
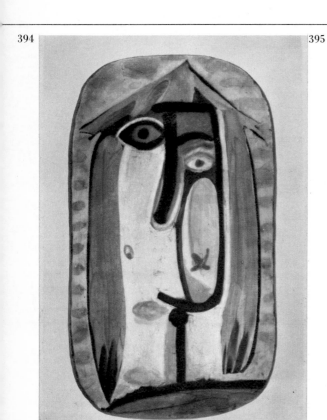

395
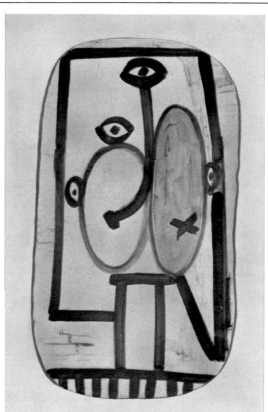

396
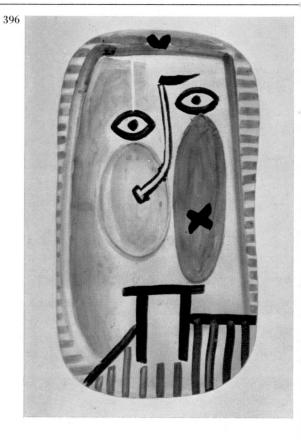

397
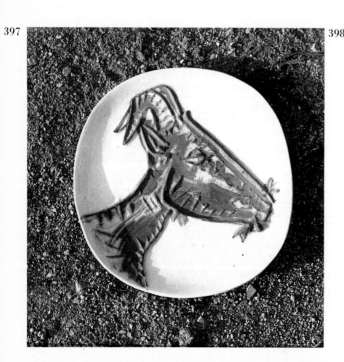

398
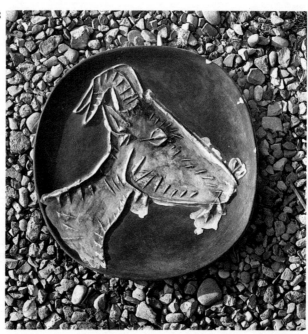

399. Vase with goats. Height 23 cm., diameter at top 12 cm., diameter at
bulge 20 cm. Dated 6-6-52, original print, edition.
400. Other side of No. 399.

question, whether by way of flattery or —just
as probably— from spiritual laziness, was unani-
mously adopted and widely used.

But before all this happened quite an exten-
sive collection of pieces had already been built
up here, forming a coherent whole but dealing
with a great variety of subjects. The first was
that of the face, a passionately absorbing, eternal
theme, which was studied over and over again
under a hundred new aspects.

Should we be astonished at this inexhaustible
source of inspiration that lies hidden in the face?
At this obsessive remodelling to which it is end-
lessly subjected? For it is *the* face that is in ques-
tion, not just *a* face. Going from the particular to
the universal, is there anything in nature more
moving, more unfathomable, than this mirror
of the soul that reflects with heart-breaking tran-
sience the most tenuous of lights, the slightest
passing shadows? And that is merely the fleeting
aspect of a single face. How many faces are there
still, among the numberless faces of which none
resembles either itself or others?

A comprehensible spell, and one that may well
work upon a man who is not content to describe
the face that everybody can see, but goes much
further and invents all the other faces, the faces
that nobody will ever see: sun-faces, devil-faces,
faces of rain and faces of pearls, heads of goats,
snouts of minotaurs, faces of bulls. And all of these
evocations, real or mythical, were recounted to
infinity as he made his way through the twisting
tunnels of this fabulous labyrinth.

This unleashing of a flood of studies on one
face or another has always been one of Picasso's
leit-motifs. At every stage in his career he has
come back to it with delight, using all the methods
at his disposal, as if it were an unselfconscious
gesture.

399

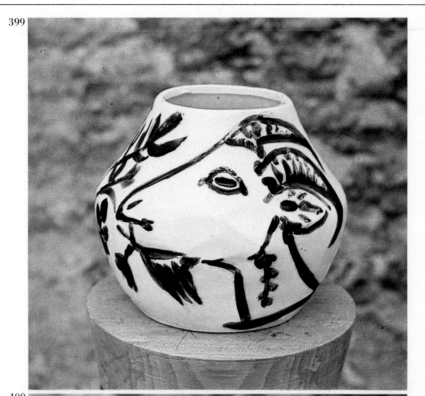

400

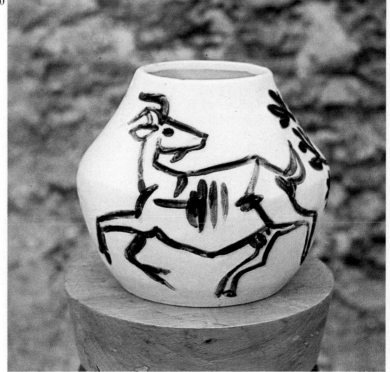

401. Large rectangular plate. Goat's head in profile (another variation).
 Height 31 cm., length 51 cm. Dated 5-6-52, original print, edition.
402. Tile. Face. 15 × 15 cm. Dedicated to Mme. Ramié.
403. Round plate. Goat's head in profile. Diameter 40.5 cm. Dated 1956.

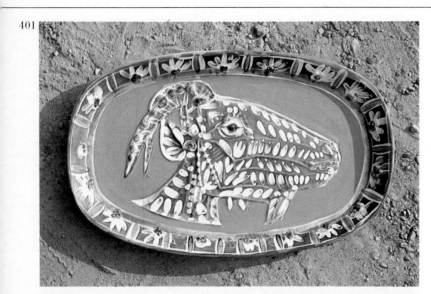

401

402

These plates, however, also suggested other motifs: their very nature encouraged him to garnish them with the sort of things they usually contain. Hence a series of fish, fruits, vegetables and other subjects of a less romantic kind: reliefs of fish, black-puddings, fried eggs, shellfish. Virtuoso exercises that were not continued.

There were also important series of still lifes: flowers, bouquets, glasses and bottles, knives, scissors. Some landscapes. A long series of nightbirds.

But there was, above all, a very extensive thematic development of bucolic variations: Virgilian countrysides, mythological scenes amid rocks, evocations of Parnassus, piping shepherds and capering goats, centaurs and winged horses, Bacchanals, fauns and satyrs, nymphs and mermaids. A whole episode, in short, devoted to the pastoral serenity of the Aegean, to the incomparable simplicity of a carefree world, steeped in legends of Attic grace and full of the joy of life. When themes like this fill the spirit, it must be because the need to express them mirrors the state of mind of the one describing them. All this leads one to suppose that when Picasso let his imagination dream of the unalloyed sweetness of the Arcadian shepherd's life he was merely listening to the inner song of his own life at that time.

A charming kind of bestiary then brings us a cloud of fairy birds, birds such as one has never seen but would love to hear some time, even though their warbling might not equal the charm of their enchanted plumage.

Finally, one of the widest ranges in the whole collection of plates is that which features bullfighting. Picasso never failed to attend the bullfights held in Nîmes or Arles, and for days afterwards he would evoke the arduous hours of those

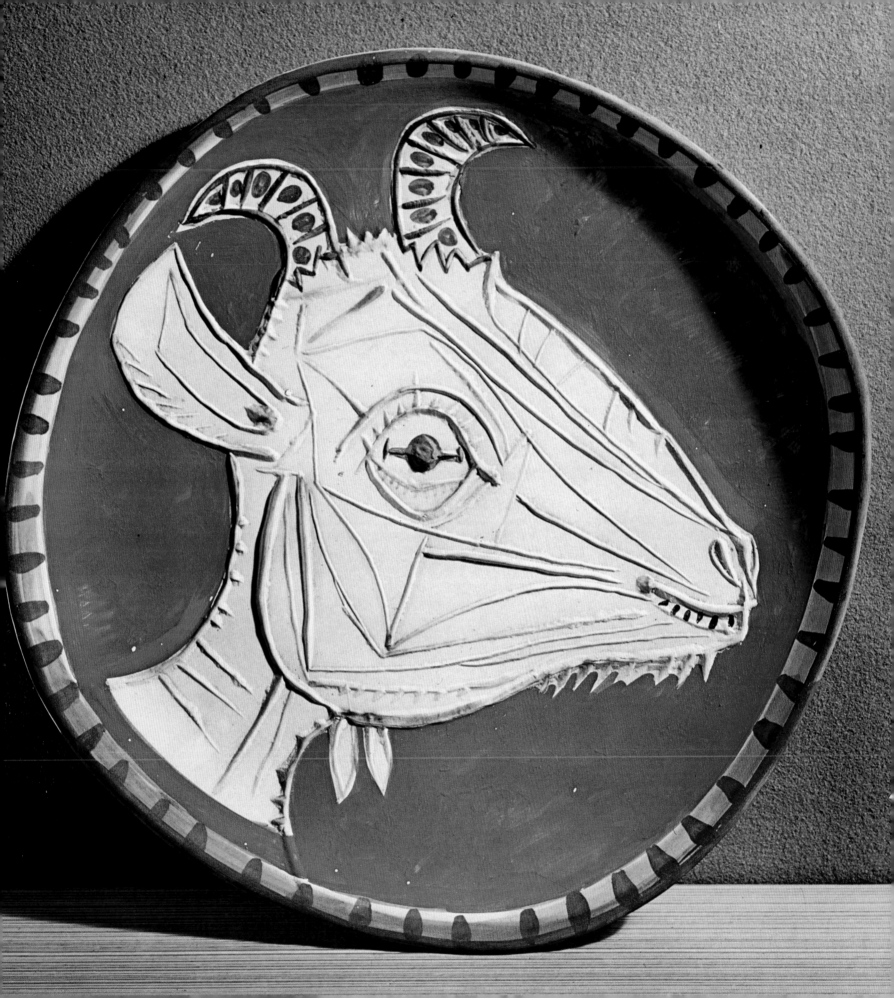

404. Round plate in colour. Face on grid in white earthenware. Diameter
42 cm. Dated 1956, original print, edition.

404

intense dramas: he felt impelled to announce their too-absorbing content and translate its still-quivering intensity.

And so the corrida unfolds before us through all its *suertes*, thanks to this astonishing vision of things that Picasso captures with all the impact of a snapshot. Fleeting yet dense impressions, which he must find it impossible to confide save by entrusting them to a faithful medium. Passion, emotion and respect, the fascinations that appear in the closely-observed description of these glittering scenes, with their mingled violence and skill, courage and elegance: the parade of the bullfighters behind the dashing alguazils in their seventeenth-century costumes, the bulls erupting from the pen, daring passes with the cape, the *suerte de varas* with the ponderous picadors, picadors alone with their pompon-decked hats, nimble *banderilleros* lining up the bull, pigtailed matadors flaunting their capes or dedicating a

bull, passes with the *muleta*, dramatic swordthrusts, the dead bull piteously dragged away. Nor are the tossings and gorings forgotten: indeed they were more particularly evoked after the tragic death of the great Manolete, which Picasso felt so deeply.

Speaking of bull-fighting, we should recall that time when Vallauris, too, had its bullring and its regular seasons, under the auspices of Picasso himself.

On the first Sunday in August, every year from 1954 to 1960, a portable ring with room for thousands of spectators was brought from Arles and set up in the big square of the Town Schools.

The fiesta would begin on the Saturday night: a whole spectacle of taurine fantasy, featuring bulls with their horns tipped with balls, comic bull-fights, clowns, *razzetas* and other such games, and bringing an entirely new kind of entertainment to a public as yet unfamiliar with the world of the bulls.

On the Sunday afternoon a magnificent poster would announce the matadors —sometimes quite famous ones— who came to pay their homage. Then the sham bull-fight would begin, more like a *capea* in a Spanish village than anything else and greatly delighting Picasso, for he always, of course, presided over the fiesta.

The half-grown bulls would be fought either by the visiting matadors or by *caballeros en plaza*, mounted bullfighters performing in the Portuguese fashion, but with blunted lances.

This spectacle was always highly appreciated and often went on until after nightfall. Returning the bulls to the corral, however, no matter how it was done, took much longer than the bullfight itself. The trained oxen were not persuasive enough and the young bulls would choose to disport themselves in the freedom of the arena rather

405. Round plate in colour. Centaur with polychrome decoration. Diameter
42 cm. Dated 1956, original print, edition.

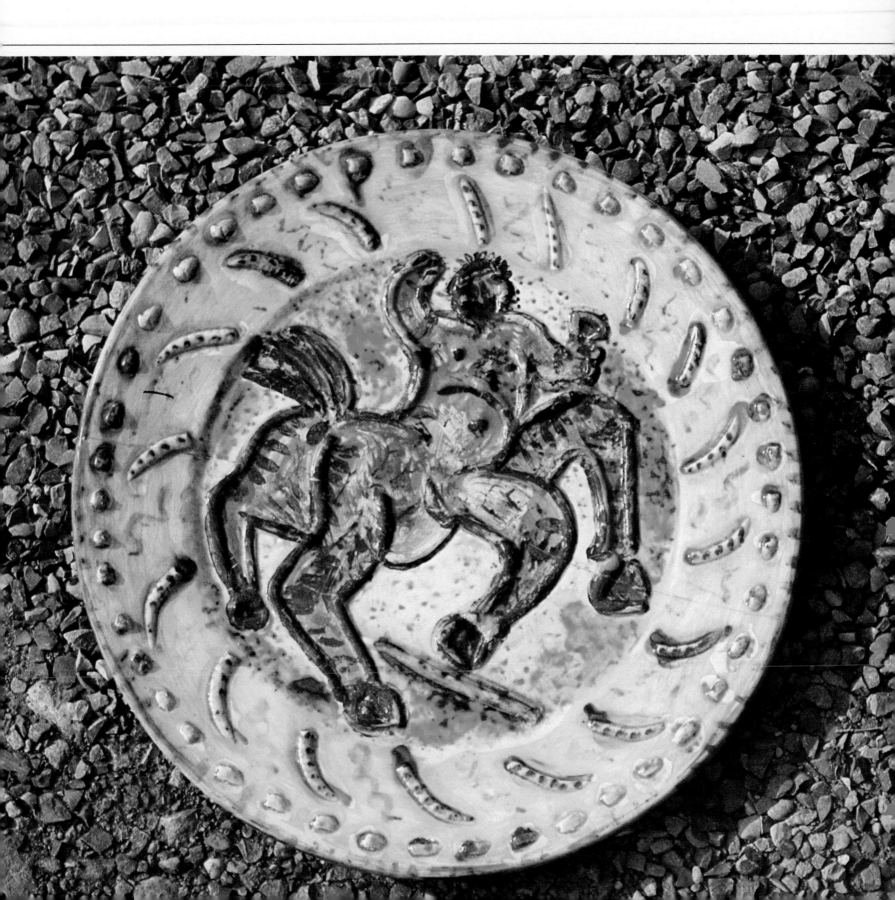

406. Reverse of No. 405.
407. Large round plate. White Vallauris ware. Diameter 42 cm. Dated 1956, original print, edition.
408. Rounded square plate. Black mask. 31×31 cm. Dated 1956, original print, edition.

409. Round plate in colour. Faun in white earthenware. Diameter 42 cm. Dated 1956, original print, edition.
410. Large round plate. Bull's head in white earthenware. Diameter 42 cm. Dated 6-10-60, original print, edition.

406

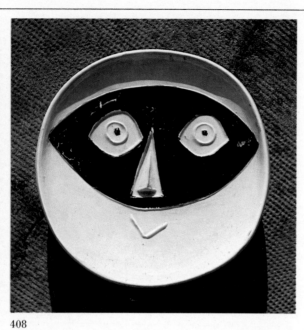

408

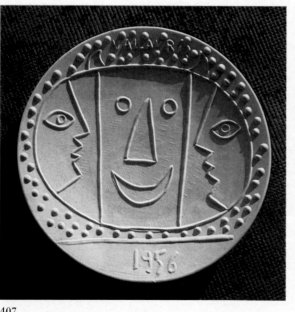

407

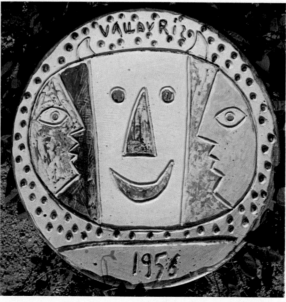

409

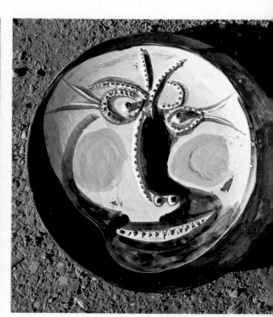

410

411. Rounded square plate in colour. Face of man wearing tie, in white earthenware. Diameter 25 cm. Dated 6-10-60, original print, edition.

412. Large round plate in colour. Tortured face with palm-leaves, in white earthenware. Diameter 42 cm. Dated 1956, original print, edition.

413. Large round plate. Face incised and in relief. Diameter 42 cm. Dated 1956, original print, edition.

414. Rounded square plate in colour. Bouquet with apple, in white earthenware. Diameter 24 cm. Dated 22-1-56, original print, edition.

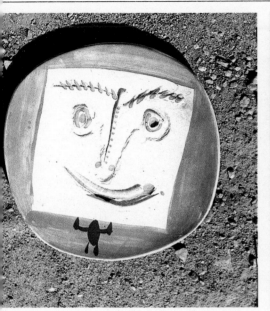 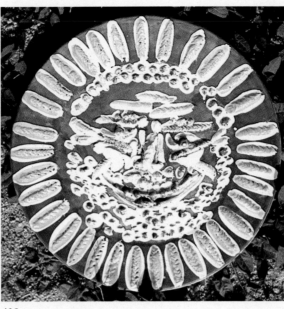 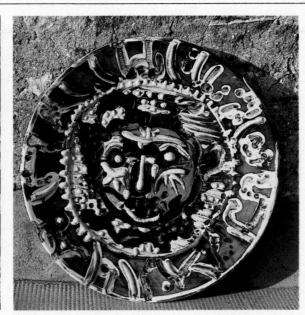

412

413

than be tamely shut up in their boxes, which sometimes gave rise to impromptu and not uniformly successful lassoing parties.

It should be mentioned, for the sake of truth, that in these simulated bull-fights, which could be very dangerous, we sometimes witnessed quite bad gorings; none, fortunately, with serious consequences, but many that did spectacular damage to the bullfighters' 'suits of lights'.

The bullring is sometimes represented on very elongated oval plates, the elliptical shape of which enables the interior of the building to be represented in perspective, with all the spectators on the tiered seats and the arena itself —and the bull-fighters— in the centre.

As I said before, these bull-fighting themes constitute a very extensive series and, though this series has been rather discontinuous over the years, each new season saw it resumed with fresh notations. The account it gives, in short, so often analysed with a full knowledge of the subject and taken up again with all the ardour of the

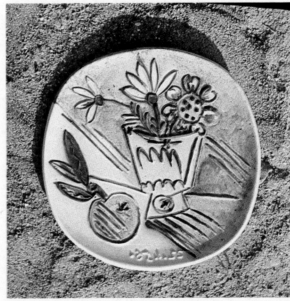

414

415. Assembled tiles. Two bouquets. 61.5×91 cm. Dated 1956.
416. Assembled tiles. Figures dancing the *sardana*. 15.7×45.8 cm. Dated 1956.
417. Assembled tiles. The *sardana*. 41.2×82 cm. Dated 5-4-56.
418. Assembled tiles. Pastorale. 41.2×82 cm. Dated 5-4-56.
419. Round plate. Lance-thrust. 39×39 cm. Dated 1956, original print.

415

416

417

418
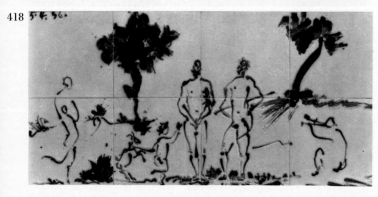

aficionado that lurks in every Spaniard, constitutes a respectful homage to the great epic of bullfighting, so essentially Iberian in character, to which new and powerful chapters are added each year, both in Spain and in South America.

This ethic of tradition found an entirely natural prolongation in the shape of a remarkable collection of large, round plates, which came to be called 'Spanish plates'. Their form, indeed, does have something of that typical and profoundly creative spirit that animates the traditional Spanish way of life. In outline they have a fairly noticeable bulge at the centre, then a softly rounded hollow and, finally, a wide and slightly convex border, the whole possessing an undulating appearance that is very graceful and elegant. This form was conceived as an interpretation of a plate that was in everyday use in Spain many years ago. There are still some original specimens to be found in collections of pieces from that heyday of Spanish ceramics that was illuminated by the reflections of the famous Hispano-Moresque lustreware. Such a conception is, in any case, a proof of absolutely Mozarabic beginnings, while the inspiration it reflects is of a specifically Iberian character.

In this series of Spanish plates Picasso returns to the familiar themes one is always so unfailingly pleased to find again in new graphic treatments. The particular line and surface of these pieces do indeed impose severe demands on whoever wishes to illustrate them. The violent presence of the subjects that now filled these surfaces might easily remind us of those aggressive figurations that used to ornament the shields of the infantry in the armies of Charles V: round bucklers arming the foot-soldiers and intended both to protect the attacker and terrify the attacked. That is, no doubt, the reason why we find in this

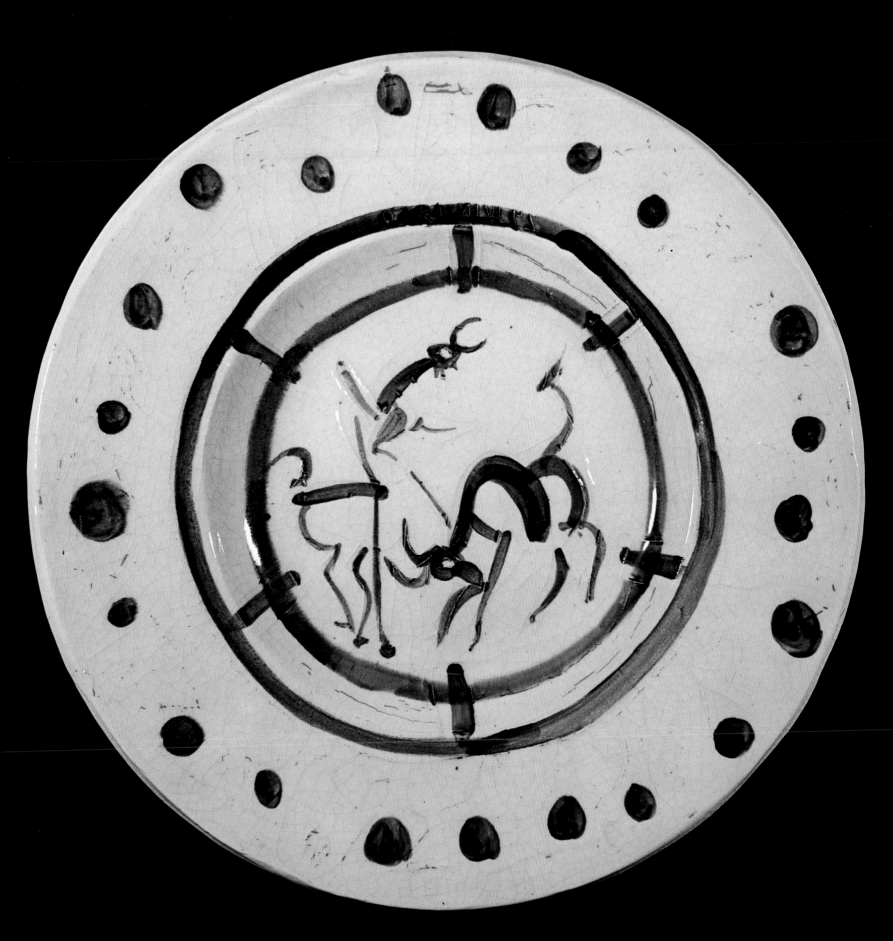

420. Large round plate in colour. Faun on horseback in white earthenware. Diameter 42 cm. Dated 1956, original print.

421. Large round plate. *Jacqueline at the easel* in white earthenware. Diameter 42 cm. Dated 1956, original print, edition.

422. Large chequered vase. Face in white earthenware. Height 38 cm., diameter at the bulge 45 cm., diameter at the top 10 cm. Dated 1956, original print, edition.

423. Large Peking-type vase. Other side of No. 431.

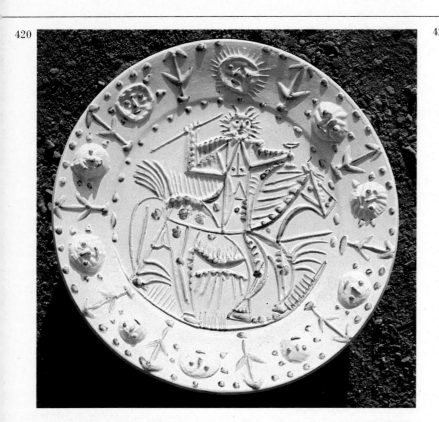

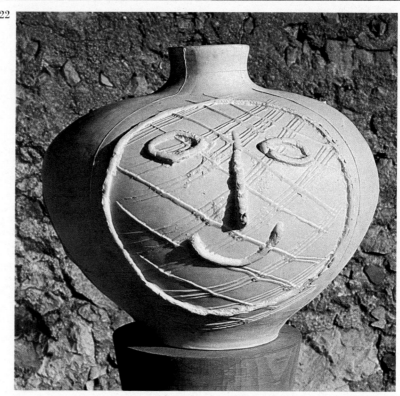

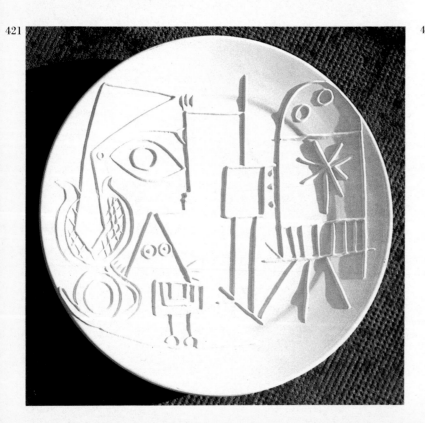

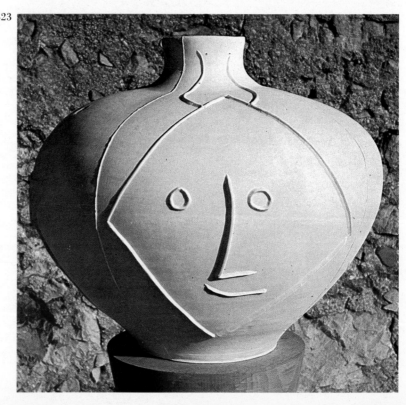

424. Small convex wall plaque. Beach scene on patinated ground in white earthenware. Diameter 18.5 cm. Dated 1956, original print, edition.

424

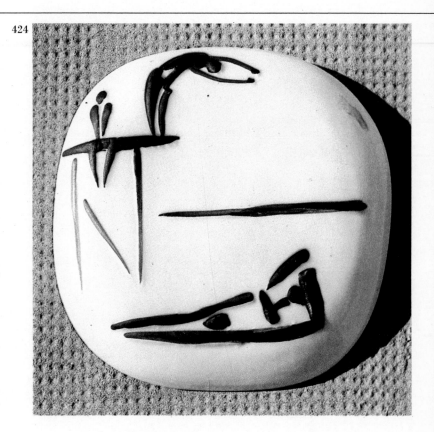

series of Spanish plates the hallucinatory faces of owls, ferocious fish with their air of dragons and a long bull-fighting sequence flourishing all the emblems and trophies of honour and offence.

If it were possible, or licit, to formulate a tendency, one would be inclined to claim that in the whole of his *oeuvre*, so lavish in universal gifts, it is here that we find the most characteristic signs of Picasso's vigorous expressiveness.

Apart from those great rhythms that constitute the general order of the plates, there are other subjects that obviously follow the same cycle of evolution, subjects with multiple and quite different forms and processes, which do not form one of those complete or continuous thematic programmes that are sometimes the consequence of a particular event creating circumstances favourable to art. This diversity, under all its ever-changing aspects, constantly maintains our interest in the wealth of invention itself and in no way excludes either the mastery evident in the work or the variety of its media.

But now our attention is drawn to another sphere of art, though one equally rich in curious innovation; for now we leave flat surfaces for a while and enter the third dimension, the world of volume. This world, however, is not yet quite that of sculpture. For before lyric sculpture there are also volume/image and volume/function. And Picasso now chose the image/function. Raiding the drying-boards and carrying off any of the waiting pieces —pots, pitchers or vases intended for everyday use— he found pretexts in their forms for transposing them into all kinds of unexpected imagery.

Painting the attributes of the substitutes on the flanks of the original form, he gave the latter a totally different definition and transformed its significance.

425. Small convex wall plaque. Profile of Jacqueline on a light ground in
white earthenware. Diameter 18.5 cm. Dated 1956, original print,
edition.

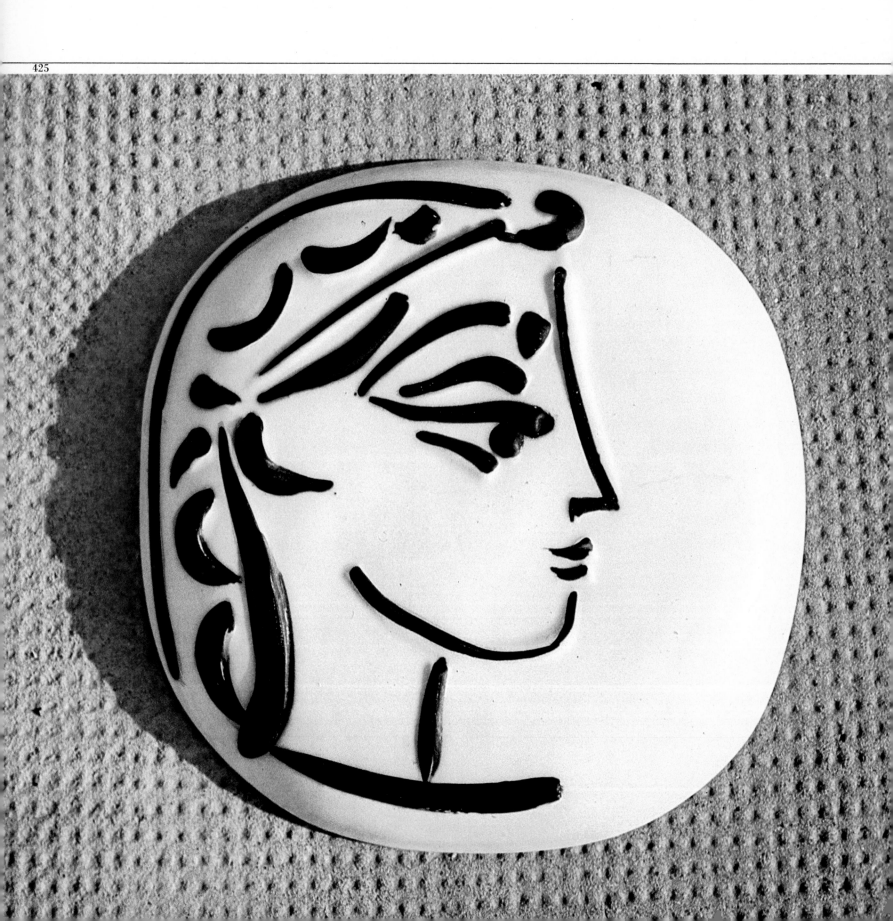

425

426. Convex wall plaque. Two dancers on a light ground in white earthenware. Diameter 18.5 cm. Dated 1956, original print, edition.

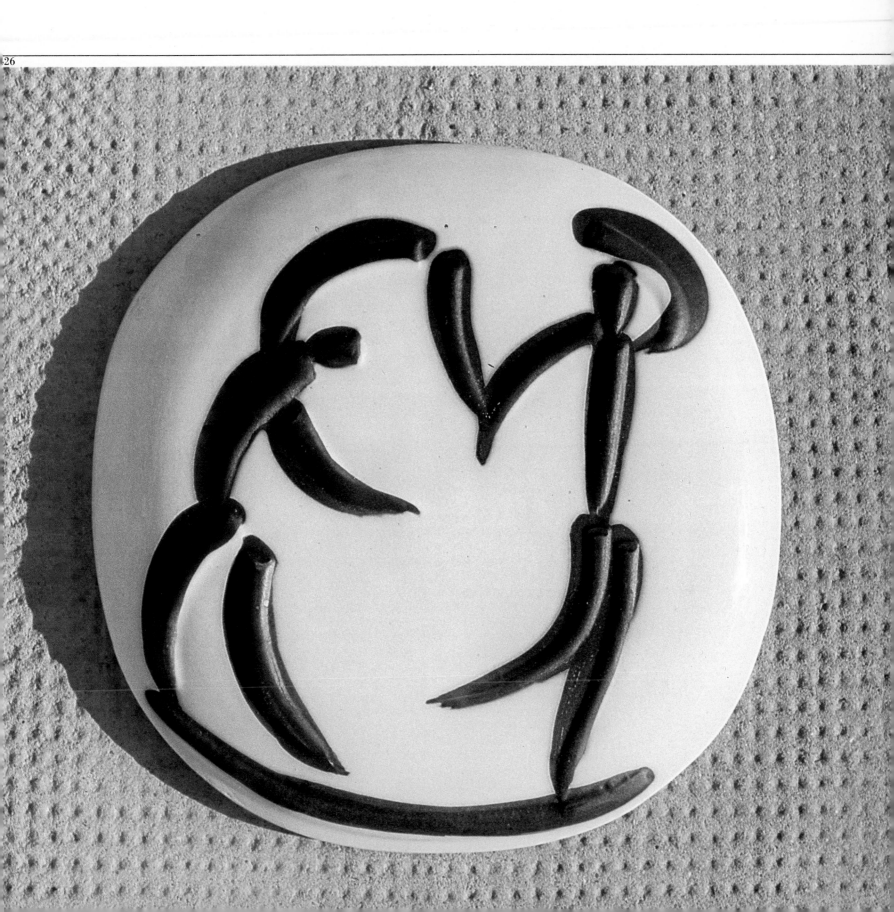

26

427. Large round plate in colour. Face with leaves in white earthenware. Diameter 42 cm. Dated 1956, original print, edition.

428. Large round plate in colour. Face framed in a square in white earthenware. Diameter 42 cm. Dated 1956, original print, edition.

429. Large round plate in colour. Tortured faun's face in white earthenware. Diameter 42 cm. Dated 1956, original print, edition.

430. Large chequered vase. Other side of No. 422.

431. Large Peking-type vase. White earthenware. Height 38 cm., diameter at top 10 cm., diameter at bulge 45 cm. Dated 1956, original print, edition.

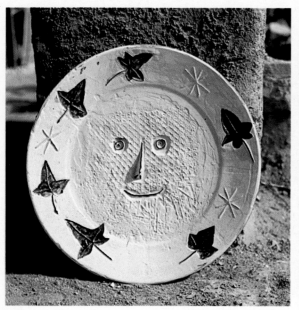

427

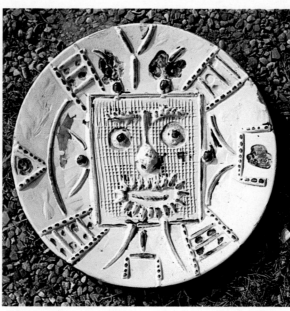

428

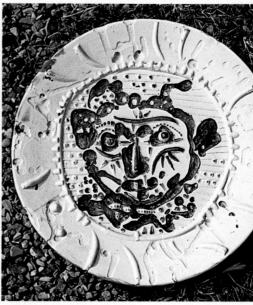

429

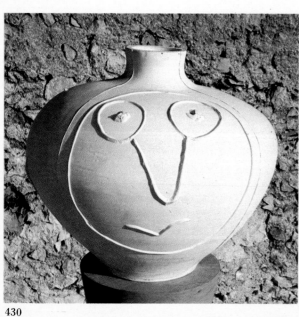

430

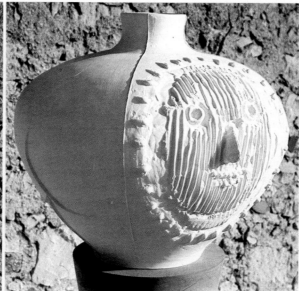

431

432. Another view of No. 431 (main face).

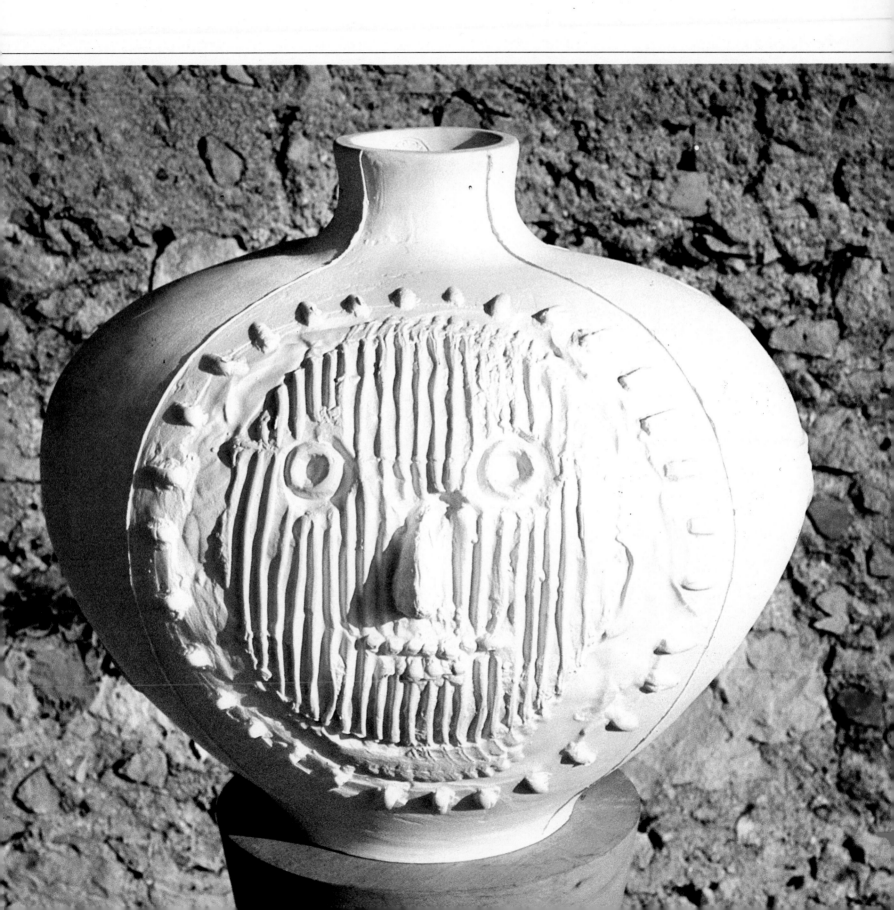

182

433. Tile on base. Bearded man's head. 38×39.5 cm. Dated 1956.

434. Tile on base. Bearded man's head (reverse of No. 433). 38×39.5 cm. Dated 1956.

435. Tile on base. Bearded face. 22×33.5 cm. Dated 1956.

436. Tile on base. Black owl with round body (other side of No. 437). 37.5× 39 cm. Dated 1956.

437. Tile on base. Black owl with round body. 37.5×39 cm. Dated 1956.

438. Tile on base. Bearded face (other side of No. 435). 22×33.5 cm. Dated 1956.

439. Tile on base. Varnished owl (other side of No. 440). 38×39 cm. Dated 1956.

440. Tile on base. Varnished owl. 38×39 cm. Dated 1956.

441. Tile. Adult and child on the seashore. 20×35.5 cm. Dated 20-2-57.

433
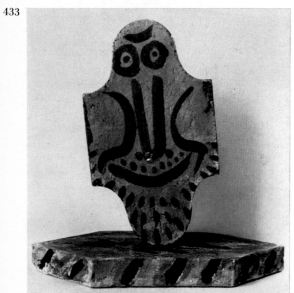

436
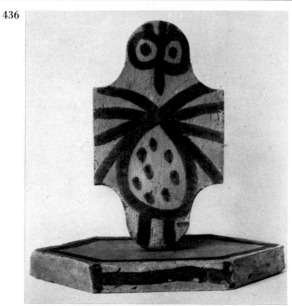

439
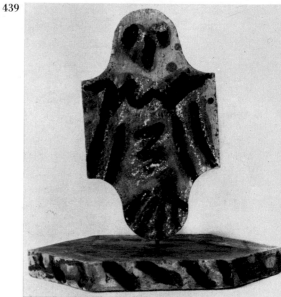

434
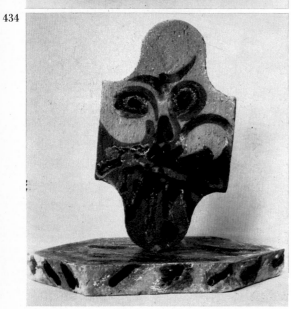

437
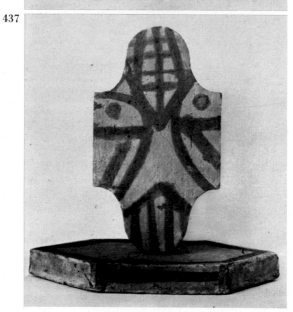

440
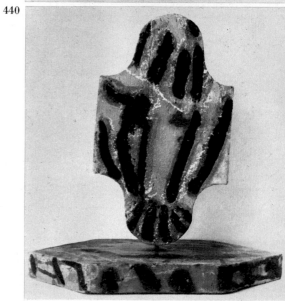

435
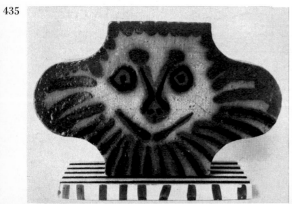

438
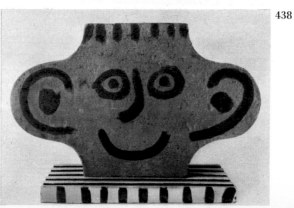

441
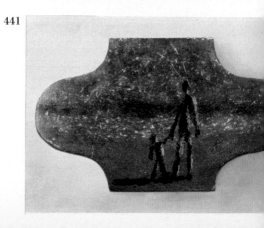

442. Tile on base. Black owl on earth ground. 38 × 39 cm. Dated 1956.

443. Tile on base. Black owl on earth ground (other side of No. 442). 38 × 39 cm. Dated 1956.

444. Tile. Bull. 20.5 × 34 cm. Dated 20-2-57.

445. Tile. Dark varnished owl (other side of No. 446). 38 × 39.5 cm. Dated 1956.

446. Tile. Dark varnished owl. 38 × 39.5 cm. Dated 1956.

447. Tile. Three figures (other side of No. 450). 20.5 × 34 cm. Dated 2-3-57.

448. Tile on base. Man's head, unvarnished (other side of No. 449). 36 × 39.5 cm. Dated 1956.

449. Tile on base. Man's head, unvarnished. 38 × 39.5 cm. Dated 1956.

450. Tile. Three figures. 20.5 × 34 cm. Dated 2-3-57.

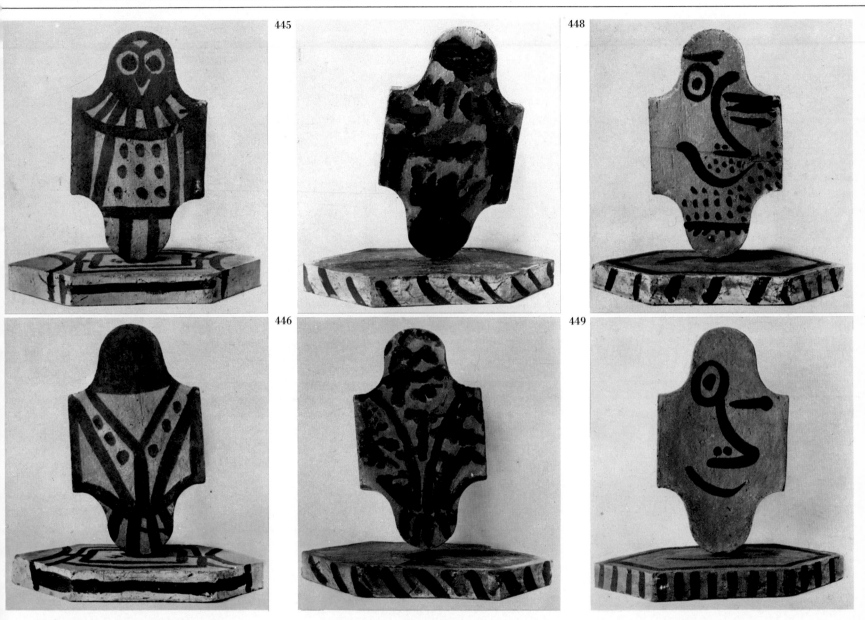

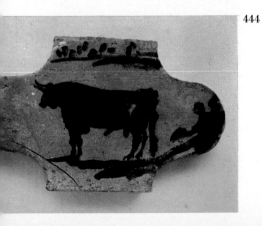

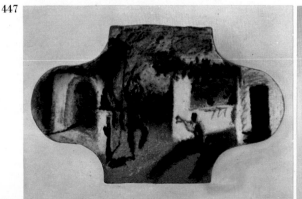

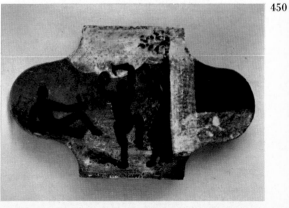

451. Tile with carving. Bearded man's head. 39×20 cm. Dated 1956.
452. Tile. Figure walking. 20×34 cm. Dated 20-2-57.
453. Sculpture. Hispano-Moresque owl. Height 34 cm. Dated 1956.

454. Tile. Musicians. 20×35.5 cm. Dated 26-2-57.
455. Tile. Musicians (other side of No. 454). 20×35.5 cm. Dated 26-2-57.
456. Tile. Three figures. 20×39.5 cm. Dated 6-3-57 - V.

451
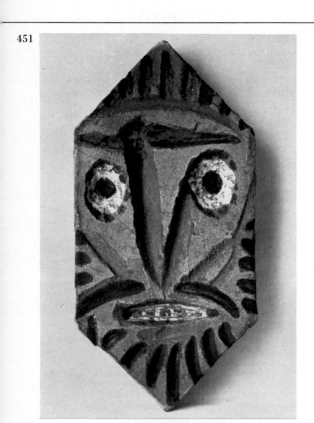

454
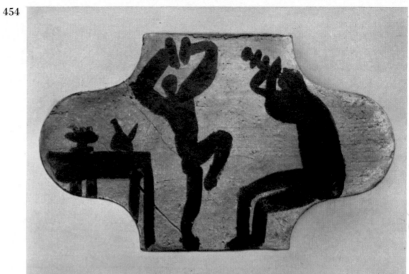

452
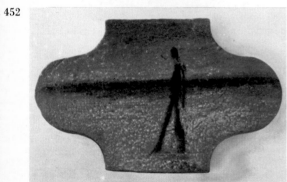

455
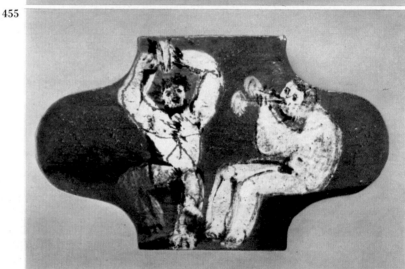

453
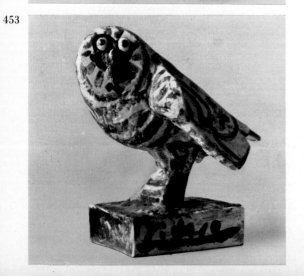

456
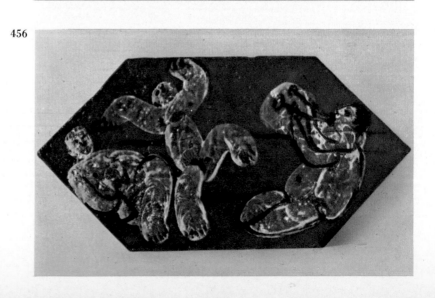

457. Tile. Double-faced owl. 35 × 20 cm. Dated 15-3-57.
458. Tile. Two figures. 20 × 39.5 cm. Dated 6-3-57 - II.
459. Tile. Four figures. 20 × 39.5 cm. Dated 6-3-57 - VI.
460. Tile. Double-faced owl (other side of No. 457). 35 × 20 cm. Dated 15-3-57.

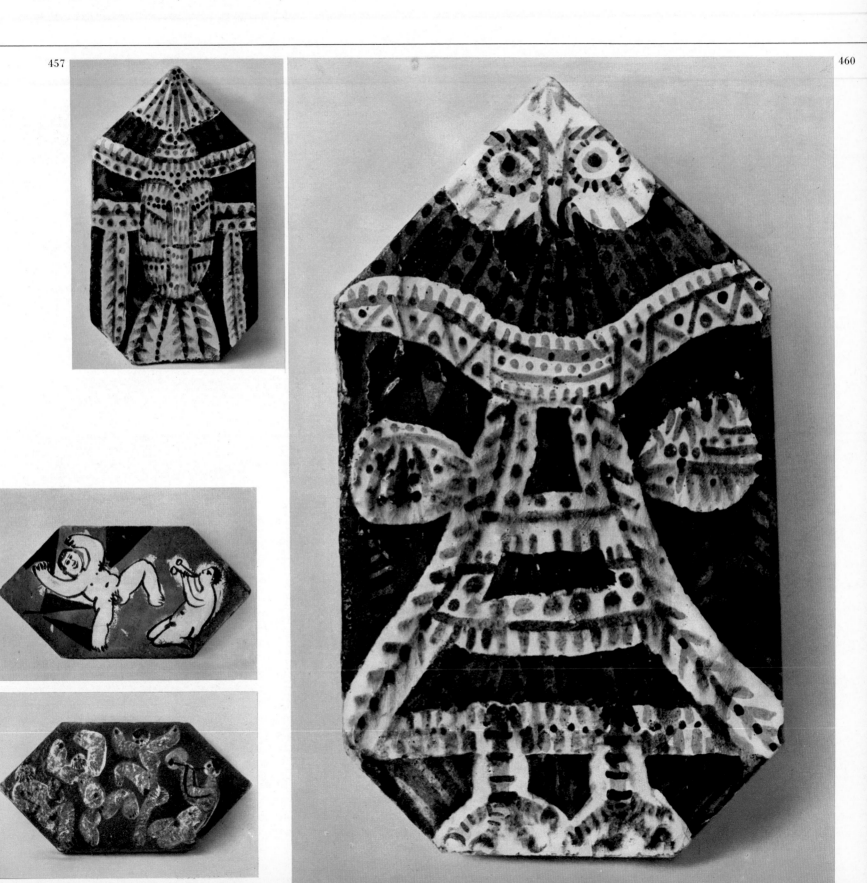

461. Hexagonal tile. Faun's head. 16.5 × 15 cm. Dated 1957.
462. Hexagonal tile. Bull. 15 × 16.5 cm. Dated 18-2-57.
463. Hexagonal tile. Dance. 14.5 × 14.5 cm. Dated 5-3-57.
464. Tile. Owl (triangular body) in black and white on earth ground. 34 × 20 cm. Dated 1956.

465. Tile. Owl (triangular body) in black and white on earth ground (other side of No. 464). 34 × 20 cm. Dated 1956.
466. Tile. Owl (round body) in black and white on earth ground. 33 × 20 cm. Dated 1956.
467. Tile. Owl (round body) in black and white on earth ground (other side of No. 466). 33 × 20 cm. Dated 1956.

461
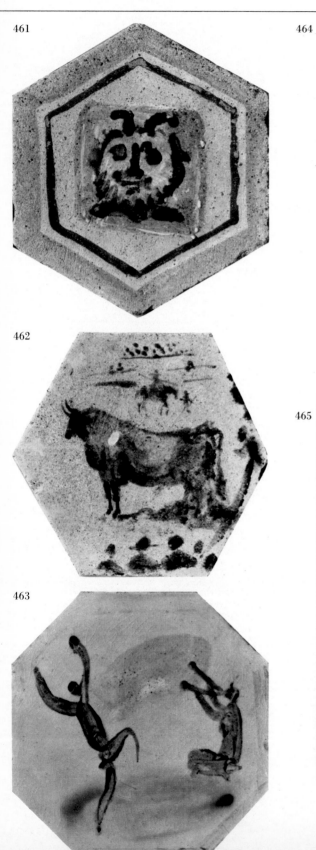

462

463

464
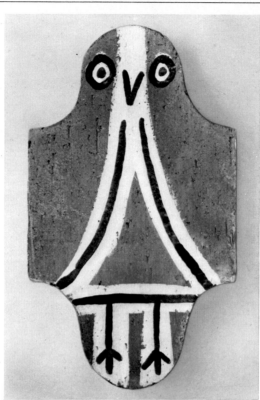

465

466
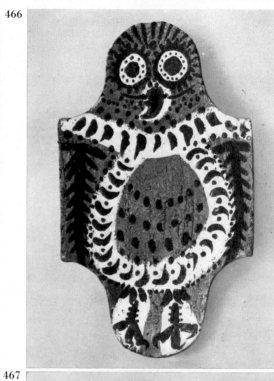

467

468. Lamp-shade. Parrot. Height 36.4 cm. Dated 1960.
469. Tile. Owl in black and white on earth ground (other side of No. 470). 34 × 20.5 cm. Dated 1957.
470. Tile. Owl in black and white on earth ground. 34 × 20.5 cm. Dated 1957.

470

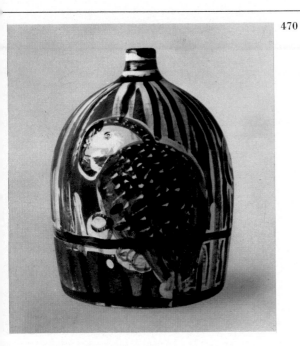

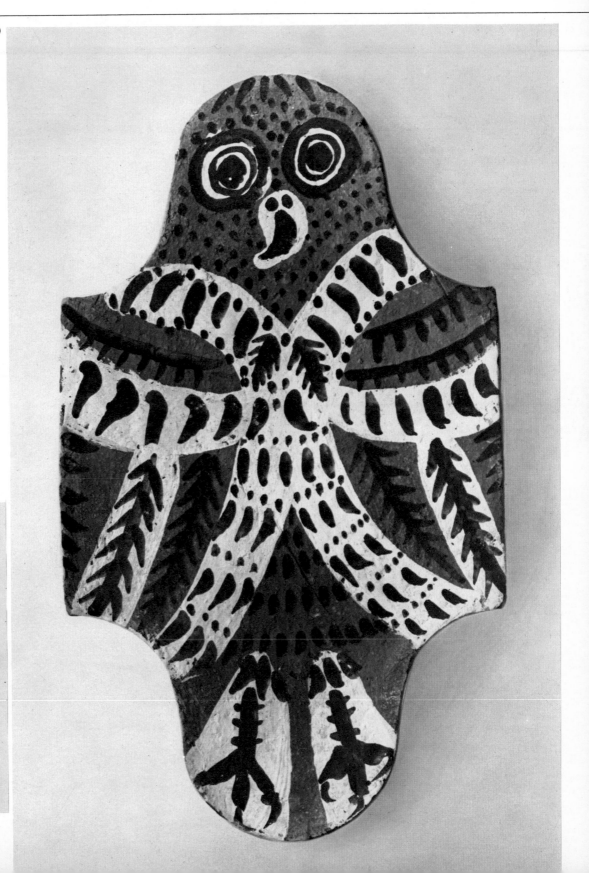

469

471. Plaque. Bacchic scene. 25.5×30.5 cm. Dated 9-3-57.
472. Plaque. Other side of No. 473. 25.5×30.5 cm. Dated 8-3-57.
473. Plaque. Player, dancer and drinker. 25.5×30.5 cm. Dated 8-3-57.
474. Plaque. Other side of No. 471. 25.5×30.5 cm. Dated 9-3-57.

475. Plaque. Player, dancer and drinker. 25.5×30.5 cm. Dated 7-3-57.
476. Plaque. Other side of No. 475. 25.5×30.5 cm. Dated 30-3-57.

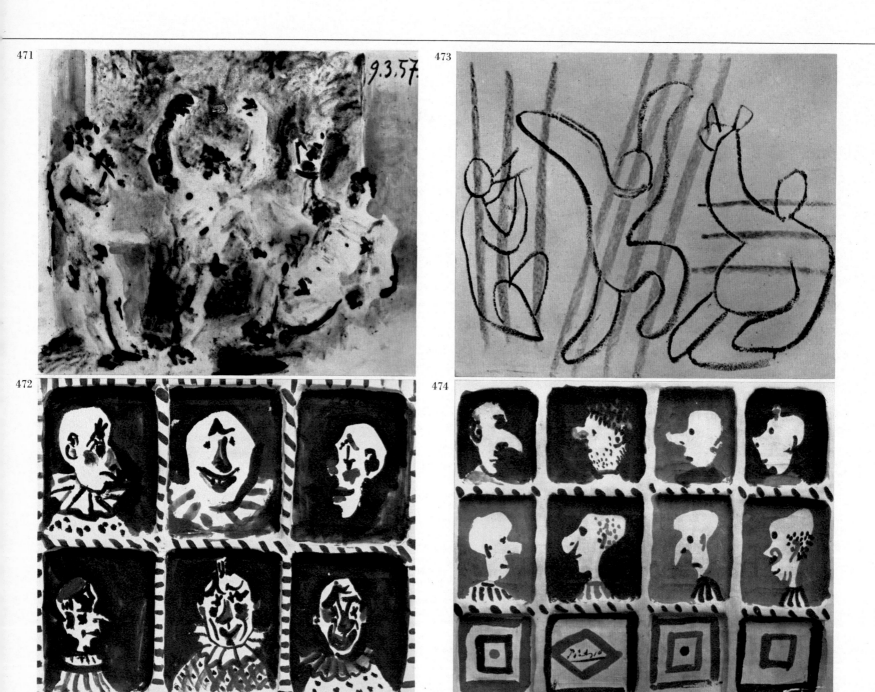

477. Plaque. Player, dancer and drinker. 25.5×30.5 cm. Dated 11-3-57.

478. Plaque. Player, dancer and drinker. 25.5×30.5 cm. Dated 8-3-57.

479. Green, blue and pink plaque. Other side of No. 478. 25.5×30.5 cm. Dated 8-3-57.

480. Plaque. Player, dancer and drinker. 25.5×30.5 cm. Dated 11-3-57.

481. Plaque. Player, dancer and drinker. 25.5×30.5 cm. Dated 7-3-57.

482. Plaque. Other side of No. 481. 25.5×30.5 cm. Dated 7-3-57.

483. Plaque. Player, dancer and drinker. 25.5×30.5 cm. Dated 11-3-57.

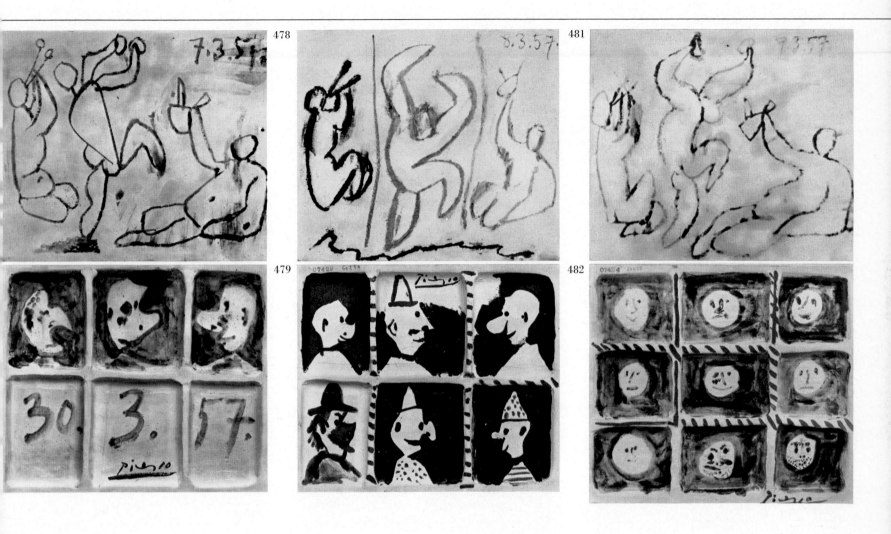

478

481

479

482

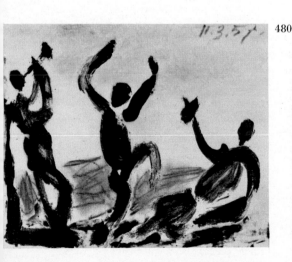

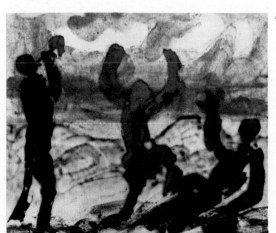

480

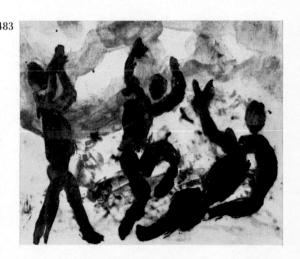

483

484. Plaque. Drinker, dancer and player. 25.5 × 30.5 cm. Dated 7 and 30-3-57.
485. Plaque. Other side of No. 484. 25.5 × 30.5 cm. Dated 7 and 30-3-57.
486. Plaque. *The Drinkers*. 30.5 × 25.5 cm. Dated 11-1-57 and 10-2-57.
487. Plaque. Bouquet of flowers. 30.5 × 25.5 cm. Dated 5-3-57.

488. Plaque. Other side of No. 487. 30.5 × 25.5 cm. Dated 5-3-57.
489. Tile. Man's bust. 20 × 20 cm. Dated 10-3-57.
490. Plaque. Man's head. 30.5 × 25.5 cm. Dated 11-3-57.
491. Plaque. Two characters. 25.5 × 30.5 cm. Dated 9-3-57.

484
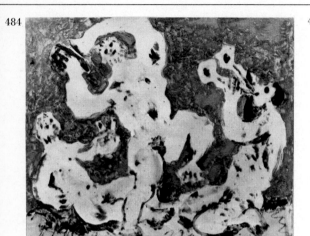

485
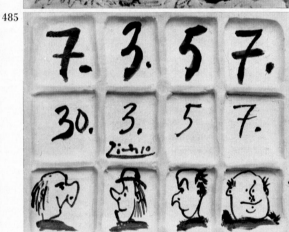

486
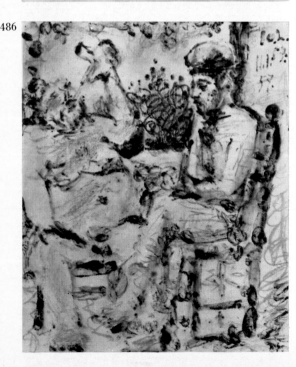

487
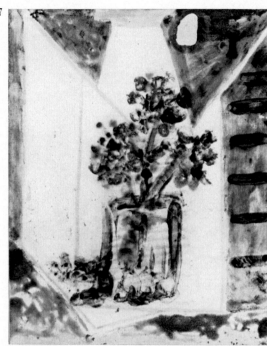

488
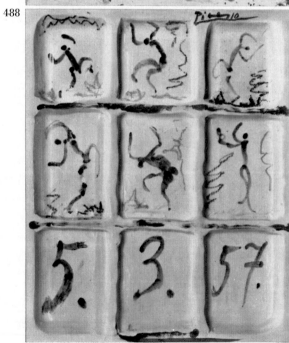

489
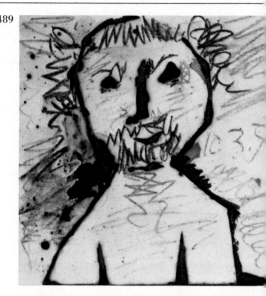

490
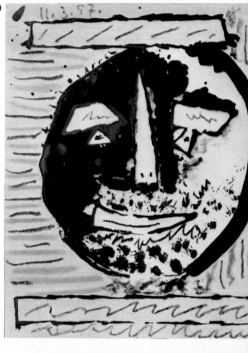

491
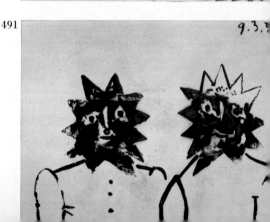

492. Assembled tiles. Drinkers in an arbour. 61×61 cm. Dated 1957.

493. Plaque. Piper. 25×25 cm. Dated 25-5-61.

494. Plaque. Dancer with ass. 25×25 cm. Dated 27-2-61.

495. Plaque. Ass braying. 25×25 cm. Dated 27-2-61.

496. Plaque. Faun with ass. 25.5×25.5 cm. Dated 27-2-61, Museum für Kunst und Gewerbe, Hamburg.

497. Plaque. Musician with ass. 25.5×25.5 cm. Dated 25-2-61, Museum für Kunst und Gewerbe, Hamburg.

498. Plaque. Musician with ass. 25.5×25.5 cm. Dated 25-2-61, Museum für Kunst und Gewerbe, Hamburg.

492 493

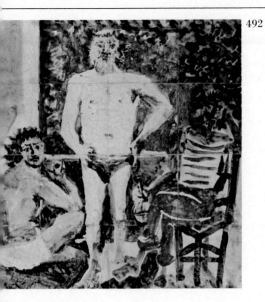
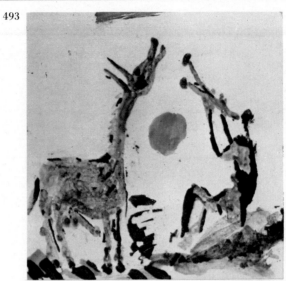

496

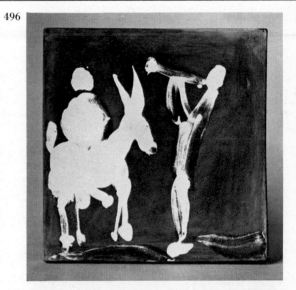

494

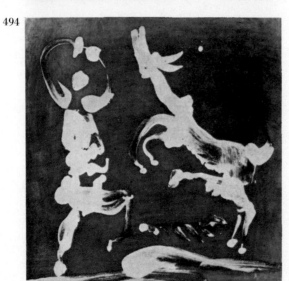

497

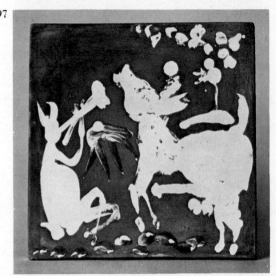

495

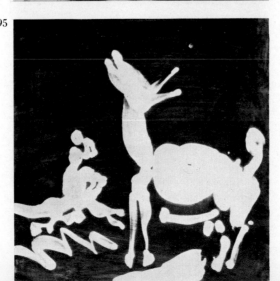

498

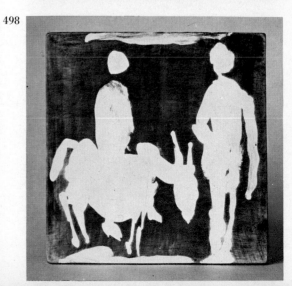

499. Round plate. Owl on the ground. Diameter 44 cm. Dated 27-3-57.

500. Round plate. Black owl roosting (with owl on the reverse). Diameter 42.5 cm. Dated 7-5-57.

501. Plaque. Other side of No. 503. 25.5 × 25.5 cm. Dated 9-3-57.

502. Plaque. Dance. 23.5 × 15 cm. Dated 1957.

499

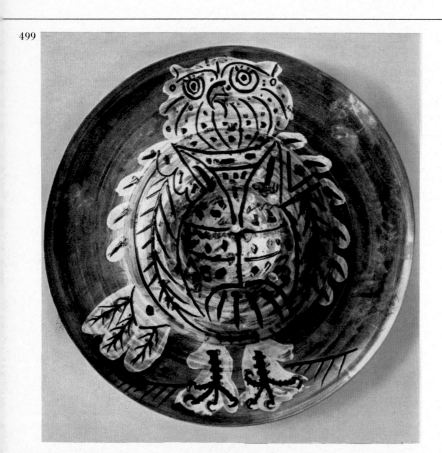

501

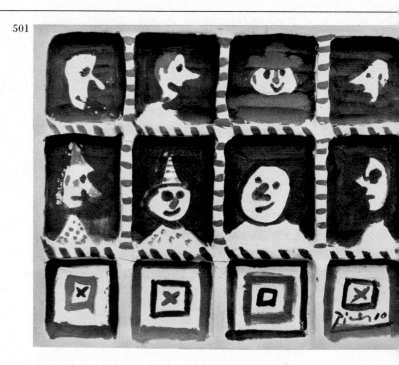

500

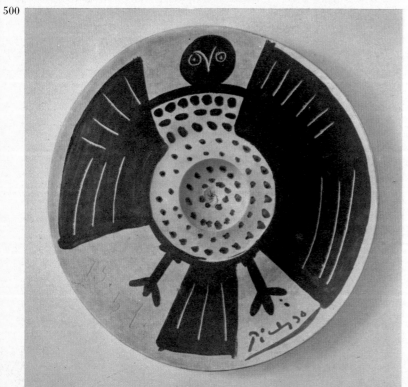

502

503. Plaque. Player, dancer and drinker against a green, blue and mauve
 sky. 25.5 × 25.5 cm. Dated 9-3-57.

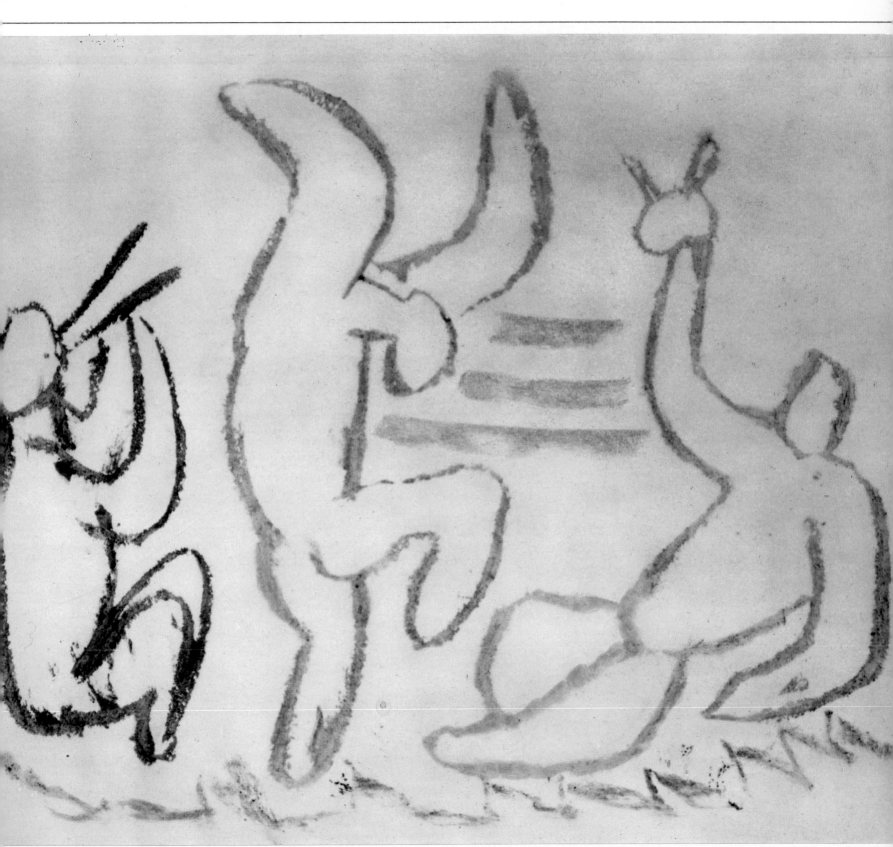

504. Round plate. Owl on blue ground. Diameter 43.5 cm. Dated 26-3-57.

505. Round plate. Reverse of No. 507, with bull-fight scene. Diameter 42.5 cm. Dated 26-3-57.

506. Round plate. Owl on blue ground. Diameter 45 cm. Dated 27-3-57.

507. Round plate. White owl on blue ground. Diameter 42.5 cm. Dated 26-3-57.

508. Round plate. Owl on blue ground (reverse of No. 504). Diameter 43.5 cm. Dated 26-3-57.

509. Round plate. White and brown owl. Diameter 44.5 cm. Dated 10-3-57.

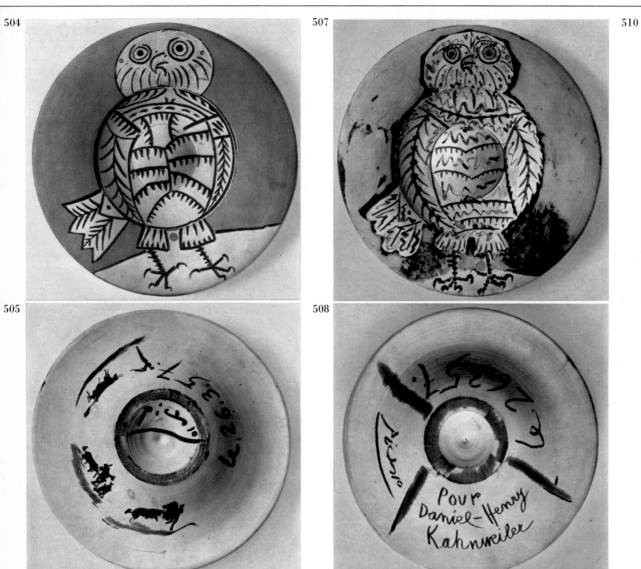

504

507

510

505

508

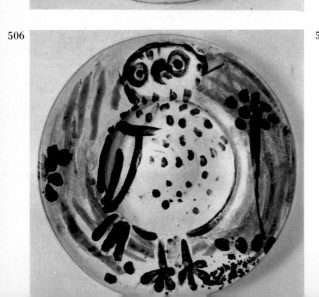

506

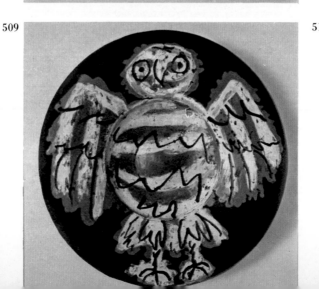

509

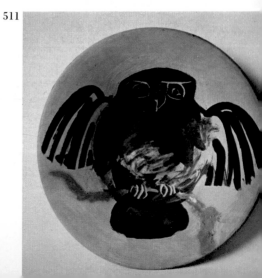

511

510. Round plate. Faun with owl, in relief (reverse of No. 512). Diameter 41.5 cm. Dated 28-4-57.

511. Round plate. Owl. Diameter 44 cm. Dated 10-5-57. Museum für Kunst und Gewerbe, Hamburg.

512. Round plate. Faun with owl, in relief. Diameter 41.5 cm. Dated 28-4-57.

512

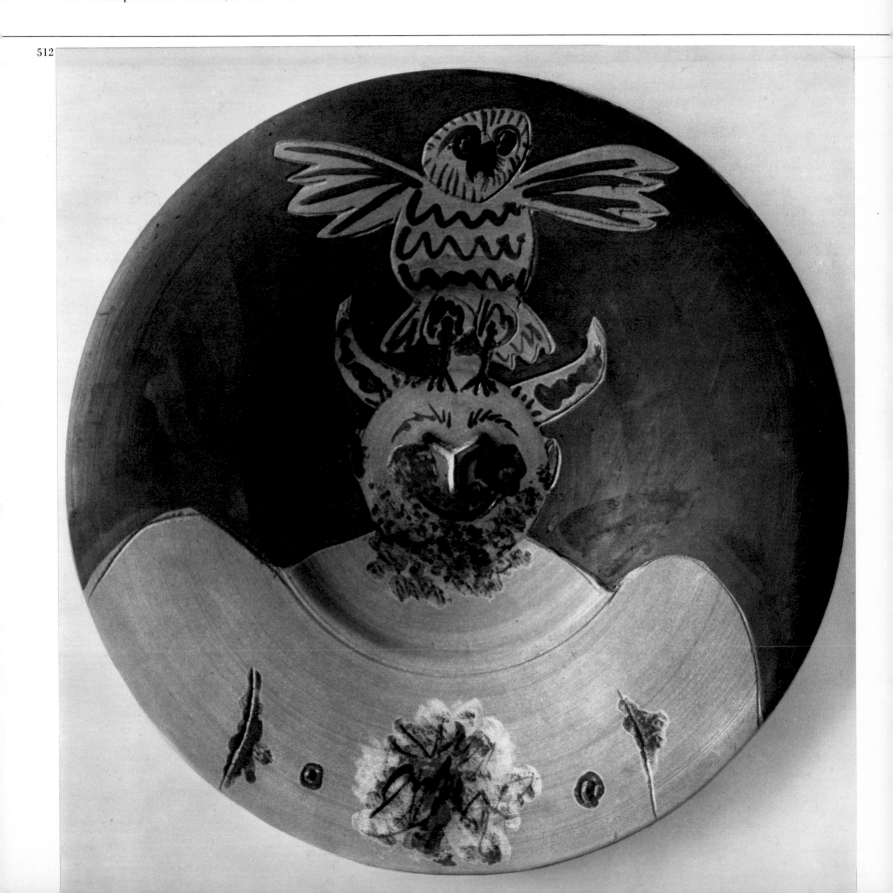

513. Round plate. Black owl roosting (other side of No. 515). Diameter
42.5 cm. Dated 7-5-57.

513

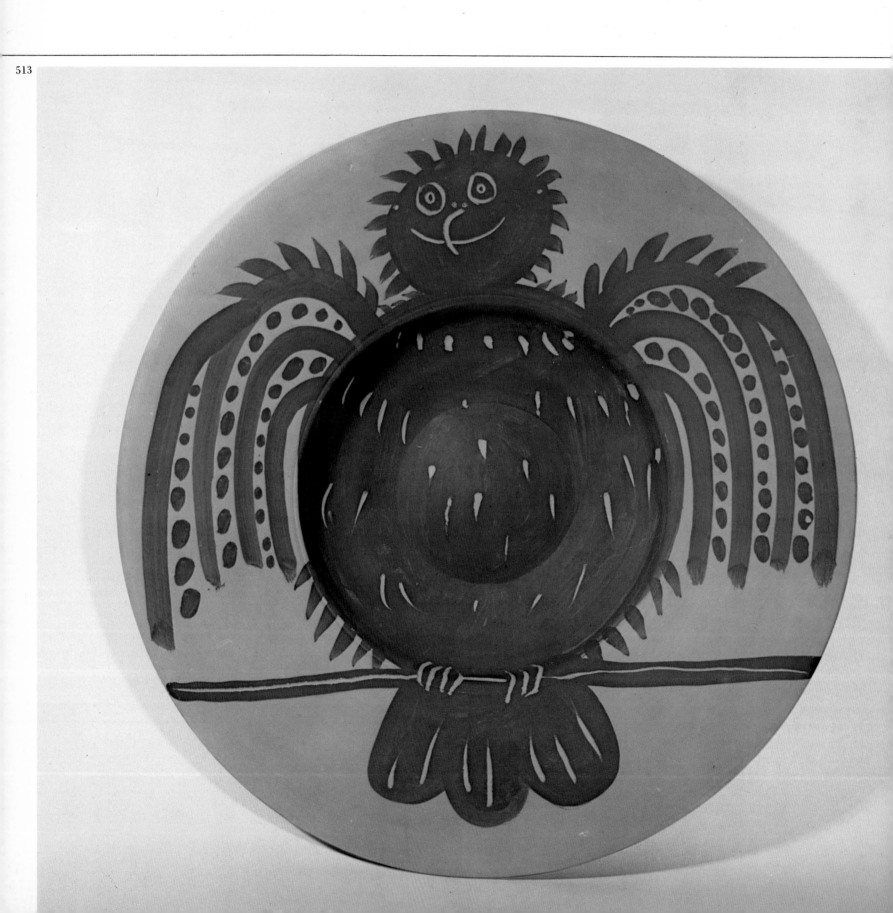

514. Round plate. Red owl on black ground. Diameter 45 cm. Dated 10-5-57.

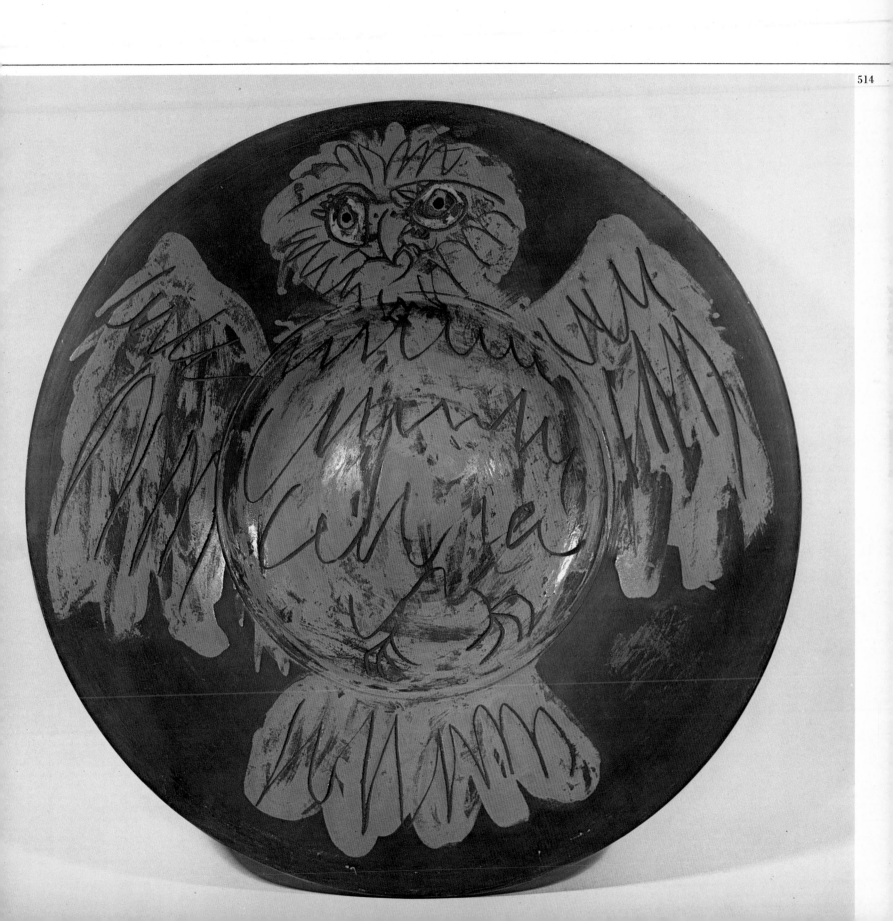

515. Round plate. Black owl roosting. Diameter 42.5 cm. Dated 7-5-57.

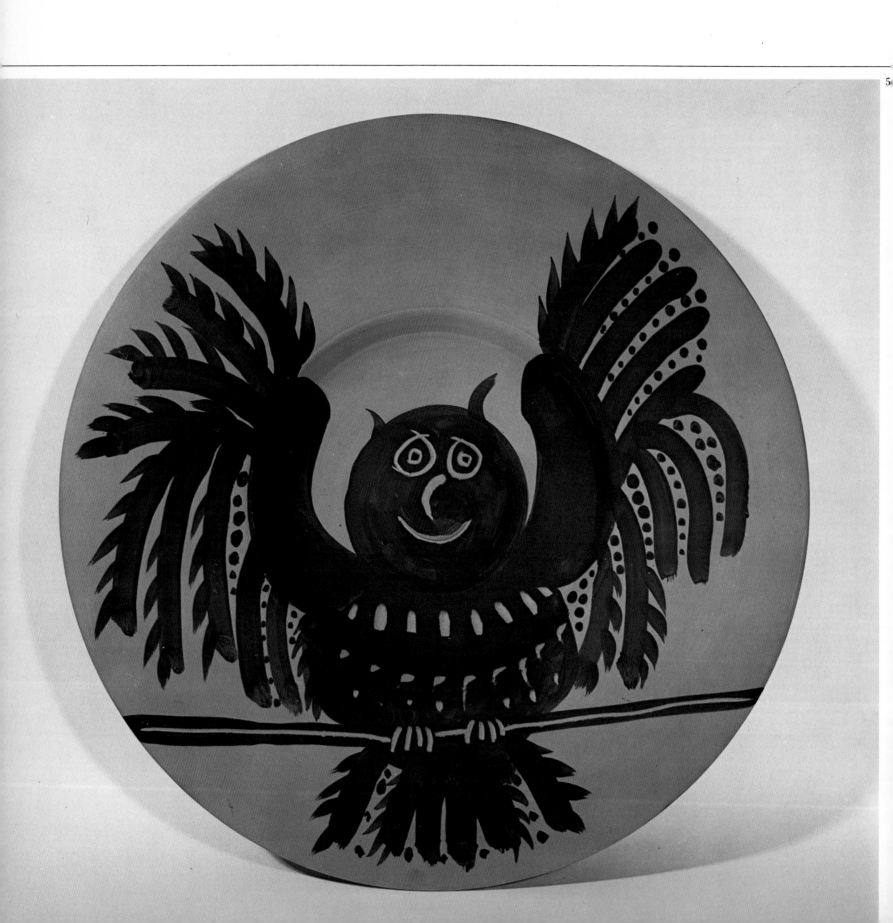

516. Reverse of No. 49 ('Bird and flowers').

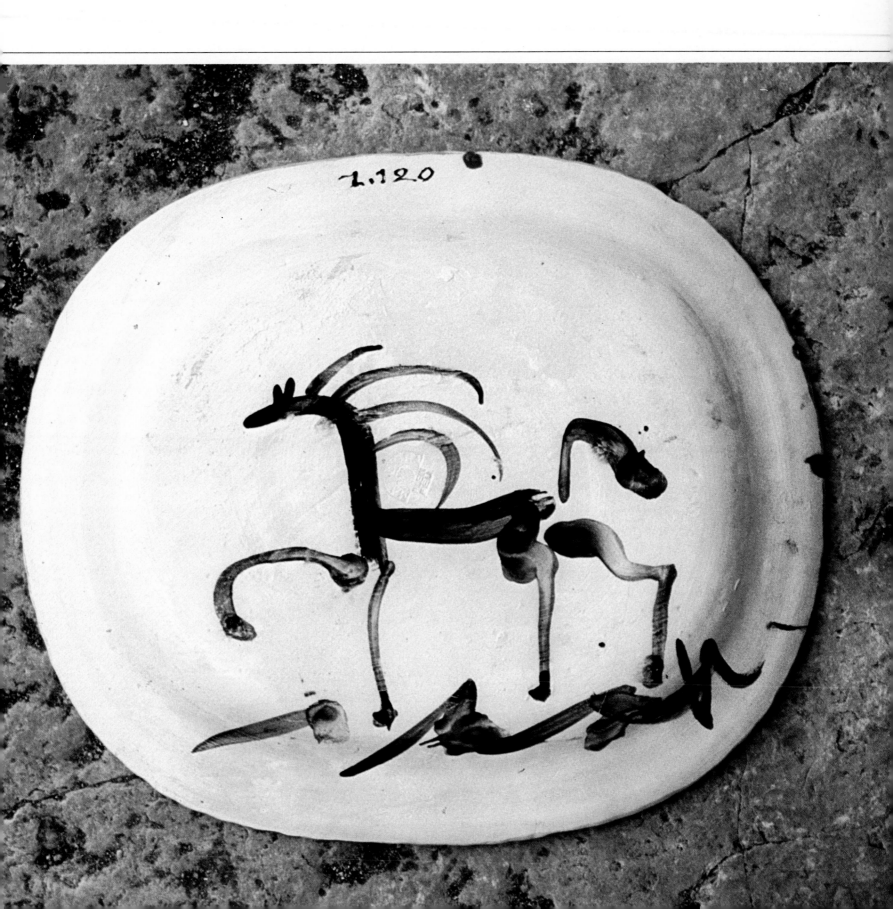

517. Round plate. White owl on earth ground. Diameter 43.5 cm. Dated
25-3-57.

517

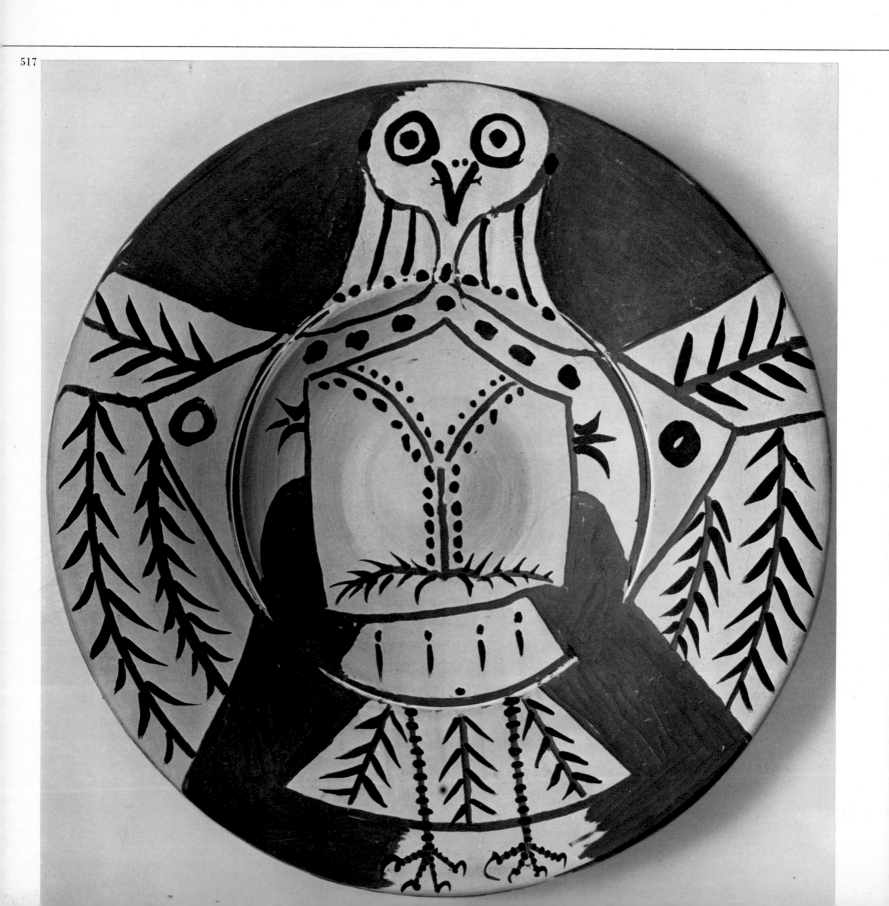

518. Round plate. White owl on earth ground (reverse of No. 517). Diameter 43.5 cm. Dated 25-3-57.

519. Round plate. Animal. Diameter 45 cm. Dated 23-3-57.

520. Round plate. Animal (reverse of No. 519). Diameter 45 cm. Dated 23-3-57.

521. Round plate. Bull. Diameter 23.5 cm. Dated 22-1-57.

522. Round plate. Lance-thrust. Diameter 23.5 cm. Dated 22-1-57.

523. Round plate. Bull. Diameter 23 cm. Dated 22-1-57.

524. Round plate. Lance-thrust. Diameter 23 cm. Dated 22-1-57.

525. Plate. *Pase de cabeza.* 66×28.5 cm. Dated 18-6-57, Museum für Kunst und Gewerbe, Hamburg.

518
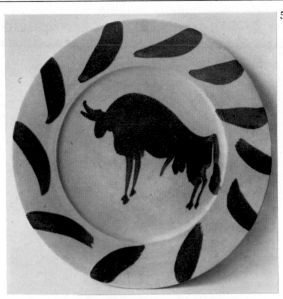
521
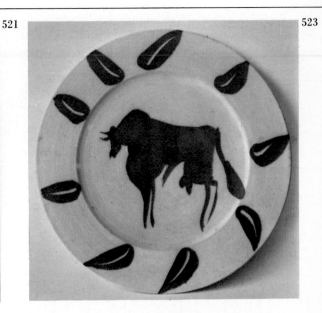
523
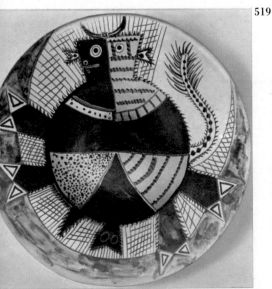
519
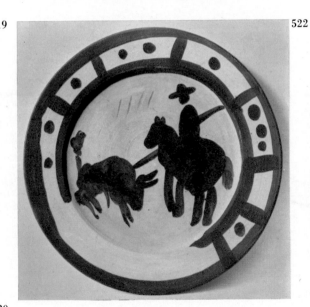
522
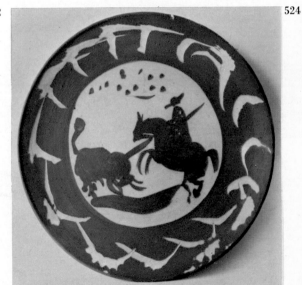
524
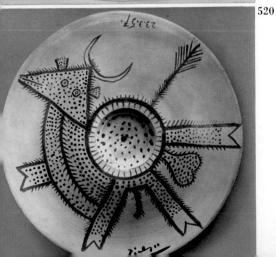
520
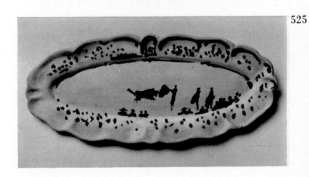
525

526. Round plate. Dead bullfighter. Diameter 23 cm. Dated 22-1-57.
527. Plate. Bullfighters entering the ring. 65.5 × 28.5 cm. Dated 24-6-57.
528. Round plate. Bull. Diameter 40 cm. Dated 22-1-57.

To a certain extent he was repeating here the method used by the unknown artist of Lascaux when he included the protuberances of the walls of his cave in drawing the rumps of his bisons. The same principle can be applied in using the arrangement of the volumes of an object, conceived in a given state, in order to vary their definition. A big, flat, potbellied pitcher with a curving handle, for instance, if we paint in perspective on its sides, can be made to represent a magnificent bull, detailed on all of its planes. A vase with slender flanks on a rounded base can be used to evoke the figure of a woman whose waist will be that of the vase itself. A round pitcher with a flat handle becomes a woman's face, the handle being made to represent her plaited hair. A round-bellied jug will be the head of some swaggering *arriviste*, his fleshy jowls identified with the belly of the jug itself.

This way of adapting and re-shaping things by means of a mischievous subterfuge of appearances is something very much in Picasso's line; it is not a question of a sterile, automatic system, but rather a particular way of seeing the universe afresh and deflecting its perceptible progress in accordance with the artist's own fantasy.

When I think of all the boredom the world of the future will suffer from the excesses of mechanization, I must confess how happy I feel to have a magician of such genius near me who can contribute some spiritual quality to a part of living that we shall inevitably be deprived of by dry-as-dust reason and cold calculations.

This image/function series soon broadened out considerably; beginning as an exceptionally vigorous sort of amusement, it impressed everybody with its liveliness and individuality, to such an extent that very soon the object itself was hardly noticeable at all, supplanted by its own

526
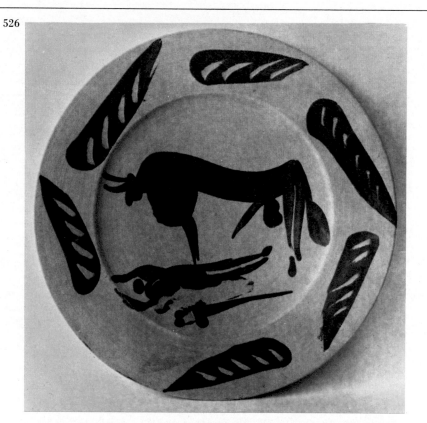

527
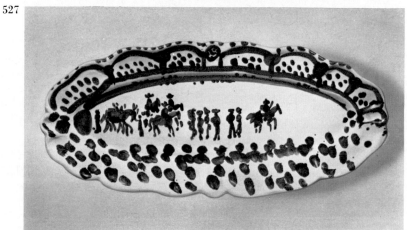

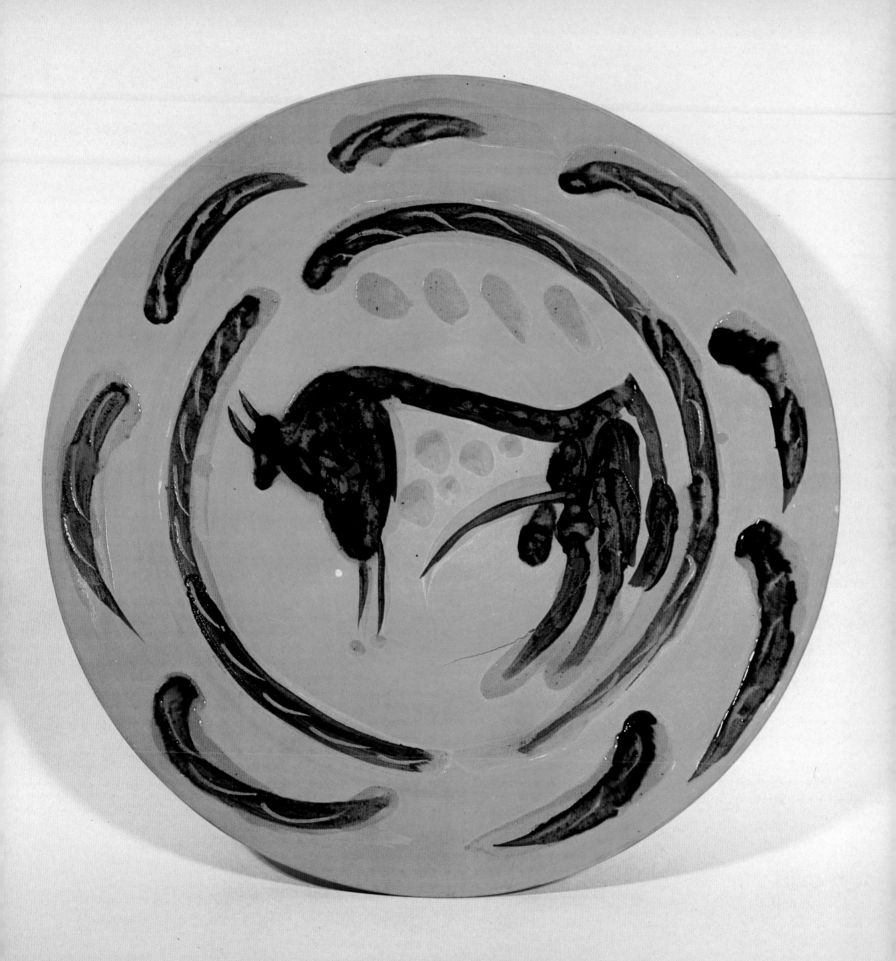

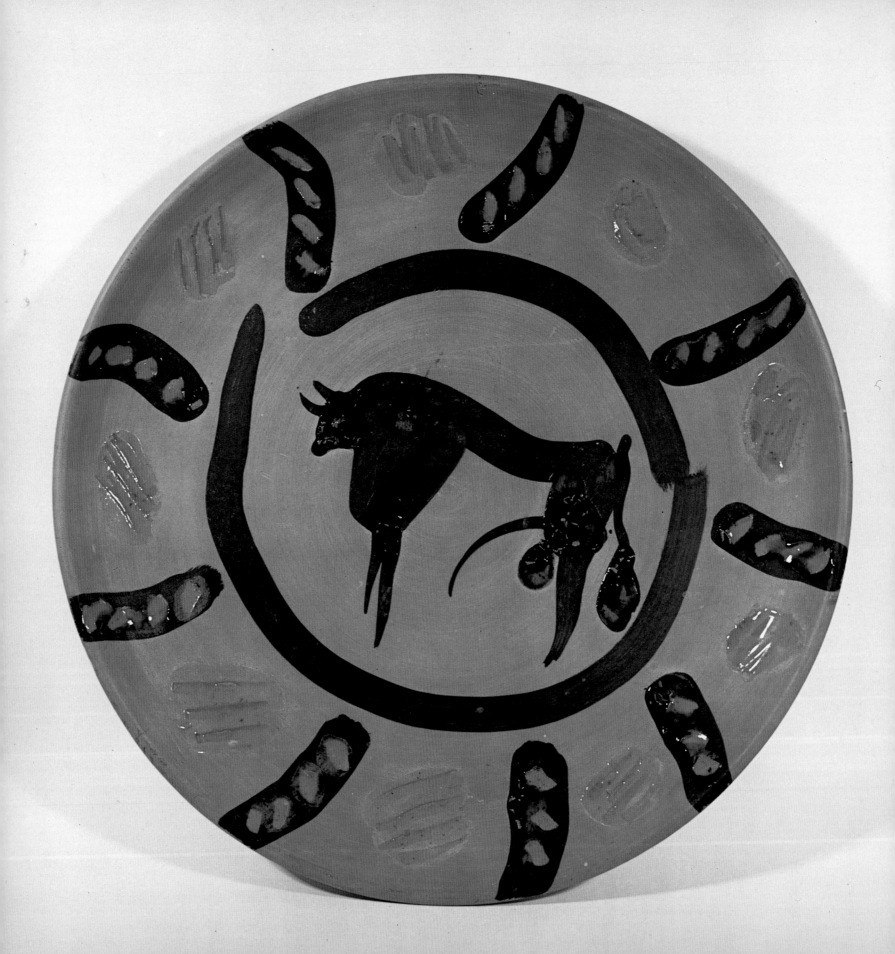

529. Round plate. Bull. Diameter 40 cm. Dated 22-1-57.

530. Round plate. Sailor. Diameter 45.5 cm. Dated 2-4-57.

531. Round plate. Reverse of No. 530. Diameter 45.5 cm. Dated 2-4-57.

532. Round plate. Fish in relief on black ground. Diameter 45 cm. Dated 12-4-57.

533. Round plate. Clown. Diameter 43 cm. Dated 31-3-57.

534. Round plate. Reverse of No. 533. Diameter 43 cm. Dated 31-3-57.

535. Round plate. Two fish. Diameter 42.5 cm. Dated 14-4-57.

536. Round plate. Clown. Diameter 43.5 cm. Dated 2-4-57.

537. Round plate. Reverse of No. 536. Diameter 43.5 cm. Dated 2-4-57.

538. Round plate. Tray with fruit. Diameter 42.5 cm. Dated 10-5-57.

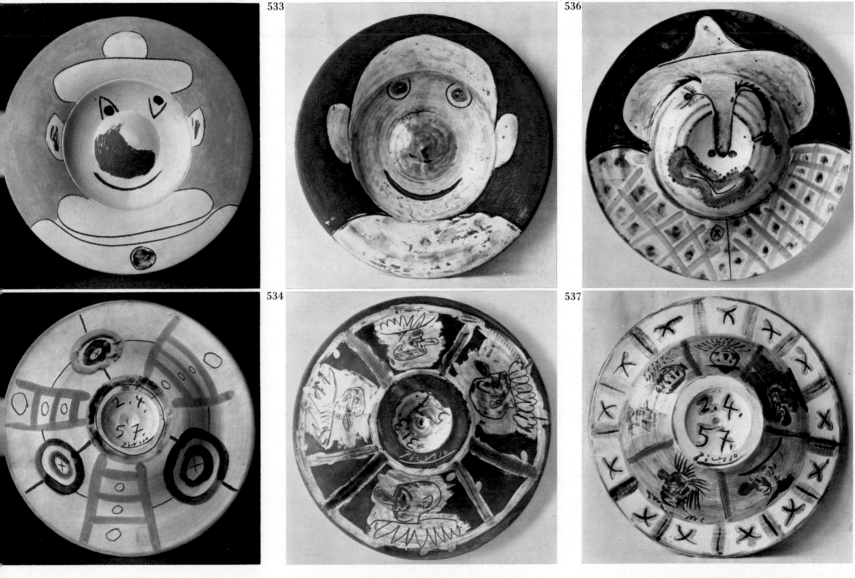

533

536

534

537

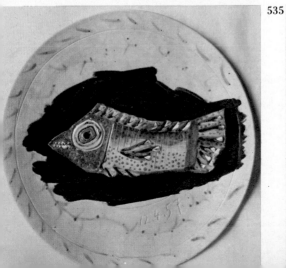

535

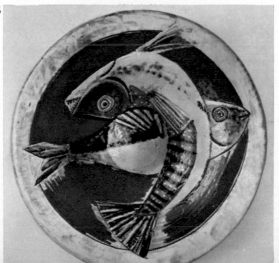

538

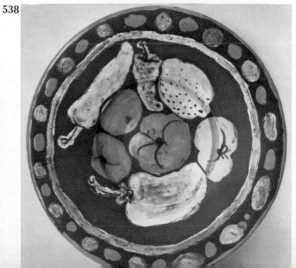

539. Round plate. Seven fish on earth ground. Diameter 44 cm. Dated 10-4-57.

540. Round plate. Reverse of No. 539. Diameter 44 cm. Dated 10-4-57.

541. Round plate. Two fish in relief on red ground. Diameter 43 cm. Dated 11-4-57.

542. Round plate. Reverse of No. 541. Diameter 43 cm. Dated 11-4-57.

543. Round plate. Three fish on grey ground. Diameter 43 cm. Dated 11-4-57.

544. Round plate. Reverse of No. 543. Diameter 43 cm. Dated 11-4-57.

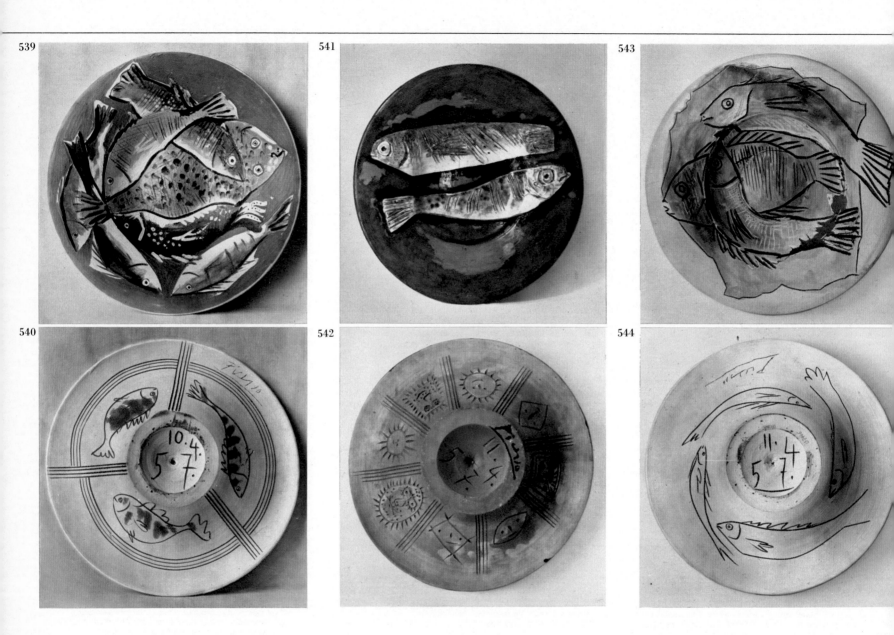

545. Plate. Fish on pink ground. Diameter 42 cm., depth 6.2 cm. Dated 16-5-57.

546. Round plate. Fish in relief on white ground. Diameter 44 cm. Dated 4-4-57.

547. Round plate. Large black fish. Diameter 42 cm. Dated 16-4-57.

548. Round plate. Reverse of No. 547. Diameter 42 cm. Dated 16-4-57.

549. Round plate. Three fish on white ground. Diameter 43 cm. Dated 13-4-57.

550. Round plate. Three fish. Diameter 44 cm. Dated 11-4-57, Museum für Kunst und Gewerbe, Hamburg.

551. Round plate. Three black fish. Diameter 43 cm. Dated 15-4-57.

552. Round plate. Three fish in black and blue. Diameter 41 cm. Dated 15-4-57.

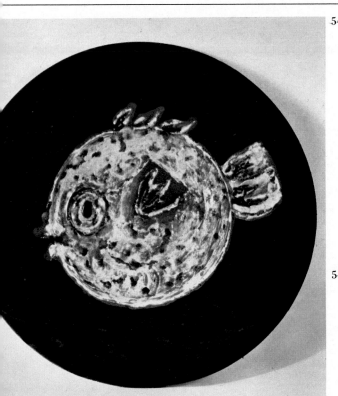

547

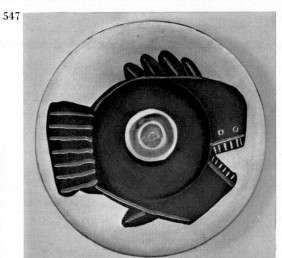

549

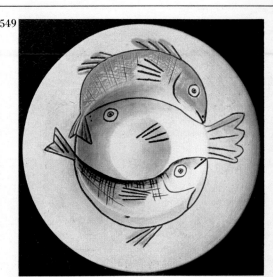

548

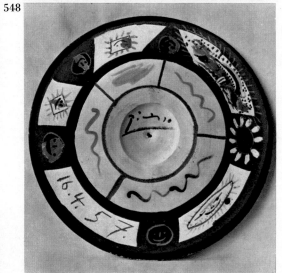

550

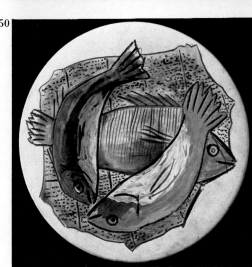

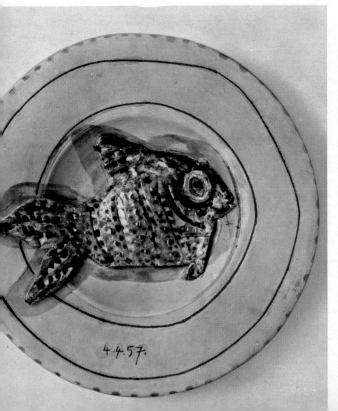

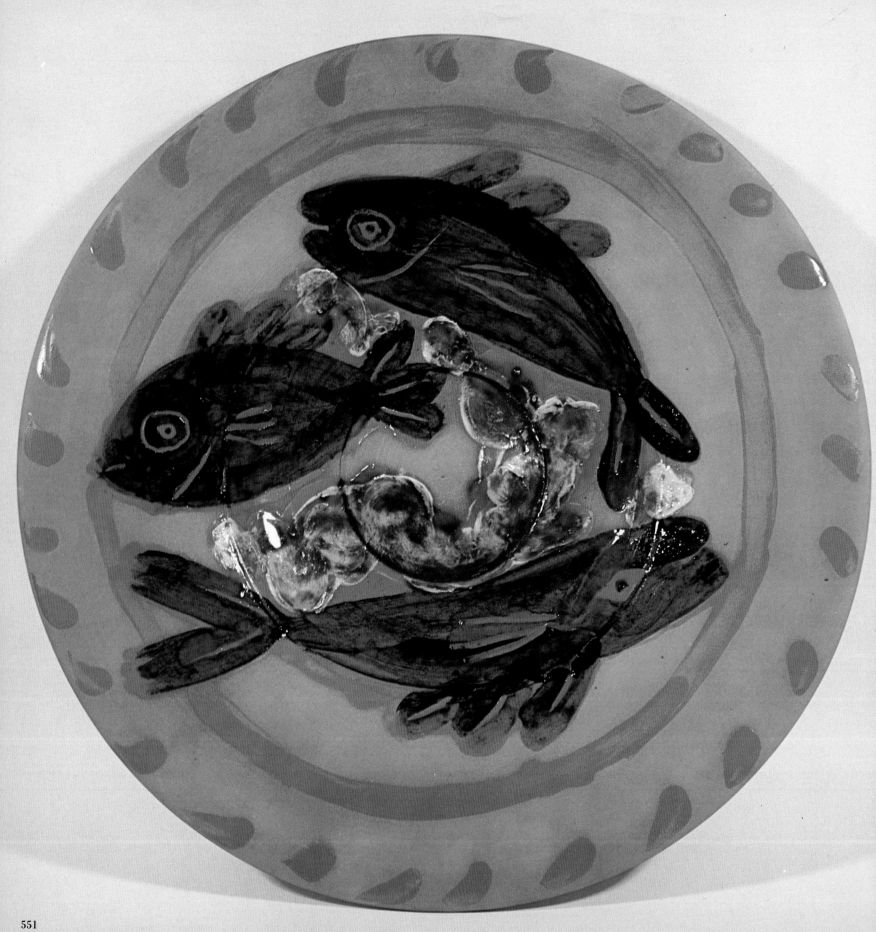

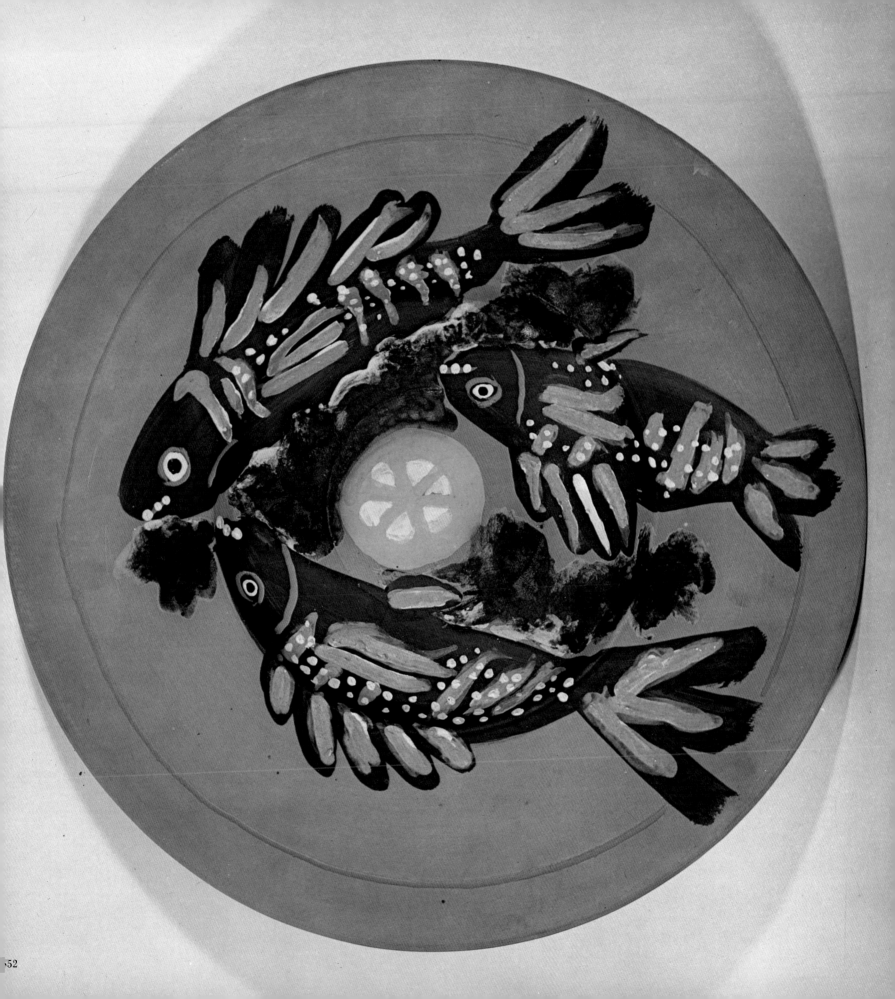

metamorphosis. And so this surprising wager came off and the whole field was laid open to devouring imagination as long as there was a sufficient supply of pieces capable of such transformations.

Having reached this stage in our subject, we should stop for a moment in order to give a more exact definition to this part of the work, inasmuch as its essential character is to be found in its graphic permanence. Once accustomed to his new mission, the painter found in it all his habits, his gestures, his power. He transposed himself, in fact, on to this unknown and capricious material. But he very quickly succeeded in developing, in this field too, the whole fullness of his possibilities of expression, accomplishing with the greatest of ease that part of his work that might be called 'pictorialized ceramic'.

It would be wrong to suppose that the different components of the whole made their appearance in the course of a period strictly defined in time. If I have divided them here into groups according to general characteristics, it is only for convenience in writing. Is it not, after all, a feature of all such elaboration that it begins as an adventure into the unknown? And in this case there were, as is proper, beginnings, abandonings, abatements and resumptions, all frequently overlapping in accordance with the varying propitiousness of circumstances, or with the artist's humour.

VIII. THE POSSIBILITIES OF CERAMICS

And now a third stage begins, a stage that might reasonably be included in the category of ceramic sculpture, inasmuch as it belongs by nature to the elaboration in space of formal descriptive compositions.

Here, in effect, we are dealing with constructions whose final result is achieved, not by modelling in successive stages, but by a previous juxtaposition of fragments first shaped on the potter's wheel. Consequently, the symmetry on their vertical axis gives them a certain stiffness: rectilinear or variously curving cylinders, elongated spindles, open cones, closed geometrical shapes and some inorganic forms intended to be used as joints or limbs.

Beginning with a carefully studied and analysed sketch, the different pieces needed for the structuring of the project are put in hand. After being slightly reinforced, they are joined together and the overall composition is thus built up. An essential part of this operation is the gluing together of the different pieces to be assembled, and for this a dilution of ceramic paste is used. The operation concludes with an additional modelling, in which a sensitive hand is needed to give suppleness to any lines that seem too inert.

To carry out these combinations, with their complex outlines, demanded a certain technical

imagination in solving the insidious problems they posed. The work consisted, in effect, of using a material which was malleable at the moment of handling it in order to obtain structures whose very configuration subjected them to opposing internal tensions that ran the risk of warping them. It was also essential to prevent the lower parts from being crushed by the increasing weight of the upper parts.

Total elasticity was the main advantage to be gained from using the plastic ceramic paste in its first freshness. But this elasticity, on the other hand, entailed formidable risks of torsion or flexion. As the work progressed we had to improvise ways of keeping the *ensemble* in its original state, until the reinforcing of the walls could give it a more reliable solidity.

In the course of the final and integral drying, moreover, this paste undergoes a retraction of about one-tenth of its volume, so that permanent attention must be paid to controlling the effects of this phenomenon and maintaining the even, steady progress of the work; for any over-brusque or irregular contraction may cause the joints to come irreparably unstuck.

But such difficulties bring with them all the interest to be found in the endeavour to force the impossible. It was in this spirit that, despite everything, the most daring projects were executed. Their realization constituted a sort of challenge to the very order of things, particularly to the law of gravity. But since each one of us was bent on achievement at all costs, and it was by now established that with Picasso everything is possible, the enterprise was successful every time, to the honour and satisfaction of all.

Once the separate elements have been thus united and joined together once and for all in the logical order of their final form, there is still one major operation in store for them. Extracted from their inert mass, they are now about to receive —by means of a sumptuous transfusion, the incomparable secret of which is possessed only by their creator— that principle of life by which the abstract subject becomes a tangible object. That is the reason why Picasso, when he reaches this stage, never fails to question himself on a point he considers to be of the utmost importance. Hardly has he finished a work, no matter what it may be, when his most pressing concern is to know whether —to quote the expression that he always loves to use— 'it respires'.

'Respire', that magic word in which we seem to find together three other words with a common root: aspiration, inspiration, spirit. All three represent phases through which life passes and

212

553. Large dish (turned on the wheel). Miscellany of bulls. Diameter 46 cm.,
 depth 11 cm. Dated 26-1-58.

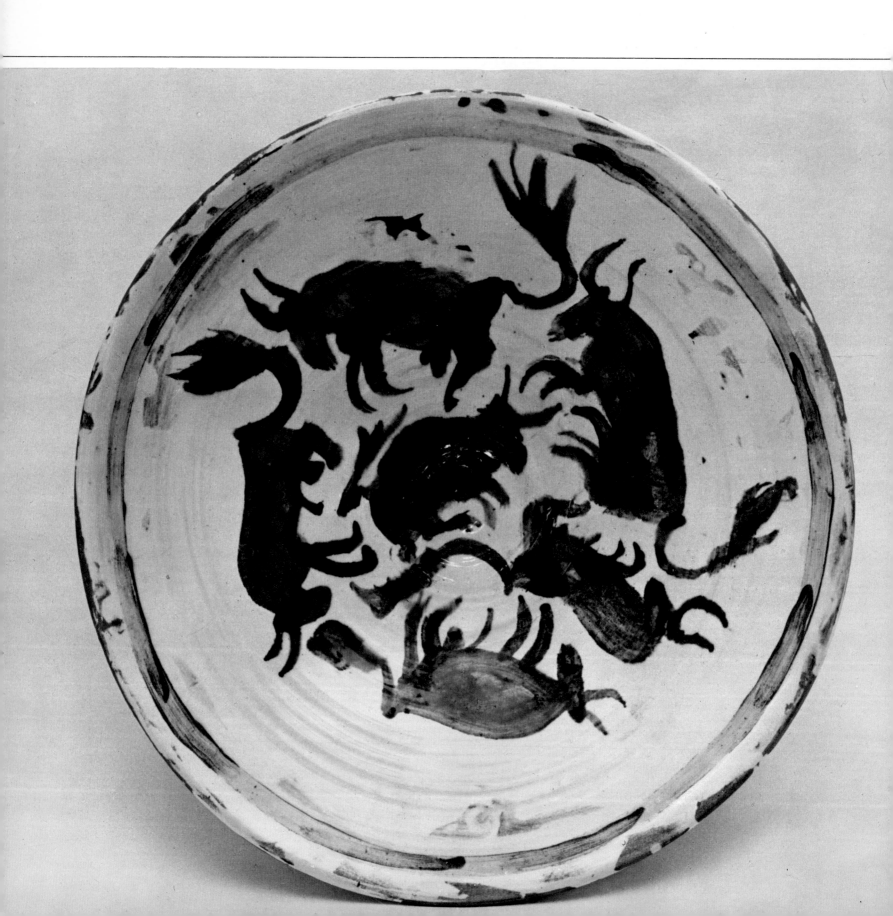

554. Large hollow dish. Face. Diameter 43 cm., depth 10.8 cm. Dated 30-1-58.

555. Round plate in colour. Face in thick relief in white earthenware. Diameter 42 cm. Dated 11-6-59, original print, edition.

556. Rounded square plate in colour. Face with square eyes in white earthenware (same piece as No. 559). Diameter 24 cm. Dated 29-6-59, original print, edition.

557. Rounded square plate in colour. Bearded face in white earthenware. Diameter 24 cm. Dated 29-6-59, original print, edition.

554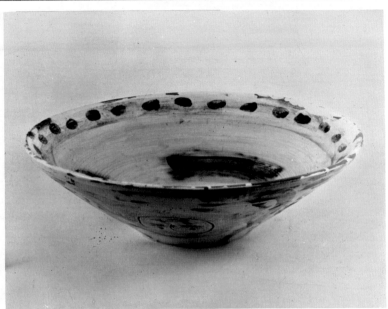

556

555

557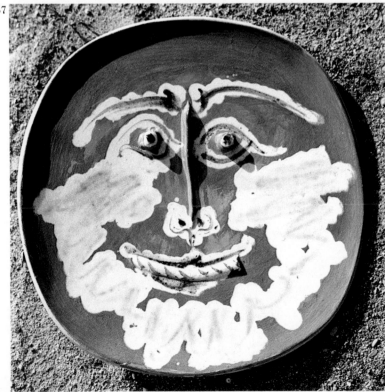

558. Large panel. Circus scenes painted on background of tiles. 94 × 174 cm. Dated 6-12-57, Jean and Huguette Ramié Collection.

558

without which nothing that is thought can be exchanged. The life thus given to the amorphous matter is born of some intimate touch, a mysterious pressure, an inflection barely followed up, an imperceptible connection between two latent values. And the revelation of the emotion that is released at the moment when the perceptible gesture is about to perform its all-powerful mission will suddenly endow the inert creation with the radiant force of the spirit. A crucial moment this, so esoterically described in the Book of Genesis, in which the breath of life, in obedience to the divine injunction, penetrates the still raw clay with its grace.

It would be impertinent, however, to suppose that this transfiguration of matter is exclusively concerned with supports allusive to a morphology that touches our common, everyday animality more or less closely. By an extension that each one of us can easily discover in himself, the troubling presence and insistent breathing of any object or form often appear in the midst of our accustomed principles, our arbitrary conventions of the absolute, our state as thinking creatures. They give us the inner life that enables us to correspond unhindered with the received, transmitted and insinuating thought that thrusts itself upon us. The very stones are often charged with the most moving messages. Vehicles for intentions and emotions, they bear the stigmata of life-giving time and radiate the contained power of the movement they describe. Before they are deemed worthy, however, a sovereign will has had to endow them with the attributes of that confusing mystery which forces everybody, god or man, to question himself before revealing it.

And so we find Picasso anxious to know if 'it respires', if the breath of life has penetrated, if in what he has modelled or put together his hand

has really engendered and magnified these new forms, giving them —with all his faith— the august soul of things.

For we are now approaching a strange world, in which everything vibrates or explodes, the world of fable and legend, of reality and imagination, the world of the past, the present and the future, of logic and the irrational, of things sacred or mythical, of the poetic dream or the cruellest of fictions.

A great multitude rushes forward, overwhelming you with its presence, imposing its tumults, its charms and its surprises and carrying you off into a universe that is constantly called in question, oppressive, fascinating, overpowering, mysterious.

Its character now becomes an integral part of the sculptural work that Picasso has carried out in the most universal materials. While a great many of these pieces were left in their original ceramic form, some others were cast in bronze after their final firing.

To begin with, architectural structures of a geometrical tendency, skilful representations of volumes, effects of style in relationships of values or of arrangements in space, forms broken down by strict cutting which recall the effects of analytical Cubism with its ever-fertile ideas. Complex assemblies with incoherent —even disquieting— appearances, demanding thorough analysis of secret intentions and salutary meditation on the diversity of the primitive solutions. Overhanging superimpositions of volumes, masses with their axes off-centre, pieces with dislocated articulations, counterbalanced symmetries, conical shapes with broken rhythms, studies of curves massed by means of imperceptible tangential points.

Here the material does not seem to play a really determinant plastic role; it is used because its flexible nature facilitates instantaneous execution, but later on it becomes possible to use it abstractly and consider only an ideal form, almost unreal in space and constructed on the relationships between light and shade, mass and void. And in this, we must suppose, there is a demand for absolute commitment in which the merit of intention equals that of interest.

Beginning with a more tangible figuration, Picasso presents us with entirely personal visions —always created by assembling preconceived elements— of anthropomorphic or zoomorphic forms, creatures of fascinating presence: owls, condors, night-birds or birds of prey, voracious in both look and attitude. But there are also dream-birds: pigeons, doves or turtle-doves, peaceable and chaste. An incursion into some of the periods of mythology permits us to discover innumerable fauns' heads, enterprising and mischievous, fiery steeds, minotaurs of terrifying aspect, vast-shouldered centaurs, colossal figures of men. And impassioned studies of goats' heads, always a favourite subject with Picasso, who evidently finds an echo of Cubist principles in this animal structure composed of sharply-defined planes and angles.

The vigour of bull-fighting is also displayed, in figures of bulls with enormous chests surmounted by tiny heads. This contrast produces an impressive sense of the brooding strength of all this corpulence totally concentrated on its effort. There are also some bulls' heads, analysed with patience and obstinacy.

Very special consideration should be accorded to an enchanting series of statuettes which soon received the name of 'Tanagras'. These little figures were modelled on vases conceived in forms that were fashioned when still quite soft after emerging from the kiln.

559. Rounded square plate in colour. Face with pinched nose in white earthenware. Diameter 24 cm. Dated 29-6-59, original print, edition.

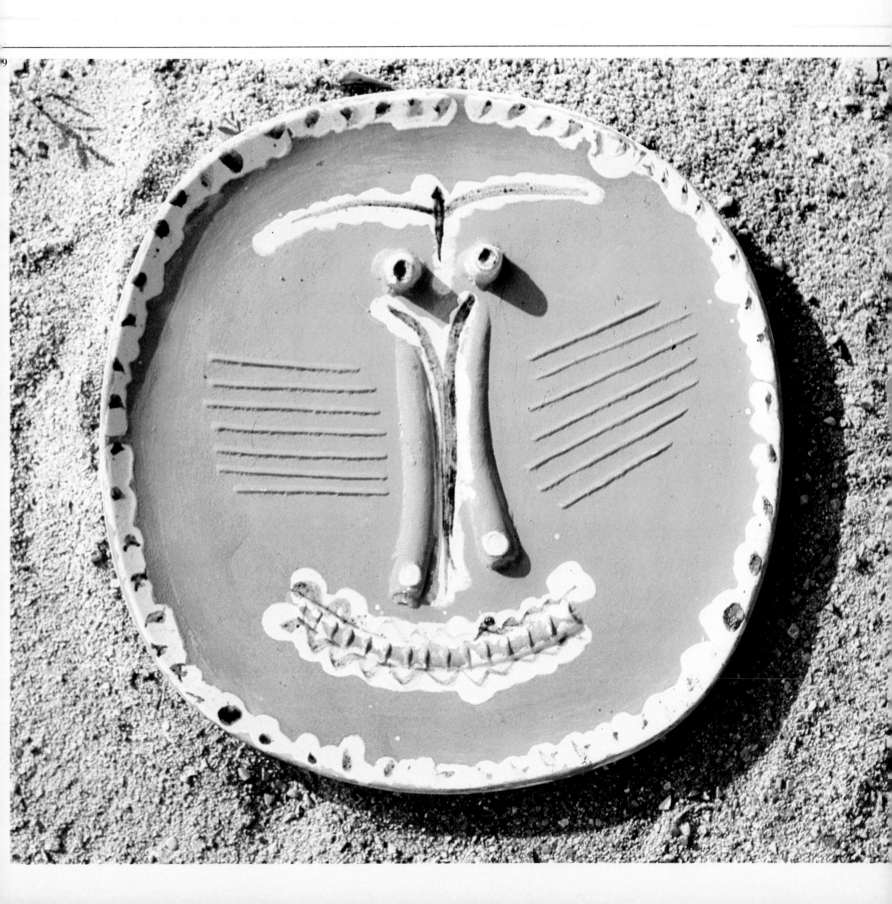

CORRIDA *SERIES*

560. Round plate. *Paseo*, black decoration on ochre earthenware. Diameter 42 cm. Dated 1-7-59, original print, edition.

561. Round plate. *Banderillas*, black decoration on ochre earthenware. Diameter 42 cm. Dated 1-7-59, original print, edition.

562. Round plate. *Picador*, black decoration on ochre earthenware. Diameter 42 cm. Dated 1-7-59, original print, edition.

563. Round plate. *Pase de muleta*, black decoration on ochre earthenware. Diameter 42 cm. Dated 1-7-59, original print, edition.

560
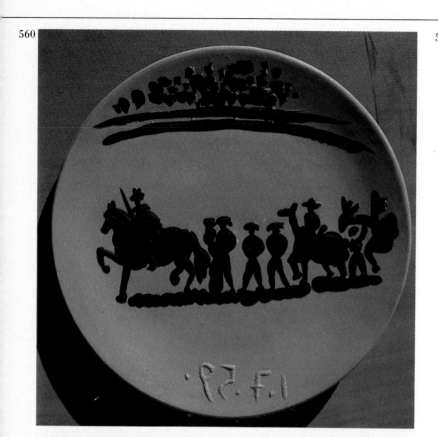

562
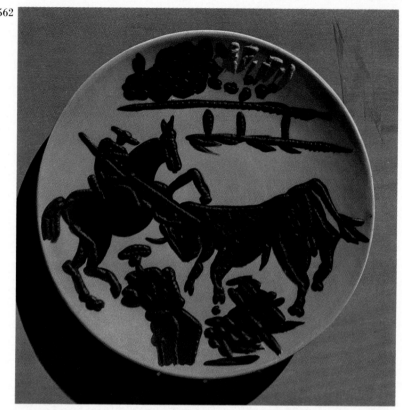

561
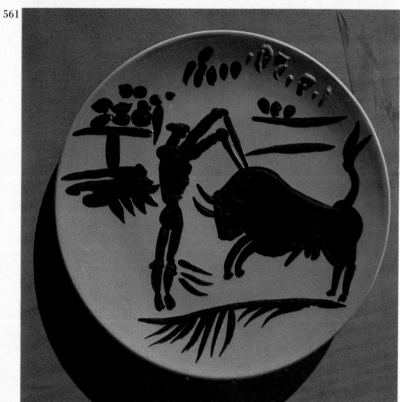

563
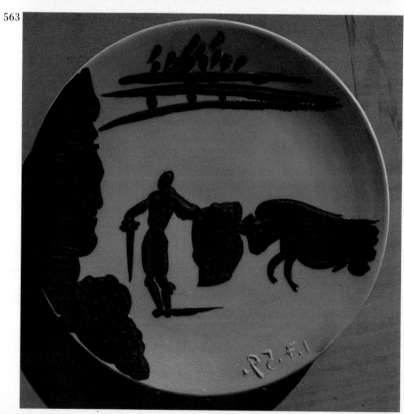

564. Round plate. *Pase de capa*, black decoration on ochre earthenware.
Diameter 42 cm. Dated 1-7-59, original print, edition.

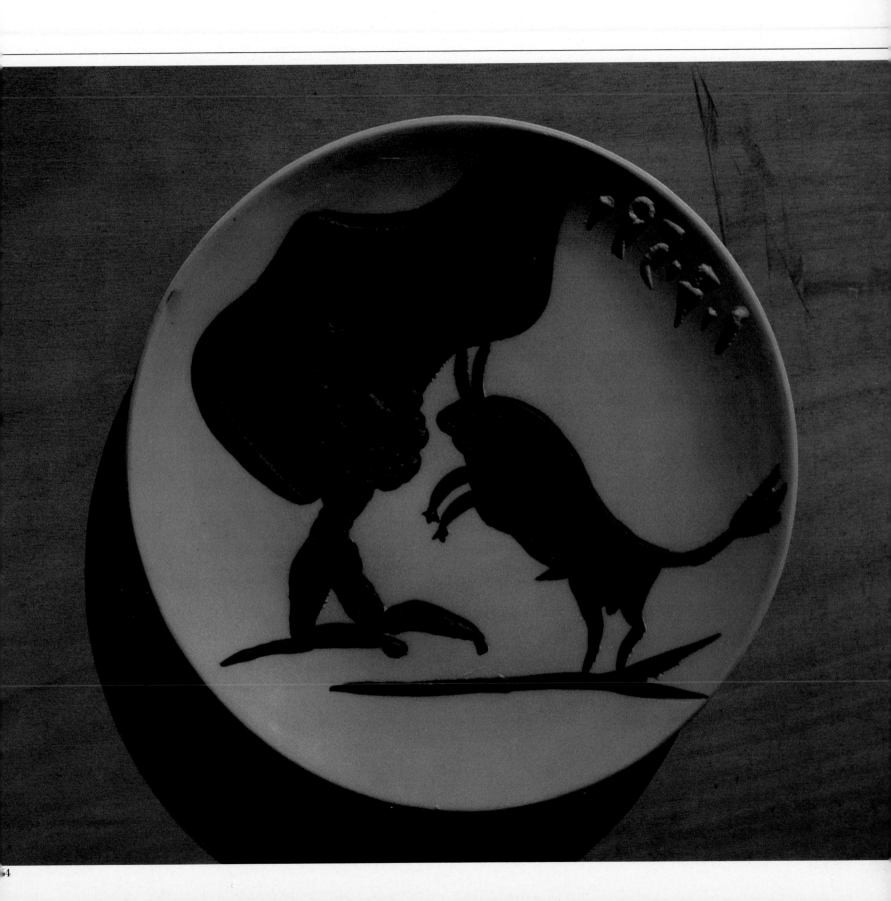

565. Round plate. *Estocada*, black decoration on ochre earthenware. Diameter 42 cm. Dated 1-7-59, original print, edition.

566. Round plate. *Arrastre*, black decoration on ochre earthenware. Diameter 42 cm. Dated 1-7-59, original print, edition.

565
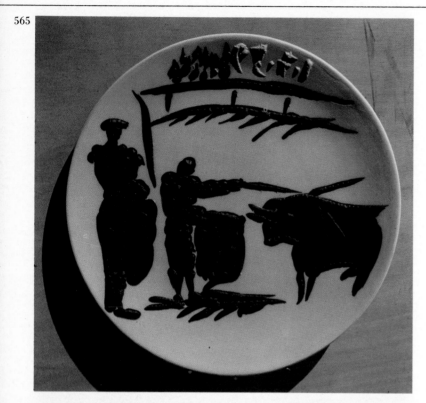

566
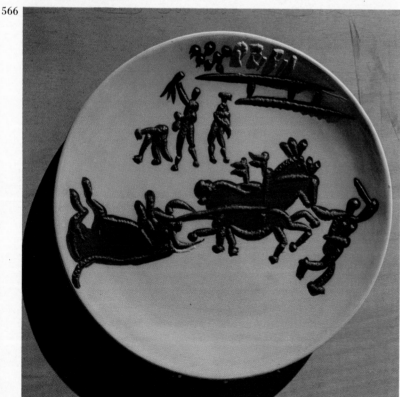

In this connection it is remarkable to see how much the great majority of vases tend to take on a human structure. From the base, on a supporting circle or polygon much smaller than the upper, balancing diameter, the two flanks rise in a gradual widening towards a shouldering that limits the body of the vase itself. Above this shouldering a contraction of the walls forms the neck, which is in turn surmounted by the widening of the collar. This neck and collar, if closed or crowned by a top section in the shape of an egg, can easily be made to represent a head.

Employing this ideal morphology, Picasso could obtain whatever he desired from it simply by taking these natural outline sketches in his hands and modifying them to suit his fancy, by pressure, flexion, twisting or whatever other kind of distortion he was seeking. One particular notion was rather shrewd: this 'outline sketch', as has been said, was closed at the top and therefore perfectly air-tight, filled with air and virtually incompressible. Thus it could be subjected to all kinds of conformation without any risk of being crushed, which made it possible to carry out different previous trials before giving it its definitive shape. It was only after the reinforcing, when there was no longer any risk of collapse, that an almost invisible hole was pierced in the wall, to facilitate internal evaporation and prevent the piece from bursting in the kiln.

These were the conditions in which this engaging group of characters was created, with their delicate gestures and attitudes full of the grace and serenity of an age which, precisely because it is no more, in this rendition is to some eyes all the more precious.

Thus pursuing the plastic possibilities of ceramic paste in its most widely varying applications, Picasso could not fail to notice, and be

567. Round plate. *Cogida*, black decoration on ochre earthenware. Diameter
42 cm. Dated 1-7-59, original print, edition.

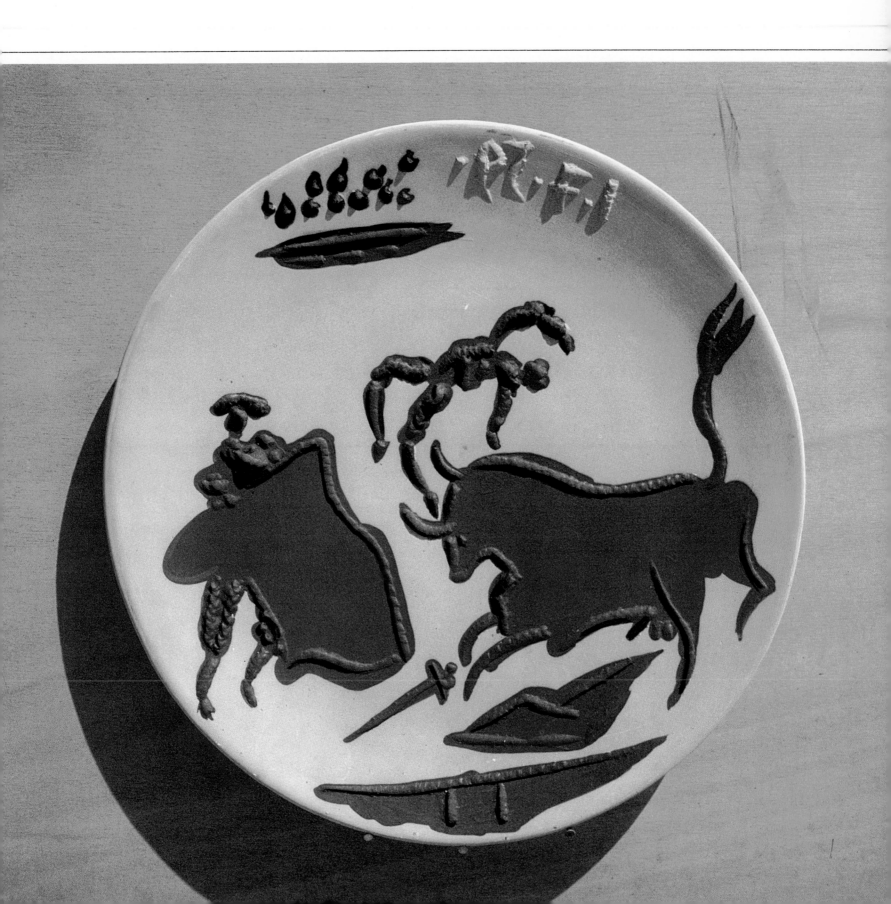

fascinated by, the way in which it is used in the form of freshly-worked sheets for printing.

A vertical frame of copper wires, tightly stretched and strictly equidistant, is passed through a cake of paste which has been properly kneaded and trimmed. The mass of paste is thus horizontally divided into so many smooth sheets of regular thickness and can then be pressed on to negative moulds and made to adopt, in positive form, all the nuances of the previously incised motifs. This method was retained and later applied when the authenticity and fidelity of original ceramic prints in limited editions, warranted and numbered, needed to be guaranteed.

For the time being, however, the research in progress was aimed at a very different method of using these flexible sheets, so malleable and yet at the same time so alive. What principally interests Picasso, at all times, is the possibility of capturing from life, as it were, and limiting in the very act, not so much the motif he is composing as the act of defining it. He seems to find it essential that this act should be seen as a kind of conjuring trick, by means of which something is produced before anything has been suspected. This attitude in no way corresponds to a spirit of demonstration, which would be rather vain and ridiculous, but —quite precisely— to a need for truth which derives exclusively from his natural spontaneity.

For such purposes sheets of freshly-worked paste offered the artist inestimable advantages: he only had to take them in his hands at any given moment in order to drape them, pucker them, pinch them or even inflate them and thus transform them, in an instant, into a whole throng of subjects taking their tangible shapes as if by magic.

It was thus that we saw pigeons, doves and turtle-doves placed on their nests to hatch, with the greatest care, those hopeful families still in the limbo of the birds of peace. Hands, too: refined hands, almost unreal in their realism, emerging from the starched linen of solemn cuffs and seeming to recall the perfect technique of some virtuoso pianist of the past.

These objects should be accepted as practical exercises with a definite place in this ceramic world, where they bear witness to the extent of the research into which Picasso has ventured so successfully.

And since we are still dealing with this impressive collection of volumes, we must not forget to speak of the subjects of those multiform compositions that Picasso carved out of blocks of unfired clay entirely dried. The consistence of this material is comparable to that of certain soft woods which can be easily carved into the most intricate shapes with well-sharpened tools. With the important advantage, however, that once the work is finished a high-temperature firing can give it the enduring appearance and toughness of the hardest stone. The dimensions and subjects of these studies were usually determined by the forms that much earlier (and extremely hazardous) experiments had attempted in these blocks of hardened clay.

Quite often they were simply what was left over from larger blocks, broken or crushed and abandoned to the dry air in some forgotten corner.

Despite these very strange conditions, however, or perhaps because of them, the nature of the material in which these objects were worked gave them a density and evocative power that were vehemently perceptible. Sufficient merits, undoubtedly, to justify the decision later taken to have bronze casts taken of the best pieces of this period. On that account, naturally, the originals

568. Spanish plate, turned on the wheel. Frieze of centaurs on ochre earthen-
ware. Diameter 40.5 cm., depth 5.5 cm. Dated 23-11-59.

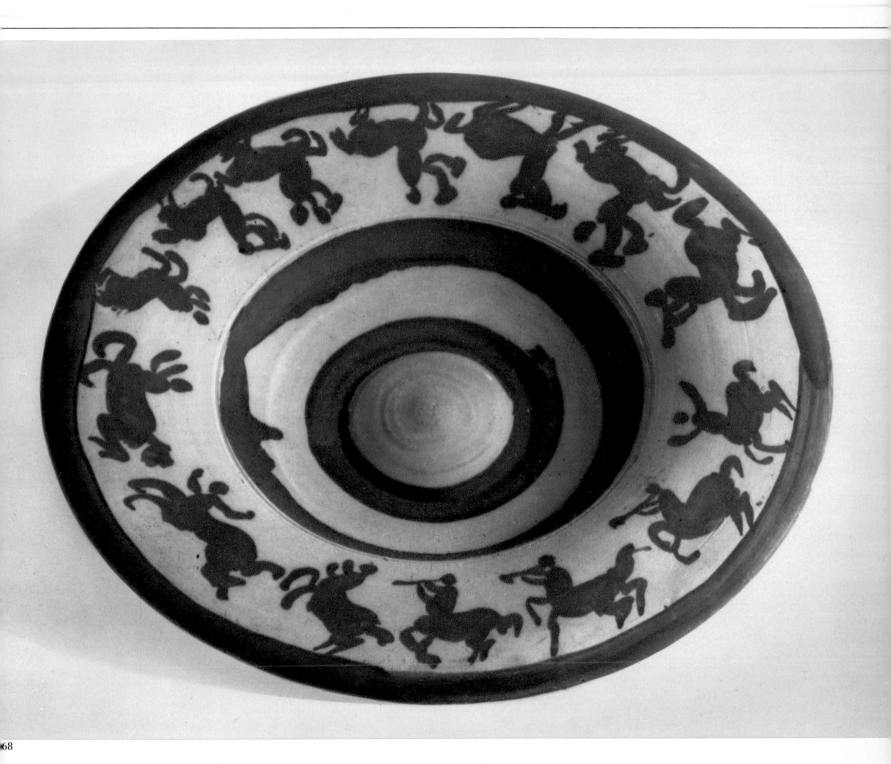

CORRIDA *SERIES.* Same print as Nos. 560 to 567

569. Round plate. *Paseo,* polychrome decoration on white earthenware. Diameter 42 cm. Same print as No. 560, edition.

570. Round plate. *Estocada,* polychrome decoration on white earthenware. Diameter 42 cm. Same print as No. 565, edition.

571. Round plate. *Cogida,* polychrome decoration on white earthenware. Diameter 42 cm. Same print as No. 567, edition.

569
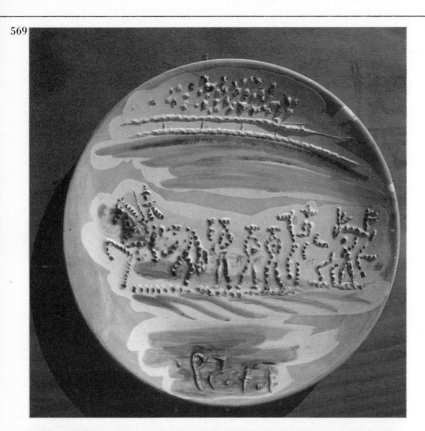

571
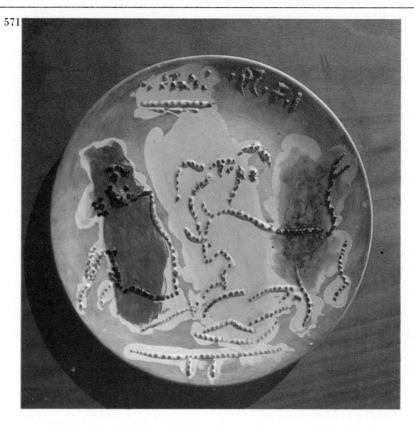

570
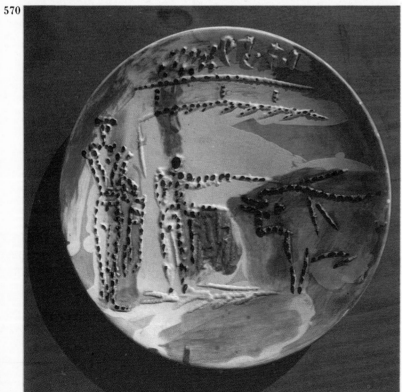

572. Round plate. *Banderillas*, polychrome decoration on white earthenware.
Diameter 42 cm. Same print as No. 561, edition.

572

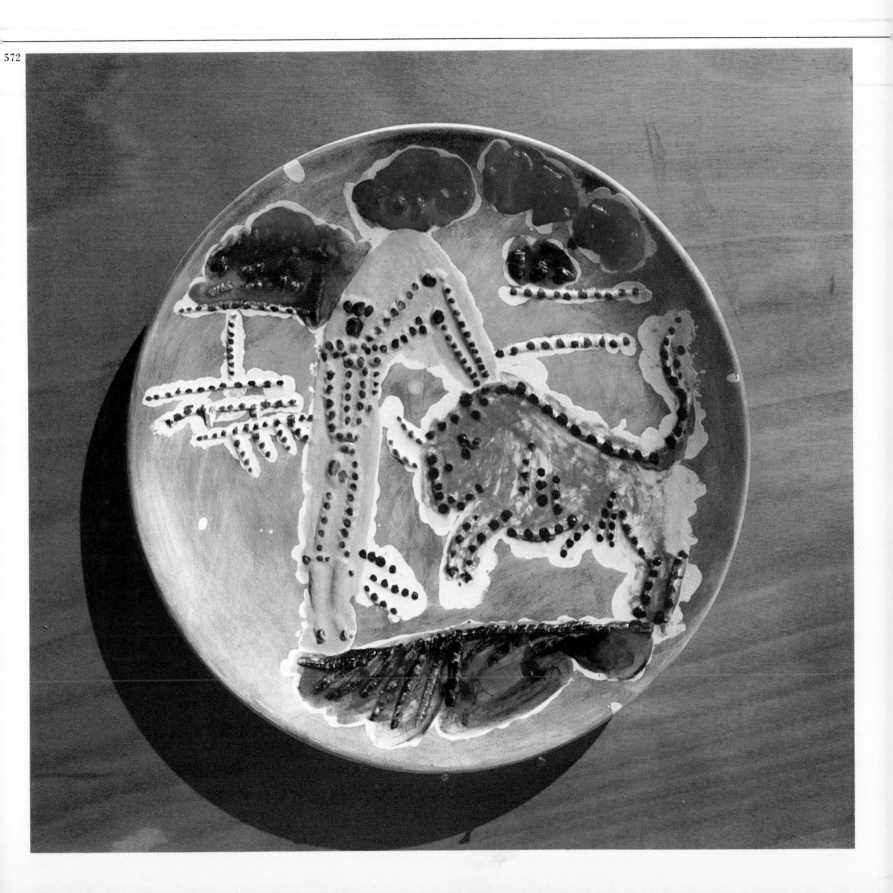

573. Round plate. *Picador*, polychrome decoration on white earthenware. Diameter 42 cm. Same print as No. 562, edition.

574. Round plate. *Pase de capa*, polychrome decoration on white earthenware. Diameter 42 cm. Same print as No. 564, edition.

575. Round plate. *Pase de muleta*, polychrome decoration on white earthenware. Diameter 42 cm. Same print as No. 563, edition.

576. Round plate. *Arrastre*, polychrome decoration on white earthenware. Diameter 42 cm. Same print as No. 566, edition.

573

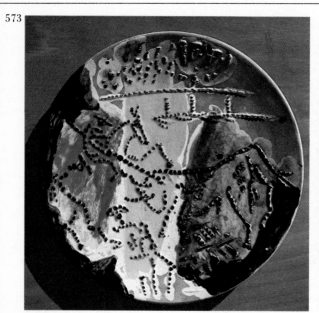

575

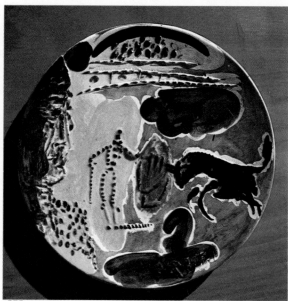

576

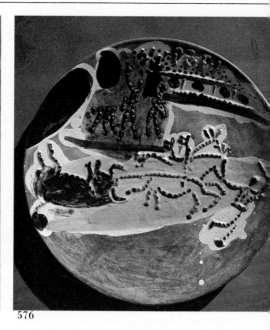

574

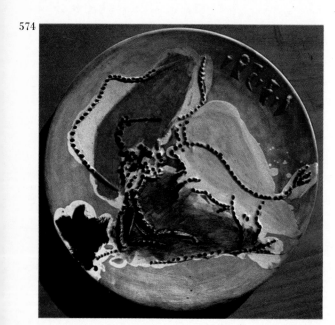

were neither lost nor withdrawn from the ceramic collections from which they came.

Another way of using unfired clay is to be found in Picasso's fascinated and persevering search for old potsherds, cracked or shattered, fired or unfired, which he comes across in the bins that overflow with waste fragments. He loves to transform them, either by giving them a new interpretation or by adding or subtracting something to change their original purpose.

It was in this way that a considerable collection of earthenware casseroles with rounded borders had features painted on their outer faces and were transformed into stage masks. The casserole could be held in front of the performer's face by the handle, like an Andalusian fan, and did not affect either the declamation or the carrying power of the voice.

Much has been thought and written on the magic of the mask, on the strange, intolerable, bewitching presence it confers upon whoever chooses to lend it his head and borrow its face.

577. Round plate in colour. Picador and bull in thick relief, white earthen-
ware. Diameter 42 cm. Dated 1959, original print, edition.

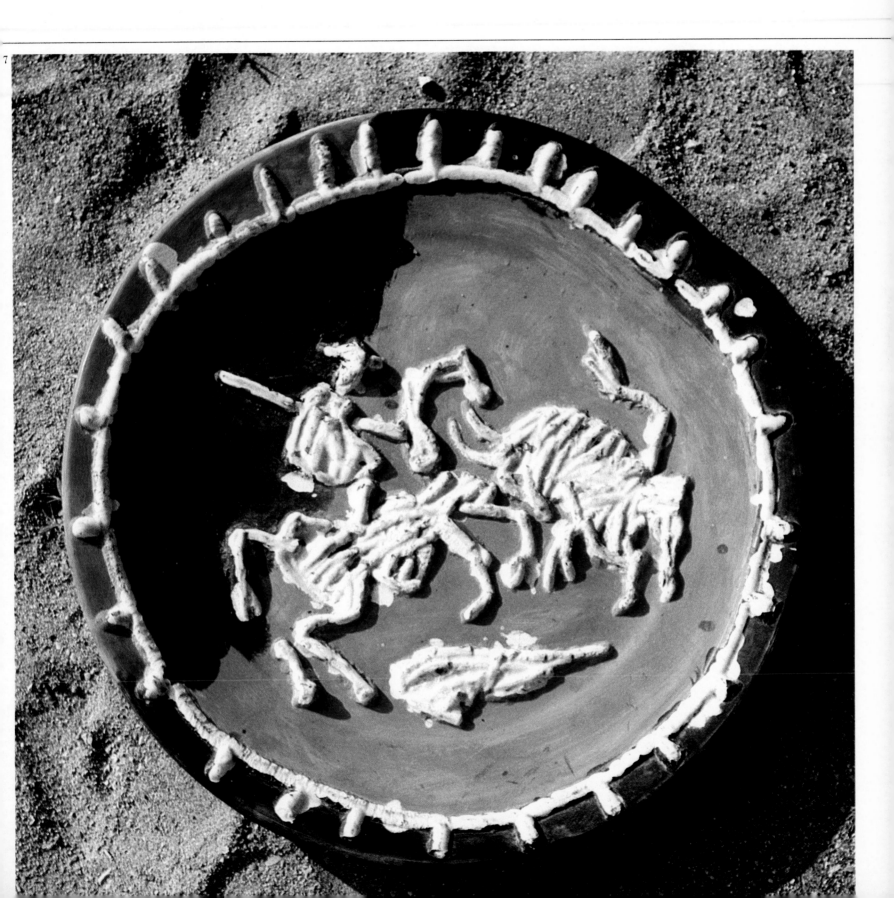

578. Turned and modelled form. Woman's head, painted. Height 24 cm., total width 19 cm. Incised in 1954, painted in 1961, signed and dedicated to Mme. Ramié.

579. Deep plate. Decorated. Diameter 29 cm. Signed and dedicated to Mme. Ramié.

580. Turned and modelled form. Woman's head crowned with flowers in polychrome paint. Height 24 cm., total width 19 cm. Variation on No. 578 (with more colouring), signed and dedicated to Mme. Ramié.

581. Reverse of No. 579. Signed and dedicated 'Pour Suzanne Ramié son fidèle sujet Picasso. Son élève'. Dated 12-10-61.

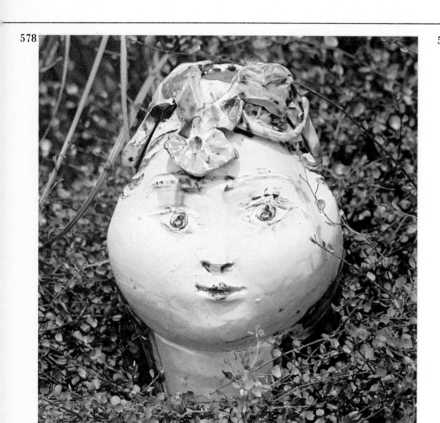

578

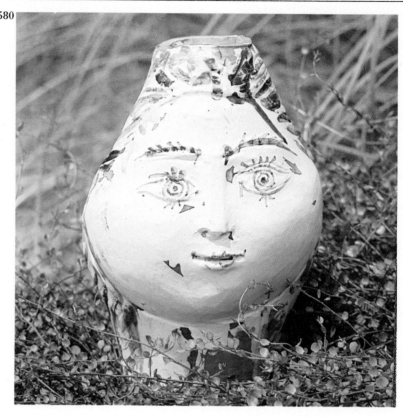

580

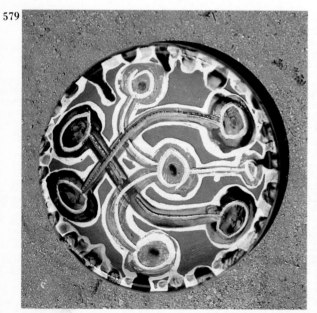

579

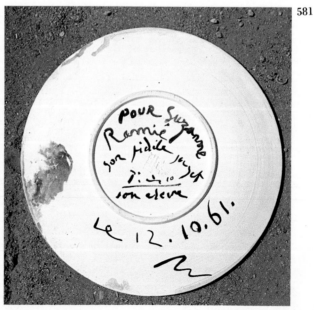

581

582. Another view of Nos. 578 and 580.
583. Round plate in colour. Dishevelled woman on white earthenware.
Diameter 26 cm. Dated 20-8-63, original print, edition.

582

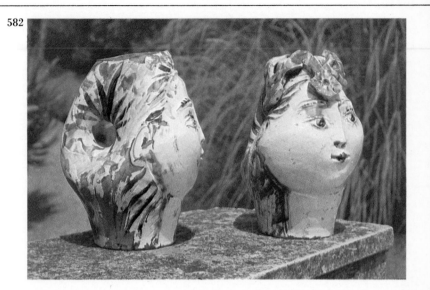

Picasso's masks, created out of wretched pieces of clay rescued from the pulverizer, came back to life with all the intensity of Greek tragedy. It is difficult to express the sense of shock produced by the contrast between the fated immobility of these rigid countenances and the dramatic agitation of the feelings that torture them, apparently expressed with so much verbal impetuosity.

All this potential violence found an outlet one day in improvised scenes in which acquaintances, friends or casual visitors were invited to take part; all well-disposed, quick-witted people, they suddenly revealed their talent for mime in their ability to enter into Picasso's imaginative world without a rehearsal and with a sense of the opportune that appeared in a flash out of nowhere. An astonishing juggling with words, the privilege of that single show that was carried off by the sun in the glitter of a summer afternoon, and of which nothing remains, in the hearts of the friends who were there, but the memory of an incomparable coruscation now dimmed.

583

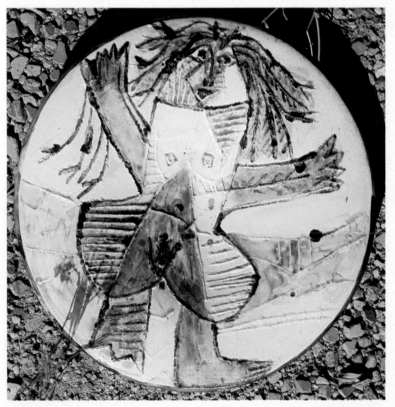

584. Two-handled vase. Large bird. 59×41×44 cm. Dated 14-2-61.
585. Other side of No. 587.
586. Base of No. 587 (showing dedication).

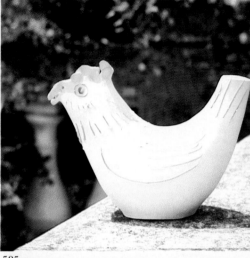

585

586

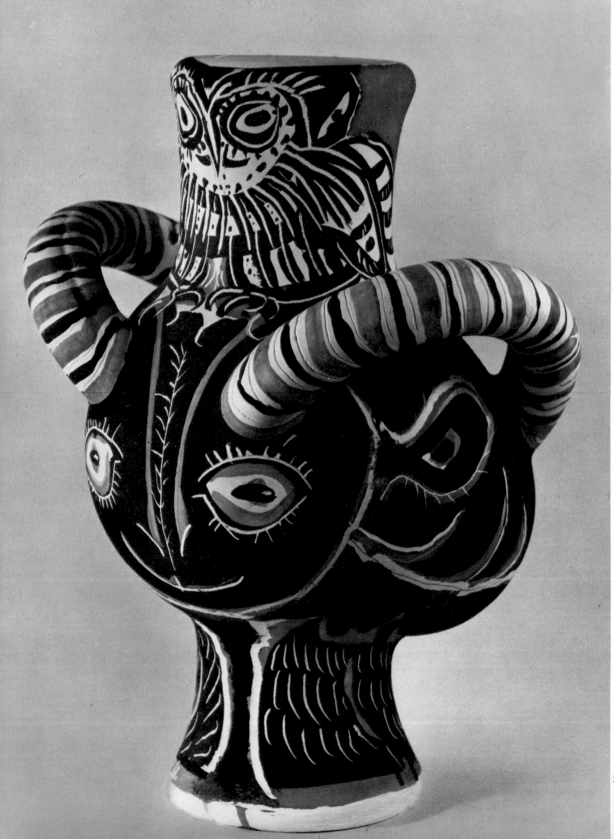

584

587: Turned and modelled piece. Bird in white clay. Height 20 cm., length
28 cm. Dated 13-2-62. Signed and dedicated Pour Suzanne Ramié.
Son ami Picasso'.

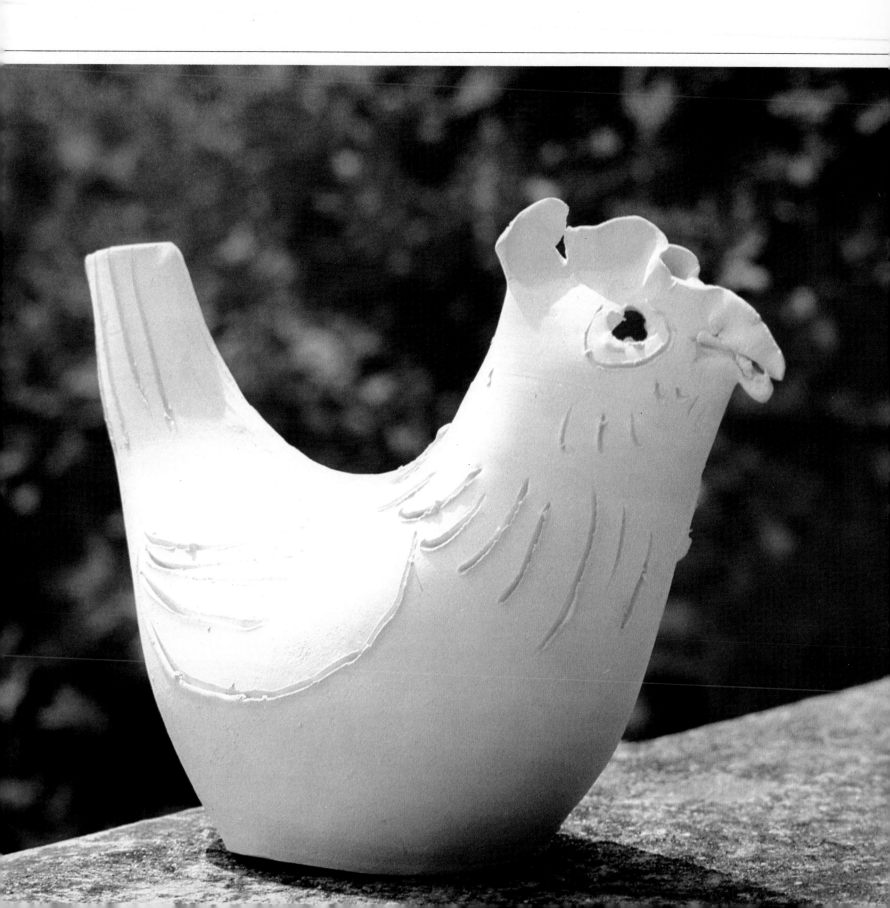

IX. A LIMITLESS CREATION

And now we must discover Picasso under a very different aspect, in his activities as a tiler or, rather, as a tile-decorator. This was a period during which a kind of liaison was effected between the flat surface of the painter's canvas and that of the ceramic backing. In this case the backing took the form either of faience tiles, in the usual shapes and of fairly small dimensions, or of much larger-proportioned fired clay tiles, both being elements that could be treated either individually or as components of a larger area.

These convenient conditions made it easy to return, though with very different media, to the usual working rhythm of an easel-painter, in the treatment of space and the demands of the surfaces.

Assemblies that grouped multiple elements were used for compositions of vast dimensions. The most famous of these (*Still life with coffee-pot, Circus Games, Paloma in a Polish jacket*, etc.) are evidence of the noble possibilities of mural ceramics thus brought into man's daily surroundings and used with a vision similar to that of the tapestries of an earlier age. Likewise they constitute the regeneration of a form of expression which, thanks to its very permanence, is called upon to participate in the events of the rooms it adorns, revealing itself, moreover, as an essential contribution to a renewed conception of large graphic wall-areas as the proper decoration and artistic representation of their age.

A considerable number of the smaller pieces represented scenes influenced by the events of the day and also, to a large extent, evocations of Spain: portraits of eighteenth-century personages, noble ladies in all their finery, court dignitaries, iridescent country scenes that seem to come straight from the pages of Camoens or Cervantes, but also portraits of close friends in costumes of the age of Ferdinand and Isabella.

This prodigality of conceptualizing was turned to good account for a great many trials of technique which really went far beyond the bounds of the conceivable, with astonishing and infinitely diversified inventions which for a time left the greatest theorists of contemporary ceramics astounded: the contrasting of matt and glossy surfaces by covering the brush on the unglazed parts; reserving the matt surfaces by impregnating them with hot paraffin and immersing them in the enamelling bath; polychrome ceramic patinas re-fired with a brushing of oxides, which permitted graduated tone-values.

The culminating point of these experiments, as regards both quality and success, seems to have

been reached in the series of fifty tiles done in the spring of 1969. In this work of perpetual discovery and fruitful experience, we find sparkling new evidence of the artist's excellence. This series was composed during the evening that closed a long day devoted to painting. And yet this whole collection of fifty new pieces was finished in a few hours.

Passing from one technique to the other without the slightest difficulty as he bent over the tiles arranged in front of him, Picasso's enthusiasm kept him on course at the same speed and almost with the same brushes. The result of this surprising superimposition of techniques was ceramic treated as if it were oil-painting that had borrowed the media of the former to add them to its own qualities.

A feature worth noticing in this particularly unexpected conception is the predominance of effects which, notoriously, are seldom seen on account of the difficulties or risks entailed: the treatment involving wide streaks of colour, for instance, which can only be done by squashing thick brushfuls of paint on to the surface, and likewise the use of ceramic pigments in a weak solution, permitting the graduation of shades as the thickness expends itself rather as in wash-drawing.

This duality in media was still further reinforced by another unexpected and equally innovating feature. For these tiles, plaques and bricks were not, after all, fashioned at random in capricious formats; the plaster moulds from which they came had first been incised to take a motif previously designed for placing on its backing after the second firing.

The analysis of such a conception, carried out in two separate operations and introducing a complementary technical factor, shows up the act of a precise intention: its result is a kind of painting that interprets and controls an idea already outlined in incised strokes which give the whole an added vigour.

By reason of their small dimensions, these single tiles could not aspire to depict any very emphatic subjects. Their surfaces were rather more suitable for portraits, and the portraits were duly carried out: known or unknown faces, masked or unveiled, solar or lunar, mythological or secular. And also, in passing, faces of owls and of cavaliers seen in profile.

The presentation of these original works aroused resounding interest. Results of this sort, affirming such authority over matter, can only fill you with humility and envy. How many years are necessary, indeed, years of vigilant

588. Fragment of brick. Face. 22 × 13 × 9.5 cm. Dated 12-7-62.
589. Fragment of brick. Face. Height 13 cm. Dated 19-7-62.

588

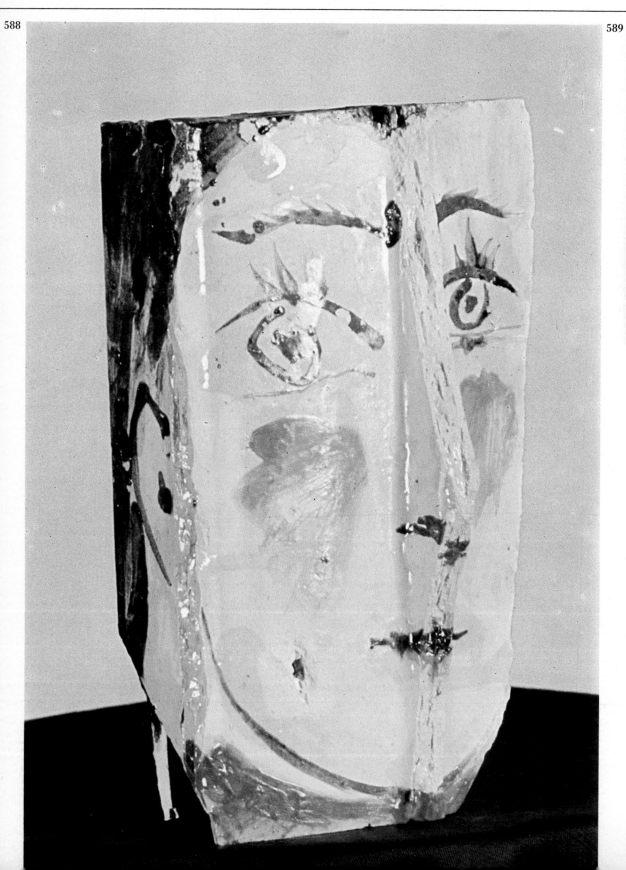

589

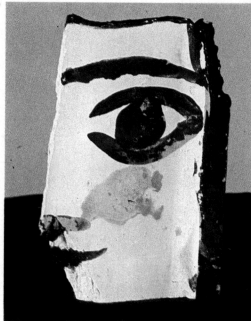

590. Fragment of brick. Face. 14 × 13 cm. Dated 17-7-62.
591. Fragment of brick. Face. Height 19 cm. Dated 19-7-62.
592. Fragment of brick. Woman's face. 22 × 12 × 8 cm. Dated 14-7-62.

592

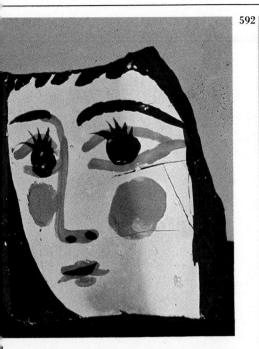

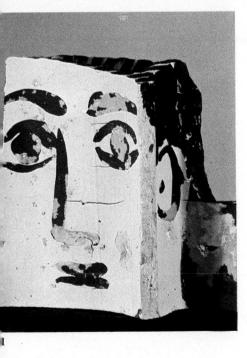

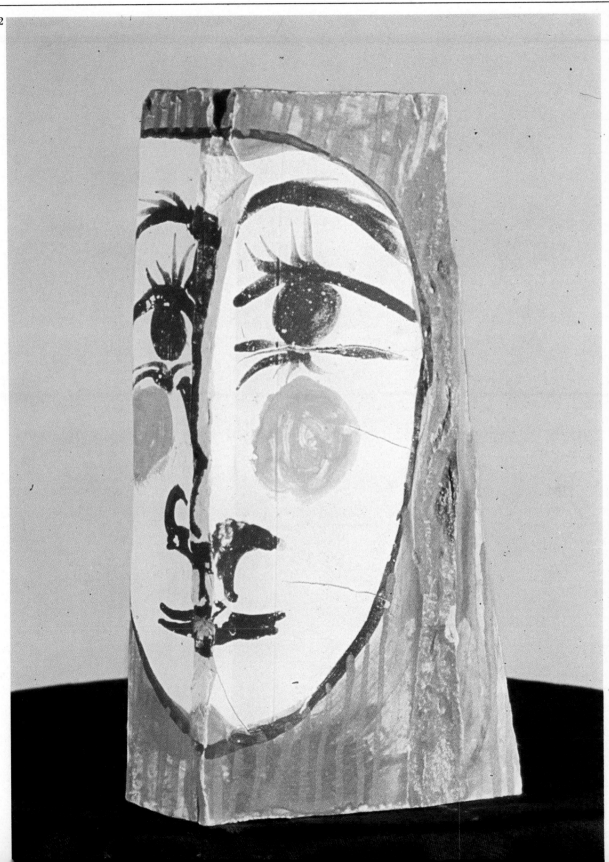

593. Fragment of brick. Face. Dated 19-7-62.
594. Fragment of brick. Face. 22 × 12.5 × 8.5 cm. Dated 17-7-62.

593

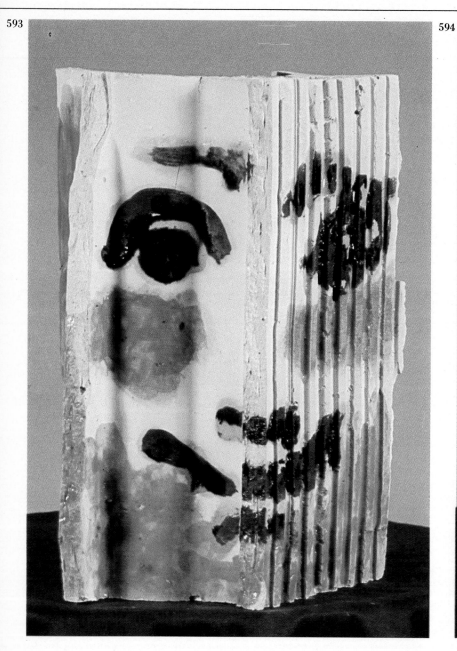

594

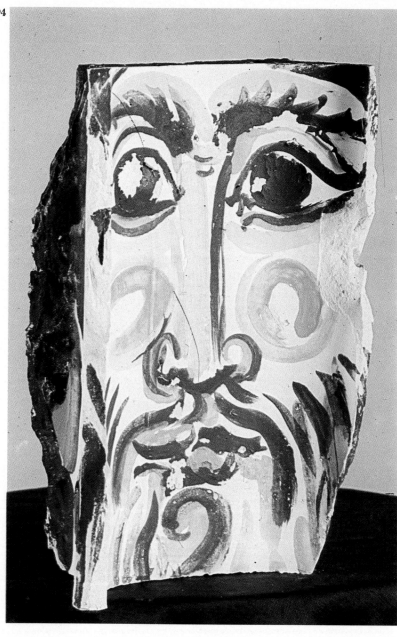

595. Fragment of brick. Face. Dated 19-7-62.
596. Fragment of brick. Face. Dated 19-7-62.

595

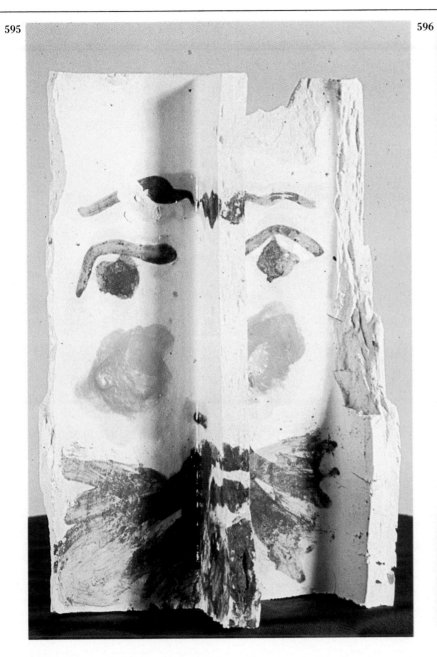

596

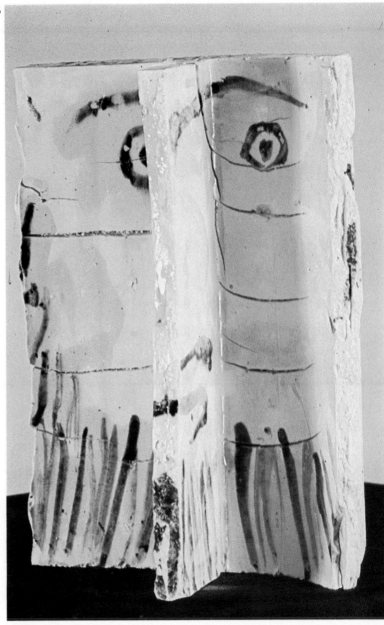

597. Fragment of brick. Face. Dated 19-7-62.
598. Fragment of brick. Woman's face. Height 15 cm. Dated 17-7-62.
599. Fragment of brick. Face. Dated 19-7-62.

597

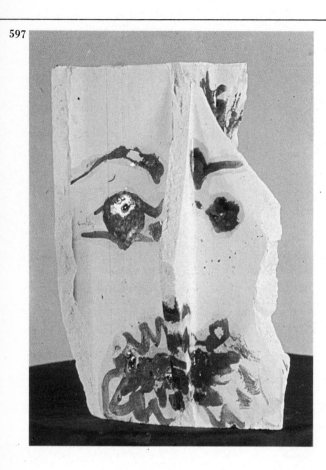

598

599

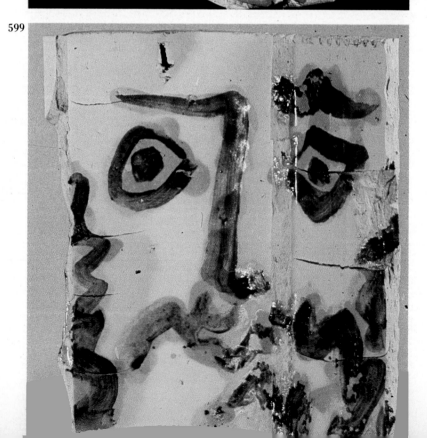

studies, deductions confirmed and successful im-
provisations, to deserve the exuberant fruit of
a constancy and sagacity never properly appreci-
ated. A lesson in things, a lesson of character are
simultaneously presented to us as a proposition,
as a momentary conclusion to a multitude of
subjects, present or future.

And what shall we still be privileged to dis-
cover in the years to come, as long as Picasso con-
tinues to feel this raging need to re-work, unremit-
tingly, whatever he has just conceived and even
what he has just carried out? To the hesitant
meditations of centuries in which the fear that
everything had already been said acted as an
inner restraint on the exuberance of thought,

600. Fragment of brick. Face. Dated 12-7-62.
601. Roofing tile. Face. Dated 19-7-62.
602. Jagged fragment of brick. Face. 22 × 13 × 9.5 cm. Dated 12-7-62.
603. Roofing tile. Face. Dated 19-7-62.

600

602

601

603

240

604. Plaque in pitted clay. Jacqueline with long neck. 26.5 × 22.5 cm. Dated 10-7-62.
605. Plaque in pitted clay. Jacqueline on a russet ground. 26.5 × 22.5 cm. Dated 11-6-62.
606. Plaque in pitted clay. Bust of woman. 26.5 × 22.5 cm.

604

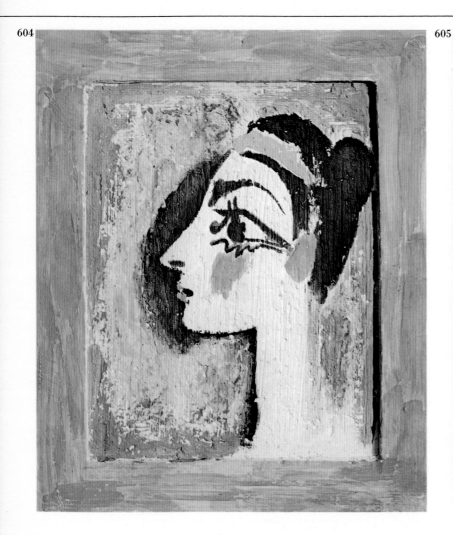

605

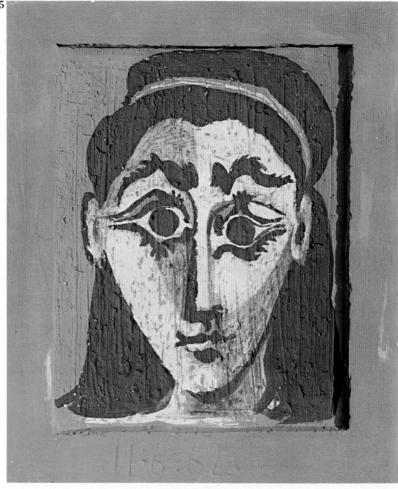

606

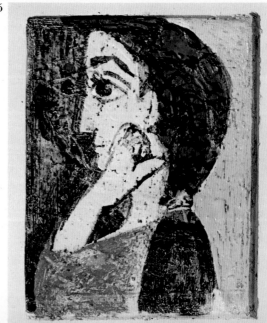

607. Plaque in pitted clay. Man with long hair. 26.5×22.5 cm. Dated 26-5-62-II.

608. Curved brick. Character. Dated 19-7-62.

609. Plaque in pitted clay. Jacqueline in a hat. 26.5×22.5 cm. Dated 10-7-62.

610. Plaque. Two figures with a dog. 26.5×22.5 cm. Dated 25-5-62.

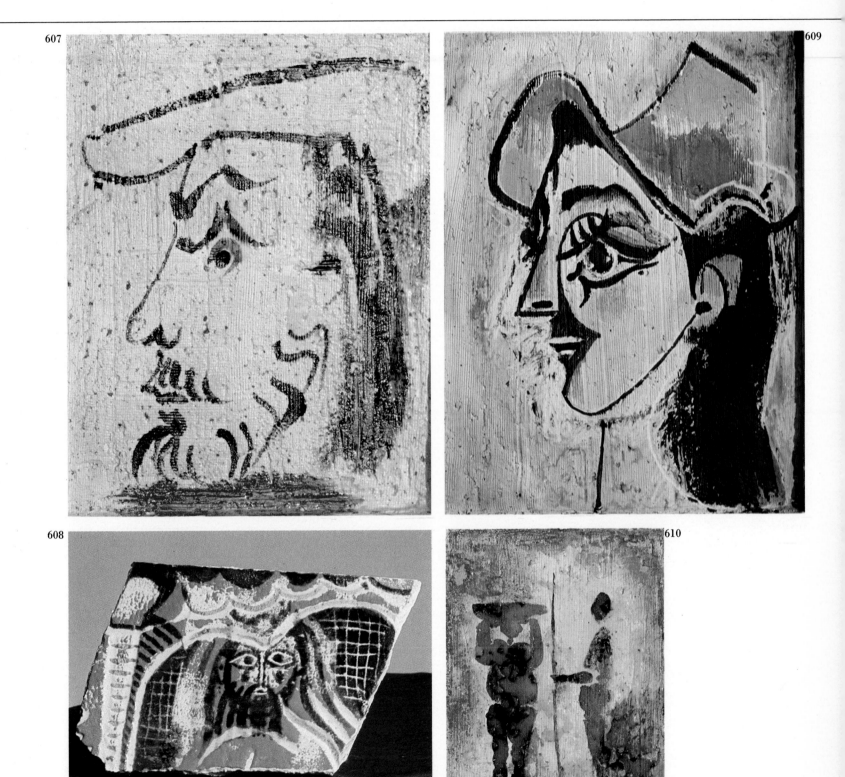

607

609

608

610

611. Plaque in pitted clay. Woman's head. 26.5 × 22.5 cm. Dated 10-6-62.

612. Plaque in pitted clay. Incised head. 26.5 × 22.5 cm. Dated 11-6-62.

613. Plaque in pitted clay. Jacqueline framed in yellow. 26.5 × 22.5 cm. Dated 10-6-62-IV.

614. Plaque in pitted clay. Jacqueline in blue shadow. 26.5 × 22.5 cm. Dated 10-6-62-V.

611

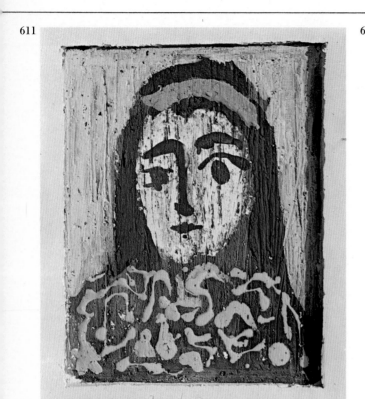

613

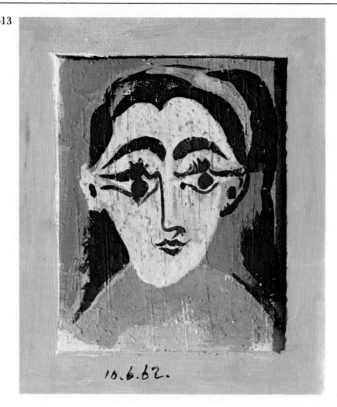

612

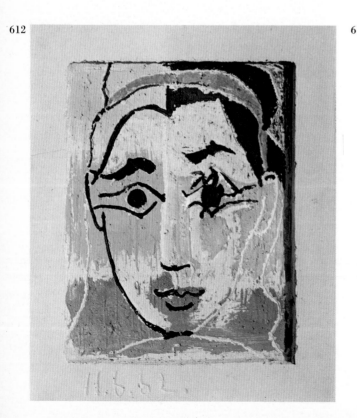

614

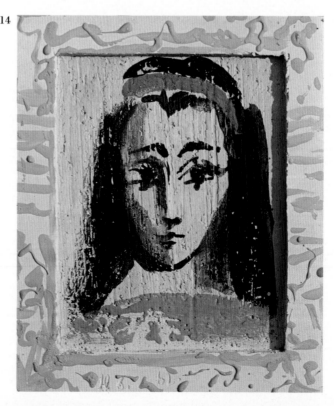

615. Plaque in pitted clay. Jacqueline with a grey bandeau. 26.5 × 22.5 cm. Dated 10-6-62.

616. Plaque in pitted clay. Jacqueline in a pink dress. 26.5 × 22.5 cm. Dated 11-6-62.

617. Plaque in pitted clay. Jacqueline with a chignon. 26.5 × 22.5 cm. Dated 13-6-62.

618. Plaque in pitted clay. Jacqueline in cameo. 26.5 × 22.5 cm. Dated 11-6-62.

615
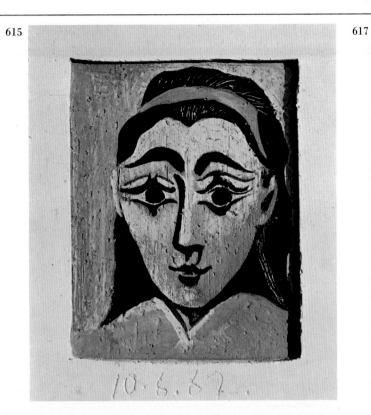

617
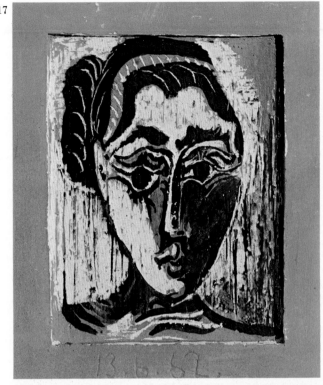

616
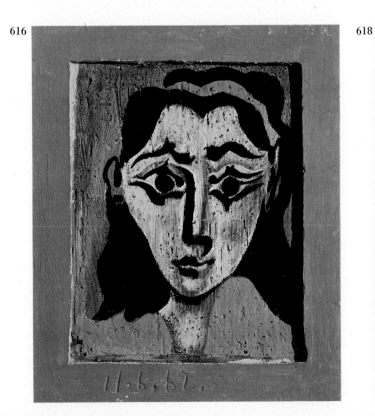

618
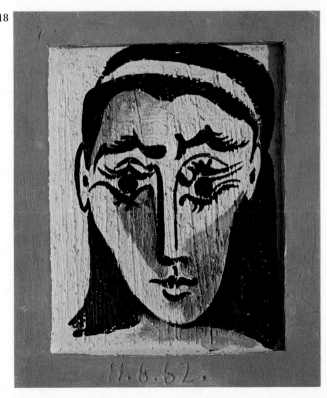

619. Plaque in pitted clay. Man in a ruff. 26.5 × 22 cm. Dated 26-5-62.

619

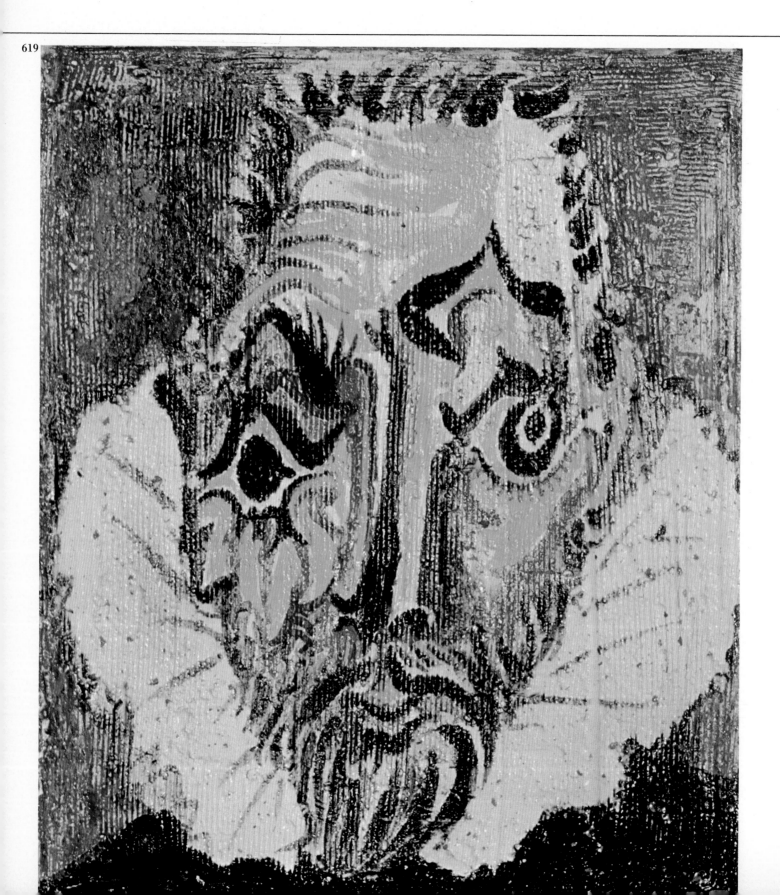

620. Plaque in pitted clay. Jacqueline with long hair. 26.5 × 22.5 cm. Dated
 4-7-62.

620

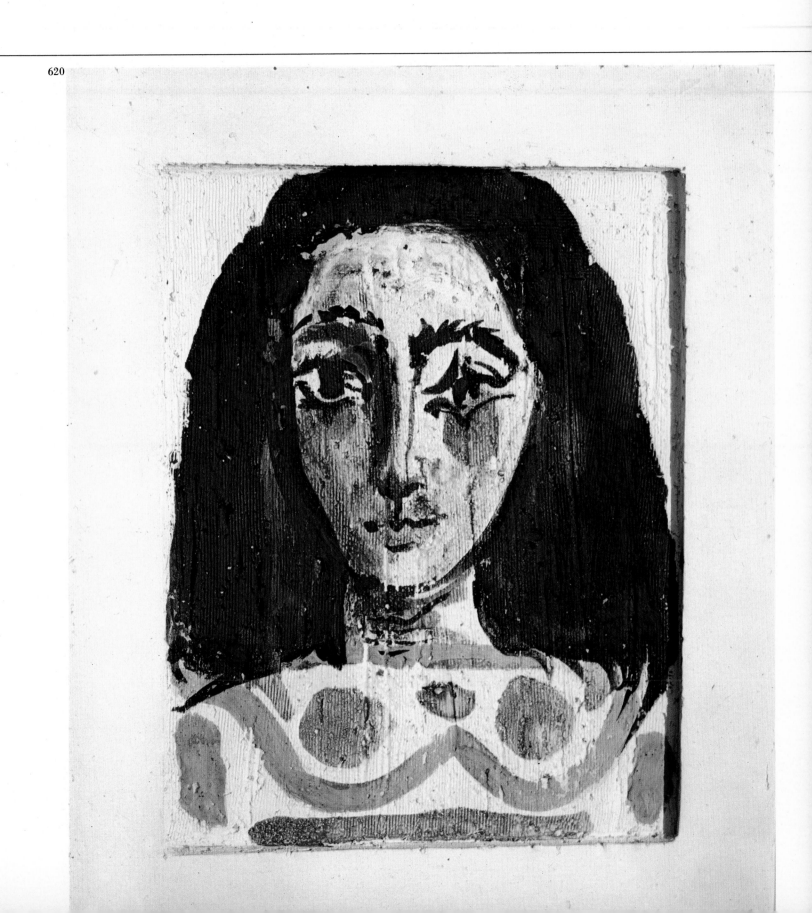

621. Tile. Erotic scene.

621

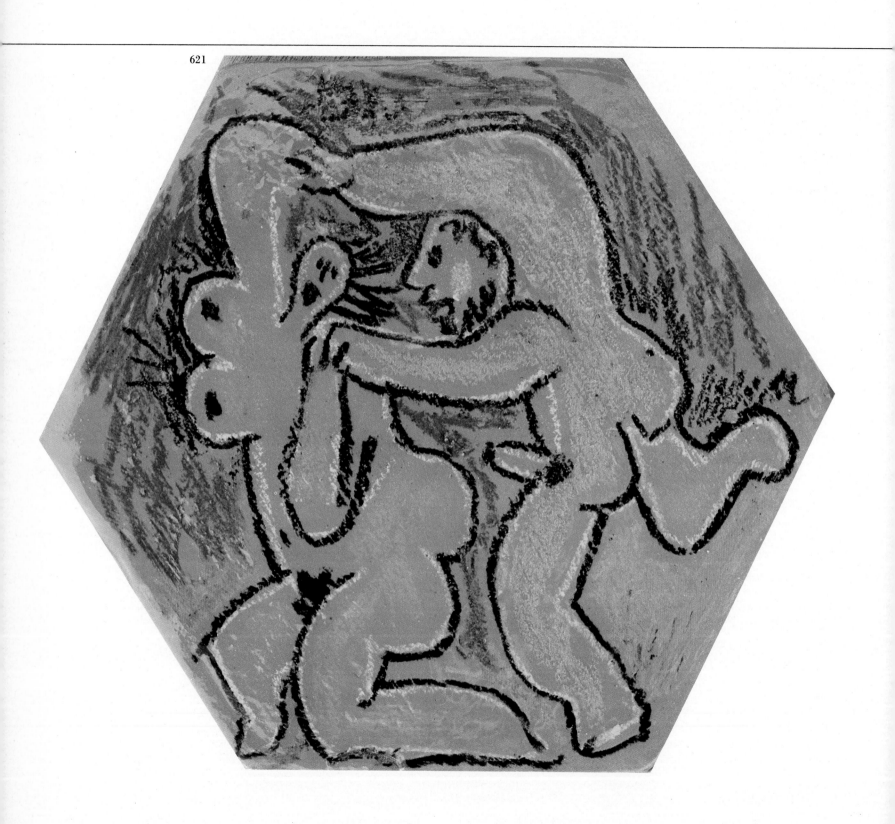

622. 4 tiles. Erotic scenes. 16.5 × 19 cm. Dated 14-8-62.

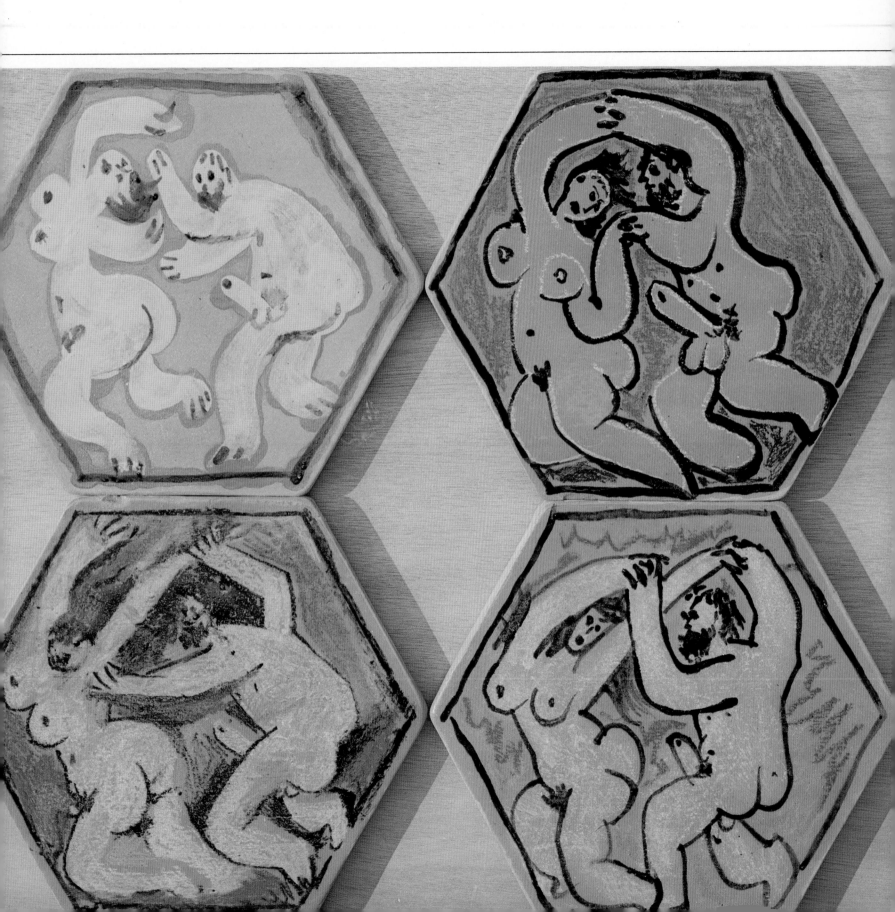

623. Tile. Erotic scene. 16.5 × 19 cm. Dated 14-8-62.
624. Tile. Erotic scene. 16.5 × 19 cm. Dated 14-8-62.
625. Tile. Erotic scene. 16.5 × 19 cm. Dated 14-8-62.
626. Tile. Erotic scene. 16.5 × 19 cm. Dated 14-8-62.

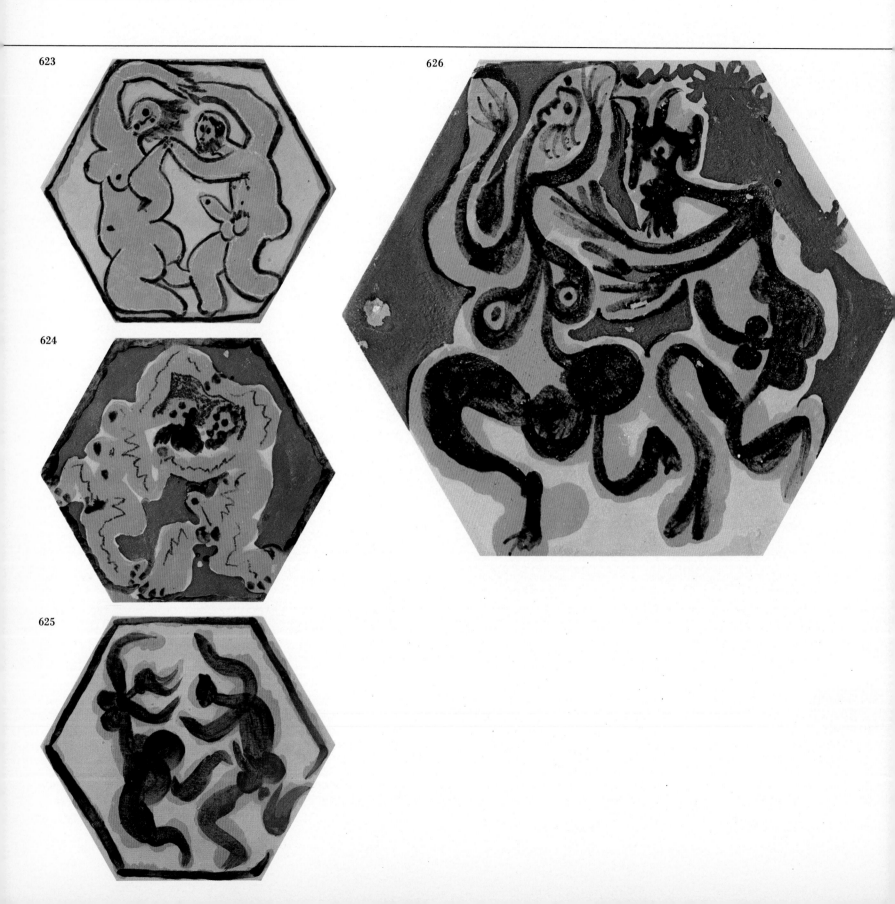

623

624

625

626

627. 4 tiles. Erotic scenes.

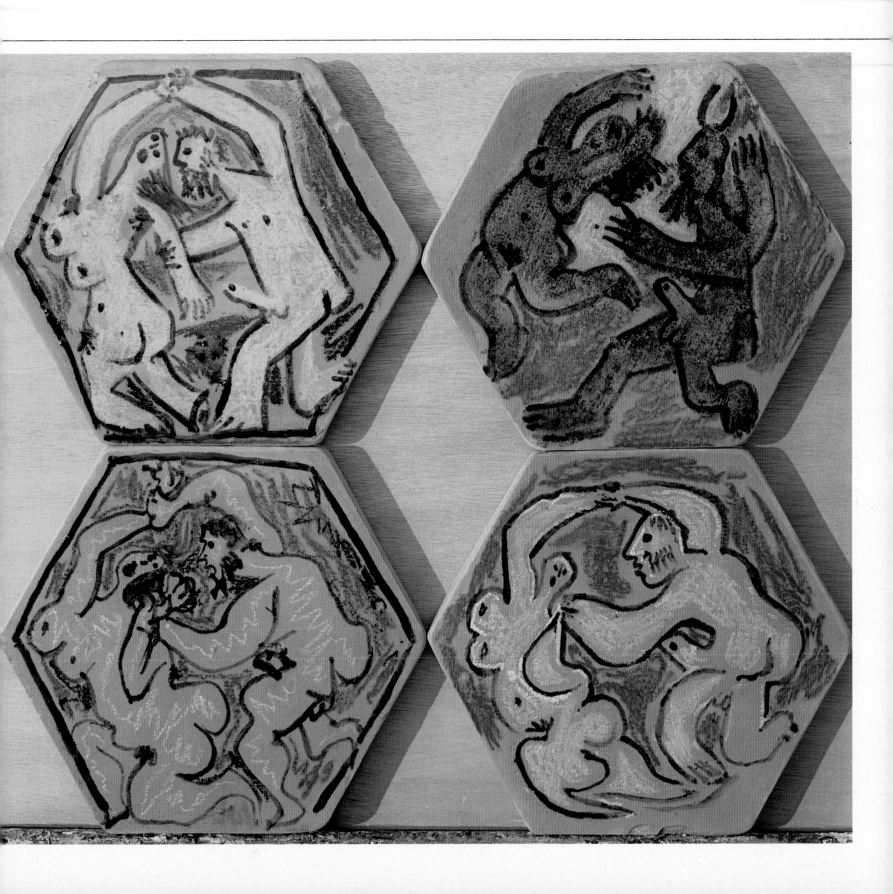

628. Composition on two planes. Face. 22 × 16 × 8 cm. Dated 12-7-62.
629. Roman tile. Face. 50.7 × 22 cm. Dated 31-7-63.

628

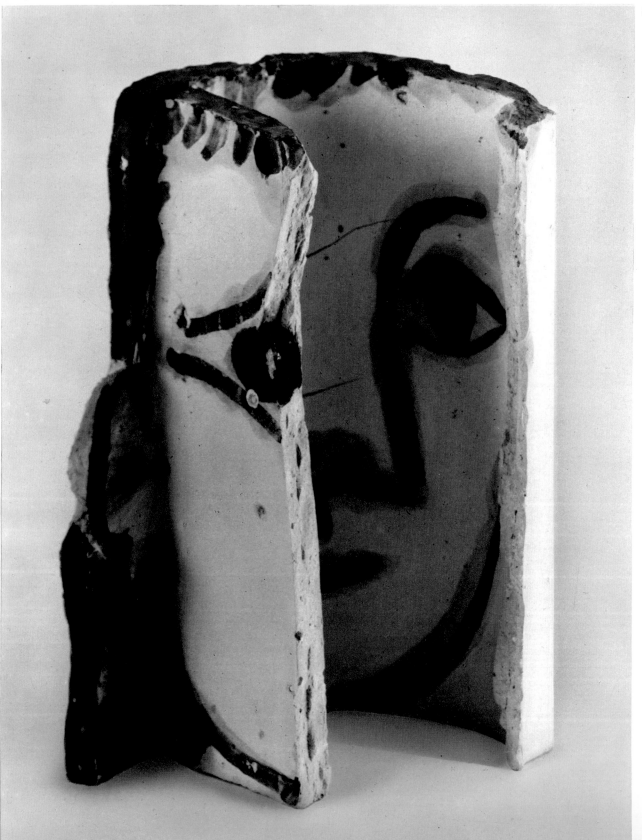

629

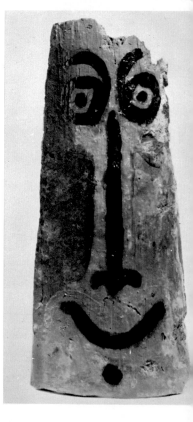

630. Large decorative panel composed of 12 glazed tiles. Composition: man and woman. Dimensions of each tile: 25×25 cm. Dated 15-6-63.

631. Roman tile. Face. 22×48.2 cm. Dated 31-7-63.

632. Round plate in colour. Cubist face in white earthenware. Diameter 42 cm. Dated 6-10-60, original print, edition.

630

632

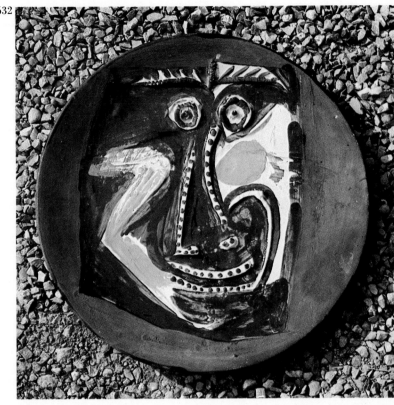

631

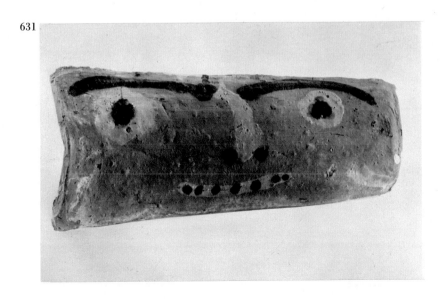

our age responds with the repeated affirmation of what is said and what has already been said, a repetition that is not meant as a declaration of impotence but as a possibility of diversification. And in this field Picasso is the master. He made us see this quite clearly in the final sequence of Clouzot's film *Mystère de Picasso*, offering us the unparalleled spectacle provided by the unconstrained modulation of a canvas in the course of painting entitled *La Plage de la Garoupe*. With the dramatic dismissal of the insignificance of this subject a hundred works appear before our eyes, conceived, tested, corrected, rejected and taken up again with an urgency of transformation and repetition, connecting and disconnecting in turn and thus making us witnesses of the anguish suffered by the man who feels driven to create.

633. Rectangular plaque. Small female bust in pink earthenware. Height
 33 cm., width 25 cm. Dated 1964, print on original linocut, edition.

633

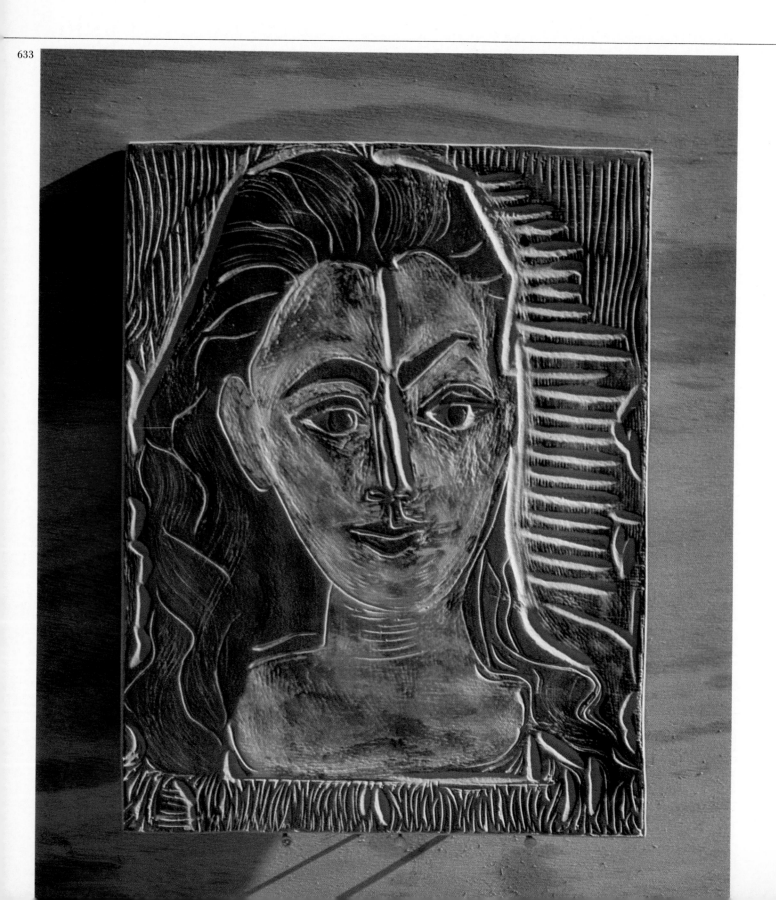

634. Rectangular plaque. Woman with fluffy hair in pink earthenware.
Height 33 cm., width 25 cm. Dated 1964, print on original linocut, edition.

634

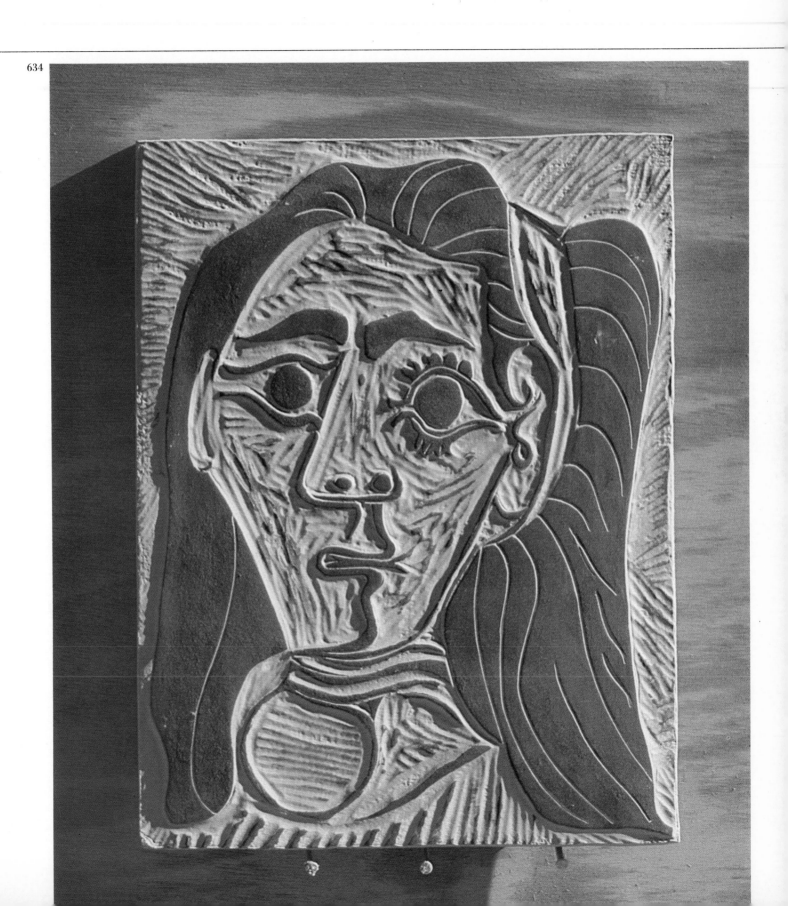

635. Rectangular plaque. Woman with flowered hat in pink earthenware. Height 33 cm., width 25 cm. Dated 1964, print on original linocut, edition.

636. Rectangular plaque. Small crowned female head in pink earthenware. Height 33 cm., width 25 cm. Dated 1964, print on original linocut, edition.

637. Plaque in pink clay. Still life, painted.

635
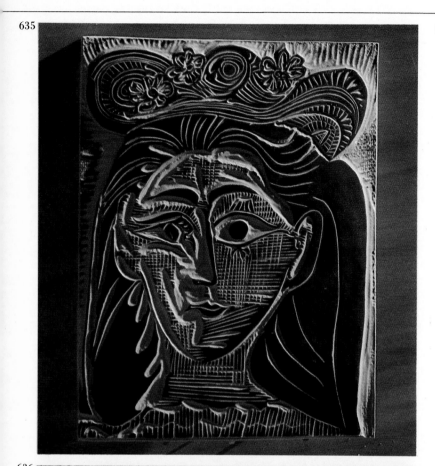

636
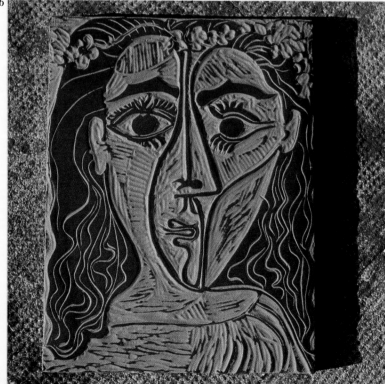

637
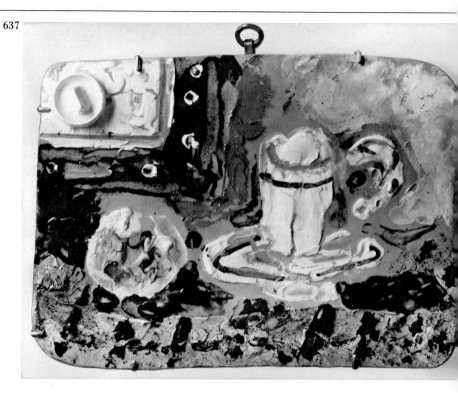

A similar exaltation is exerted and set aflame throughout the great story of one man's soul constituted by this monument erected by Picasso both to his own talent and to the greater glory of ceramics. But in this severe material nothing can be obliterated: every variation of the theme involves space, demanding an ever more daring renewal for every new departure on a new support.

This obligation within which one encloses oneself explains quite clearly the profusion of repetitions whose principal *raison d'être* is in being unlike one another. Here again we discover the effect of the principles recently admitted which demonstrate that space and time are simply views of the spirit. Confirming this quite Einsteinian perspective, would it not really seem that in this feverish rhythm there is perhaps a paean to freedom, intoned at the top of the artist's voice in the bursting joy of a limitless creation?

638. Rectangular plaque. Glass under lamp, in pink earthenware. Height
 33 cm. Dated 1964, print on original linocut, edition.
639. Large rectangular plaque in colours. Woman's head in trimmed hat,
 pink earthenware. Height 60 cm., width 50 cm. Dated 1964, print on
 original linocut, edition.

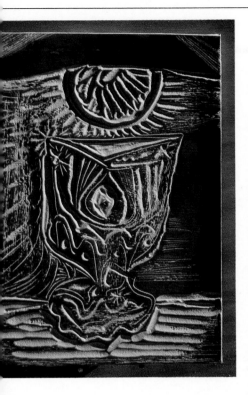

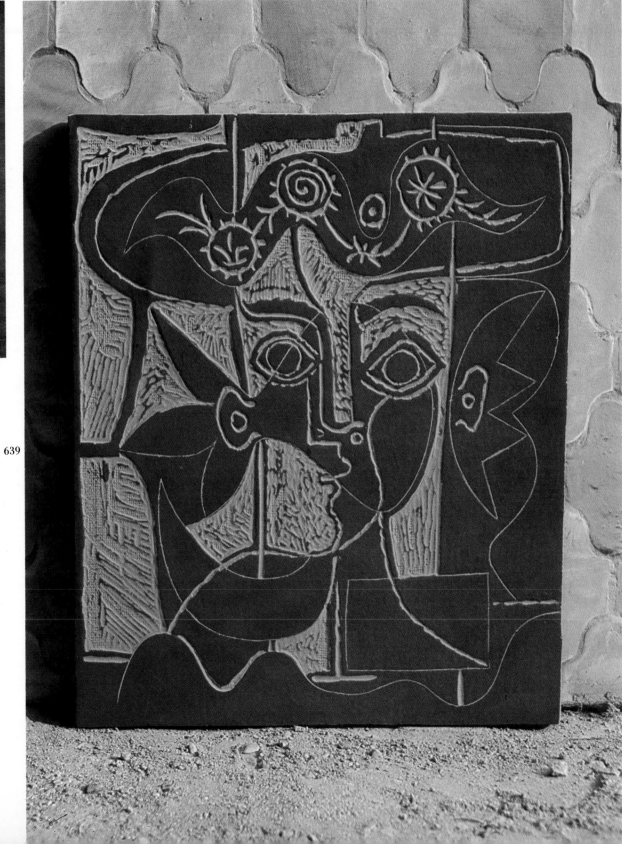

639

X. AN OVER-PUNCTILIOUS FORTUNE

This long description with its innumerable facets has now faithfully followed all the most capricious highways and by-ways along which inventive fancy loves to linger. And at this moment there comes to my mind a little play on words as a reflection, an odd, barbaric reflection, but one that may have a more particular interest in some eyes. After having held each one of these pieces in my hands, weighing them, turning them over and enjoying them repeatedly, truth compels me to declare most solemnly that the work of Picasso has not been spoiled by any *picassure*.

The coincidence of these two words might undoubtedly lead the reader to believe it a contrived effect, yet nothing could be further from the truth. The French term *picassure* is a very old one in pottery and is used to describe a defect that comes from an excess of lead and reveals itself either in the form of brown, halo-like stains or as accumulated crystallizations. But the facts exist, as incontrovertible: despite all the risks courted by Picasso in the course of his incessant experimenting, it must be confessed that he has never had occasion to cause or deal with an accident of this kind or known by this name.

At all events, even though something of the sort might easily have occurred, the fact would certainly not have failed to be admitted as one of those bad jokes which an over-punctilious fortune has always been so right to mistrust. Let us thank him, then, for what he was wise enough, once again, to avoid!

640. Large rectangular plaque. *Le déjeuner sur l'herbe*, in pink earthenware.
Height 50 cm., length 60 cm. Dated 1964, print on original linocut,
edition.

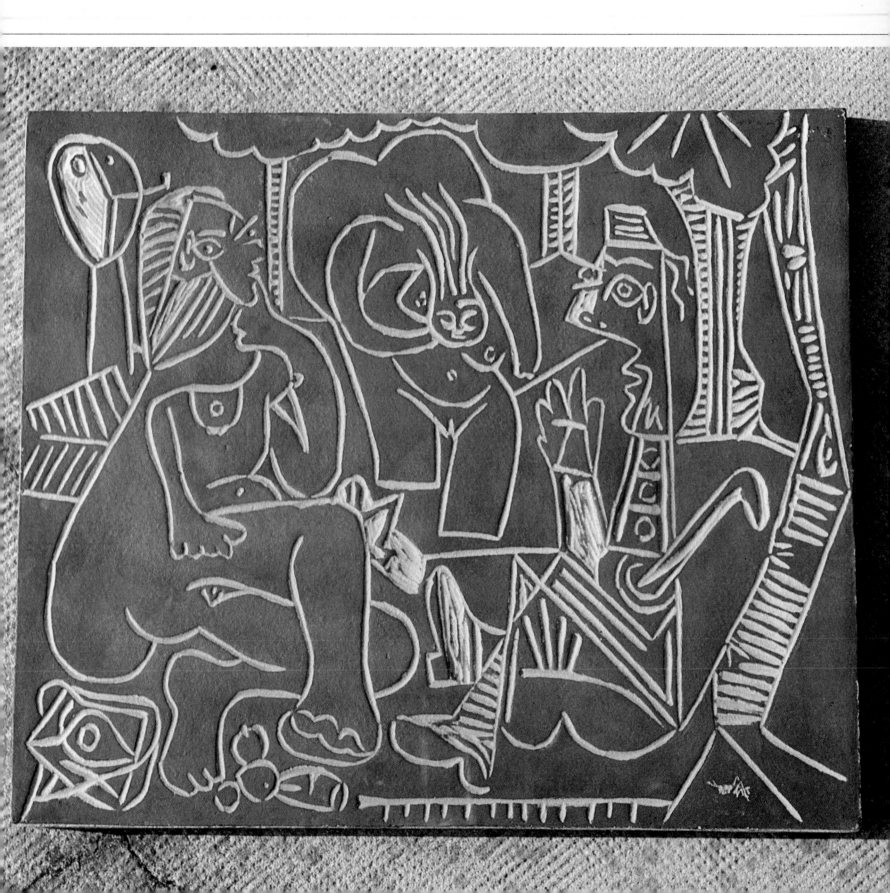

XI. FORMS OF PICASSO'S CERAMICS

With Picasso, almost by definition, nothing is ever finished and everything is in an incessant state of recommencement. Despite this perpetual turbulence, and as far as the extent of my knowledge permitted, I have here given as honest a description as possible of the most decisive —and also the most sensitive— components of what we have agreed to call his original work in ceramics.

The term 'original', as admitted by common convention, is applied to all work that comes from the artist's own hand, without the intervention of any third party and also without any intention or possibility of repetition.

By extension, however, this publicly and universally accepted term has been permitted to apply similarly to all graphic work in which the generating medium (stone, wood, copper, plaster) has indeed been delivered by the hand of the creator, but the definitive support is obtained by the intervention of a craftsman working under the artist's personal supervision, permitting editions of a limited and numbered amount of copies and thus authenticating and warranting this original series.

As regards Picasso's ceramic work, it was undoubtedly accepted that all the work thus accumulated to enrich and rejoice such spirits as can appreciate these satisfactions should be scattered for ever in museums, private galleries and even the artist's own collection.

But if such was to be the indisputable fate of that part of the work that is called 'original', in other respects it was highly desirable to consider the possibility of redevelopment, in accordance with the principle of the original repetition and under conditions of warranted authenticity, that would permit a greater diffusion of some parts of the work. It therefore became necessary to seek media and processes that would satisfy the strictest demands of the term 'original' in its severest sense.

The potters of ancient Greece seemed to have provided for this already, anticipating our intention in the method they used for making faithful reproductions of the motifs in relief that decorated the borders, bases and walls of many vases, by means of engraving in negative on rollers of hardened plaster. By passing these rollers very firmly over the walls of the vases while still soft, these ancient potters made a print in relief of the subject engraved on the rollers, which gave them a remarkably faithful reproduction. On the other hand, this method suffered from a latent weakness: the dry plaster wore out quickly after repeated contact with the moist ceramic paste. But it was immediately evident that this restric-

641. Large round plate. Face seen in three-quarter profile in white earthenware. Diameter 42 cm. Dated 17-1-65, original print, edition.

642. Large round plate. Face seen full-face in white earthenware. Diameter 42 cm. Dated 17-1-65, original print, edition.

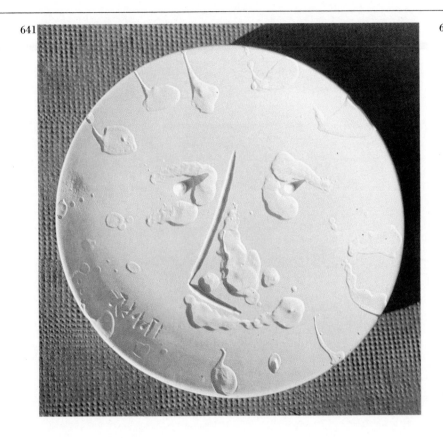

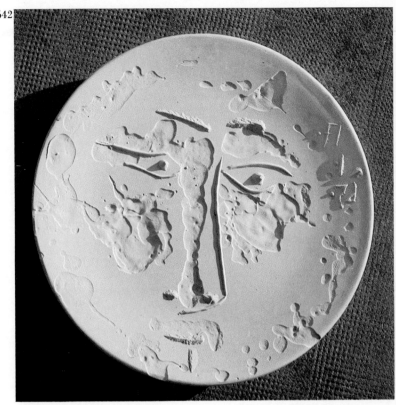

tion could become an excellent guarantee of a natural limitation of the edition by wear, thanks to the very nature of the process.

The essence of this method consisted in obtaining a good engraving on an extremely fine plaster and only gradually conducting the operations to allow the mould to dry.

And so, after our recent adventures in the world of sculpture with all its attributes, we were now beginning on an equally authentic footing a new chapter of Picasso's work in engraving.

And engraving it is. For this work, by reason of what it contributes and what it contains, must certainly be considered an integral part of Picasso's total graphic work.

Regarding this new possibility of expansion, we must first of all consider the capacity of a particularly inquisitive spirit that brought to ceramics a surplus of enthusiasm of the most astonishing kind. For many people ceramics merely evokes the idea of a pot. That is part of the truth. We must remember, however, that man's ingenuity has not yet finished making use of all that can be offered, in its very nature, by such complex simplicity. Since the first pot there has been a whole world of continual innovation.

In the business that now concerns us the most satisfactory conditions of employment were quickly decided, with Picasso's scrupulous obstinacy. Once the procedure was properly settled, a new era could begin.

Once any form has been conceived, it must first of all be modelled in its negative in plaster, which is called the mould. This piece is precisely

the inverse volume of an object in space, void being replaced by mass and vice versa. Once this negative mould has been thoroughly dried and hardened, all that remains to be done is to incise, on the wall thus prepared, the grooves that will form the engraving. The positive of this engraving will be its inverse: a relief.

Here, indeed, we have a process identical with that used in dry-point engraving, in which the graver incises the motif on the plate, from which, after inking, it will be transferred to its support.

In this case the plastic support is a sheet of paste trimmed and smoothed for the purpose, which is pressed on to the plaster and adopts all the irregularities produced by the engraving. It is of interest, nevertheless, to emphasize the fact that this plaster surface is capable of receiving relief as well as plaster: all one has to do is deposit liquid plaster on it while it is setting, the liquid plaster immediately becoming an integral part of the other. Suitably placed, this relief can still be worked, chiselled and modified at will. It will, of course, come out as a hollow on the positive. Thus with the same mould we can both engrave the surface and at the same time set off this engraving with a suitable relief. The term 'ceramic engraving', then, must be considered an exact description, on account of the similarity of its principles and operations to those of all the other processes used.

The year 1950 saw the beginning of a collection intended to present a wide range of pieces on different themes and of varying degrees of importance. For each of these pieces it was necessary to make a careful preliminary study of its possibilities, in order to make the operations easier and preserve its authentic character. This was done quite successfully.

At the beginning of this new venture over a hundred subjects were presented; an extremely interesting collection, such as had never before been produced. Among the most celebrated pieces we should not fail to mention:

A series of large vases, 80 centimetres in height, with a bulbous base supporting straight, widening sides, in pink biscuit glaze. The decoration consisted of four female nudes embracing the vase, the waist of each following that of the vase itself. The design was engraved with a stylet on a form in freshly-worked paste and transferred by casting. An edition of 25 copies was produced and was soon exhausted. The moulds were then used for another edition, intended to be added to the stock of original works: the chaste nudity of the four naked women was covered with 'garments' that seemed even more shocking and draped in flowery transparencies. These were followed by a series of vases of similar form and dimensions, which presented the same design in the guise of dancers in Orphic attitudes. The same engraving process and the same number of copies.

An edition of 50 pots modelled in the shape of a woman's head crowned with flowers, in white biscuit glaze. Picasso insisted on personally signing all the copies in this edition with indelible oxide. The mould of this edition was re-employed for various artist's proofs embellished with repainted and re-fired ornaments and added to the stock of originals.

An edition of 50 sets of 8 plates each, representing 8 bull-fighting scenes: the parade, passes with the cape, picadors, *banderilleros*, passes with the *muleta*, a tossing, a death-thrust and a dead bull being dragged out. This ensemble, known as the 'Pink corrida',

is composed of round plates in pink earthenware, 42 centimetres in diameter. The motifs in relief were emphasized by heightening with black oxide. The moulds of this set were also used to furnish a second version, which was produced under the same conditions. But this time the motifs in relief, instead of being accentuated with black strokes, were presented on great polychrome stains; hence the set, 'Stained corrida'.

A series christened 'White paste', consisting of 20 plates with a diameter of 40 centimetres, in white or pink biscuit glaze and with engravings or reliefs straight from the mould, with no retouching or heightening. Here we can see the demand by sculpture for the illumination that, alone, knows how to convey a sense of truth and life.

A series of 25 vases in white biscuit glaze and in the shape of a slightly flattened bowl, 50 centimetres high and 50 centimetres in maximum diameter, which were decorated with fish and birds in *roux* on a biscuit background.

Two series of 25 vases each, in white biscuit glaze and in the shape of a flattened bowl, 36 centimetres high and 46 centimetres in maximum diameter. Decorated with faces on variously fluted backgrounds.

Plaques in *chamottée* paste and in two formats, the larger 62 by 52 centimetres and the smaller 33 by 25, produced in editions of 50 and 100 copies. In this process a cast taken from a linocut is transferred to plaster moulds. There are engraved motifs in red on a black background.

The collection of 40 tiles for Easter 1969, in widely differing formats. A theme previously conceived, as already mentioned: engraved and transferred to a pink biscuit glaze, then finished with wide streaks of paint brushed on. The dimensions were 31 by 31 centimetres, 21 by 21, 17 by 17 and 16.5 by 9. The editions were of 50 or 100 copies.

Besides these masterpieces, a collection of single pieces of great variety:

'Face-plates', with a central theme of 4 interlaced profiles.

Plates with fauns playing flutes.

Great round plates with bullfighting themes: among others the plate known as the 'Corrida', with its borders peopled by a host of tiny spectators watching the central scene of Picadors.

Plate in pink biscuit glaze accentuated with white engobe, showing 2 left hands clasping a fish: motifs in relief accentuated with black oxide.

Vase with a faun's head, etc.

Many of these editions were very soon exhausted. The collection, however, constantly flowering anew, grew and broadened with the production of new editions, its interest maintained by an ever-present and topical creativeness.

Apart from the original ceramic prints as direct engravings, another way of diffusing certain parts of the work was studied and put into practice with meticulous patience under Picasso's supervision. Thus were born the collections called 'editions according to the original'. They are exclusively graphic works, carried out either in strokes or in broad streaks of paint, on motifs pricked out and fixed beforehand. And thanks to very precise reproducing processes both in the graphic work involved and in the ceramic bases employed, the greatest possible fidelity

643. Square plaque in colour. Owl's head in pink earthenware. 21.5 × 21.5 cm. Dated 12-68, print on original linocut, edition.
644. Square plaque in colour. Face with slanting features in pink earthenware. 21.5 × 21.5 cm. Dated 12-68, print on original linocut, edition.

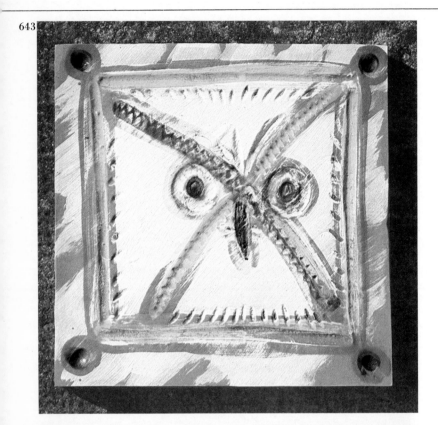

643

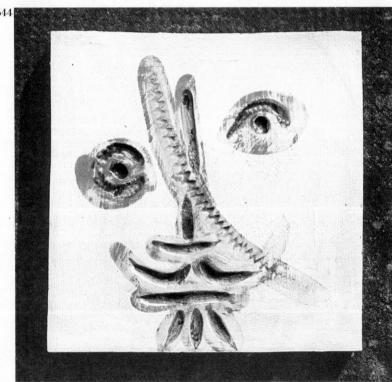

644

was achieved in transposing the effects. It was essential to keep the composition and the application of the colours very simple, for any over-exuberance would risk variations in temperature, which would be difficult to check and might destroy any hope of precision in the tone-values to be transferred.

From the beginning, therefore, the piece to be edited had been checked with regard to its particular reactions, in view of the state and conditions for which it was already intended, in such a way that the most perfect precision in the conformity of the whole could be guaranteed without any possible risk of irregularity.

This collection began with a fish service of 26 pieces, featuring 26 different studies of fish under cover on white earthenware. The edition was of 300 sets, with 26 inseparable copies each. Then came:

A fruit service, 'Fruits of Provence', consisting of 13 pieces in a square shape with slightly rounded corners. Concentrating more particularly on regional and exotic fruits, in 13 different studies. Polychrome motifs on a white background under cover. White earthenware.

A dessert service called 'Face Service' of 13 pieces, round plates featuring 13 different faces. Motifs in red and white on a dense black engobe background. White earthenware. The first artist's proof of this service was presented to Miss Rita Hayworth on the occasion of her marriage to Aly Khan.

A tall vase with 2 big handles in the shape of a great bird, in white earthenware with motifs in oxides under cover. Produced in 3 series of 25 copies each: one with bull-fighting subjects, the second representing a bird with green tones predominating and the third a

645. Square plaque in colour. Head of man with long hair in pink earthenware. 31×31 cm. Dated 12-68, print on original linocut, edition.

646. Square plaque in colour. Face with green nose in pink earthenware. 21.5×21.5 cm. Dated 12-68, print on original linocut, edition.

647. Square plaque in colour. Pink earthenware. Same print as No. 645. 31×31 cm. Dated 12-68, edition.

648. Square plaque in colour. Cubist face with white stains in pink earthenware. 21.5×21.5 cm. Dated 12-68, print on original linocut, edition.

645
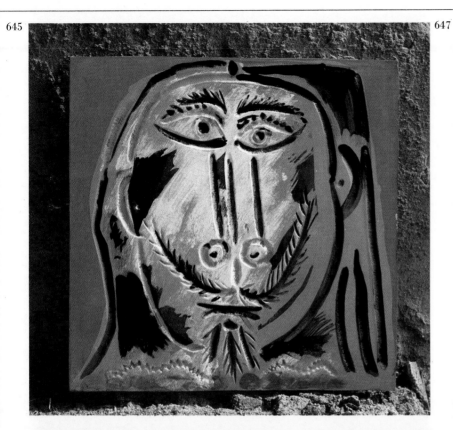

647
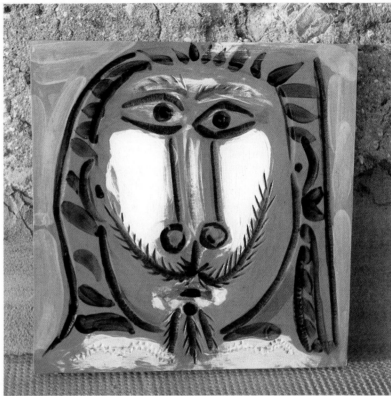

646
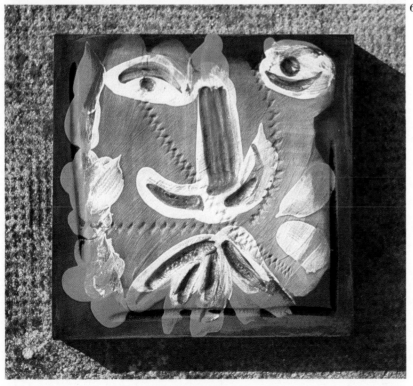

648
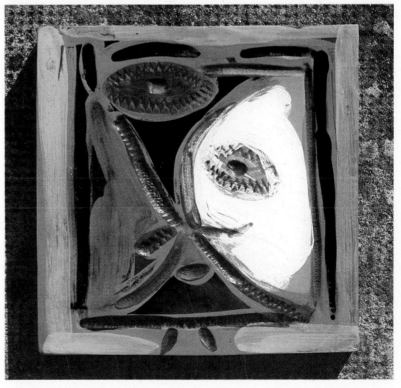

649. Six incised tiles with polychrome painting. Dated Decembe 1968,
 original prints, edition.

649

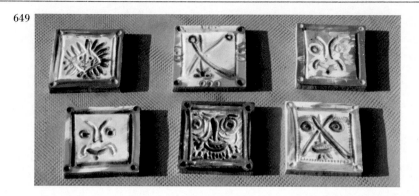

variation in red and black on the theme of unreal faces.

1963 saw the appearance of a series of 204 original plates intended for an edition devoted to birds and faces. Production was then carried out in small, numbered series according to the rate of exhaustion of the preceding ones.

The collection also includes a range of pieces differing widely in conception and execution: plates, wall-plaques, rectangular, round or oval dishes, pots and vases; pitchers of all sizes and in particular interpretations.

As is the case with the original ceramic prints, these editions form a fundamentally mobile *ensemble*, on account of the incessant withdrawal of exhausted editions and the introduction of new ones.

It would be a needless drudgery to make an inventory here of the work which, over the last twenty years, has given rise to this continual movement of the pieces multiplied and dispersed in this way. These two great media of diffusion —the original ceramic prints and the editions according to originals— are evidence of their creator's determination not to confine any of his works in a sort of inaccessible and redoubtable apotheosis. The processes employed have proved so satisfactory in every detail that even Picasso himself is often guilty of mistaking the copy for the original. It was, therefore, a genuine way of putting documents of real worth and exactitude in the hands of the most discerning of art-lovers and in the most favourable conditions.

650. Square plaque in colour. Woman's face (*Pomona*) in pink earthenware.
31 × 31 cm. Dated 12-68, print on original linocut, edition.

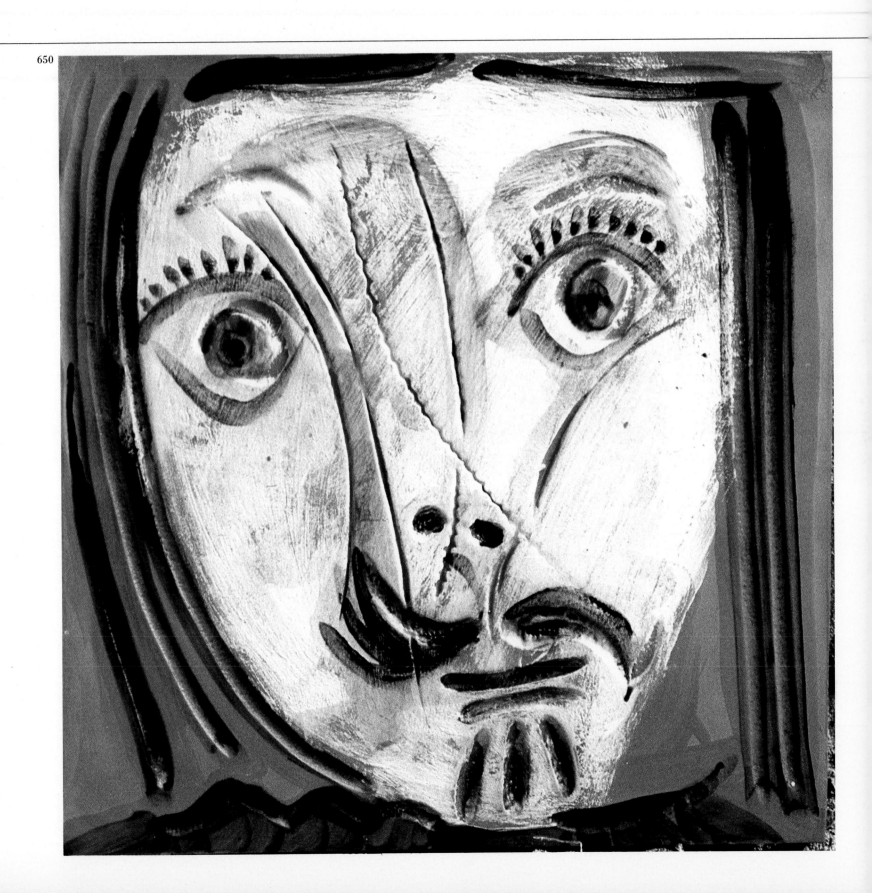

650

XII. RENDEZVOUS AT VALLAURIS

We now approach the end of a work intended to be an enunciation of the elements, intentions and living conditions that form a collection of living testimonies, and thus to help the reader to penetrate as closely as possible to the very centre of Picasso's universe of ceramics. Conditioning by events, remote or hidden motives and the surrounding influence of things and beings all influence the everyday arrangements, to say nothing of such imponderables as the principles to be submitted to or mastered— after all, in part responsible for the future character of the work.

These considerations do not claim either to determine the causes or explain the effects of the force which, at a given moment, impels a man to fulfil himself by fulfilling —in a way chosen by himself alone— the message of which he considers himself the bearer. But it is natural that such a story should be told, if only for the easier guidance, on this great journey, of any reader capable of taking an interest in a phenomenon of such far-reaching importance for the knowledge of contemporary ceramics and its future. Fleeing from the sterile puerility of anecdote, the present writer —Picasso's fellow-labourer and witness— has thought it preferable to give his account something of the rigour of authenticity rather than attempt an excessively systematic analysis, totally devoid of spontaneity or cordiality.

Such was the spirit of my intention: an endeavour to recount, perhaps with excessive enthusiasm at times, how the work of these arduous, feverish years developed day by day. There is nothing more dangerous than to attempt to make too close an examination of a condition that is woven out of the most tremendous simplicity. For the truth is —the passage of time helping to soften the remembrance of all the efforts, constraints and setbacks— that the whole of this wonderful story unfolded in circumstances of the most limpid simplicity, the most engaging serenity.

And engaging is certainly the word, for, after devoting the whole of 1947 to this new passion, Picasso gradually deserted his studio in Paris. Yielding once more to the soft enchantments of this rediscovered Mediterranean life, he settled down permanently in Vallauris in 1948, in order to continue, in peace and quiet, the work begun with such dash and fire. From that day on he was never to leave.

But a very large circle of the *habitués* of Picasso's Paris studio could not resign themselves to the idea of being thus abandoned and deprived

651. *Gus* (typical Provençal piece). Painted and incised (wood-fired kiln).
Single piece, signed and dedicated 'Pour Mme. Ramié'.

652. Reverse of No. 651.

653. Group of three plaques.

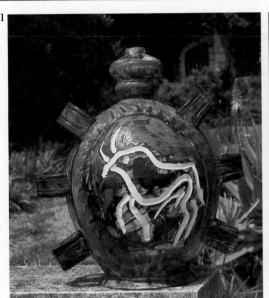

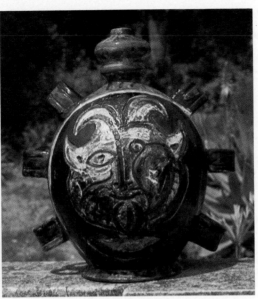

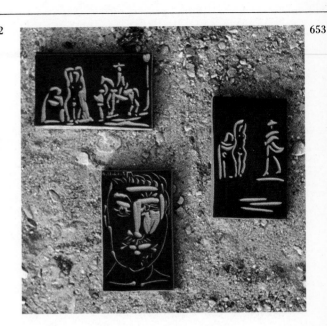

of such an irreplaceable presence. Curiosity, too, led them to come down and see for themselves how their friend handled his new vocation. Each of them made the journey to contribute ideas and prove his ever-faithful sympathy by a more or less discreet attendance. And that was how Vallauris in those days became, like Compostela in an earlier age, a great rendezvous to which everyone wanted to make his pilgrimage. And it must be admitted that such a resolve was worth the trouble in any case, if only for the health of the soul, or at the very least for the sake of constancy in friendship.

And so every pause in the work was the signal for an exchange of news, opinions, advice, projects, stories... At these moments —which, to tell the truth, were always brief— the workshop became a sort of Universal Academy of the highest standing, attended by the day's most celebrated international figures.

As a quietus to my memory and, at the same time, to emphasize the homage that each of them by his mere presence among us was paying to Picasso, to ceramics and to Vallauris at one and the same time, I trust I may be permitted to mention here the names of some of them, for the majority have since become friends of mine too.

Among the painters, sculptors and engravers: Abidine, Adam, Bazaine, Georges Braque, Victor Brauner, Marc Chagall, J. Fin, Foujita, François Hugo, Jean Hugo, Elie Lascaux, Henri Laurens, Jean Lurçat, Henri Masson, Antonio Magnelli, Henri Matisse, Miró, Manuel Ortiz, Edouard Pignon, Rodríguez, Maurice Utrillo, Vertès, Vilató, Yencesse.

Writers: Georges Boudaille, Jean Bouret, Pierre Daix, Frank Elgard, Michel Leiris, Josep Palau i Fabre, Hélène Parmelin, Maurice

654. Square plaque in colour. Face surrounded by ringlets in pink earthenware. 31 × 31 cm. Dated 12-68, print on original linocut, edition.

655. Square plaque in colour. Face surrounded by ringlets in pink earthenware (same piece as No. 654, with different colouring). 31 × 31 cm. Dated 12-68, print on original linocut, edition.

654

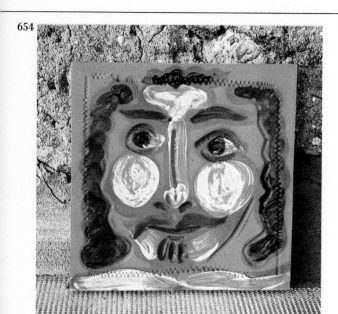

655

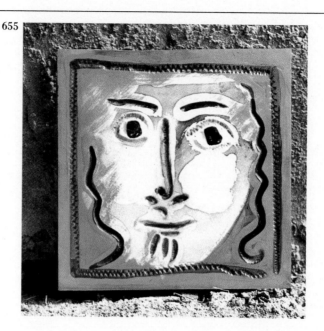

Raynal, Claude Roy, Philippe Roy, Sabartès, Vercors.

Poets: Louis Aragon, Jean Cocteau, Paul Eluard, Jacques Prévert, Pierre Reverdy, André Verdet.

Actors, photographers and cinema reporters: P. Blanchard, Brassai, J. Cartier Bresson, Georges Clouzot, Charles Chaplin, Douglas Duncan, Luciano Eimer, Jean Marais, Engle Morath, André Villers, Eric von Stroheim.

From the world of art: Jean Cassou, Ida and Marc Chagall, Georges Huysman, Illiazd, D. H. Kahnweiler, Le Corbusier, Paul Léon, Frank MacEwen, River, G. H. Rivière, Mouton Rothschild, Georges Salles, Skira, Tériade.

Musicians: Guy Bernard, Honneger, Darius Milhaud, Lily Pons, Francis Poulenc, Arthur Rubinstein, Germaine Taillefer, Maurice Yvain.

Collectors: Douglas Cooper, Ilya Ehrenbourg, Joseph H. Hirschhorn, F. D. Lasker, Henri Laugier, Sir Roland Penrose, J. K. Tannhauser, F. Wertheimer.

From the world of politics: Marcel Cachin, André Malraux, Georges Palewski, Maurice Thorez.

In the midst of this flow of such varied thoughts, which in his heart he appreciates in spite of everything, Picasso is always present and himself, meditating, discovering the nature of things, seeking the means to reveal them. To reveal them at the very moment when nobody is thinking about them —or believes in them— any longer. Gathering from near or far, sympathizing in all that may obsess, provoke or attract him, these secret or public pilgrims became a phenomenon very familiar to him.

And yet he remains a solitary creator: in the midst of this communal way of working, his constant milieu, he always surprises us with this sort of public stripping that enables him to participate and isolate himself at the same time.

Whether or not this attitude is to be interpreted as an unveiling intended to hide something as yet unformulated, it is for all of us, at any rate, a sort of necessity of total participation in the daily task, like a factor of intense liberation that is fulfilled in the creative act that awaits him.

* * *

When he talks, as he often does, of these years entirely given up to his activities in our workshop, Picasso loves to recall that time when he found in what he had chosen to do among us, not only an undoubtedly rather rustic serenity, but also an abiding sense of trust, together with the respectful peace that came from the completion of his work. Such auspicious abundance, such simplicity in the hearts of all around him, must indeed have created that inner rapture that causes man's nature to chant, in joy, his eternal need to live. I need hardly say that all the work done in Vallauris is a living reflection of those moments when Picasso, moved by some imperious necessity, proclaimed to the universe at large this message of faith and joy.

And so this peaceful work continued, while the days passed, the wheels hummed, the kilns blazed. And in parallel evolution, as the desired destiny of things worked itself out, we found that at every moment the Master was becoming a little more the Friend, a little more the one who, beyond the common concerns of the day, interested himself in what touches men closest.

For how can you spend years working like this beside a man without finally knowing what moves him, what obsesses him, what devastates or delights him? To what secret work were we all really applying ourselves? To the task of treating the oxides carefully or to the task of revealing the characters, the virtues, the plans of each and every one of us? To both, undoubtedly. And the fact that the dual progress blended intimately, with heartening strictness and increasingly exact certainty, very soon seemed the most absolutely natural of revelations.

For it was so simple, this rhythm of existence where everything continued, without falsehood or secrecy, happened so that nothing to do with any one of us could be alien to the others.

And so many years passed away like this! So great a part of the man's conscious life and unsparing thought! With gentle insistence through each passing day, by some imperceptible twist of existence we were granted, not only the inner joy of witnessing the daily work so prodigiously performed, but also the additional —and incomparable— gift of friendship. This revelation, which filled us with such joy, now finds its most fervent fulfilment in the homage we render here to the artist and the friend. To the friend indeed, but also to Picasso's total permanence, inasmuch as he seemed to feel no sense of the fleeting nature of time in his behaviour, in his nature or in his work.

One would imagine him to be a character suddenly sprung, one hardly knows when, from some land of myth where all beings are born adult, helmeted with intelligence, strapped into the severe outlines of genius and equipped with seven-league boots of imagination that take them at one bound right across those dream countries where time has no value at all. For all that really

656. Square plaque in colours. Lion's head in pink earthenware. 31 × 31 cm.
Dated 12-68, print on original linocut, edition.

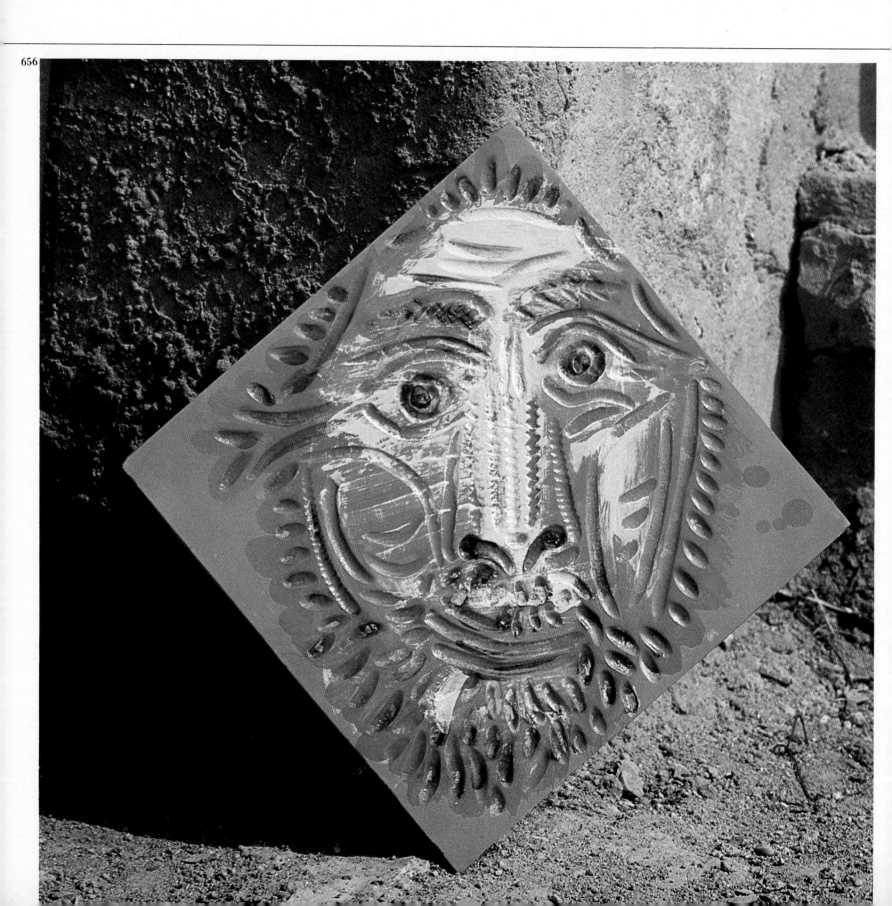

656

657. Square plaque in colour. Lion's head in pink earthenware. 31 × 31 cm.
Dated 12-68, print on original linocut, edition.

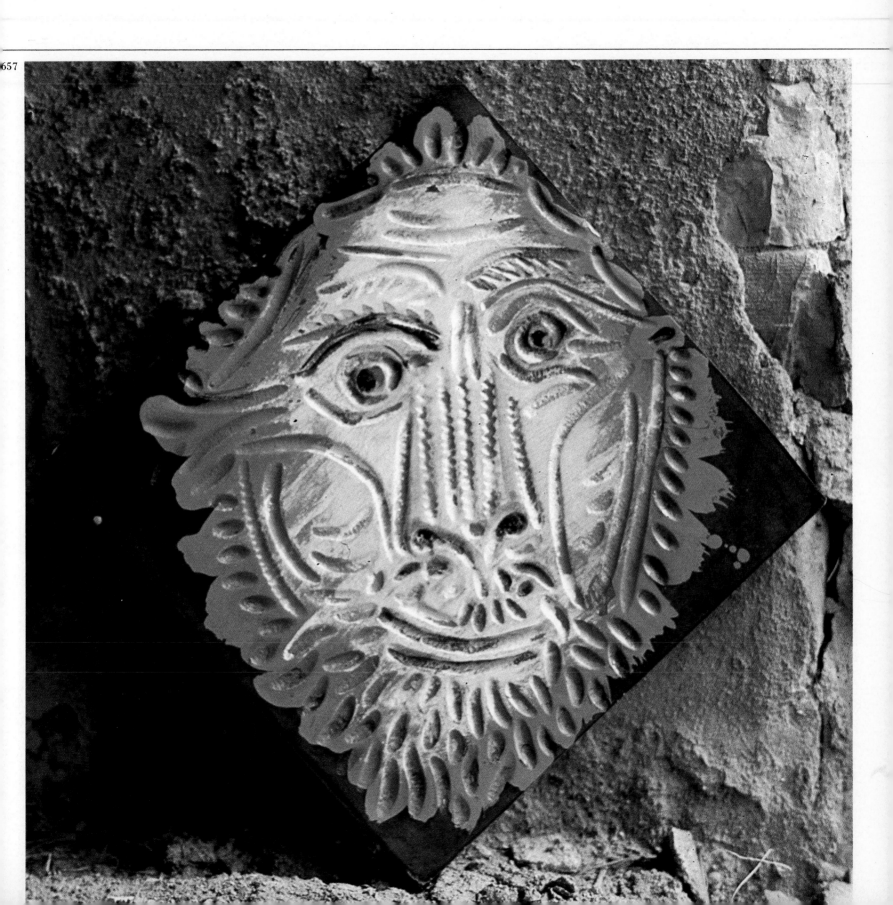

658. Square plaque in colour. Face with slanting features in pink earthenware. 21.5 × 21.5 cm. Dated 12-68, print on original linocut, edition.

659. Square plaque in colour. Dark Neptune in pink earthenware. 21.5 × 21.5 cm. Dated 12-68, print on original linocut, edition.

660. Square plaque in colour. Face with goatee in pink earthenware. 31 × 31 cm. Dated 12-68, print on original linocut, edition.

661. Square plaque in colour. Man's face in pink earthenware. 31 × 31 cm. Dated 12-68, print on original linocut, edition.

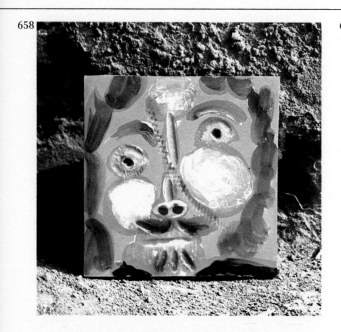

658

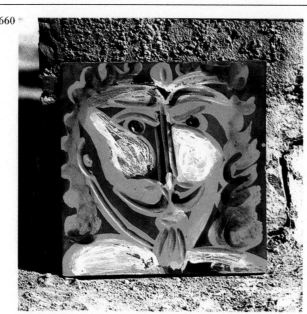

660

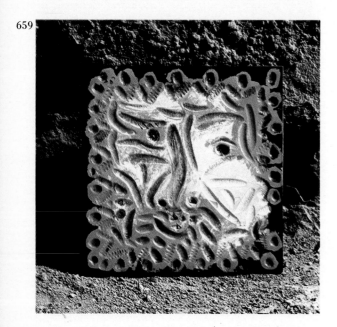

659

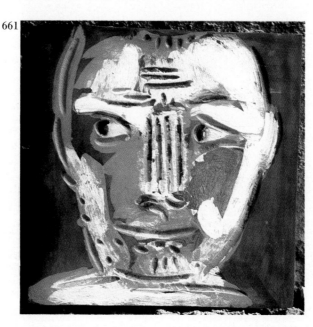

661

662. Rectangular plaque. Woman's face and 5 potter's marks on pink earthenware. 31.5 × 28 cm. Dated 13-3-71, original print, edition.

663. Rectangular plaque. Figure with curves and 7 potter's marks on pink earthenware. 31.5 × 27 cm. Dated 13-3-71, original print, edition.

664. Rectangular plaque. Face with round nose and 4 potter's marks on pink earthenware. 31.5 × 27 cm. Dated 13-3-71, original print, edition.

665. Rectangular plaque. Figure with triangle and 8 potter's marks on pink earthenware. 31.5 × 27 cm. Dated 13-3-71, original print, edition.

666. Rectangular plaque. Face with four little faces in potter's marks on pink earthenware. 31.5 × 27 cm. Dated 13-3-71, original print, edition.

667. Rectangular plaque. Face with ruff and 4 potter's marks on pink earthenware. 31.5 × 27 cm. Dated 13-3-71, original print, edition.

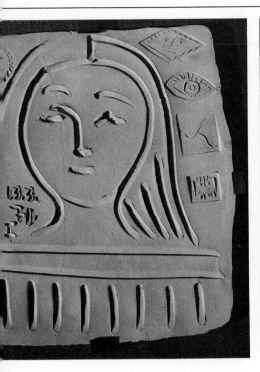

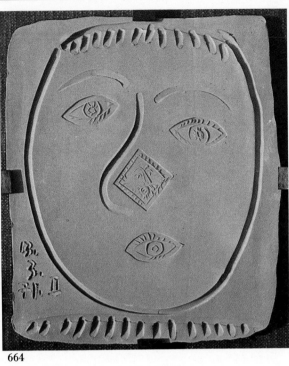
664

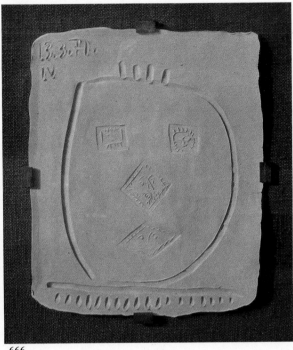
666

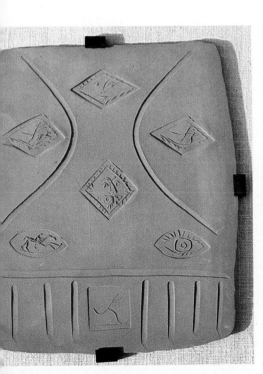
665

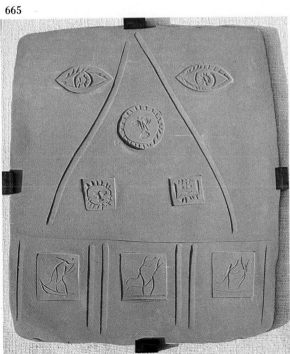

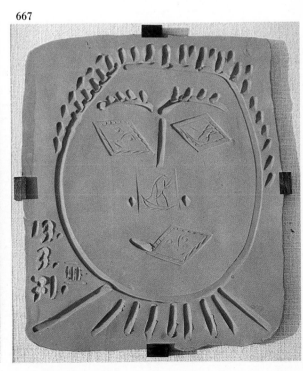
667

matters to him is the simple, essential fact of existing.

Existing in a sort of marvellous, immanent continuity that pays no heed to what time demands or to what it is granted and is thus dispensed from all temporal obligations. For it is then that he attains, in all its fullness and universality, the fevered possession of the unknowable spirit of the instant.

And it is in the very substance of his work, through the essence distilled from his language and rejecting all constraint, that Picasso protests against everything that can be measured and opposes everything that has its origins in a beginning, a limit or a contingency.

It would be just as useless to exhaust oneself in careful calculation of what has been or will be done, of what was accomplished and what might still have been accomplished. The only fact that mattered —essential, solid, authentic and moving— was that Picasso was there among us each morning, always immutable in his vehement mobility, constant in his uncoercible nature, devoured by his unremitting eagerness to possess his age.

In his *Esprit des Lois*, Montesquieu quotes Socrates as an example to all his friends. Not only as the author of *Phaedon*, of *Timaeus* or of the *Dialogues*, but rather —and above all— because when Socrates awoke every morning he gave thanks to the gods for having permitted him to exist in the age of Plato.

Yes, of Plato, the whole development of whose thought he knew, with whose entire ethical system he was familiar, whom he followed step by step in the evolution of his meditations and principles.

Montesquieu marvels at this man who, with constancy and passion, had towered over his age

with absolute authority. And he concludes by affirming that only those who can capture the spirit of their age will be found worthy of homage and respect by future generations.

This idea of the integral possession of a moment in time by the 'leading' spirit of that moment has of course already been studied, analysed and proclaimed more than once. Possession in this case, naturally, is not meant in any sordid financial sense; it means, rather, having a care for one's age, assuming and assimilating its conception, participating in its evolutionary movement, plumbing the depths of its creative activity, taking its imprint, as it were, and projecting it beyond oneself: it means, in short, in the words of Pascal, 'incessantly comparing and measuring the ephemeral greatness and eternal wretchedness of the human heart'.

Now it is evident that Picasso, in the most profound forms in which he has applied himself to this task, has successfully taken possession of the universality of his age in order to mould it and mark it deeply. That is why, like Socrates, we can rejoice each morning and give thanks to the gods for having permitted us to experience the signal favour of sharing for so long the existence of this great paladin of his age and of penetrating, through him, to the very essence of our time. And this wonderful contemporary of ours was indeed revered as a sort of Wise Man of the East who brought with him the gold, frankincense and myrrh of his presence, his thought, his work.

As for us, who have endeavoured to follow in the paths he traced, we can congratulate ourselves on having been born into an age which, despite its uncertainties and threats, its exactions and troubles, is regenerated by the privilege it has been granted of producing and fostering such

prodigal spirits, such fertile geniuses, as the one who holds all our present attention today and who has, without question, influenced his world profoundly for centuries to come.

And to this mover of so many contrary currents, who also reveals himself as a titanic purveyor of dynamic ideas activating the immanent evolution of mankind, our thanks are due for the gift he makes us of himself in the day-to-day development of his thought. With the exciting discoveries we make each day through the accomplishment of his creative mission, special days dawn when life is blessed with a new flavour and takes on a still more precious aspect.

For all of this, undoubtedly, we must be grateful to him, but still more intensely for everything in him that succeeds in transfiguring the value of man, the sureness of his judgment, the breadth of his knowledge, his faithfulness in friendship. And above all for that immensely surprising gift of his, so wholly intuitive as to be almost mediumistic, which permits him to see beyond mere events and to discover, to divine and to analyse all men and all things.

And when we consider all the reasons Picasso gave us for going beyond reason, when we evoke the memory of all the emotion and friendship his presence aroused, we must readily admit, in all simplicity, that despite ourselves we are still mute and heavy with too much feeling even now, our arms empty but our hearts filled with fervour, in that inability to which his eternal ardour reduces us, the inability to offer him anything in return but the spectacle of his own work!

It is my earnest wish that this celebration of friendship, this palpable testimony, may serve to recall above all else the feelings of affectionate attachment which, thanks to the magic of their creation, henceforth bind us all to Picasso.

Though time may boast of respecting nothing that is not built with its help, I am filled with precious certainty when I think that these exceptional years have been sincere witnesses to what the world considers, in essence and substance, most profoundly permanent: a universal creation in ceramics and an unfailing friendship.

Two things, indeed, that time, with our help, has so patiently constructed that they can never be destroyed.

WORKS IN SERIES

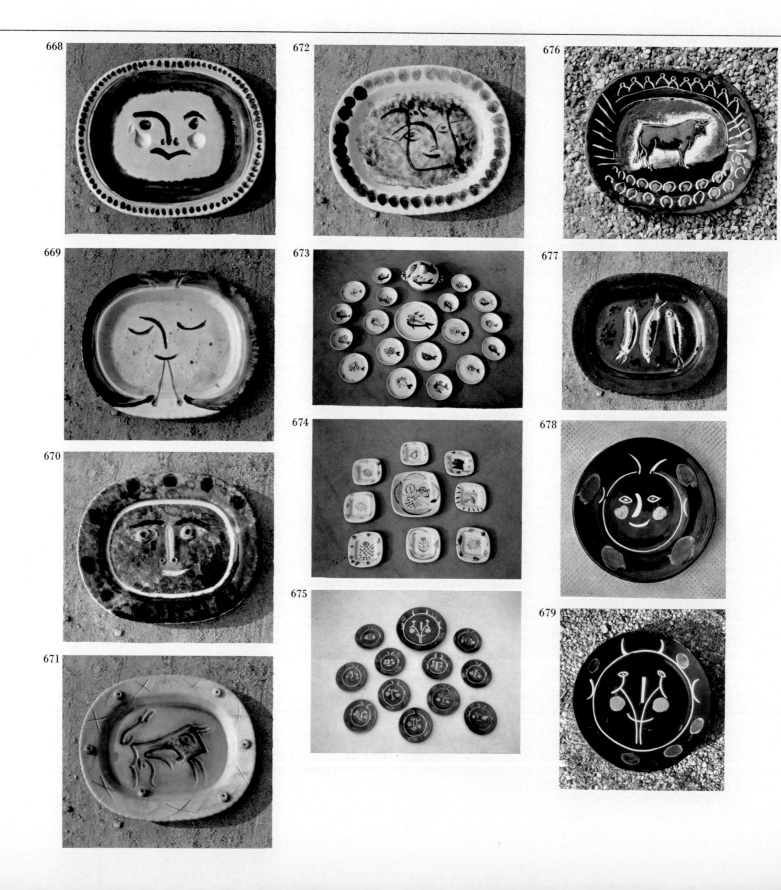

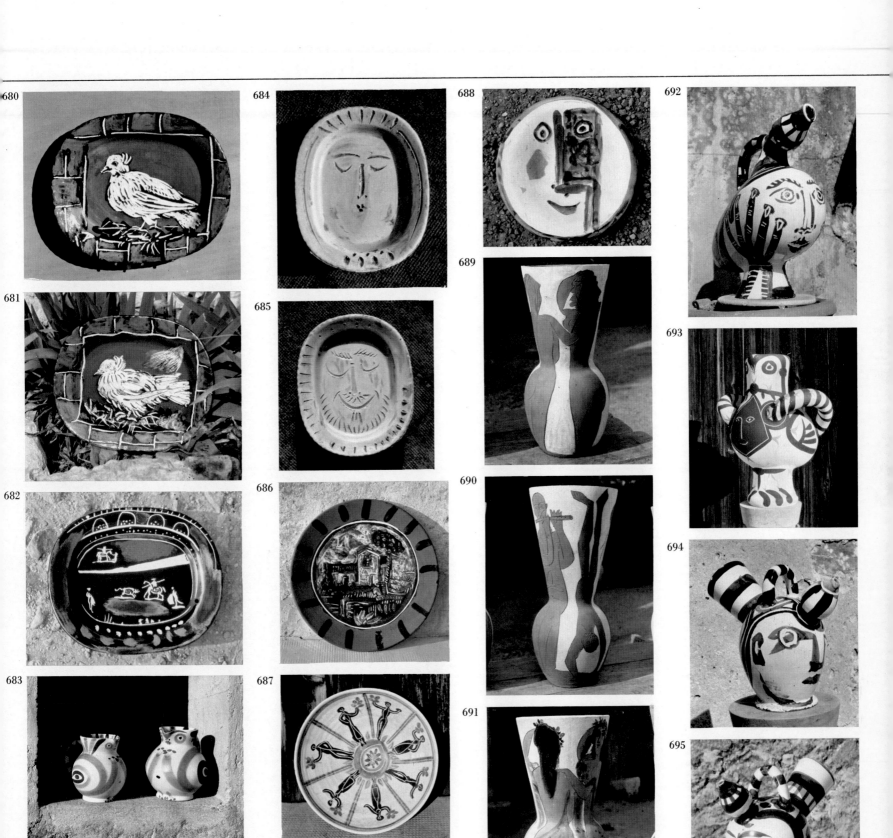

680

681

682

683

684

685

686

687

688

689

690

691

692

693

694

695

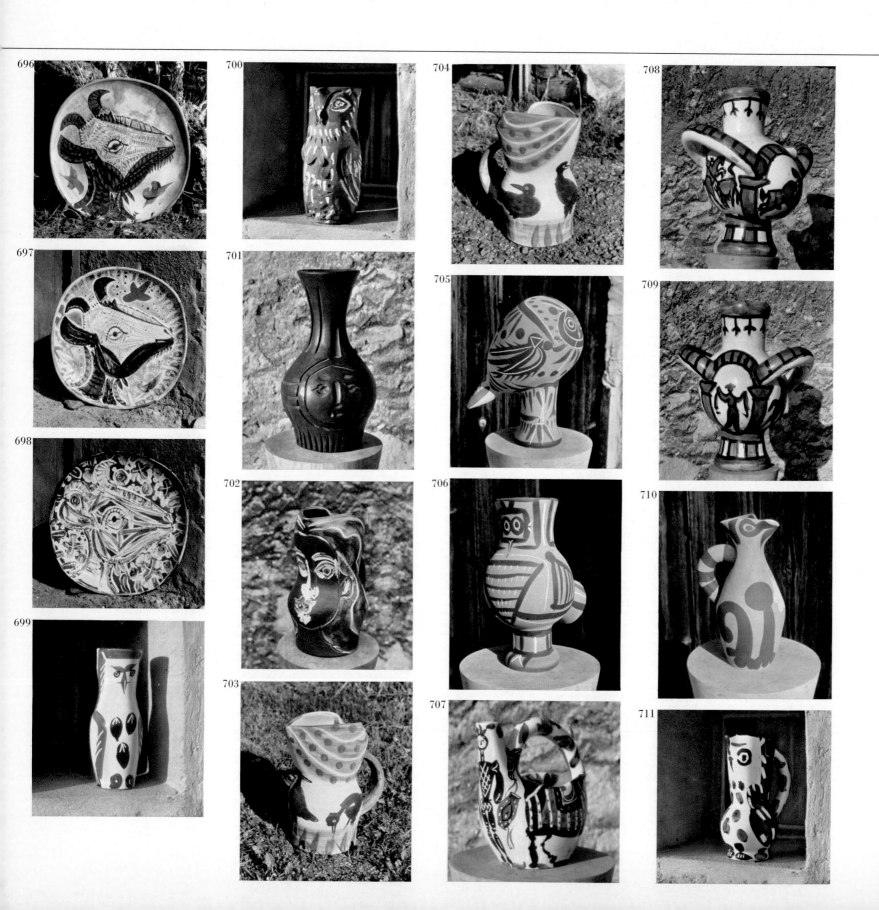

696

697

698

699

700

701

702

703

704

705

706

707

708

709

710

711

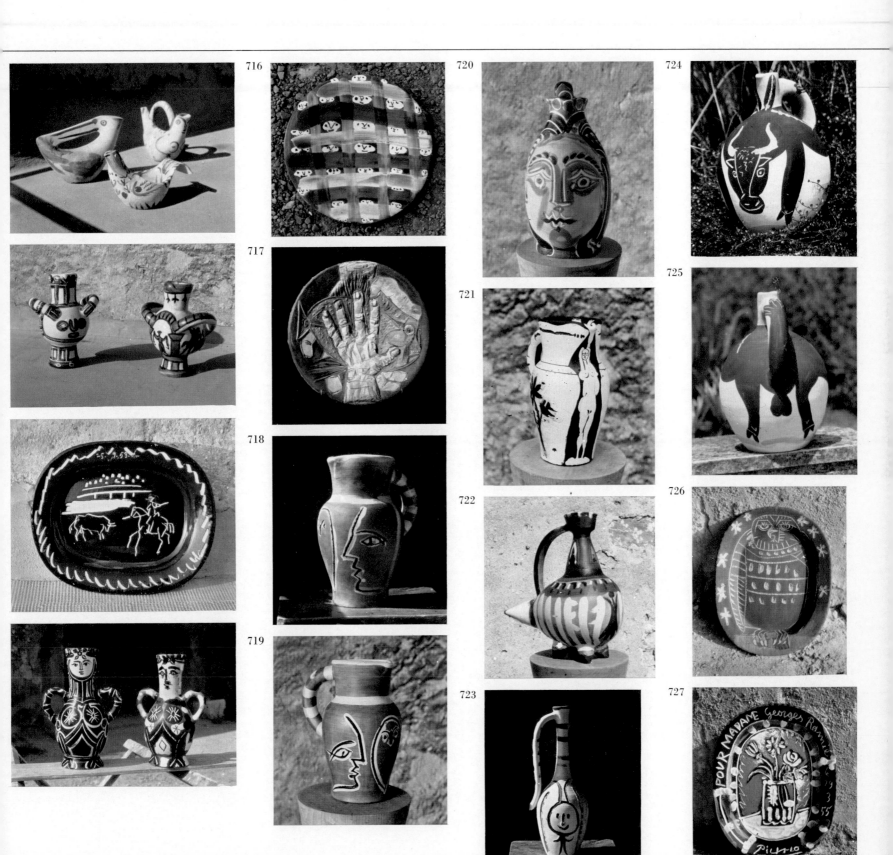

716

717

718

719

720

721

722

723

724

725

726

727

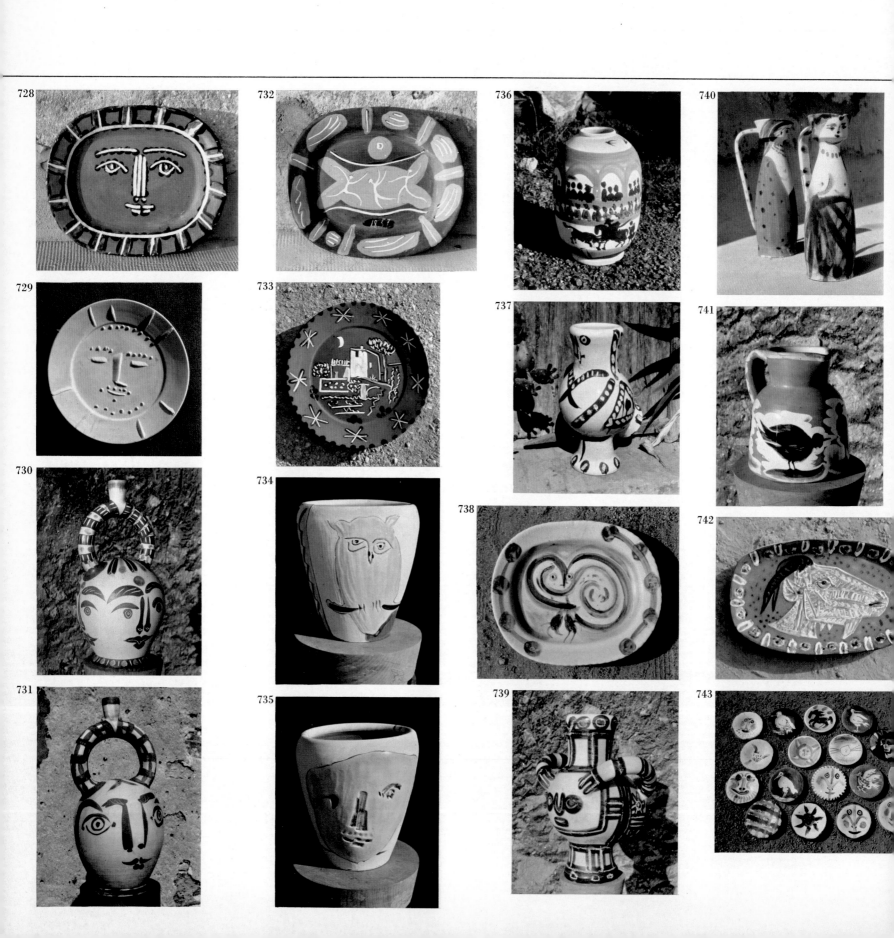

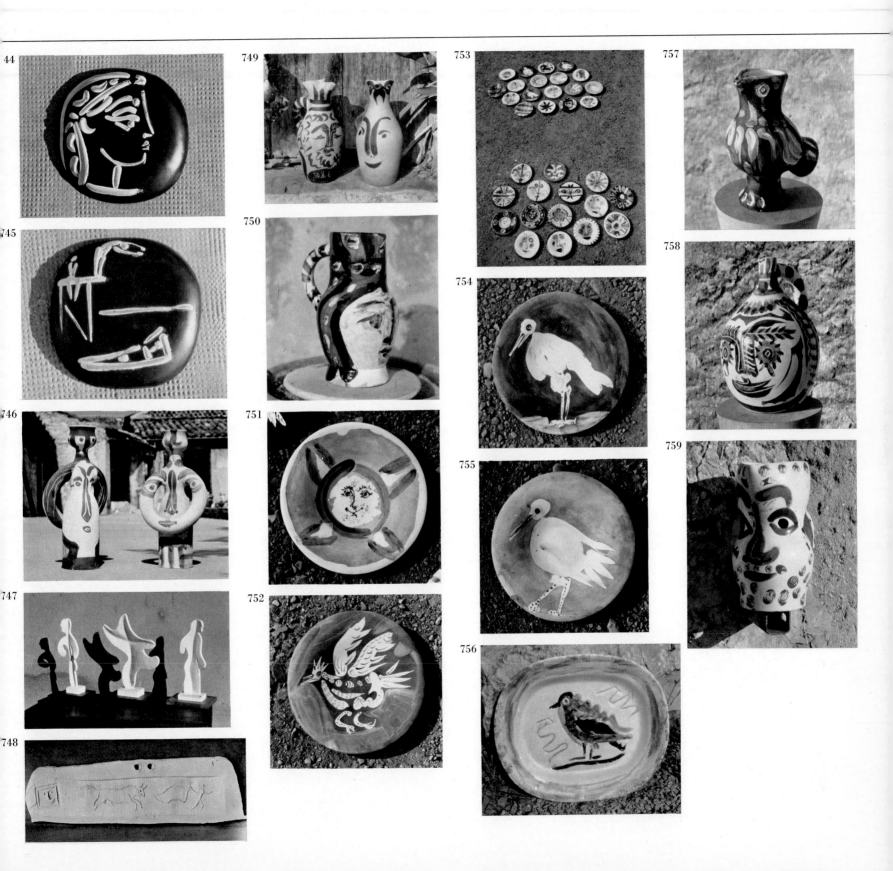

INDEX OF ILLUSTRATIONS

1. Plate. Centaur and giant fighting. 29×65.5 cm. Dated 20-10-47.

2. Plate. Faun's head. 31.5×37.5 cm. Dated 15-10-47.

3. Plate. Faun's head. 32×38 cm. Dated 11-10-47.

4. Plate. Faun's head. 32×38 cm. Dated 16-10-47-X.

5. Plate. Faun's head. 32×38 cm. Dated 10-47.

6. Plate. Woman's head. 32×38 cm. Dated 1947.

7. Plate. Bird. 32×38 cm. Dated 1947.

8. Plate. Spotted face. 32×38 cm. Dated 1947.

9. Plate. Polychrome face. 32×38 cm. Dated 1947.

10. Plate. Small incised face. 32×38 cm. Dated 1947.

11. Plate. Painted face. 32×38 cm. Dated 1947.

12. Plate. *Corrida*. 31.5×37.5 cm. Dated 1947.

13. Plate. Bearded faun's head (on blue ground). 38×32 cm. Dated 11-12-47-II.

14. Plate. Centaur with bow. 31.5×37 cm. Dated 1947.

15. Plate. Fish (in relief). 38×31.5 cm. Dated 1947.

16. Plate. Bird. 32×38 cm. Dated 2-10-47.

17. Plate. Water-melon. 37.5×31 cm. Dated 1947.

18. Plate. Bird. 31.5×38 cm. Dated 1947.

19. Plate. *A pass with the cape*. 32×38 cm. Dated 24-9-47.

20. Composition of four elements. Faun's head. 50×40.5 cm. Dated 1947.

21. Plate. Faun's head. 38×32 cm. Dated 19-1-48-IV.

22. Plate. Fish. 31×38 cm. Dated 1948.

23. Plate. Octopus. 32×38 cm. Dated 1948.

24. Plate. Black-pudding and eggs. 31×37 cm. Dated 1948.

25. Plate. Face. 32×38 cm. Dated 1948.

26. Plate. Faun's head. 38×32 cm. Dated 10-3-48-IV.

27. Plate. Faun's head. 38×32 cm. Dated 10-3-48-III.

28. Plate. *Banderillero*. 32×37 cm. Dated 1948.

29. Plate. Faun's head. 39×32 cm. Dated 10-3-48.

30. Oval plate. Faun's head. 29×65.5 cm. Dated 8-3-48-II.

31. Plaque. Woman's bust. 52×32.5 cm. Dated 1948.

32. Plaque. Woman's head. 36×33.5 cm. Dated 1948.

33. Plate. Faun's head. 32×38 cm. Dated 9-3-48-I.

34. Plaque. Coffee-pot and glass. 33.5×36 cm. Dated 1948.

35. Plate. Faun's head. 38×32 cm. Dated 12-3-48.

36. Plate. Faun's head. 32.5×38.5 cm. Dated 6-3-48-II.

37. Plaque. Fruit-dish. 33×52.5 cm. Dated 1948.

38. Vase, turned and modelled. Woman. Height 47.5 cm. Dated 1948.

39. Still life on a sphere. Height 42 cm. Dated 1948.

40. Still life on a sphere. Height 42 cm. Dated 1948.

41. Still life on a sphere. Height 42 cm. Dated 1948.

42. Still life on a sphere. Height 42 cm. Dated 1948.

43. Plate. Polychrome bird. 32×38 cm. Dated 1948.

44. Plate. Incised bird. 32×38 cm. Dated 1948.

45. Plate. The blue pigeon. 31×37 cm. Dated 1948.

46. Plate. Bird in flight. 31.5×38 cm. Dated 1948.

47. Plate. Bird. 32×38 cm. Dated 1948.

48. Plate. Owl. 31×37.5 cm. Dated 1948.

49. Plate. Bird and flowers. 32×38 cm. Dated 1948.

50. Rounded square plate. 4 Profiles. 26.5×26.5 cm. Dated 1948, original print, edition.

51. Plate. Red bird. 31×37 cm. Dated 1948.

52. Plate. Bird on decorated ground. 31×37 cm. Dated 1948.

53. Plate. Face painted in relief on grained ground. 31×37 cm. Dated 12-4-48.

54. Plate. Reverse of No. 53. 31×37 cm. Dated 12-4-48.

55. Plate. *The Horseman*. 37.5×31 cm. Dated 1948.

56. Plate. *Banderillas*. 31×37.5 cm. Dated 1948.

57. Plate. Picador. 32×38 cm. Dated 1948.

58. Plate. Centaur. 31×37.5 cm. Dated 1948.

59. Plate. Faun with pipes. 31×37 cm. Dated 1948.

60. Plate. Fish. 24.5×32.5 cm. Dated 1948, Museum für Kunst und Gewerbe, Hamburg.

61. Oval plate. Grapes. 32.5×24.5 cm. Dated 1948.

62. Plate. Cluster of grapes (blue ground). 38×30.5 cm. Dated 1948.

63. Plate. Grapes and apple. 31×37.5 cm. Dated 1948.

64. Oval plate in colour. Mottled fish. White earthenware. 34×41.5 cm. Dated 1952, several versions, original print, edition.

65. Plate. Melon and knife. 31×37 cm. Dated 1948.

66. Plate. Melon with cutlery. 31×37 cm. Dated 1948.

67. Oval plate in colour. Fish in profile. White earthenware. 25×33 cm. Dated 1951, original print, edition.

68. Oval plate in colour. Version of No. 67, original print, edition.

69. Oval plate in colour. Version of No. 67, original print, edition.

70. Vase. Condor. Height 34 cm. Dated 1948.

71. Jug. Centaur. Height 25 cm. Dated 1948.

72. Jug. Men's heads. Height 33 cm. Dated 1948.

73. Jug. Shepherds. Height 25.5 cm. Dated 1948.

74. Candlestick. *The three women*. 28×19 cm. Dated 22-1-48. Dedicated 'Pour Mme. Ramié'. 30-8-63. Not issued.

75. Vase. Woman with draperies. Height 37.5 cm. Dated 1948.

76. Modelled piece. Woman's head. Height 28.5 cm. Dated 1948.

77. Vase. Goat. Height 32 cm. Dated 1948.

78. Modelled piece. Sitting bird. 23.5×39 cm. Dated 4-2-48.

79. Jug. Painted nudes. Height 34 cm. Dated 1948.

80. Jug. Nudes. Height 34 cm. Dated 1948.

81. Sculpture. Owl mounted on a base. 20×21×13 cm. Dated 30-12-49.

82. Rounded square plate. Picador, incised in thick relief. 20×24 cm., original print, edition.

83. Plate. Bird on blue ground. 31×37.5 cm. Dated 1949.

84. Plate. Bird eating a worm. 32×38 cm. Dated 1949.

85. Plate. Dove on bed of straw, signed and dedicated to Mme. Ramié. 32×39 cm. Dated 22-12-49.

86. Plate. Bearded faun. 39×32.5 cm. Dated 8-2-49.

87. Plate. Faun's head. 38×32 cm. Dated 8-2-49.

88. Plate. Faun's head. 32.5×38.5 cm. Dated 8-2-49.

89. Plate. Faun's head. 32×38.5 cm. Dated 5-2-49.

90. Plate. Satyr's head. 35×35 cm. Dated 30-1-49.

91. Plate Picador (on pink ground). 32×38 cm. Dated 1949.

92. Plate. Picador (on blue ground). 32×38 cm. Dated 1949.

93. Plate. Centaur hunting. 31 × 37.5 cm. Dated 1949.

94. Plate. Picador (brown). 31 × 37.5 cm. Dated 1949.

95. Plate. Lance-thrust. 32 × 38 cm. Dated 1949.

96. Plate. Picador (blue). 32 × 38 cm. Dated 1949.

97. Plate. Picador (brown and white). Diameter 22 cm. Dated 29-9-53, original print, edition.

98. Rounded square plate. Polychrome picador. 24 × 24 cm. Dated 29-5-53, original print, edition.

99. Large plate. Picador, incised and painted. Diameter 42 cm., original print.

100. Turned and modelled figurine. Woman with hands hidden. 47 × 15 × 9 cm. Dated 1949.

101. Wheel-thrown and modelled figurine. Lady in mantilla. 47 × 11.5 × 7 cm. Dated 1949.

102. Pot. Other side of No. 103. Height 19 cm. Dated 15-9-50.

103. *Hercules and Omphale*. Height 19 cm. Dated 15-9-50.

104. Kiln piece. Woman standing. Painted in engobe on refractory clay. 102 × 22.5 cm. Dated 18-9-50, Vallauris.

105. Kiln piece. Man's face. Painted in engobe on refractory clay. 101.5 × 20.5 cm. Dated 23-9-50, Vallauris.

106. Ornamental panel composed of four plaques. Still life. 98.5 × 99 cm. Dated 1950, Musée Picasso, Antibes (France).

107. Plate. Man's head. 44 × 42 cm. Dated 1951.

108. Plate. Bearded faun. 35 × 35 cm. Dated 1952.

109. Sculpture. Black owl. Height 33 cm. Dated 1952.

110. Sculpture. White owl. Height 33 cm. Dated 1952.

111. Sculpture. Owl (white face). Height 34 cm. Dated 12-12-52.

112. Sculpture. Owl painted in engobe. 34 × 35 × 22 cm. Dated 11-11-51.

113. Sculpture. Black and white owl. Height 34 cm. Dated 10-11-52.

114. Two-handled vase. Double face. 39 × 48 × 20 cm. Dated 1952.

115. Jug. Parrot. Height 25 cm. Dated 1952.

116. Large vase (green). 39 × 45 cm. Undated.

117. Jug. Women at the water's edge (incised). 35 × 28 cm. Dated 9-11-52.

118. Plate. Still life (in relief). 37.5 × 31 cm. Dated 1954.

119. Oval plate. Bull charging. 30 × 66 cm. Dated 24-11-53.

120. Oval plate. Lance-thrust. 30 × 66 cm. Dated 24-11-53.

121. Oval plate. Two picadors. 30 × 66 cm. Dated 24-11-53.

122. Rounded square plate. Picador's horse rearing. 36.5 × 36.5 cm. Dated 1953.

123. Rectangular plate. Picador in bull-ring. 32 × 38 cm. Dated 1948, dedicated to Mme. Ramié.

124. Rectangular plate. Picador and bull-fighter. 31 × 49 cm. Dated 23-3-53.

125. Rectangular plate. Picador. 32 × 51 cm. Dated 23-3-53.

126. Oval plate. Lance-thrust and drawing away of the bull. 87 × 31 cm. Dated 23-3-53.

127. Square plate. Lance-thrust. 33 × 32 cm. Dated 23-3-53.

128. Plate. Lance-thrust. 37 × 37 cm. Dated 21-3-53.

129. Modelled piece in white clay. Small bull. 9 × 25 × 13 cm. Dated 1953.

130. Turned and modelled figurine. Woman standing. 39 × 10.5 × 5.5 cm. Dated 1953.

131. Wheel-thrown and modelled figurine. Woman with clasped hands. 29 × 7 × 7 cm. Dated 1953.

132. Figurine on a base, wheel-thrown, modelled and painted. Woman with unbraided hair in long dress. Height 30 cm., base 15 × 23 cm. Dated 1953.

133. Wheel-turned and modelled figurine. Woman squatting. 29 × 17 × 15 cm. Dated 1953.

134. Sculpture on turning. Ruffled pigeon. 20 × 21 cm. Dated 29-1-53.

135. Piece modelled after turning. Pigeon, incised and painted. Height 13 cm., length 23 cm. Dated 14-10-50, dedicated to Mme. Ramié.

136. Dedication of No. 135. 'Pour Madame Ramié. Son élève Picasso'.

137. Modelling on a rough piece of clay. Dove. 14 × 20 × 10 cm. Dated 7-1-53.

138. Sculpture on turning. White pigeon sitting. 12 × 17 cm. Dated 26-1-53.

139. Sculpture on turning. Grey pigeon sitting. 16 × 27 cm. Dated 27-1-53.

140. Sculpture on turning. Crested pigeon. 25 × 29 cm. Dated 27-1-53.

141. Modelling on a rough piece of clay. Dove. 15 × 25 × 13 cm. Dated 1953.

142. Modelling on a rough piece of clay. Dove with eggs. 14 × 22 × 20 cm. Dated 29-1-53.

143. Sculpture on turning. Pigeon brooding. 17 × 18 cm. Dated 27-1-53.

144. Sculpture on turning. Blue pigeon sitting. 24 × 14 cm. Dated 29-1-53.

145. Sculpture on turning. Chestnut pigeon. 14.7 × 24.5 cm. Dated 27-1-53, Museum für Kunst und Gewerbe, Hamburg.

146. Sculpture on turning. Pigeon scratching. 21 × 25 cm. Dated 27-1-53.

147. Sculpture on turning. Black and white pigeon. 22.5 × 19 cm. Dated 26-1-53.

148. Modelling on a rough piece of clay. Dove. 15 × 26 × 13 cm. Dated 1953.

149. Sculpture on turning. Blue pigeon. 30 × 25 cm. Dated 27-1-53.

150. Modelling on a rough piece of clay. Dove. 12 × 22 × 13 cm. Dated 1953.

151. Sculpture. Owl (red-streaked). Height 34 cm. Dated 22-2-53.

152. Sculpture. Owl (red and grey). Height 34 cm. Dated 7-2-53.

153. Sculpture. Owl (red and white). Height 34 cm. Dated 22-2-53.

154. Sculpture. Grey owl. Height 34 cm. Dated 1953.

155. Sculpture. Angry owl. Height 30 cm. Dated 1953.

156. Sculpture. Angry owl. Height 30 cm. Dated 1953.

157. Sculpture. Angry owl. Height 30 cm. Dated 1953.

158. Sculpture. Owl painted in engobe. 34.5 × 26 × 33 cm. Dated 5-1-53, Vallauris. Signed.

159. Sculpture. Owl (grey layer-work). Height 34 cm. Dated 1953.

160. Sculpture. Owl ochre layer-work). Height 34 cm. Dated 1953.

161. Sculpture. Owl (grey). Height 34 cm. Dated 9-2-53.

162. Vase. Three faces. 24.5 × 28 cm. Dated 5-12-53.

163. Jug. Sun (in pastel crayon). 33 × 26 cm. Dated 4-6-53.

164. Jug. Woman's head. 36.5 × 25 cm. Dated 7-8-53.

165. Jug. Beach scene. 33 × 26 cm. Dated 4-7-53.

166. Jug. Arum lilies. Height 30 cm. Dated 20-4-53.

167. Jug. Female nude. Height 32 cm. Dated 1953.

168. Vase. Centaur and face. 27 × 25 cm. Dated 15-4-53.

169. Jug. Circus scenes. 35 × 18 cm. Dated 9-1-54.

170. Vase. Other side of No. 172. Decorated with strokes. 24 × 28 cm. Dated 19-12-53.

171. Jug. Decoration painted on patinated ground. 29.5 × 24 cm. Dated 12-1-54.

172. Vase. Face in profile. 24 × 28 cm. Dated 19-12-53.

173. Plate. Fish in relief. 31 × 31 cm. Musée d'Art Moderne, Céret (France).

174. Plate. Black-pudding and eggs. 31×37 cm. Dated 28-3-51, Musée d'Art Moderne, Céret (France).

175. Cupel. *Corrida*. Diameter 17.3 cm. Dated 14-4-53, Musée d'Art Moderne, Céret (France).

176. Cupel. *Corrida*. Diameter 17.3 cm. Dated 14-4-53, Musée d'Art Moderne, Céret (France).

177. Cupel. *Corrida*. Diameter 17.3 cm. Dated 14-4-53, Musée d'Art Moderne, Céret (France).

178. Cupel. *Corrida*. Diameter 16 cm. Dated 13-4-53, Musée d'Art Moderne, Céret (France).

179. Cupel. *Corrida*. Diameter 17 cm. Dated 17-4-53, Musée d'Art Moderne, Céret (France).

180. Cupel. *Corrida*. Diameter 17 cm. Dated 17-4-53, Musée d'Art Moderne, Céret (France).

181. Cupel. *Corrida*. Diameter 16.5 cm. Dated 14-4-53, Musée d'Art Moderne, Céret (France).

182. Cupel. *Corrida*. Diameter 17 cm. Dated 14-4-53, Musée d'Art Moderne, Céret (France).

183. Cupel. *Corrida*. Diameter 16.6 cm. Dated 14-4-53, Musée d'Art Moderne, Céret (France).

184. Cupel. *Corrida*. Diameter 17.6 cm. Dated 14-4-53, Musée d'Art Moderne, Céret (France).

185. Cupel. *Corrida*. Diameter 17.5 cm. Dated 16-4-53, Musée d'Art Moderne, Céret (France).

186. Cupel. *Corrida*. Diameter 17.2 cm. Dated 17-4-53, Musée d'Art Moderne, Céret (France).

187. Cupel. *Corrida*. Diameter 16.3 cm. Dated 15-4-53, Musée d'Art Moderne, Céret (France).

188. Cupel. *Corrida*. Diameter 16 cm. Dated 15-4-53, Musée d'Art Moderne, Céret (France).

189. Cupel. *Corrida*. Diameter 17 cm. Dated 17-4-53, Musée d'Art Moderne, Céret (France).

190. Cupel. *Corrida*. Diameter 16.5 cm. Dated 17-4-53, Musée d'Art Moderne, Céret (France).

191. Cupel. *Corrida*. Diameter 17.5 cm. Dated 16-4-53, Musée d'Art Moderne, Céret (France).

192. Cupel. *Corrida*. Diameter 17 cm. Dated 16-4-53, Musée d'Art Moderne, Céret (France).

193. Cupel. *Corrida*. Diameter 17 cm. Dated 15-4-53, Musée d'Art Moderne, Céret (France).

194. Cupel. *Corrida*. Diameter 17 cm. Dated 14-4-53, Musée d'Art Moderne, Céret (France).

195. Cupel. *Corrida*. Diameter 17 cm. Dated 16-4-53, Musée d'Art Moderne, Céret (France).

196. Cupel. *Corrida*. Diameter 17 cm. Dated 16-4-53, Musée d'Art Moderne, Céret (France).

197. Cupel. *Corrida*. Diameter 17 cm. Dated 15-4-53, Musée d'Art Moderne, Céret (France).

198. Cupel. *Corrida*. Diameter 17.5 cm. Dated 16-4-53, Musée d'Art Moderne, Céret (France).

199. Cupel. *Corrida*. Diameter 16 cm. Dated 13-4-53, Musée d'Art Moderne, Céret (France).

200. Cupel. *Corrida*. Diameter 15.6 cm. Dated 12-4-53, Musée d'Art Moderne, Céret (France).

201. Cupel. *Corrida*. Diameter 16 cm. Dated 14-4-53, Musée d'Art Moderne, Céret (France).

202. Cupel. *Corrida*. Diameter 17.5 cm. Dated 16-4-53, Musée d'Art Moderne, Céret (France).

203. Cupel. *Corrida*. Diameter 15.5 cm. Dated 14-4-53, Musée d'Art Moderne, Céret (France).

204. Vase. Animal form with handle and four feet. Height 36 cm. Dated 11-1-54, Musée d'Art Moderne, Céret (France).

205. The pigeon. Dated 14-10-53, Musée d'Art Moderne, Céret (France).

206. Rounded square plate. Profile of Jacqueline. White earthenware, 41.5×41 cm. Dated 22-1-56, edition, Musée d'Art Moderne, Céret (France).

207. Jug. Female nude. Height 35.5 cm. Dated 9-1-54, Musée d'Art Moderne, Céret (France).

208. Jug. Landscape. Height 31 cm. Dated 26-9-58, Musée d'Art Moderne, Céret (France).

209. Rectangular plate. Blue ground, face painted in relief. 38.5×31 cm. Dated 29-10-47, Musée Picasso, Antibes (France).

210. Plate. Reverse of No. 209. Dated 29-10-47, Musée Picasso, Antibes (France).

211. Rectangular plate. Faun's face incised, very light colouring. 38.5×31 cm. Dated 1947, Musée Picasso, Antibes (France).

212. Rectangular plate. Small face incised on patinated ground in beige and green. 38.5×31 cm. Dated 1947, Musée Picasso, Antibes (France).

213. Rectangular plate. Face in blobs of paint with green border. 38.5×31 cm. Dated 1947, Musée Picasso, Antibes (France).

214. Rectangular plate. Face in thick dabs of white enamel on a brown ground. 38.5×31 cm. Dated 1947, Musée Picasso, Antibes (France).

215. Rectangular plate. Faun's head in wide strokes on a beige ground. 38.5×31 cm. Dated 1947, Musée Picasso, Antibes (France).

216. Rectangular plate. Faun's face in a square incised on a brown and russet ground. 38.5×31 cm. Dated 1947, Musée Picasso, Antibes (France).

217. Rectangular plate. Face with downcast eyes, in relief with a brown border. 38.5×31 cm. Dated 1947, Musée Picasso, Antibes (France).

218. Rectangular plate. Picador leaving the bull-ring, blue ground, brown border. 38.5×31 cm. Dated 1947, Musée Picasso, Antibes (France).

219. Rectangular plate. Fauns dancing, light brown on ivory ground. 38.5×31 cm. Dated 1947, Musée Picasso, Antibes (France).

220. Rectangular plate. Bull-fight scene, picador on blue ground. 38.5×31 cm. Dated 1947, Musée Picasso, Antibes (France).

221. Rectangular plate. Bull-fight scene, picador in black on grey ground with black border. 38.5×31 cm. Dated 1947, Musée Picasso, Antibes (France).

222. Rectangular plate. Bull-fight scene, picador on green ground. 38.5×31 cm. Dated 1947, Musée Picasso, Antibes (France).

223. Rectangular plate. Bull-fight scene, picador in black on grey ground with pink border. 38.5×31 cm. Dated 1947, Musée Picasso, Antibes (France).

224. Rectangular plate. Bull-fight scene, picador in brown on beige ground. 38.5×31 cm. Dated 1947, Musée Picasso, Antibes (France).

225. Rectangular plate. Brown bull on beige ground with green border. 38.5×31 cm. Dated 1947, Musée Picasso, Antibes (France).

226. Rectangular plate. Bull-fight scene, picador in brown strokes on beige ground. 38.5×31 cm. Dated 1947, Musée Picasso, Antibes (France).

227. Rectangular plate. Bull-fight scene, *banderilleros* in brown on light ground. 38.5×31 cm. Dated 1947, Musée Picasso, Antibes (France).

228. Rectangular plate. Centaurs fighting, in russet on cream ground with yellow and black border. 38.5×31 cm. Dated 1947, Musée Picasso, Antibes (France).

229. Reverse of No. 228.

230. Rectangular plate. Two blue fish on an ivory ground with brown border. 38.5×31 cm. Dated 1947, Musée Picasso, Antibes (France).

231. Rectangular plate. Two fish (1 russet, 1 blue) in relief, with brown and green border. 38.5×31 cm. Dated 1947, Musée Picasso, Antibes (France).

232. Rectangular plate. Two fish incised, ivory with touches of green. 38.5×31 cm. Dated 1947, Musée Picasso, Antibes (France).

233. Rectangular plate. Two fried eggs and a piece of black-pudding on a grey ground. 38.5×31 cm. Dated 1947, Musée Picasso, Antibes (France).

234. Rectangular plate. Two fish painted (1 blue, 1 beige) on an ivory ground with red border. 38.5×31 cm. Dated 1947, Musée Picasso, Antibes (France).

235. Rectangular plate. An aubergine and a knife on a checked ground in two different blues. 38.5×31 cm. Dated 1947, Musée Picasso, Antibes (France).

236. Rectangular plate. Still life with a candlestick on a black and white ground. 38.5×32 cm. Dated 1947, Musée Picasso, Antibes (France).

237. Rectangular plate. Still life with glass and apple, in brown, beige and blue. 38.5×32 cm. Dated 1947, Musée Picasso, Antibes (France).

238. Rectangular plate. Still life with grapes on a russet ground. 38.5×32 cm. Dated 1947, Musée Picasso, Antibes (France).

239. Rectangular plate. Still life with grapes and scissors, in beige and brown. 38.5×32 cm. Dated 1947, Musée Picasso, Antibes (France).

240. Rectangular plate. Still life with tomatoes on a russet ground. 38.5×32 cm. Dated 1947, Musée Picasso, Antibes (France).

241. Rectangular plate. Melon on a checked ground in blue. 38.5×32 cm. Dated 1947, Musée Picasso, Antibes (France).

242. Rectangular plate. Brown bird on green ground with blue border. 38.5×32 cm. Dated 1947, Musée Picasso, Antibes (France).

243. Rectangular plate. Owl incised on a brown ground with touches of beige. 38.5×32 cm. Dated 1947, Musée Picasso, Antibes (France).

244. Rectangular plate. Owl incised on a beige ground with touches of green. 38.5×32 cm. Dated 1947, Musée Picasso, Antibes (France).

245. Jug. Female busts in matt paint. Height 25 cm., width 14 cm. Dated 1947, Musée Picasso, Antibes (France).

246. Jug. Other side of No. 247.

247. Jug. Green floral motifs and white enamel. Height 24 cm., width 10 cm. Dated 1947, Musée Picasso, Antibes (France).

248. Jug. Decorated with female nudes in glossy black and white. Height 24 cm., width 10 cm. Dated 1947, Musée Picasso, Antibes (France).

249. Jug. Decorated with a goat in matt patina. Height 25 cm., width 13 cm. Dated 1947, Musée Picasso, Antibes (France).

250. Other side of No. 249. Piper.

251. *Bourrache* (Provençal wine-jug). Floral decoration in black and ivory on patinated ground. Height 60 cm., width 30 cm. Dated 1947, Musée Picasso, Antibes (France).

252. Large bird with two handles. Decorated with superimposed faces. Height 49 cm., width 30 cm., length 33 cm. Dated 1947, Musée Picasso, Antibes (France).

253. Large piece composed of four elements forming a bird. Height 71 cm., width 18 cm., length 35 cm. Dated 1947, Musée Picasso, Antibes (France).

254. Other side of No. 253.

255. Turned, modelled and painted piece. Condor in russet and brown. Height 39 cm., length 41 cm., width 15 cm. Dated 1947, Musée Picasso, Antibes (France).

256. Turned piece. Owl, eyes in relief, yellow lead sulphide glazing. Height, 22 cm., length 25 cm., width 12 cm. Dated 1947, Musée Picasso, Antibes (France).

257. Another view of No. 256.

258. Formed piece composed of an assembly of turned elements. Bull on pink earth ground. Height 37 cm., length 37 cm., width 23 cm. Dated 1947, Musée Picasso, Antibes (France).

259. Formed piece. Kid, decoration painted in engobe. Height 32 cm., width 15 cm., depth 28 cm. Dated 1947, Musée Picasso, Antibes (France).

260. Other side of No. 258.

261. Turned, modelled and painted piece. Woman, engobe decoration under beige-brown glaze. Height 30 cm., width 13 cm., depth 13 cm. Dated 1947, Musée Picasso, Antibes (France).

262. Other side of No. 261.

263. Formed piece composed of an assembly of turned elements. Grey and black bird. Height 38 cm., width 12 cm., depth 29 cm. Dated 1947, Musée Picasso, Antibes (France).

264. Other side of No. 263.

265. Turned, modelled and painted piece. Woman with long neck in pink and black clay. Height 28 cm., width 9 cm. Dated 1947, Musée Picasso, Antibes (France).

266. Turned and assembled piece. Woman with amphora, engobe decoration on natural ground. Height 45 cm., width 32 cm., depth 14 cm. Dated 1947, Musée Picasso, Antibes (France).

267. Other side of No. 266.

268. Turned, modelled and incised piece. Woman in ivory and brown under glaze. 35×11×11 cm. Dated 1947, Musée Picasso, Antibes (France).

269. Other side of No. 268.

270. Turned, modelled and painted piece. Woman, 29×9×7 cm. Dated 1947, Musée Picasso, Antibes (France).

271. Square plate in colour. Still life with spoon in white earthenware. 33×33 cm. Dated 22-12-52, original print, edition.

272. Provençal *bourrache*. Faun playing pipes. 59×33 cm. Dated 6-10-47, signed and dedicated 'Pour Mme Ramié'.

273. Other side of No. 272. Centaurs fighting.

274. Provençal *bourrache*. Polychrome decoration with woman and flowers, Musée de St.-Étienne (France).

275. Plate. Figures in matt finish on green ground. Diameter 23 cm. Dated 23-3-53.

276. Round bowl in colour. Hands on fish in pink earthenware. Diameter. 31.5 cm. Dated 1953, original print, edition.

277. Oval plate. Coloured variation on Nos. 67, 68, 69 (obverse). Width 25 cm., length 33 cm. Dated 1949, original print, Museo de Cerámica de Barcelona (Spain).

278. Oval plate. Coloured variation on Nos. 67, 68, 69 (obverse). Width 25 cm., length 33 cm. Dated 1948, original print, Museo de Cerámica de Barcelona (Spain).

279. Rectangular plate. Water-melon with knife and fork. Width 30 cm., length 37 cm. Dated 1949, Museo de Cerámica de Barcelona (Spain).

280. Rectangular plate. Dove on bed of straw. Width 32.5 cm., length 38.5 cm. Dated 1949, Museo de Cerámica de Barcelona (Spain).

281. Large wine-jug (Provençal *bourrache*). Decorated with faces. Height 61 cm., diameter at base 16 cm. Dated 3-8-52, Museo de Cerámica de Barcelona (Spain).

282. Two-handled vase. Height 19.5 cm., diameter at base 16 cm. Dated 9-5-51, Museo de Cerámica de Barcelona (Spain).

283. Jug. One handle and two spouts. 21×24×15 cm. Dated 1952, Museo de Cerámica de Barcelona (Spain).

284. Reverse of No. 50. Dedicated to S. Ramié and signed Picasso, Vallauris 17-3-35 (by mistake instead of 17-3-53).

285. Rectangular plate. Man's head incised on black ground. Width 32 cm., length 38.5 cm. Dated 14-10-53, Museo de Cerámica de Barcelona (Spain).

286. Jug. Animal form with handle and four feet. 35×17×30 cm. Dated 5-1-54, Museo de Cerámica de Barcelona (Spain).

287. Vase. Two handles. Dated 7-1-54, Museo de Cerámica de Barcelona (Spain).

288. Jug. One handle and two spouts. Dated 1954, Museo de Cerámica de Barcelona (Spain).

289. Jug. With handle. Height 31.5 cm., diameter at base 12 cm. Dated 10-2-54, Museo de Cerámica de Barcelona (Spain).

290. Jug. Circus scenes with handle. Height 35 cm., diameter at base 10 cm. Dated 9-1-54, Museo de Cerámica de Barcelona (Spain).

291. Jug. Decorated with figures dancing the *sardana*. Height 22.9 cm., diameter at base 11 cm. Dated 1953, Museo de Cerámica de Barcelona (Spain).

292. Hexagonal tile. Bull-fight scene (obverse). 4×39×20 cm. Dated 7-2-57, Museo de Cerámica de Barcelona (Spain).

293. Hexagonal tile (reverse). 4×39×20 cm. Dated 7-2-57, Museo de Cerámica de Barcelona (Spain).

294. Jug. Landscape decoration with handle. Height 31.5 cm., diameter at base 12.5 cm. Dated 10-2-54, Museo de Cerámica de Barcelona (Spain).

295. Jug. Animal form. 35×31 cm. Dated 5-1-54.

296. Two-handled vase. Decoration painted on patinated ground. 40×23.5 cm. Dated 1954.

297. Large round plate. Picador. Diameter 42 cm. Dated 11-3-53, original print, edition.

298. Round cupel, incised. Picador. Diameter 18 cm. Dated 30-1-54, original print, edition.

299. Jug. *The painter and his model*. 38×26 cm. Dated 5-1-54.

300. Jug. Other side of No. 299. *The painter and his model*. 38×26 cm. Dated 5-1-54.

301. Round cupel, incised. Bull standing. Diameter 18 cm. Dated 30-1-54, original print, edition.

302. Jug. Birds, same technique as No. 309. 38.5×26 cm. Dated 11-3-54, Museum für Kunst und Gewerbe, Hamburg.

303. Other side of No. 302.

304. Large square vase. Owl. 50×28 cm. Dated 1954.

305. Jug. Owl. Height 30 cm. Dated 1954.

306. Jug. Decoration painted on patinated ground. 29.5×24 cm. Dated 12-1-54.

307. Vase. Artist at his easel. Height 58 cm. Dated 1954.

308. Mask. Rough piece of clay, modelled and painted.

309. Vase. Circus scenes, painted in brown resist under white enamel. Height 58 cm. Dated 9-1-54.

310. Other side of No. 309.

311. Jug. Painter with two models. 27×33 cm. Dated 6-1-54.

312. Large vase. Fish and birds on white earthenware. Height 51 cm., diameter at bulge 50 cm. Dated 1955, original print, edition.

313. Oval plate in black. Face in white earthenware. Length 38.5 cm., width 32 cm. Dated 8-4-55, original print, edition.

314. Other two sides of No. 316.

315. Jug. *The painter and his model*. 28.5×25 cm. Dated 7-1-54.

316. Large square vase with panels. Figures and heads in relief on pink earthenware. Four different sides. Dated 1954, original print, edition.

317. Tile. Faun's head. 20.5×20.5 cm. Dated 24-1-56 - V.

318. Tile. Faun's head. 15.3×15.3 cm. Dated 7-7-56 - II.

319. Tile. Faun's head. 15.3×15.3 cm. Dated 1956.

320. Tile. Bearded faun. 15×15 cm. Dated 7-7-56 - IV.

321. Tile. Faun's head. 20.5×20.5 cm. Dated 24-1-56 - XI.

322. Tile. Faun's head. 20.5×20.5 cm. Dated 27-1-56 - IV.

323. Tile. Bearded faun. 20.5×20.5 cm. Dated 25-1-56 - II.

324. Tile. Faun's head. 20.5×20.5 cm. Dated 24-1-56 - IX.

325. Tile. Faun's head. 20.5×20.5 cm. Dated 24-1-56 - X.

326. Tile. Bearded man's head. 20×20 cm. Dated 24-1-56 - III.

327. Tile. Faun's head. 20.5×20.5 cm. Dated 24-1-56 - IV.

328. Tile. Faun's head on green ground. 15×15 cm. Dated 1956.

329. Tile. Faun's head in grey and white. 15×15 cm. Dated 1956.

330. Tile. Young faun. 15×15 cm. Dated 1956.

331. Tile. Young faun. 15×15 cm. Dated 9-5-56.

332. Tile. Faun's head. 15.3×15.3 cm. Dated 7-7-56 - II.

333. Tile. Young faun. 15×15 cm. Dated 1956.

334. Tile. Faun's head on grey ground. 15×15 cm. Dated 1956.

335. Tile. Faun's head on grey ground. 15×15 cm. Dated 1956.

336. Tile. Faun's head. 15×15 cm. Dated 1956.

337. Tile. Faun's head. 20.5×20.5 cm. Dated 24-1-56 - VI.

338. Tile. Bearded faun's head. 15×15 cm. Dated 1956.

339. Tile. Faun's head. 15.3×15.3 cm. Dated 7-7-56 - XV.

340. Tile. Faun's head. 15.3×15.3 cm. Dated 7-7-56 - XI.

341. Tile. Faun's head. 15.3×15.3 cm. Dated 7-7-56 - V.

342. Tile. Bearded faun. 15×15 cm. Dated 7-7-56.

343. Tile. Face. 20.5×20.5 cm. Dated 22-2-56.

344. Tile. Faun's head. 20.5×20.5 cm. Dated 24-1-56 - VIII.

345. Tile. *The workshop*. 20.5×20.5 cm. Dated 18-2-56 - V.

346. Tile. Faun's head. 19.5×19.5 cm. Dated 1956.

347. Tile. Faun. 15×15 cm. Dated 10-5-56.

348. Tile. Bearded man's head. 20×20 cm. Dated 25-1-56 - VIII.

349. Tile. Faun's head. 20.5×20.5 cm. Dated 28-1-56 - III.

350. Tile. Mask. 20×20 cm. Dated 27-1-56 - I.

351. Tile. Faun's head. 20.5×20.5 cm. Dated 24-1-56 - II.

352. Tile. Face. 20.5×20.5 cm. Dated 28-1-56 - I.

353. Tile. Bearded faun. 20.5×20.5 cm. Dated 25-1-56 - IV.

354. Tile. Faun playing pipe. 15.2×15.2 cm. Dated 11-7-56.

355. Tile. Two nudes. 20.5×20.5 cm. Dated 16-3-56.

356. Tile. Mask. 20×20 cm. Dated 27-1-56 - X.

357. Tile. Interior of the workshop 'La Californie'. 20.5×20.5 cm. Dated 18-2-56 - III.

358. Tile. Window of the workshop 'La Californie'. 20.5×20.5 cm. Dated 18-2-56 - VI.

359. Tile. Window of the workshop 'La Californie'. 20.5×20.5 cm. Dated 18-2-56 - IV.

360. Tile. Window of the workshop 'La Californie'. 20.5×20.5 cm. Dated 18-2-56 - I.

361. Tile. The painter's studio at 'La Californie'. 25.3×30.5 cm. Dated 1956.

362. Tile. In the workshop 'La Californie'. 20.5×20.5 cm. Dated 18-2-56 - II.

363. Tile. Woman squatting. 20.5×20.5 cm. Dated 10-2-56 - II.

364. Tile. Two women. 20.5×20.5 cm. Dated 16-3-56.

365. Tile. Nude squatting. 20.5×20.5 cm. Dated 16-3-56 - III.

366. Plaque. Six bearded heads. 23.5×30.5 cm. Dated 5-12-56.

367. Plaque. Nine little pictures (9 faces). 25.5×25.5 cm. Dated 5-12-56.

368. Plaque. Twelve little pictures. 30.5×25.5 cm. Dated 5/6-12-56.

369. Plaque. Bearded man. 31×25.5 cm. Dated 19-10-56.

370. Plaque. Man's head. 30.5×25.5 cm. Dated 19-10-56.

371. Plaque. Head. 30.5×25.5 cm. Dated 19-10-56.

372. Plaque. Sun-head. 30.5×25.5 cm. Dated 19-10-56.

373. Plaque. Man in striped jersey. 31×25.5 cm. Dated 19-10-56.

374. Plaque. Adolescent. 30.5×25.5 cm. Dated 19-10-56.

375. Plaque. Bearded man with spectacles. 30.5×25.5 cm. Dated 12-8-56.

376. Plaque. Boy's head. 30.5×25.5 cm. Dated 8-8-56.

377. Plaque. Bearded man. 30.5×25.5 cm. Dated 12-8-56.

378. Plaque. Bearded man in half-profile. 31×25.5 cm. Dated 12-8-56.

379. Plaque. Alfresco concert. 30.5×26 cm. Dated 14-10-56.

380. Round plaque. Head. 30.5×29.5 cm. Dated 1956.

381. Tile. Clown's head. 20.5×20.5 cm. Dated 15-2-56 - III.

382. Assembled tiles. Three figures holding hands. 46.5×46 cm. Dated 20-7-56.

383. Tile. Bearded faun. 20.5×20.5 cm. Dated 15-2-56 - II.

384. Tile. Clown's head on blue ground. 20.5×20.5 cm. Dated 15-2-56 - V.

385. Assembled tiles. Woman's head. 61×61 cm. Dated 1956.

386. Tile. Horse. 20.5×20.5 cm. Dated 25-1-56.

387. Tile. Clown's head on white ground. 20.5×20.5 cm. Dated 15-2-56 - IV.

388. Tile. Woman's head. 20×20 cm. Dated 7-1-56.

389. Tile. Lance-thrust. 15×15 cm. Dated 1956.

390. Assembled tiles. Branch in glass. 30.5×15.3 cm. Dated 1956.

391. Tile. Picador. 19.5×19.5 cm. Dated 17-12-56.

392. Tile. Picador (reverse of No. 391). 19.5×19.5 cm. Dated 17-12-56.

393. Large rounded square plate. Profile of Jacqueline, painted. Diameter 41.5 cm. Dated 1956, original print.

394. Large plaque. Head. 56.5×33 cm. Dated 1956.

395. Large plaque. Head. 56.5×32.5 cm. Dated 1956.

396. Large plaque. Head. 56.5×32 cm. Dated 1956.

397. Rounded square plate. Goat. Diameter 26.2 cm, original print, edition.

398. Rounded square plate. Another version of No. 397. Diameter 26.2 cm, original print, edition.

399. Vase with goats. Height 23 cm., diameter at top 12 cm., diameter at bulge 20 cm. Dated 6-6-52, original print, edition.

400. Other side of No. 399.

401. Large rectangular plate. Goat's head in profile (another variation). Height 31 cm., length 51 cm. Dated 5-6-52, original print, edition.

402. Tile. Face. 15×15 cm. Dedicated to Mme. Ramié.

403. Round plate. Goat's head in profile. Diameter 40.5 cm. Dated 1956.

404. Round plate in colour. Face on grid in white earthenware. Diameter 42 cm. Dated 1956, original print, edition.

405. Round plate in colour. Centaur with polychrome decoration. Diameter 42 cm. Dated 1956, original print, edition.

406. Reverse of No. 405.

407. Large round plate. White Vallauris ware. Diameter 42 cm. Dated 1956, original print, edition.

408. Rounded square plate. Black mask. 31×31 cm. Dated 1956, original print, edition.

409. Round plate in colour. Faun in white earthenware. Diameter 42 cm. Dated 1956, original print, edition.

410. Large round plate. Bull's head in white earthenware. Diameter 42 cm. Dated 6-10-60, original print, edition.

411. Rounded square plate in colour. Face of man wearing tie, in white earthenware. Diameter 25 cm. Dated 6-10-60, original print, edition.

412. Large round plate in colour. Tortured face with palm-leaves, in white earthenware. Diameter 42 cm. Dated 1956, original print, edition.

413. Large round plate. Face incised and in relief. Diameter 42 cm. Dated 1956, original print, edition.

414. Rounded square plate in colour. Bouquet with apple, in white earthenware. Diameter 24 cm. Dated 22-1-56, original print, edition.

415. Assembled tiles. Two bouquets. 61.5×91 cm. Dated 1956.

416. Assembled tiles. Figures dancing the *sardana*. 15.7×45.8 cm. Dated 1956.

417. Assembled tiles. The *sardana*. 41.2×82 cm. Dated 5-4-56.

418. Assembled tiles. Pastorale. 41.2×82 cm. Dated 5-4-56.

419. Round plate. Lance-thrust. 39×39 cm. Dated 1956, original print.

420. Large round plate in colour. Faun on horseback in white earthenware. Diameter 42 cm. Dated 1956, original print.

421. Large round plate. *Jacqueline at the easel*, in white earthenware. Diameter 42 cm. Dated 1956, original print, edition.

422. Large chequered vase. Face in white earthenware. Height 38 cm., diameter at the bulge 45 cm., diameter at the top 10 cm. Dated 1956, original print, edition.

423. Large Peking-type vase. Other side of No. 431.

424. Small convex wall plaque. Beach scene on patinated ground in white earthenware. Diameter 18.5 cm. Dated 1956, original print, edition.

425. Small convex wall plaque. Profile of Jacqueline on a light ground in white earthenware. Diameter 18.5 cm. Dated 1956, original print, edition.

426. Convex wall plaque. Two dancers on a light ground in white earthenware. Diameter 18.5 cm. Dated 1956, original print, edition.

427. Large round plate in colour. Face with leaves in white earthenware. Diameter 42 cm. Dated 1956, original print, edition.

428. Large round plate in colour. Face framed in a square in white earthenware. Diameter 42 cm. Dated 1956, original print, edition.

429. Large round plate in colour. Tortured faun's face in white earthenware. Diameter 42 cm. Dated 1956, original print, edition.

430. Large chequered vase. Other side of No. 422.

431. Large Peking-type vase. White earthenware. Height 38 cm., diameter at top 10 cm., diameter at bulge 45 cm. Dated 1956, original print, edition.

432. Another view of No. 431 (main face).

433. Tile on base. Bearded man's head. 38 × 39.5 cm. Dated 1956.

434. Tile on base. Bearded man's head (reverse of No. 433). 38 × 39.5 cm. Dated 1956.

435. Tile on base. Bearded face. 22 × 33.5 cm. Dated 1956.

436. Tile on base. Black owl with round body (other side of No. 437). 37.5 × 39 cm. Dated 1956.

437. Tile on base. Black owl with round body. 37.5 × 39 cm. Dated 1956.

438. Tile on base. Bearded face (other side of No. 435). 22 × 33.5 cm. Dated 1956.

439. Tile on base. Varnished owl (other side of No. 440). 38 × 39 cm. Dated 1956.

440. Tile on base. Varnished owl. 38 × 39 cm. Dated 1956.

441. Tile. Adult and child on the seashore. 20 × 35.5 cm. Dated 20-2-57.

442. Tile on base. Black owl on earth ground. 38 × 39 cm. Dated 1956.

443. Tile on base. Black owl on earth ground (other side of No. 442). 38 × 39 cm. Dated 1956.

444. Tile. Bull. 20.5 × 34 cm. Dated 20-2-57.

445. Tile. Dark varnished owl (other side of No. 446). 38 × 39.5 cm. Dated 1956.

446. Tile. Dark varnished owl. 38 × 39.5 cm. Dated 1956.

447. Tile. Three figures (other side of No. 450). 20.5 × 34 cm. Dated 2-3-57.

448. Tile on base. Man's head, unvarnished (other side of No. 449). 36 × 39.5 cm. Dated 1956.

449. Tile on base. Man's head, unvarnished. 38 × 39.5 cm. Dated 1956.

450. Tile. Three figures. 20.5 × 34 cm. Dated 2-3-57.

451. Tile with carving. Bearded man's head. 39 × 20 cm. Dated 1956.

452. Tile. Figure walking. 20 × 34 cm. Dated 20-2-57.

453. Sculpture. Hispano-Moresque owl. Height 34 cm. Dated 1956.

454. Tile. Musicians. 20 × 35.5 cm. Dated 26-2-57.

455. Tile. Musicians (other side of No. 454). 20 × 35.5 cm. Dated 26-2-57.

456. Tile. Three figures. 20 × 39.5 cm. Dated 6-3-57 - V.

457. Tile. Double-faced owl. 35 × 20 cm. Dated 15-3-57.

458. Tile. Two figures. 20 × 39.5 cm. Dated 6-3-57 - II.

459. Tile. Four figures. 20 × 39.5 cm. Dated 6-3-57 - VI.

460. Tile. Double-faced owl (other side of No. 457). 35 × 20 cm. Dated 15-3-57.

461. Hexagonal tile. Faun's head. 16.5 × 15 cm. Dated 1957.

462. Hexagonal tile. Bull. 15 × 16.5 cm. Dated 18-2-57.

463. Hexagonal tile. Dance. 14.5 × 14.5 cm. Dated 5-3-57.

464. Tile. Owl (triangular body) in black and white on earth ground. 34 × 20 cm. Dated 1956.

465. Tile. Owl (triangular body) in black and white on earth ground (other side of No. 464). 34 × 20 cm. Dated 1956.

466. Tile. Owl (round body) in black and white on earth ground. 33 × 20 cm. Dated 1956.

467. Tile. Owl (round body) in black and white on earth ground (other side of No. 466). 33 × 20 cm. Dated 1956.

468. Lamp-shade. Parrot. Height 36.4 cm. Dated 1960.

469. Tile. Owl in black and white on earth ground (other side of No. 470). 34 × 20.5 cm. Dated 1957.

470. Tile. Owl in black and white on earth ground. 34 × 20.5 cm. Dated 1957.

471. Plaque. Bacchic scene. 25.5 × 30.5 cm. Dated 9-3-57.

472. Plaque. Other side of No. 473. 25.5 × 30.5 cm. Dated 8-3-57.

473. Plaque. Player, dancer and drinker. 25.5 × 30.5 cm. Dated 8-3-57.

474. Plaque. Other side of No. 471. 25.5 × 30.5 cm. Dated 9-3-57.

475. Plaque. Player, dancer and drinker. 25.5 × 30.5 cm. Dated 7-3-57.

476. Plaque. Other side of No. 475. 25.5 × 30.5 cm. Dated 30-3-57.

477. Plaque. Player, dancer and drinker. 25.5 × 30.5 cm. Dated 11-3-57.

478. Plaque. Player, dancer and drinker. 25.5 × 30.5 cm. Dated 8-3-57.

479. Green, blue and pink plaque. Other side of No. 478. 25.5 × 30.5 cm. Dated 8-3-57.

480. Plaque. Player, dancer and drinker. 25.5 × 30.5 cm. Dated 11-3-57.

481. Plaque. Player, dancer and drinker. 25.5 × 30.5 cm. Dated 7-3-57.

482. Plaque. Other side of No. 481. 25.5 × 30.5 cm. Dated 7-3-57.

483. Plaque. Player, dancer and drinker. 25.5 × 30.5 cm. Dated 11-3-57.

484. Plaque. Drinker, dancer and player. 25.5 × 30.5 cm. Dated 7 and 30-3-57.

485. Plaque. Other side of No. 484. 25.5 × 30.5 cm. Dated 7 and 30-3-57.

486. Plaque. *The Drinkers*. 30.5 × 25.5 cm. Dated 11-1-57 and 10-2-57.

487. Plaque. Bouquet of flowers. 30.5 × 25.5 cm. Dated 5-3-57.

488. Plaque. Other side of No. 487. 30.5 × 25.5 cm. Dated 5-3-57.

489. Tile. Man's bust. 20 × 20 cm. Dated 10-3-57.

490. Plaque. Man's head. 30.5 × 25.5 cm. Dated 11-3-57.

491. Plaque. Two characters. 25.5 × 30.5 cm. Dated 9-3-57.

492. Assembled tiles. Drinkers in an arbour. 61 × 61 cm. Dated 1957.

493. Plaque. Piper. 25 × 25 cm. Dated 25-5-61.

494. Plaque. Dancer with ass. 25 × 25 cm. Dated 27-2-61.

495. Plaque. Ass braying. 25 × 25 cm. Dated 27-2-61.

496. Plaque. Faun with ass. 25.5 × 25.5 cm. Dated 27-2-61, Museum für Kunst und Gewerbe, Hamburg.

497. Plaque. Musician with ass. 25.5 × 25.5 cm. Dated 25-2-61, Museum für Kunst und Gewerbe, Hamburg.

498. Plaque. Musician with ass. 25.5 × 25.5 cm. Dated 25-2-61, Museum für Kunst und Gewerbe, Hamburg.

499. Round plate. Owl on the ground. Diameter 44 cm. Dated 27-3-57.

500. Round plate. Black owl roosting (with owl on the reverse). Diameter 42.5 cm. Dated 7-5-57.

501. Plaque. Other side of No. 503. 25.5 × 25.5 cm. Dated 9-3-57.

502. Plaque. Dance. 23.5 × 15 cm. Dated 1957.

503. Plaque. Player, dancer and drinker against a green, blue and mauve sky. 25.5 × 25.5 cm. Dated 9-3-57.

504. Round plate. Owl on blue ground. Diameter 43.5 cm. Dated 26-3-57.

505. Round plate. Reverse of No. 507, with bull-fight scene. Diameter 42.5 cm. Dated 26-3-57.

506. Round plate. Owl on blue ground. Diameter 45 cm. Dated 27-3-57.

507. Round plate. White owl on blue ground. Diameter 42.5 cm. Dated 26-3-57.

508. Round plate. Owl on blue ground (reverse of No. 504). Diameter 43.5 cm. Dated 26-3-57.

509. Round plate. White and brown owl. Diameter 44.5 cm. Dated 10-3-57.

510. Round plate. Faun with owl, in relief (reverse of No. 512). Diameter 41.5 cm. Dated 28-4-57.

511. Round plate. Owl. Diameter 44 cm. Dated 10-5-57. Museum für Kunst und Gewerbe, Hamburg.

512. Round plate. Faun with owl, in relief. Diameter 41.5 cm. Dated 28-4-57.

513. Round plate. Black owl roosting (other side of No. 515). Diameter 42.5 cm. Dated 7-5-57.

514. Round plate. Red owl on black ground. Diameter 45 cm. Dated 10-5-57.

515. Round plate. Black owl roosting. Diameter 42.5 cm. Dated 7-5-57.

516. Reverse of No. 49 ('Bird and flowers').

517. Round plate. White owl on earth ground. Diameter 43.5 cm. Dated 25-3-57.

518. Round plate. White owl on earth ground (reverse of No. 517). Diameter 43.5 cm. Dated 25-3-57.

519. Round plate. Animal. Diameter 45 cm. Dated 23-3-57.

520. Round plate. Animal (reverse of No. 519). Diameter 45 cm. Dated 23-3-57.

521. Round plate. Bull. Diameter 23.5 cm. Dated 22-1-57.

522. Round plate. Lance-thrust. Diameter 23.5 cm. Dated 22-1-57.

523. Round plate. Bull. Diameter 23 cm. Dated 22-1-57.

524. Round plate. Lance-thrust. Diameter 23 cm. Dated 22-1-57.

525. Plate. *Pase de cabeza*. 66×28.5 cm. Dated 18-6-57, Museum für Kunst und Gewerbe, Hamburg.

526. Round plate. Dead bullfighter. Diameter 23 cm. Dated 22-1-57.

527. Plate. Bullfighters entering the ring. 65.5×28.5 cm. Dated 24-6-57.

528. Round plate. Bull. Diameter 40 cm. Dated 22-1-57.

529. Round plate. Bull. Diameter 40 cm. Dated 22-1-57.

530. Round plate. Sailor. Diameter 45.5 cm. Dated 2-4-57.

531. Round plate. Reverse of No. 530. Diameter 45.5 cm. Dated 2-4-57.

532. Round plate. Fish in relief on black ground. Diameter 45 cm. Dated 12-4-57.

533. Round plate. Clown. Diameter 43 cm. Dated 31-3-57.

534. Round plate. Reverse of No. 533. Diameter 43 cm. Dated 31-3-57.

535. Round plate. Two fish. Diameter 42.5 cm. Dated 14-4-57.

536. Round plate. Clown. Diameter 43.5 cm. Dated 2-4-57.

537. Round plate. Reverse of No. 536. Diameter 43.5 cm. Dated 2-4-57.

538. Round plate. Tray with fruit. Diameter 42.5 cm. Dated 10-5-57.

539. Round plate. Seven fish on earth ground. Diameter 44 cm. Dated 10-4-57.

540. Round plate. Reverse of No. 539. Diameter 44 cm. Dated 10-4-57.

541. Round plate. Two fish in relief on red ground. Diameter 43 cm. Dated 11-4-57.

542. Round plate. Reverse of No. 541. Diameter 43 cm. Dated 11-4-57.

543. Round plate. Three fish on grey ground. Diameter 43 cm. Dated 11-4-57.

544. Round plate. Reverse of No. 543. Diameter 43 cm. Dated 11-4-57.

545. Plate. Fish on pink ground. Diameter 42 cm., depth 6.2 cm. Dated 16-5-57.

546. Round plate. Fish in relief on white ground. Diameter 44 cm. Dated 4-4-57.

547. Round plate. Large black fish. Diameter 42 cm. Dated 16-4-57.

548. Round plate. Reverse of No. 547. Diameter 42 cm. Dated 16-4-57.

549. Round plate. Three fish on white ground. Diameter 43 cm. Dated 13-4-57.

550. Round plate. Three fish. Diameter 44 cm. Dated 11-4-57, Museum für Kunst und Gewerbe, Hamburg.

551. Round plate. Three black fish. Diameter 43 cm. Dated 15-4-57.

552. Round plate. Three fish in black and blue. Diameter 41 cm. Dated 15-4-57.

553. Large dish (turned on the wheel). Miscellany of bulls. Diameter 46 cm., depth 11 cm. Dated 26-1-58.

554. Large hollow dish. Face. Diameter 43 cm., depth 10.8 cm. Dated 30-1-58.

555. Round plate in colour. Face in thick relief in white earthenware. Diameter 42 cm. Dated 11-6-59, original print, edition.

556. Rounded square plate in colour. Face with square eyes in white earthenware (same piece as No. 559). Diameter 24 cm. Dated 29-6-59, original print, edition.

557. Rounded square plate in colour. Bearded face in white earthenware. Diameter 24 cm. Dated 29-6-59, original print, edition.

558. Large panel. Circus scenes painted on background of tiles. 94×174 cm. Dated 6-12-57, Jean and Huguette Ramié Collection.

559. Rounded square plate in colour. Face with pinched nose in white earthenware. Diameter 24 cm. Dated 29-6-59, original print, edition.

CORRIDA *SERIES*

560. Round plate. *Paseo*, black decoration on ochre earthenware. Diameter 42 cm. Dated 1-7-59, original print, edition.

561. Round plate. *Banderillas*, black decoration on ochre earthenware. Diameter 42 cm. Dated 1-7-59, original print, edition.

562. Round plate. *Picador*, black decoration on ochre earthenware. Diameter 42 cm. Dated 1-7-59, original print, edition.

563. Round plate. *Pase de muleta*, black decoration on ochre earthenware. Diameter 42 cm. Dated 1-7-59, original print, edition.

564. Round plate. *Pase de capa*, black decoration on ochre earthenware. Diameter 42 cm. Dated 1-7-59, original print, edition.

565. Round plate. *Estocada*, black decoration on ochre earthenware. Diameter 42 cm. Dated 1-7-59, original print, edition.

566. Round plate. *Arrastre*, black decoration on ochre earthenware. Diameter 42 cm. Dated 1-7-59, original print, edition.

567. Round plate. *Cogida*, black decoration on ochre earthenware. Diameter 42 cm. Dated 1-7-59, original print, edition.

568. Spanish plate, turned on the wheel. Frieze of centaurs on ochre earthenware. Diameter 40.5 cm., depth 5.5 cm. Dated 23-11-59.

CORRIDA *SERIES*. Same print as Nos. 560 to 567

569. Round plate. *Paseo*, polychrome decoration on white earthenware. Diameter 42 cm. Same print as No. 560, edition.

570. Round plate. *Estocada*, polychrome decoration on white earthenware. Diameter 42 cm. Same print as No. 565, edition.

571. Round plate. *Cogida*, polychrome decoration on white earthenware. Diameter 42 cm. Same print as No. 567, edition.

572. Round plate. *Banderillas*, polychrome decoration on white earthenware. Diameter 42 cm. Same print as No. 561, edition.

573. Round plate. *Picador*, polychrome decoration on white earthenware. Diameter 42 cm. Same print as No. 562, edition.

574. Round plate. *Pase de capa*, polychrome decoration on white earthenware. Diameter 42 cm. Same print as No. 564, edition.

575. Round plate. *Pase de muleta*, polychrome decoration on white earthenware. Diameter 42 cm. Same print as No. 563, edition.

576. Round plate. *Arrastre*, polychrome decoration on white earthenware. Diameter 42 cm. Same print as No. 566, edition.

577. Round plate in colour. Picador and bull in thick relief, white earthenware. Diameter 42 cm. Dated 1959, original print, edition.

578. Turned and modelled form. Woman's head, painted. Height 24 cm., total width 19 cm. Incised in 1954, painted in 1961, signed and dedicated to Mme. Ramié.

579. Deep plate. Decorated. Diameter 29 cm. Signed and dedicated to Mme. Ramié.

580. Turned and modelled form. Woman's head crowned with flowers in polychrome paint. Height 24 cm., total width 19 cm. Variation on No. 578 (with more colouring), signed and dedicated to Mme. Ramié.

581. Reverse of No. 579. Signed and dedicated 'Pour Suzanne Ramié son fidèle sujet Picasso. Son élève'. Dated 12-10-61.

582. Another view of Nos. 578 and 580.

583. Round plate in colour. Dishevelled woman on white earthenware. Diameter 26 cm. Dated 20-8-63, original print, edition.

584. Two-handled vase. Large bird. 59 × 41 × 44 cm. Dated 14-2-61.

585. Other side of No. 587.

586. Base of No. 587 (showing dedication).

587. Turned and modelled piece. Bird in white clay. Height 20 cm., length 28 cm. Dated 13-2-62. Signed and dedicated 'Pour Suzanne Ramié. Son ami Picasso'.

588. Fragment of brick. Face. 22 × 13 × 9.5 cm. Dated 12-7-62.

589. Fragment of brick. Face. Height 13 cm. Dated 19-7-62.

590. Fragment of brick. Face. 14 × 13 cm. Dated 17-7-62.

591. Fragment of brick. Face. Height 19 cm. Dated 19-7-62.

592. Fragment of brick. Woman's face. 22 × 12 × 8 cm. Dated 14-7-62.

593. Fragment of brick. Face. Dated 19-7-62.

594. Fragment of brick. Face. 22 × 12.5 × 8.5 cm. Dated 17-7-62.

595. Fragment of brick. Face. Dated 19-7-62.

596. Fragment of brick. Face. Dated 19-7-62.

597. Fragment of brick. Face. Dated 19-7-62.

598. Fragment of brick. Woman's face. Height 15 cm. Dated 17-7-62.

599. Fragment of brick. Face. Dated 19-7-62.

600. Fragment of brick. Face. Dated 12-7-62.

601. Roofing tile. Face. Dated 19-7-62.

602. Jagged fragment of brick. Face. 22 × 13 × 9.5 cm. Dated 12-7-62.

603. Roofing tile. Face. Dated 19-7-62.

604. Plaque in pitted clay. Jacqueline with long neck. 26.5 × 22.5 cm. Dated 10-7-62.

605. Plaque in pitted clay. Jacqueline on a russet ground. 26.5 × 22.5 cm. Dated 11-6-62.

606. Plaque in pitted clay. Bust of woman. 26.5 × 22.5 cm.

607. Plaque in pitted clay. Man with long hair. 26.5 × 22.5 cm. Dated 26-5-62-II.

608. Curved brick. Character. Dated 19-7-62.

609. Plaque in pitted clay. Jacqueline in a hat. 26.5 × 22.5 cm. Dated 10-7-62.

610. Plaque. Two figures with a dog. 26.5 × 22.5 cm: Dated 25-5-62.

611. Plaque in pitted clay. Woman's head. 26.5 × 22.5 cm. Dated 10-6-62.

612. Plaque in pitted clay. Incised head. 26.5 × 22.5 cm. Dated 11-6-62.

613. Plaque in pitted clay. Jacqueline framed in yellow. 26.5 × 22.5 cm. Dated 10-6-62-IV.

614. Plaque in pitted clay. Jacqueline in blue shadow. 26.5 × 22.5 cm. Dated 10-6-62-V.

615. Plaque in pitted clay. Jacqueline with a grey bandeau. 26.5 × 22.5 cm. Dated 10-6-62.

616. Plaque in pitted clay. Jacqueline in a pink dress. 26.5 × 22.5 cm. Dated 11-6-62.

617. Plaque in pitted clay. Jacqueline with a chignon. 26.5 × 22.5 cm. Dated 13-6-62.

618. Plaque in pitted clay. Jacqueline in cameo. 26.5 × 22.5 cm. Dated 11-6-62.

619. Plaque in pitted clay. Man in a ruff. 26.5 × 22 cm. Dated 26-5-62.

620. Plaque in pitted clay. Jacqueline with long hair. 26.5 × 22.5 cm. Dated 4-7-62.

621. Tile. Erotic scene.

622. 4 tiles. Erotic scenes. 16.5 × 19 cm. Dated 14-8-62.

623. Tile. Erotic scene. 16.5 × 19 cm. Dated 14-8-62.

624. Tile. Erotic scene. 16.5 × 19 cm. Dated 14-8-62.

625. Tile. Erotic scene. 16.5 × 19 cm. Dated 14-8-62.

626. Tile. Erotic scene. 16.5 × 19 cm. Dated 14-8-62.

627. 4 tiles. Erotic scenes.

628. Composition on two planes. Face. 22 × 16 × 8 cm. Dated 12-7-62.

629. Roman tile. Face. 50.7 × 22 cm. Dated 31-7-63.

630. Large decorative panel composed of 12 glazed tiles. Composition: man and woman. Dimensions of each tile: 25 × 25 cm. Dated 15-6-63.

631. Roman tile. Face. 22 × 48.2 cm. Dated 31-7-63.

632. Round plate in colour. Cubist face in white earthenware. Diameter 42 cm. Dated 6-10-60, original print, edition.

633. Rectangular plaque. Small female bust in pink earthenware. Height 33 cm., width 25 cm. Dated 1964, print on original linocut, edition.

634. Rectangular plaque. Woman with fluffy hair in pink earthenware. Height 33 cm., width 25 cm. Dated 1964, print on original linocut, edition.

635. Rectangular plaque. Woman with flowered hat in pink earthenware. Height 33 cm., width 25 cm. Dated 1964, print on original linocut, edition.

636. Rectangular plaque. Small crowned female head in pink earthenware. Height 33 cm., width 25 cm. Dated 1964, print on original linocut, edition.

637. Plaque in pink clay. Still life, painted.

638. Rectangular plaque. Glass under lamp, in pink earthenware. Height 33 cm. Dated 1964, print on original linocut, edition.

639. Large rectangular plaque in colours. Woman's head in trimmed hat, pink earthenware. Height 60 cm., width 50 cm. Dated 1964, print on original linocut, edition.

640. Large rectangular plaque. *Le déjeuner sur l'herbe*, in pink earthenware. Height 50 cm., length 60 cm. Dated 1964, print on original linocut, edition.

641. Large round plate. Face seen in three-quarter profile in white earthenware. Diameter 42 cm. Dated 17-1-65, original print, edition.

642. Large round plate. Face seen full-face in white earthenware. Diameter 42 cm. Dated 17-1-65, original print, edition.

643. Square plaque in colour. Owl's head in pink earthenware. 21.5 × 21.5 cm. Dated 12-68, print on original linocut, edition.

644. Square plaque in colour. Face with slanting features in pink earthenware. 21.5 × 21.5 cm. Dated 12-68, print on original linocut, edition.

645. Square plaque in colour. Head of man with long hair in pink earthenware. 31 × 31 cm. Dated 12-68, print on original linocut, edition.

646. Square plaque in colour. Face with green nose in pink earthenware. 21.5 × 21.5 cm. Dated 12-68, print on original linocut, edition.

647. Square plaque in colour. Pink earthenware. Same print as No. 645. 31 × 31 cm. Dated 12-68, edition.

648. Square plaque in colour. Cubist face with white stains in pink earthenware. 21.5 × 21.5 cm. Dated 12-68, print on original linocut, edition.

649. Six incised tiles with polychrome painting. Dated December 1968, original prints, edition.

650. Square plaque in colour. Woman's face (*Pomona*) in pink earthenware. 31 × 31 cm. Dated 12-68, print on original linocut, edition.

651. *Gus* (typical Provençal piece). Painted and incised (wood-fired kiln). Single piece, signed and dedicated 'Pour Mme. Ramié'.

652. Reverse of No. 651.

653. Group of three plaques.

654. Square plaque in colour. Face surrounded by ringlets in pink earthenware. 31 × 31 cm. Dated 12-68, print on original linocut, edition.

655. Square plaque in colour. Face surrounded by ringlets in pink earthenware (same piece as No. 654, with different colouring). 31 × 31 cm. Dated 12-68, print on original linocut, edition.

656. Square plaque in colours. Lion's head in pink earthenware. 31 × 31 cm. Dated 12-68, print on original linocut, edition.

657. Square plaque in colour. Lion's head in pink earthenware. 31 × 31 cm. Dated 12-68, print on original linocut, edition.

658. Square plaque in colour. Face with slanting features in pink earthenware. 21.5 × 21.5 cm. Dated 12-68, print on original linocut, edition.

659. Square plaque in colour. Dark Neptune in pink earthenware. 21.5 × 21.5 cm. Dated 12-68, print on original linocut, edition.

660. Square plaque in colour. Face with goatee in pink earthenware. 31 × 31 cm. Dated 12-68, print on original linocut, edition.

661. Square plaque in colour. Man's face in pink earthenware. 31 × 31 cm. Dated 12-68, print on original linocut, edition.

662. Rectangular plaque. Woman's face and 5 potter's marks on pink earthenware. 31.5 × 28 cm. Dated 13-3-71, original print, edition.

663. Rectangular plaque. Figure with curves and 7 potter's marks on pink earthenware. 31.5 × 27 cm. Dated 13-3-71, original print, edition.

664. Rectangular plaque. Face with round nose and 4 potter's marks on pink earthenware. 31.5 × 27 cm. Dated 13-3-71, original print, edition.

665. Rectangular plaque. Figure with triangle and 8 potter's marks on pink earthenware. 31.5 × 27 cm. Dated 13-3-71, original print, edition.

666. Rectangular plaque. Face with four little faces in potter's marks on pink earthenware. 31.5 × 27 cm. Dated 13-3-71, original print, edition.

667. Rectangular plaque. Face with ruff and 4 potter's marks on pink earthenware. 31.5 × 27 cm. Dated 13-3-71, original print, edition.

WORKS IN SERIES

668. Rectangular plate. Face in two colours. 32 × 38 cm. Dated 1947, series finished.

669. Rectangular plate. Incised face. 32 × 38 cm. Dated 1947, series.

670. Rectangular plate. Face incised and painted. 32 × 38 cm. Dated 1947, series.

671. Rectangular plate. Bull incised and painted. 32 × 38 cm. Dated 1947, series.

672. Rectangular plate. Face painted on brushed ground. 38 × 38 cm. Dated 1948, series.

673. Fish service comprising 26 pieces. Round dish: diameter 38 cm. Bowls: diameter 19 cm. Plates: diameter 22 cm. Soup tureen: diameter 32 cm. Dated 1947, series.

674. 8 plates and 1 large square serving dish: *Fruits de Provence*. Polychrome decoration. Dated 1948, series.

675. Black service: *Visages* (13 pieces). Serving dish: diameter 42 cm. Plates: diameter 24.5 cm. Dated 1948, series.

676. Rectangular plate. *Bull in ring*. 32 × 38 cm. Dated 1948, series.

677. Rectangular plate. Sardines, incised and painted. Dated 1948, series.

678. Plate from the black service *Visages*. Diameter 24.5 cm. Dated 1948, series.

679. Serving dish from the black service *Visages*. Diameter 42 cm., series.

680. Rectangular plate. Dove incised and painted (1st version). 32 × 38 cm. Dated 1948, series.

681. Rectangular plate. Dove with light on the right. 32 × 38 cm. Dated 1949, series.

682. Rectangular plate. Picador in polychrome decoration. 32 × 38 cm. Dated 1949, series.

683. Two small jugs. Decoration of owls. Height 13 cm., diameter 14 cm. Dated 1949, series.

684. Rectangular plate. Incised face. Height 38.5 cm., width 31 cm., series.

685. Rectangular plate. Incised face. Height 38.5 cm., width 31 cm., series.

686. Round plate. Landscape. Diameter 42 cm., series.

687. Round bowl. Figures. Height 11.5 cm., diameter 27 cm., series.

688. Plate. Face with polychrome decoration in glazes. Diameter 25 cm. Dated 1953, series.

689. Large vase. Female nudes in pink earthenware. Height 67 cm., diameter at bulge 38 cm. Dated 1950, series.

690. Large vase. Dancers and musicians in pink earthenware. Height 72 cm., diameter at bulge 34 cm. Dated 1950, series.

691. Large vase. Women with draperies in pink earthenware. Height 65.8 cm., diameter 32 cm. Dated 1950, series.

692. Large form. Decorated with woman's face. Length 52 cm., height 42 cm. Dated 1951, series.

693. Large bird. *Double visage*. Height 56 cm., width 41 cm., length 42 cm. Dated 1951, series.

694. Ice-jug. *Visage*. Height 31 cm., width 21 cm., length 37 cm., series.

695. Ice-jug. *Visage*. Height 31 cm., width 21 cm., length 37 cm., series.

696. Large rounded square plate. Goat's head in profile. Dated 1952, series.

697. Large rounded square plate. Goat's head in profile (same print as No. 403), coloured variation, series.

698. Large rounded square plate. Goat's head in profile (same print as No. 403), coloured variation, series.

699. Small vase. *Chouetton*. Height 25 cm., width 11 cm. Dated 1952, series.

700. Vase. *Chouette ébouriffée*. Height 30 cm., width 13 cm., series.

701. Vase. *Visage gravé noir*. Height 34.5 cm., width 20 cm. Dated 24-12-53, series.

702. Gothic jug. *Visage de femme*. Height 30 cm., total width 28 cm. Dated 7-7-53, series.

703. Same piece as No. 704 (other side).

704. Gothic jug. Decorated with birds. Height 30 cm., width 27 cm. Dated 10-4-53, series.

705. Formed piece. *Owl* in pink and black. Height 32 cm., length 30 cm., width 21 cm. Dated 1953, series.

706. Vase Owl in matt finish on russet ground. Height 26.5 cm., width 20 cm., series.

707. Jug. *Cavalier et cheval*. Height 30 cm., width 13 cm., series.

708. Large bird. *Corrida* decoration (Profile and back). Height 56 cm., width 41 cm., length 42 cm. Dated 22-6-53, series.

709. Large bird. Same piece as No. 708 (Face).

710. Jug. Black decoration on pink ground, *Chien*. Height 25.5 cm., width 15.5 cm., series.

711. Jug. 'Owl' decoration. Height 26 cm., width 19 cm., series.

712. Group of three pieces. Left: bird jug. Length 29 cm., height 20 cm. Dated 4-4-53. Series. Centre: bird jug. Turned and modelled. Length 22 cm., height 16 cm. Series. Right: jug with painted decoration. Length 24 cm., height 21 cm., series.

713. Two large birds. Left: same piece as No. 739. Right: same piece as No. 708, series.

714. Rectangular plate. *Corrida* on black ground, width 31 cm., length 38.5 cm. Dated 25-9-53, series.

715. Two vases. *Personnage avec mains sur les hanches*. Height 38 cm., diameter 22.5 cm. Series. 2 versions: 1st version on the left, 2nd version on the right.

716. Plate. Polychrome decoration with glazes. Little faces. Diameter 25 cm. Dated 1953, series.

717. Round bowl in colour. Hands on fish in pink earthenware (coloured variation on No. 276). Diameter 31.5 cm. Dated 1953, series.

718. Jug. Owl and profiles incised and painted. Height 29 cm., total width 26 cm, series.

719. Same piece as No. 718 (other side).

720. Jug. *Visage* in matt finish. Height 34 cm., width 25 cm. Dated 10-7-53, series.

721. Jug. *La Source*. Height 29 cm., width 24 cm. Dated 11-1-54, series.

722. Jug. Animal form with notifs painted and patinated. 35 × 31 cm., series.

723. Incised wine-jug. Height 44 cm., width 15.5 cm. Dated 1954, series.

724. Spherical jug. Decorated with bull. Height 29 cm., total width 24.5 cm. Dated 29-3-55, series.

725. Same piece as No. 724 (other side).

726. Rectangular plate. Owl incised and painted. 32 × 38 cm. Dated 1955, series.

727. Rectangular plate. Bouquet incised and painted. Dated 29-3-35. Dedicated to Mme. Georges Ramié, series.

728. Rectangular plate. Grey face. Height 32 cm., length 38 cm. Dated 1955, series.

729. Large round plate with border. Sleeping face in white earthenware. Diameter 42 cm. Dated 1956, series.

730. Vase. Aztec form with four faces. Height 52 cm., width 28 cm., series.

731. Formed piece. *Aztèque aux quatre visages*. Height 52 cm., width 28 cm. Dated 1957, series.

732. Rectangular plate. Dance. Width 31 cm., length 38.5 cm. Dated 1-8-57, series.

733. Large plate. Landscape. Diameter 42 cm. Dated 1957-1958, series.

734. Oval vase. Same piece as No. 735 ('owl' side).

735. Oval vase. 'Face' side. Height 24 cm., width 23.5 cm. Dated 1958, series.

736. Vase *Arènes*. Height 32 cm., diameter 22 cm. Dated 1958, series.

737. Formed piece. Owl decoration with painted features. Height 29.5 cm., width 15.5 cm. Dated 1958, series.

738. Rectangular plate. Decorated with polychrome owl. 32 × 38 cm. Dated 1959, series.

739. Large green bird. Height 56 cm., width 41 cm., length 42 cm. Dated 1960, series.

740. Two different jugs. Women painted in engobe. Height 30.5 cm, width 11 cm. Dated 1961, series.

741. Jug. Decorated with birds. Height 32 cm., width 23 cm. Dated 1962, series.

742. Rectangular plate. Goat's head in profile (same print as No. 401). Height 31 cm., length 51 cm. Dated 5-6-62, series.

743. Series of 17 plates. Polychrome decoration. Diameter 25 cm. Dated 1963, series.

744. Profile of Jacqueline. Same print as No. 425, but using a different process on a dark ground, series.

745. Beach scene. Same print as No. 424, but using a different process on a dark ground, series.

746. Two turned forms. Women. Height 27 cm., width 18 cm. Dated 1961, series.

747. Three sculptures in white clay. Characters. Left: height 28 cm., width 9 cm. Centre: height 32 cm., width 30 cm. Right: height 28 cm., width 10 cm., series.

748. Original engraving with roller on terracotta. Bullfight scene, series.

749. Two jugs. Black decoration on pink clay. Height 25.5 cm., width 15.5 cm. Dated 1963, series.

750. Jug with painted decoration. *Tête de femme*. Height 23.5 cm., total width 18 cm., series.

751. Plate. Face. Diameter 23 cm. Dated 1963, series.

752. Plate. Bird in flight. Diameter 25 cm. Dated 5-63, series.

753. Series of 33 plates. Different subjects in polychrome paint. Diameter 25 cm. Dated 1963, series.

754. Plate. White bird on grey ground. Diameter 25 cm. Dated 1963, series.

755. Plate. White bird. Diameter 25 cm. Dated 5-1963, series.

756. Rectangular plate. Polychrome bird. Height 31 cm., length 38.5 cm. Dated 1967, series.

757. Vase in the shape of an owl. Height 31 cm., width 21 cm., length 25 cm. Dated 1969, series.

758. Spherical jug. *Visage*. Height 32 cm., width 25.5 cm. Dated 1969, series.

759. Gothic jug. *Visage aux points*. Height 30 cm., total width 28 cm. Dated 1970, series.